W9-BEO-212

AMERICAN LANDSCAPE

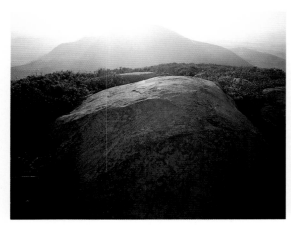 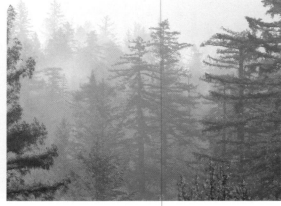 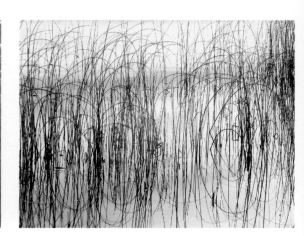

Mountains *Forests* *Grasslands*

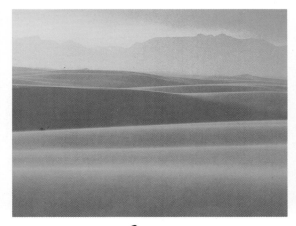
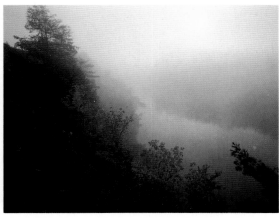
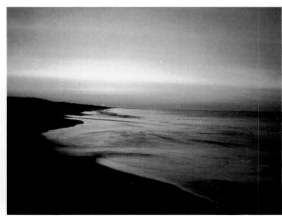

Deserts *Wetlands + Rivers* *Coastlines*

AMERICAN
LANDSCAPE

PHOTOGRAPHY BY
DAVID MUENCH

TEXT BY
T. H. WATKINS

ARROWOOD
PRESS

NEW YORK

Copyright © 1987 by Graphic Arts Center Publishing Company

All rights reserved. No part of this work may be reproduced or
transmitted in any form or by any means, electronic or mechanical,
including photocopying, recording, or any information storage and
retrieval system, without permission in writing from
Graphic Arts Center Publishing Company
P.O. Box 10306, Portland, Oregon 97296-0306

First Arrowood Press edition published in 1997.

Arrowood Press
A division of BBS Publishing Corporation
386 Park Avenue South
New York, NY 10016

Arrowood Press is a registered trademark of BBS Publishing Corporation.

This edition published by arrangement with Graphic Arts Center Publishing Company

Editor-in-Chief: Douglas A. Pfeiffer
Art Director: Robert Reynolds
Designer: Bonnie Muench
Typographer: Harrison Typesetting, Inc.

Library of Congress Catalog Card Number: 97-73070
ISBN: 0-88486-186-4

Printed in China

To the American land,
and to those who care
for its preservation.

PHOTOGRAPHING THE AMERICAN LANDSCAPE
By David Muench
A Personal Odyssey Through Nature
PREFACE

America is blessed with a spectacular array of land forms, vegetation, and climates. I have chosen this collection of photographs to celebrate our diverse American landscape—the unspoiled and pristine locations that are my constant subject. My thoughts are shared here to communicate what I feel when creating these images, surrounded and immersed in the landscape.

The power, the mystery, and the beauty of nature are my inspiration. To seek out places unchanged since creation, to explore my responses to the world around me—these are essential to my very existence. This need for beauty in our landscape is for me a lifetime search for an identity.

To retain what constantly slips away—a timeless moment, ever changing—is a challenge in this primal landscape. The photographs are, for me, reference points along a pathway, glimpses of a universe everyone shares together on this delicate, revolving earth. Fortunately, the camera—and the photographic process—serves as the critical and important medium to these fleeting glimpses of a landscape filled with natural rhythms, opposites, tolerances, mysteries, and clues. The camera serves faithfully, whether it is a Linhof Teknika 4 × 5, my primary field camera, or a Leica 35mm format.

Sensitive and perceptive images can be conveyed in numerous ways: by metaphor, by symbol, by transitory moments, or by essence (direct perception of Nature's communication). Working with those transitory moments which pass over the land has been my primary direction. These are the decisive instants when Nature speaks to us of powerful changes brought about through the millennia of time. The first ray of warm sunlight after a brutal storm, the flicker of an ephemeral rainbow, and great waterfalls on canyon walls after a heavy rain are but a few examples. Light . . . and an intense perception and awareness, an intuition for tuning in to the cycles of Nature's forces—these are the illusive tools I work with to create photographs. However, the essence of things perceived has always tugged at my photographing directions. To work with the essence of the great forces of the unknown, to attempt affirmation and harmony with those forces is a never-ending quest for the unattainable.

I cannot imagine anything richer or more varied than the American landscape. The West is expansive, dramatic, elemental in contrast to the quieter, softer, more forgiving environments of the Midwest, the South, and the East. The same processes occur in each region, but subject and vision demand sensitive approaches, diverse patterns, and new discoveries. Subject is made up of coastline, forest, mountain, grassland, desert, and wetlands. I have attempted to absorb and understand the unique elements flourishing in each region before conveying impressions of our landscape in the photographs.

Climbing up high rocky places or down deep canyons, sloshing through cold swamp waters, or sitting quietly by a reflective Alpine pool for hours has played a most critical role in the making of these photographs. A distinct perception of distance, a solid middle ground of shapes and form, and a heightened impression of foreground are qualities I continually work with to communicate that special sense of each place.

If you really wish to know our land and grasp its complexities and the fluid qualities of life itself, you must walk, observe, and touch; you must notice the flowers and be aware of the delicate lichens, which also live. They will suggest the possibility of sudden accesses of delight, insight, beauty, and joy that will entice you to keep searching and reward you for looking. They can serve as spiritual landmarks in a pilgrimage on earth that each one alone must undertake.

Mountains

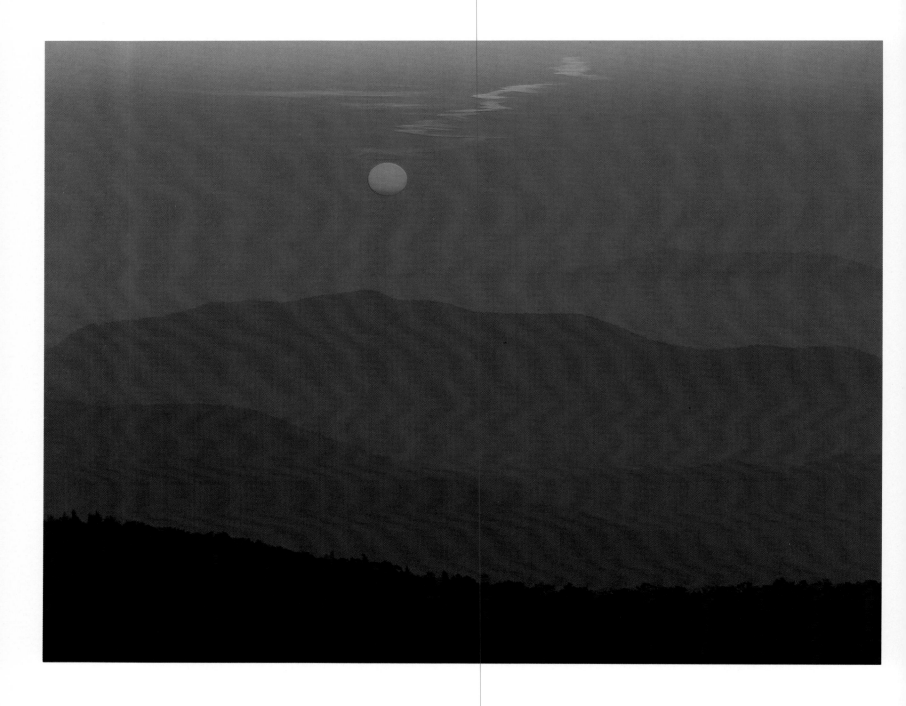

Ridge of dawn, Blue Ridge Mountains, North Carolina

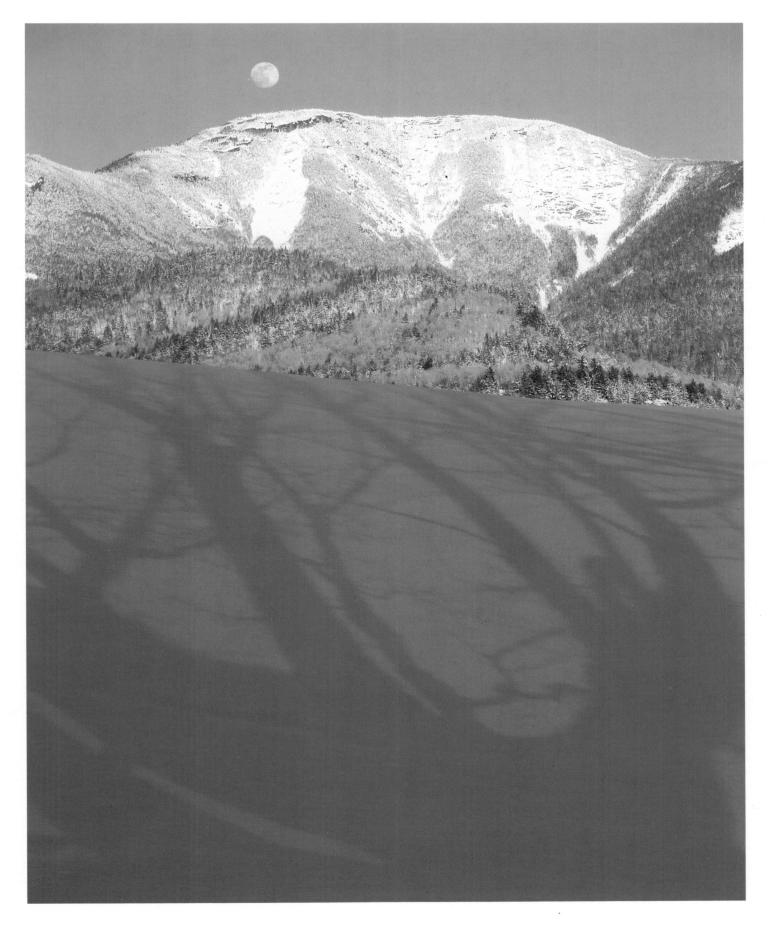

Above: Moonrise and Giant Mountain, Adirondack Mountain Park, New York

Overleaf: Passing storm from Roan Cliffs, Roan Mountain, Tennessee/North Carolina

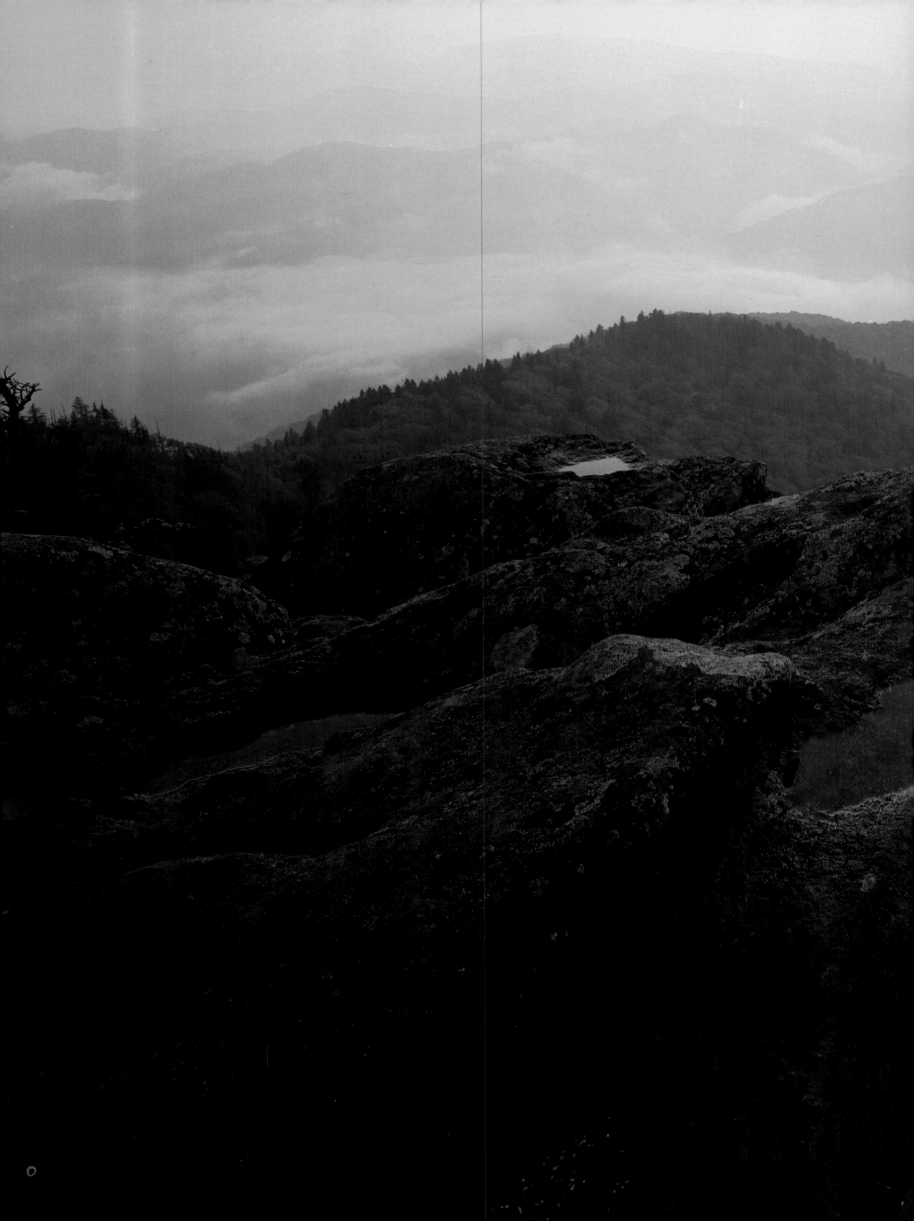

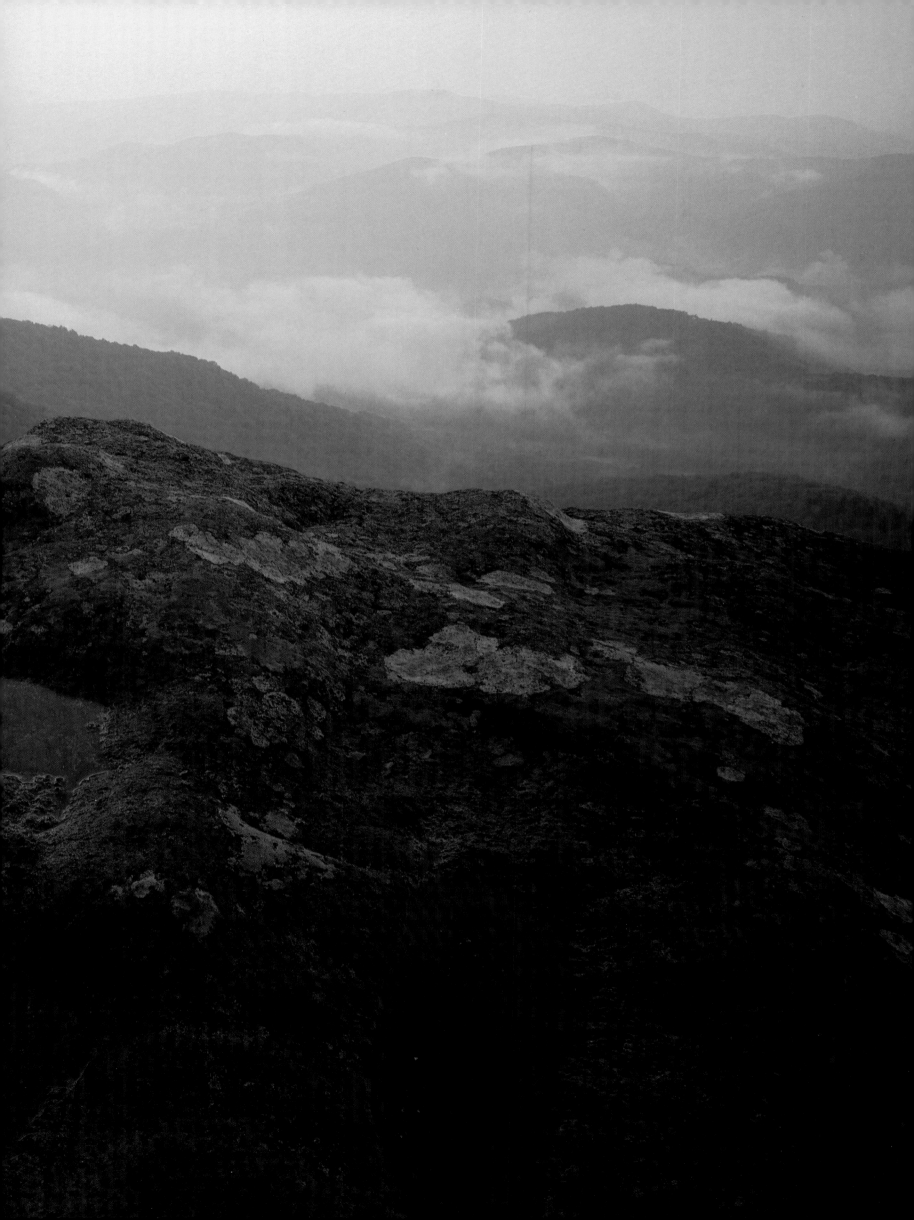

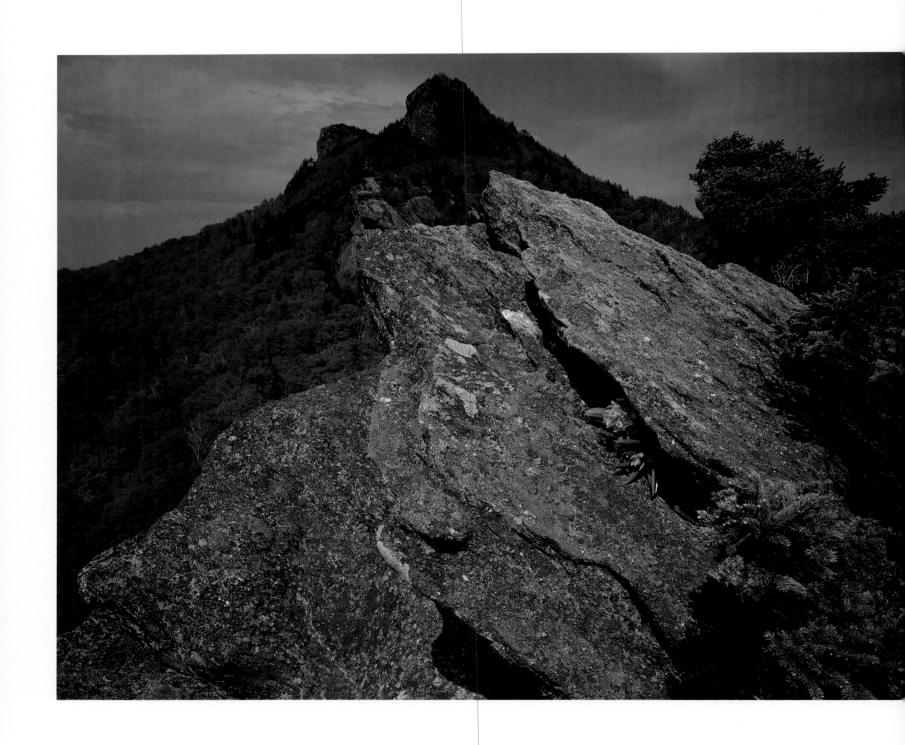

Linville Bluffs, Grandfather Mountain, North Carolina

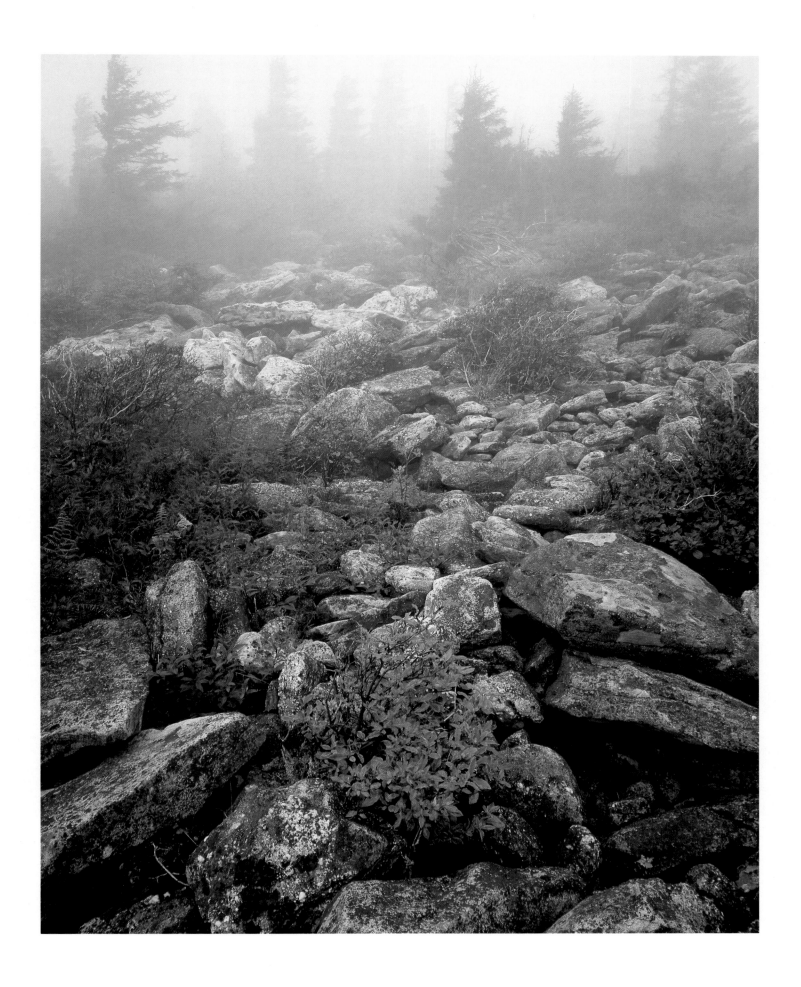

October storm over Spruce Knob Top, West Virginia

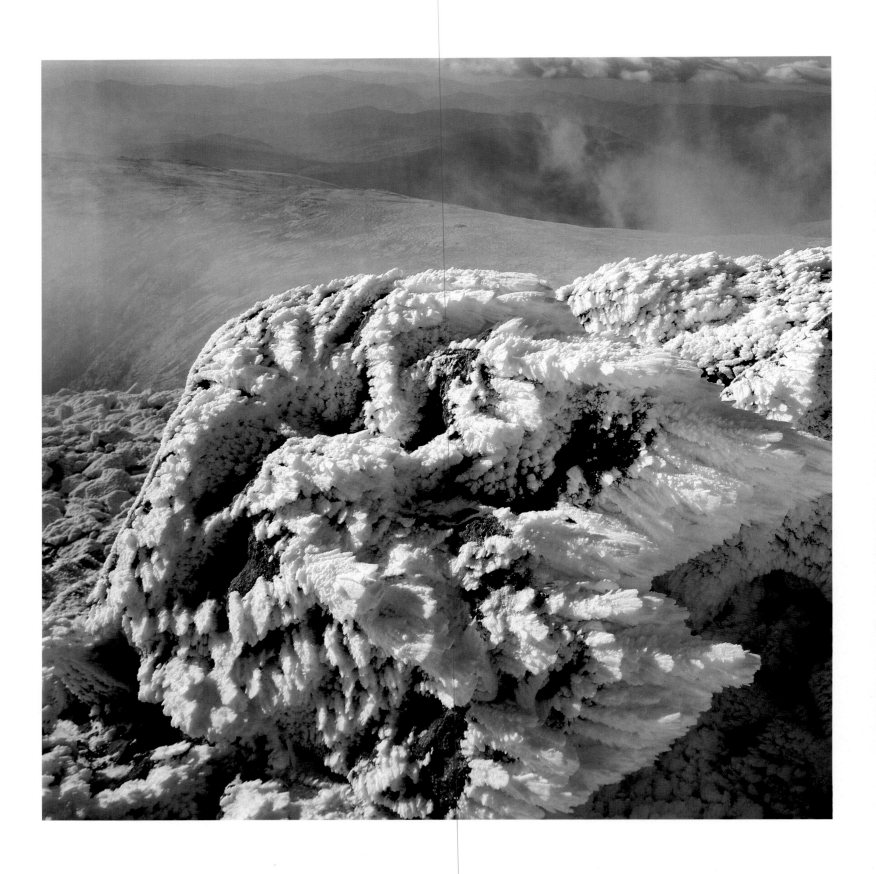

Iced toprock, Mount Washington, Presidential Dry River Wilderness, New Hampshire

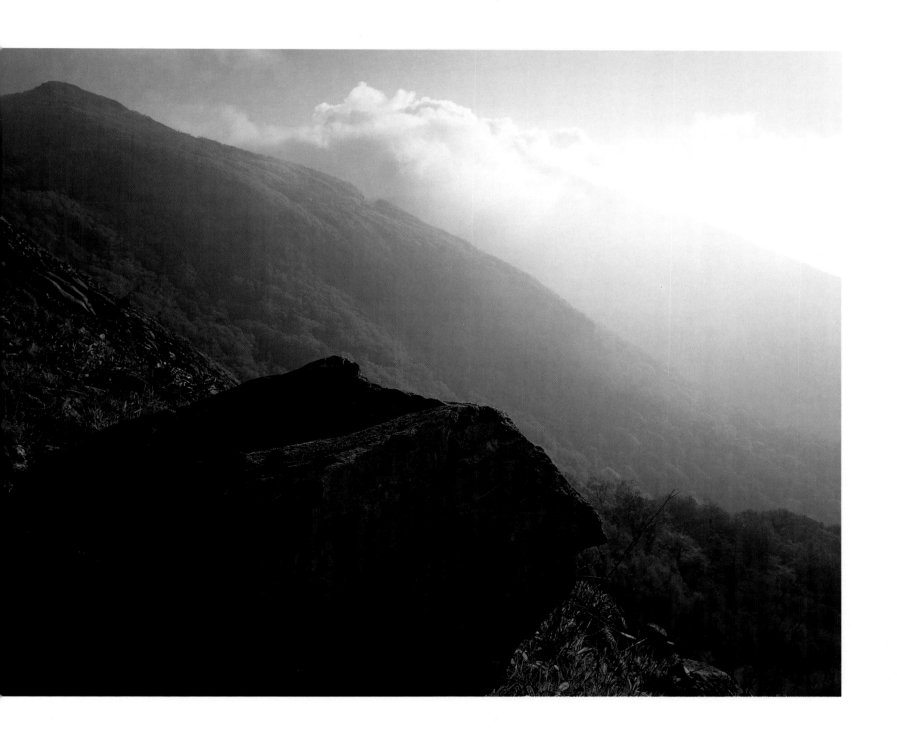

Mount Mitchell and ridges of the Black Range, North Carolina

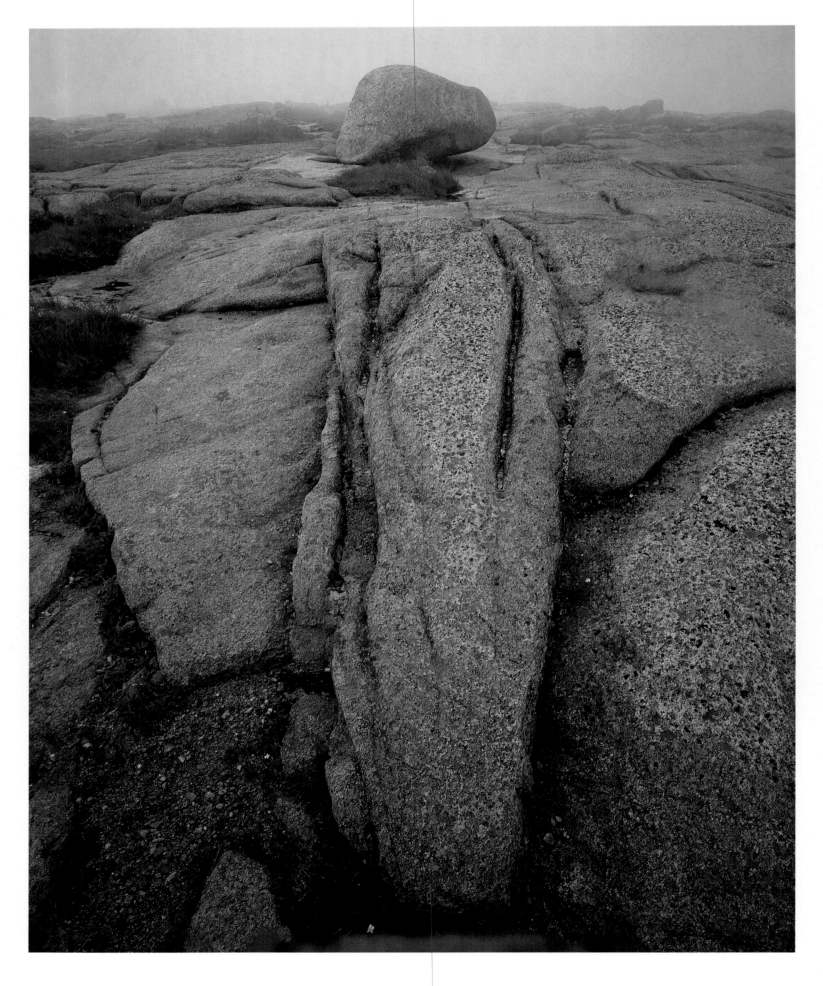

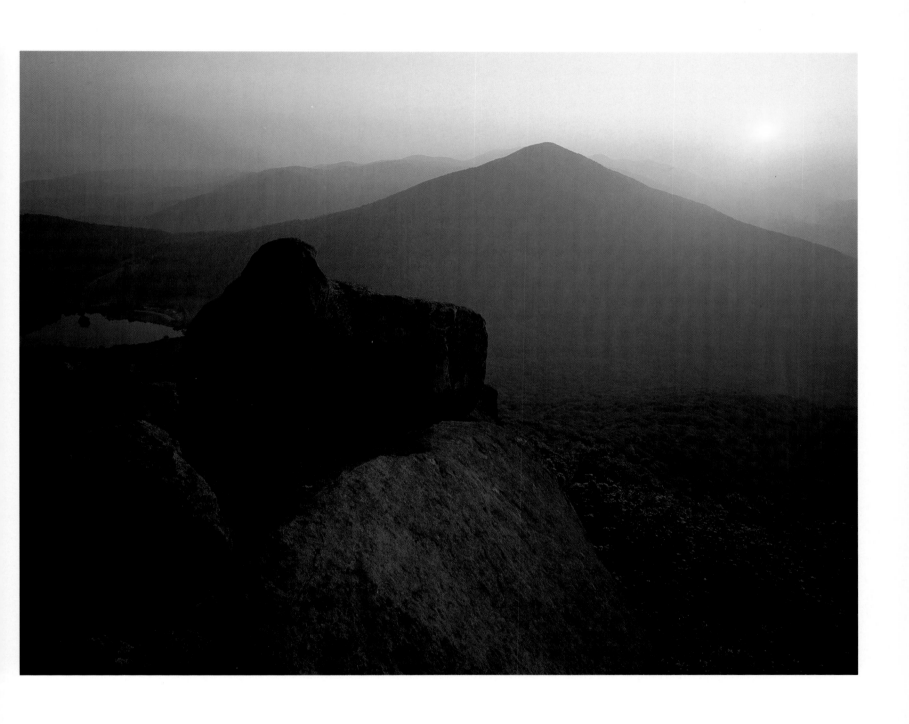

Left: Granite forms and glacial erratic, Cadillac Mountain, Acadia National Park, Maine

Above: Peaks of Otter, Blue Ridge, Virginia

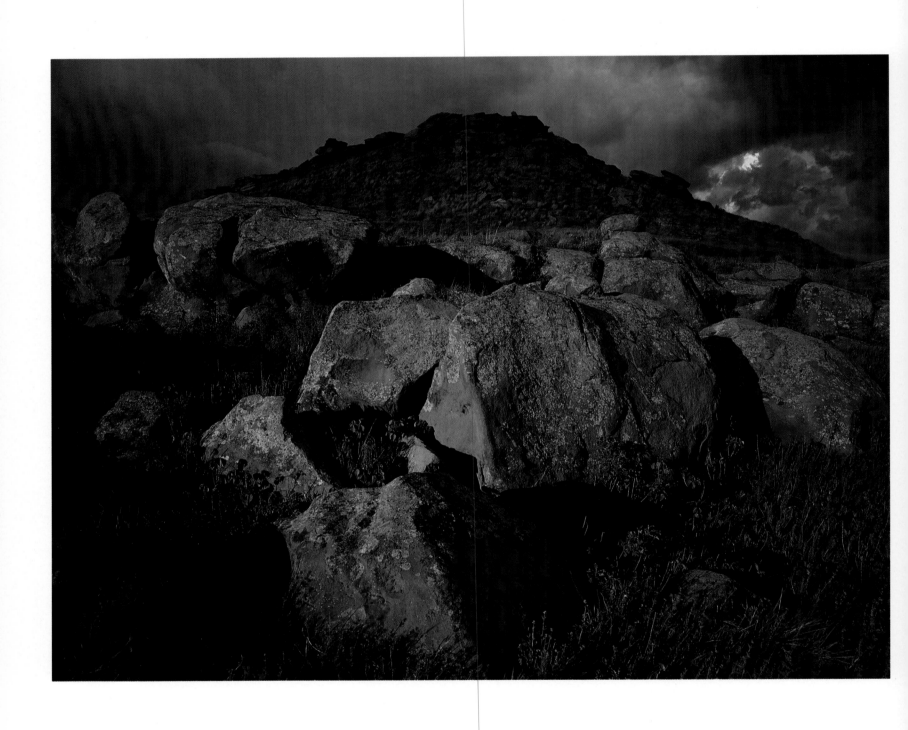

Rock outpost, Little Missouri National Grasslands, North Dakota

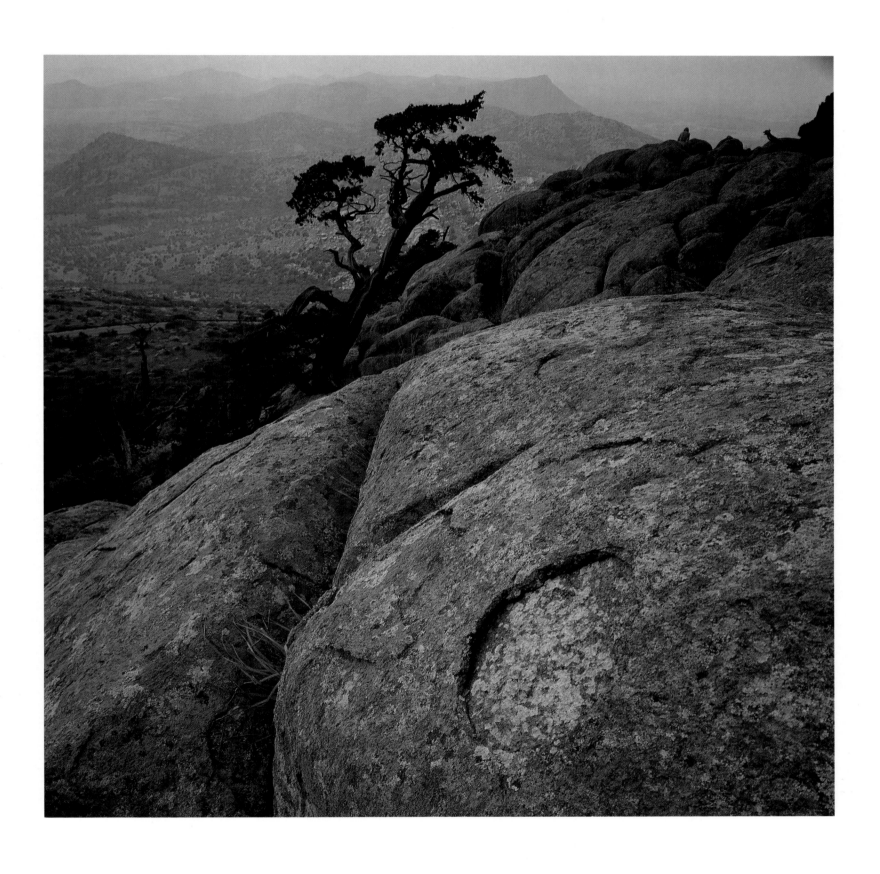

Ancient granite domes, Wichita Mountains National Wildlife Refuge, Oklahoma

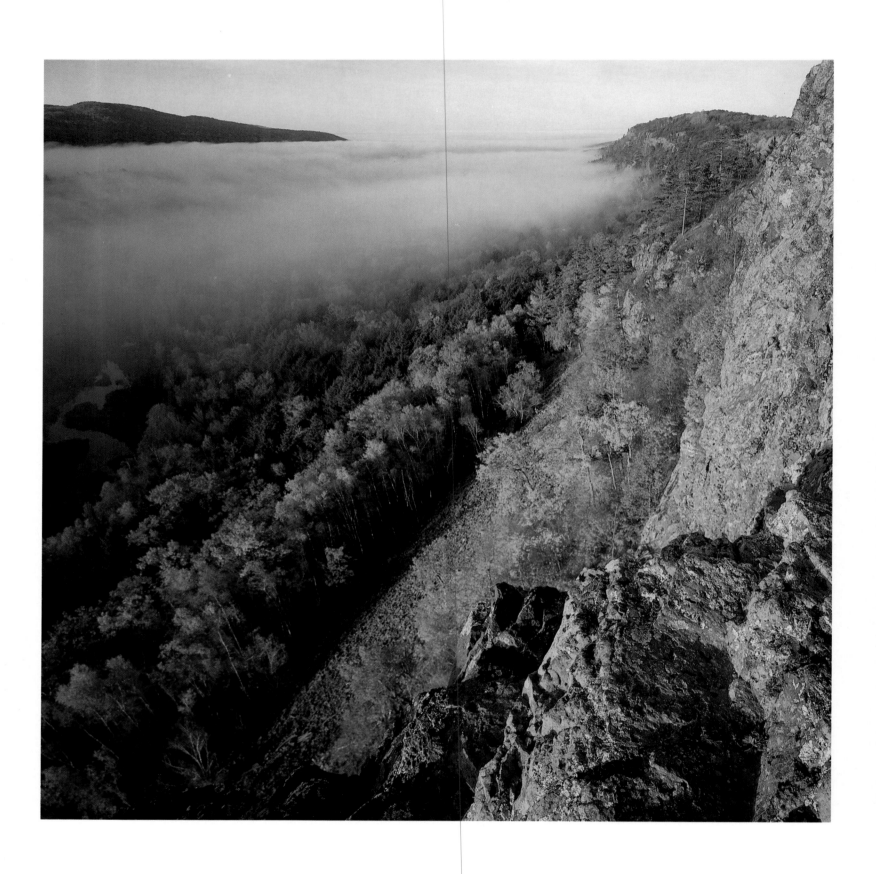

Morning fog, Porcupine Mountains Wilderness State Park, Upper Peninsula, Michigan

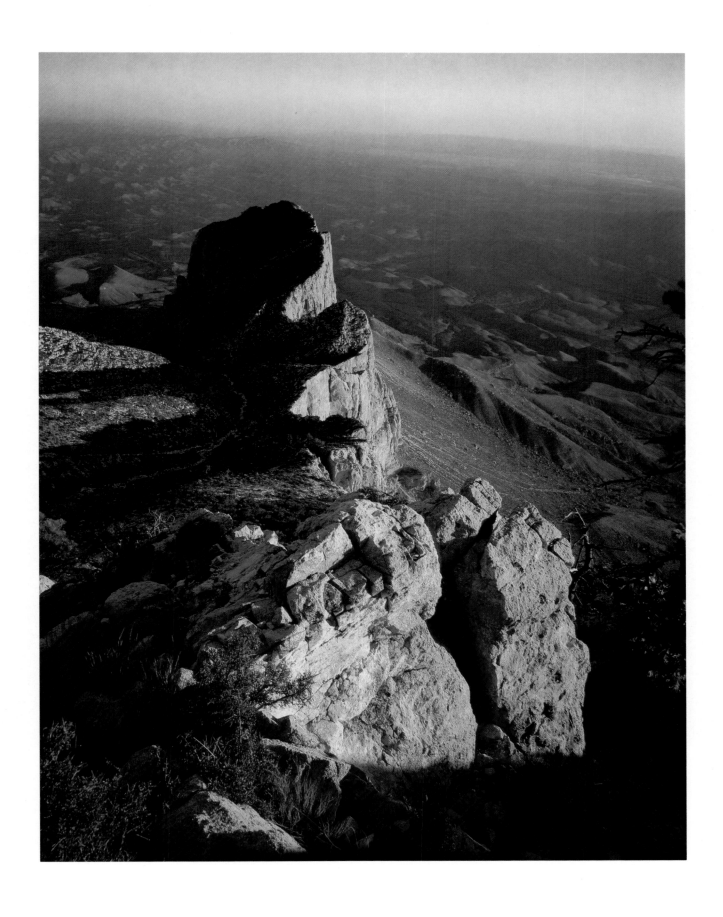

El Capitan Peak from Guadalupe Peak, Guadalupe National Park, Texas

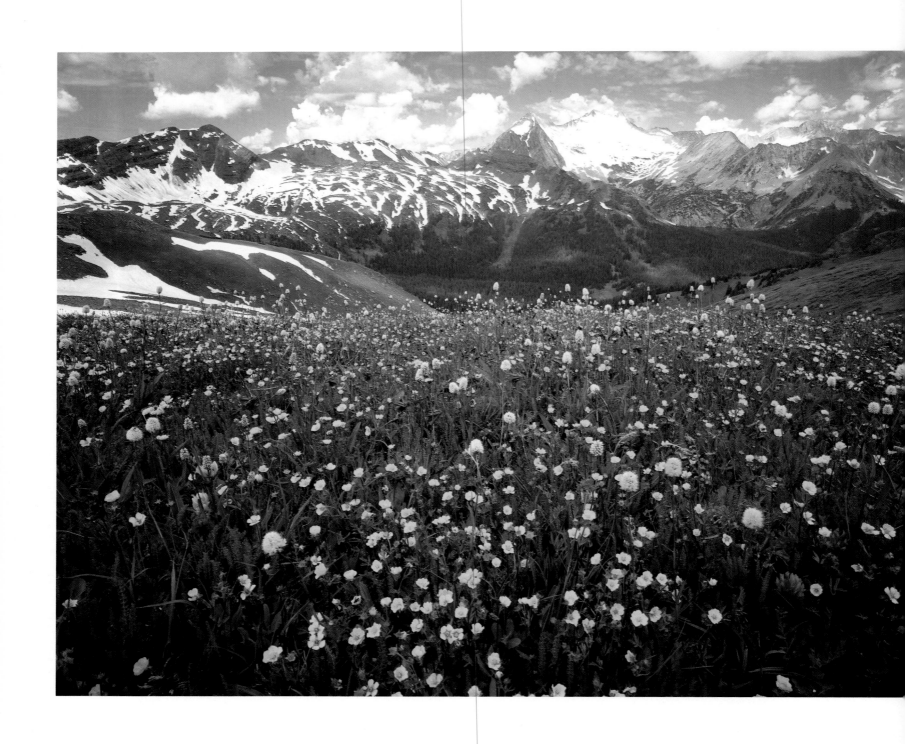

Buckskin Pass, Elk Mountains, Maroon Bells-Snowmass Wilderness, Colorado

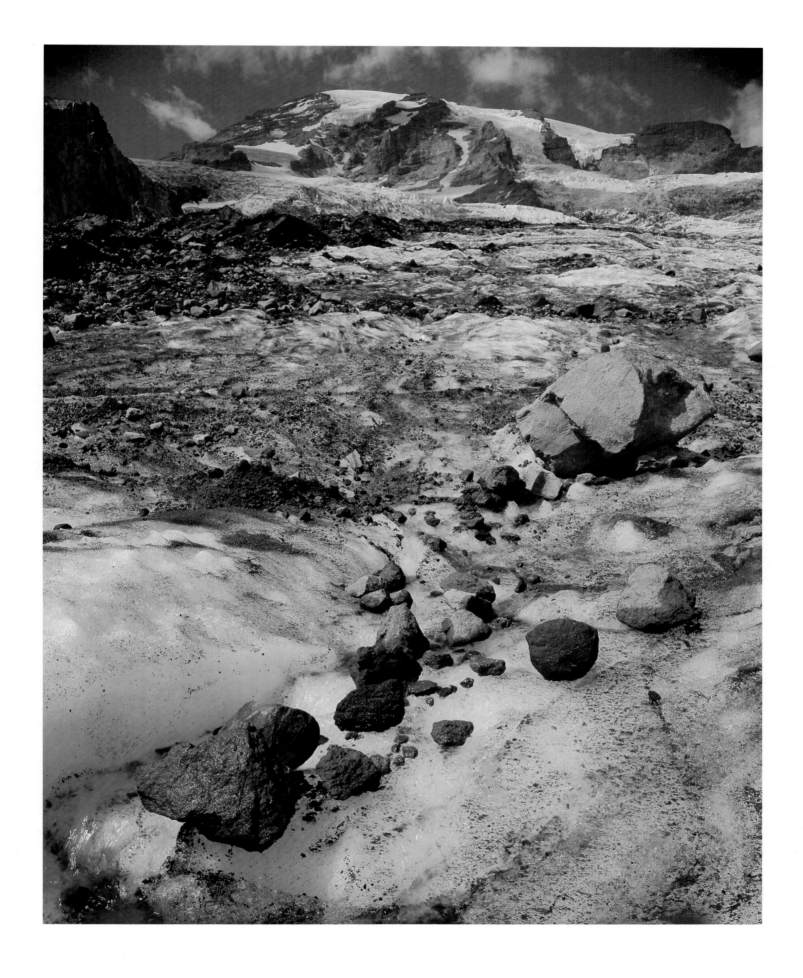

On Nisqually Glacier, Mount Rainier National Park, Washington

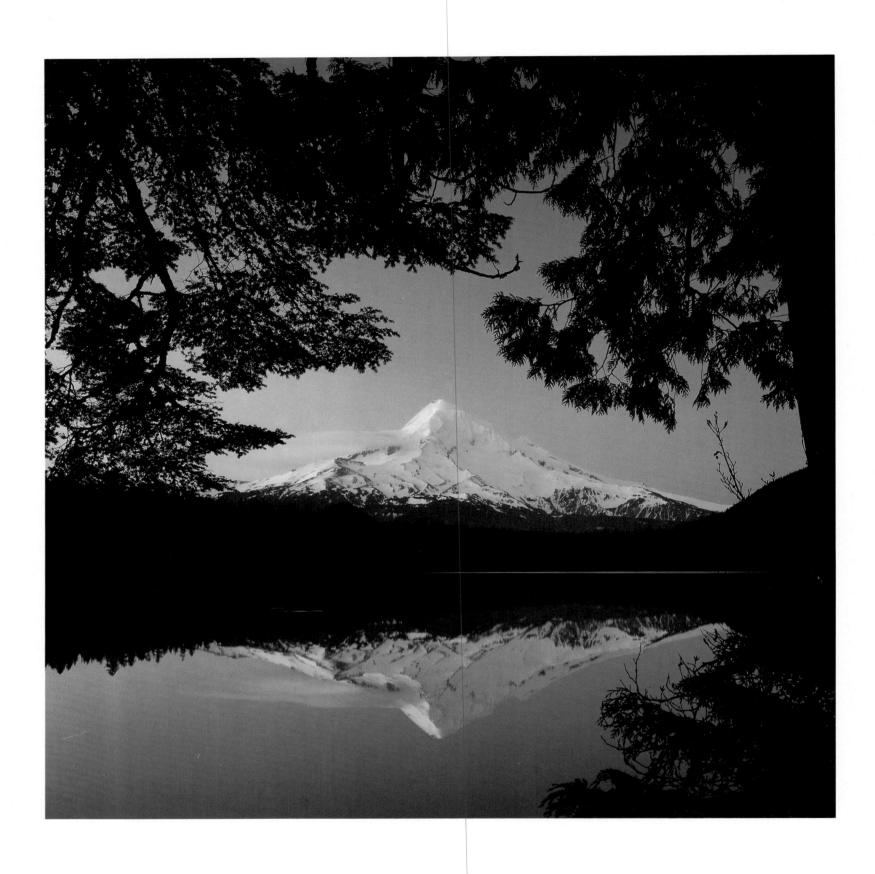

Dawn reflection of Mount Hood on Lost Lake, Mount Hood Wilderness, Oregon

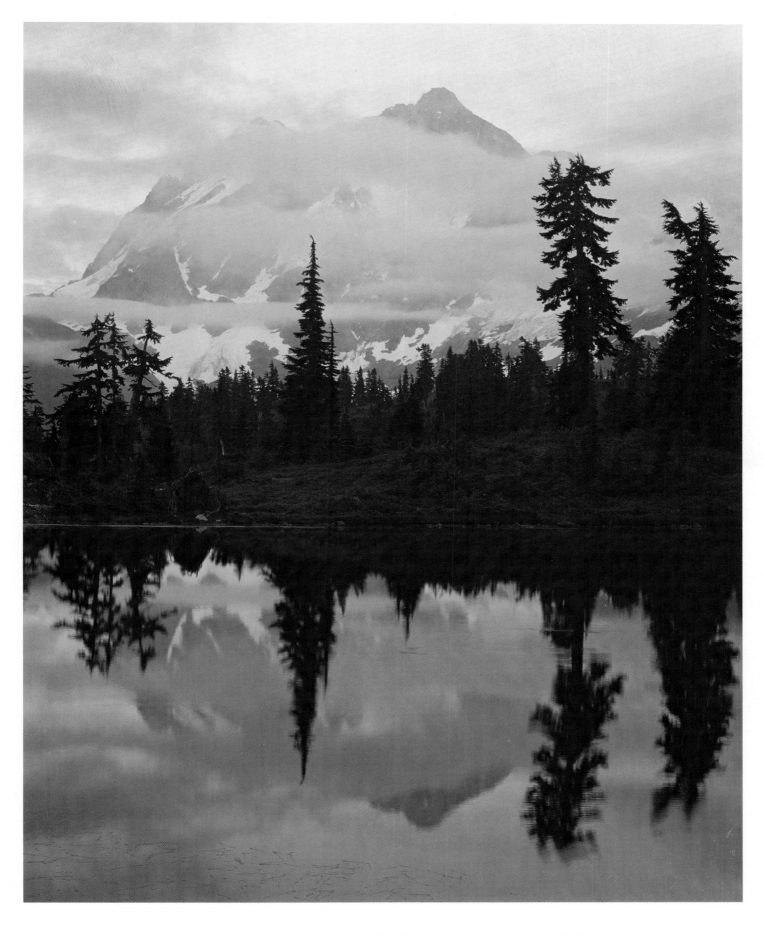

Above: Evening fog and Mount Shuksan, North Cascades National Park, Washington

Overleaf: Alpine ridge and Cowlitz Chimneys, Mount Rainier National Park, Washington

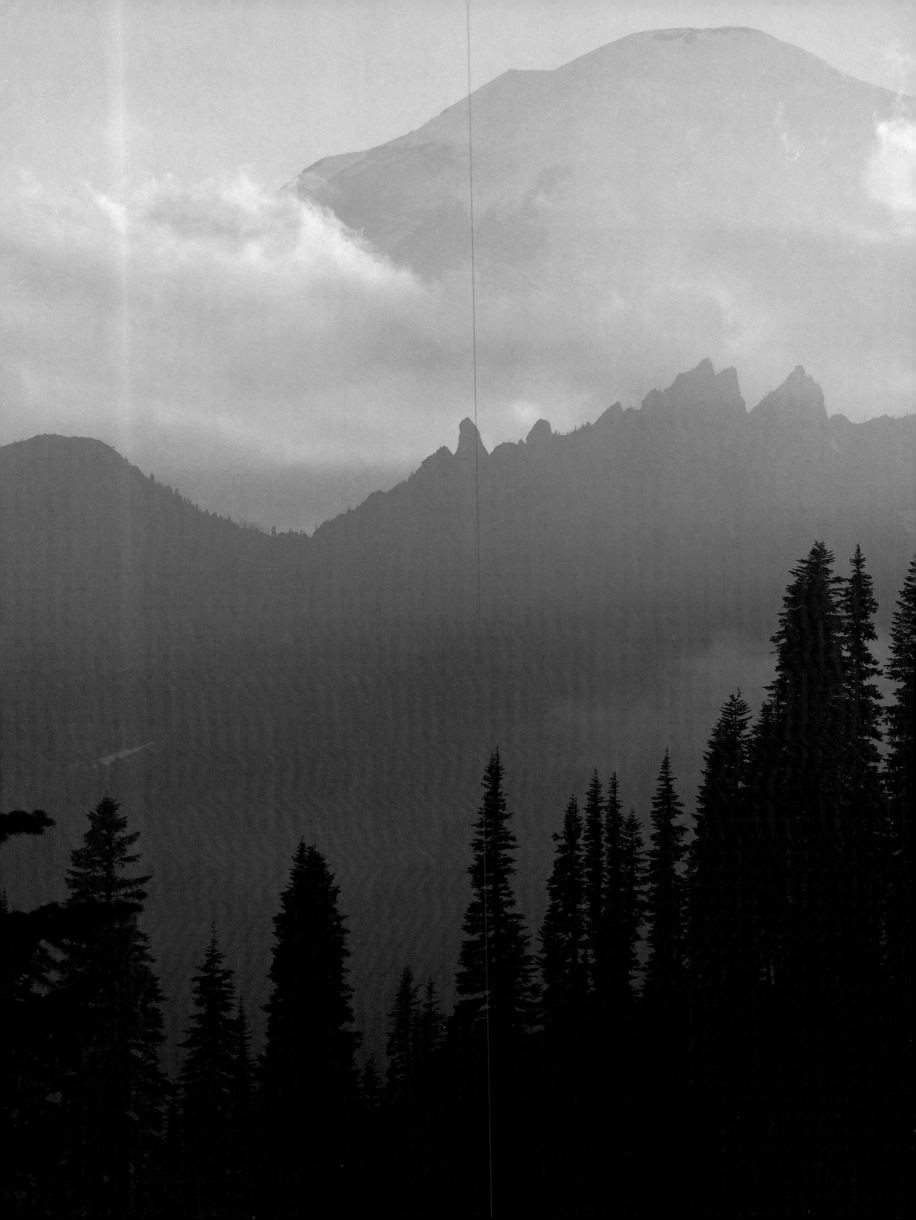

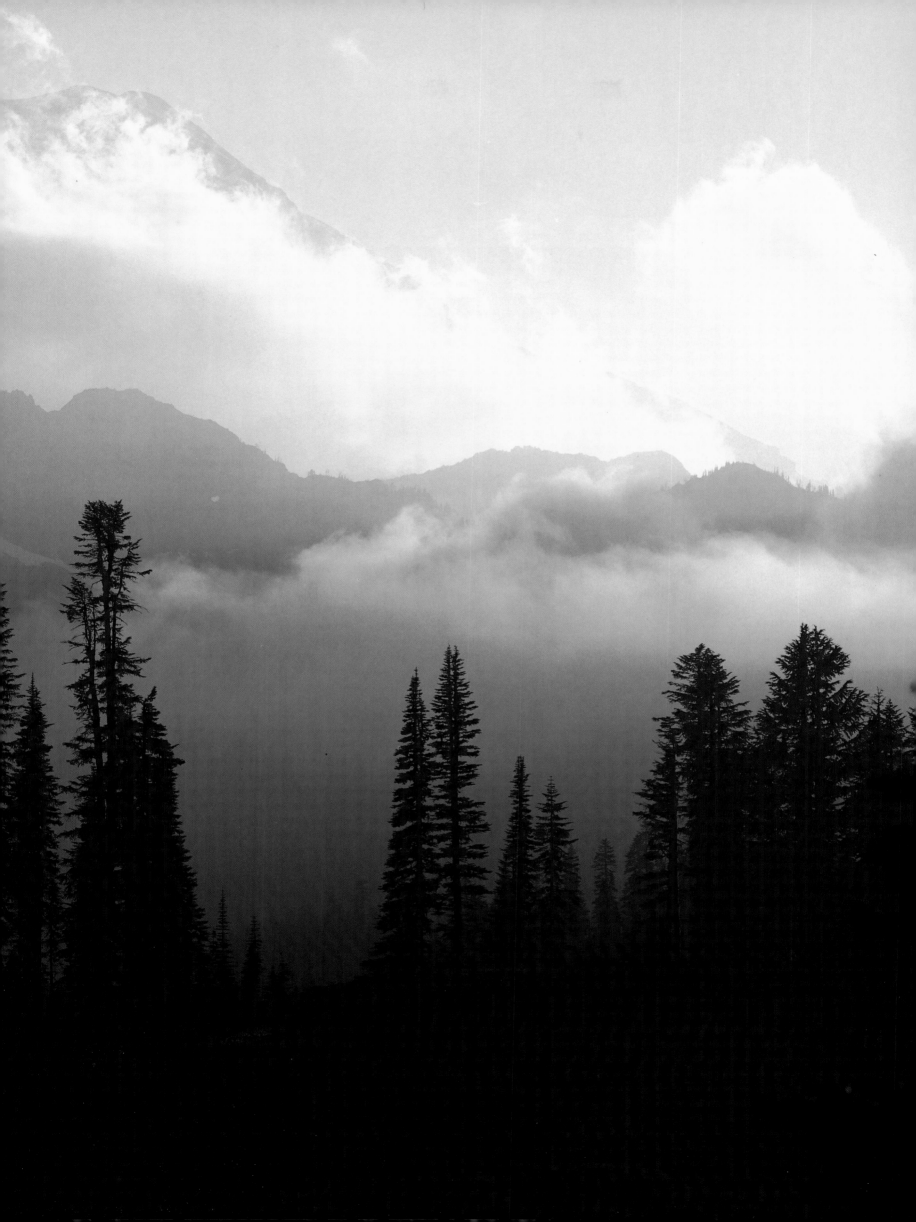

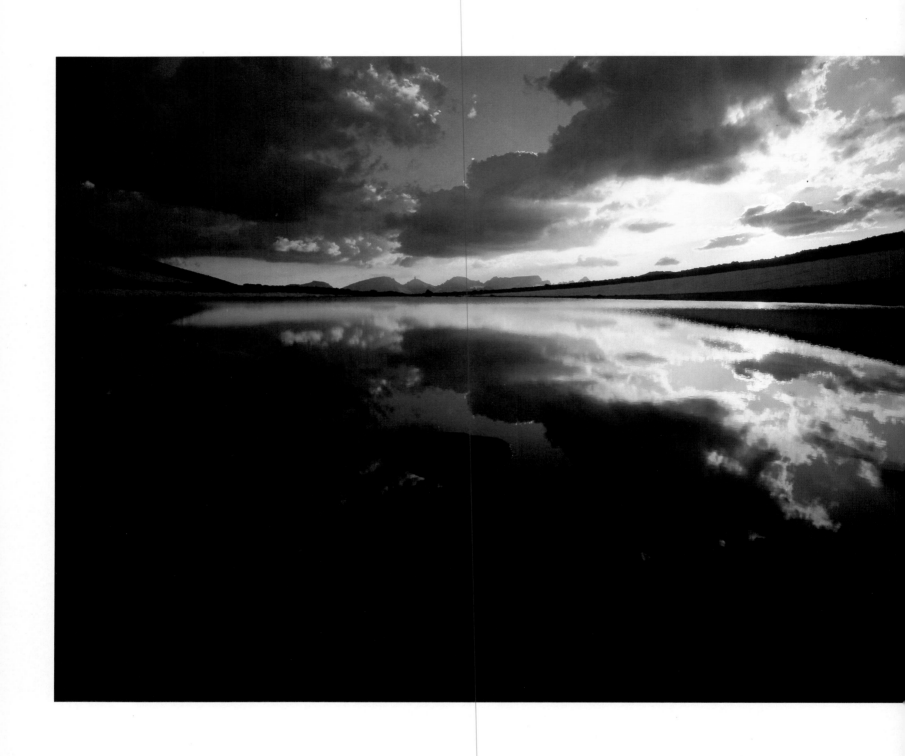

Evening pool in Shepherd Pass, Sequoia National Park, California

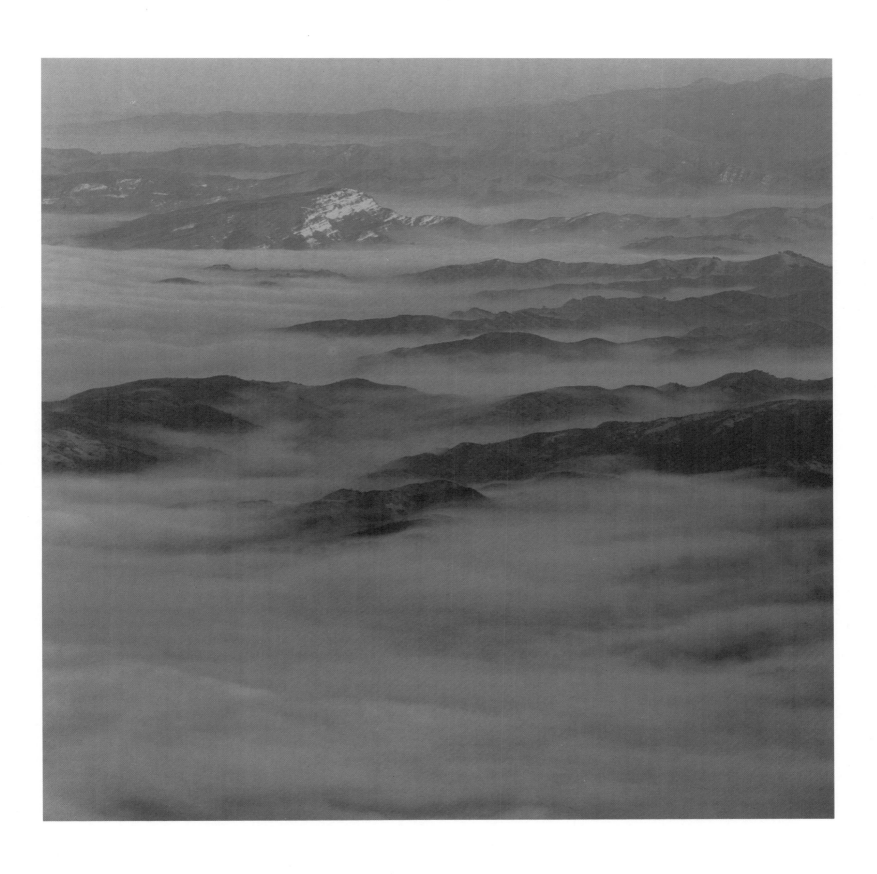

Fog-shrouded ridges, San Rafael Mountains, California

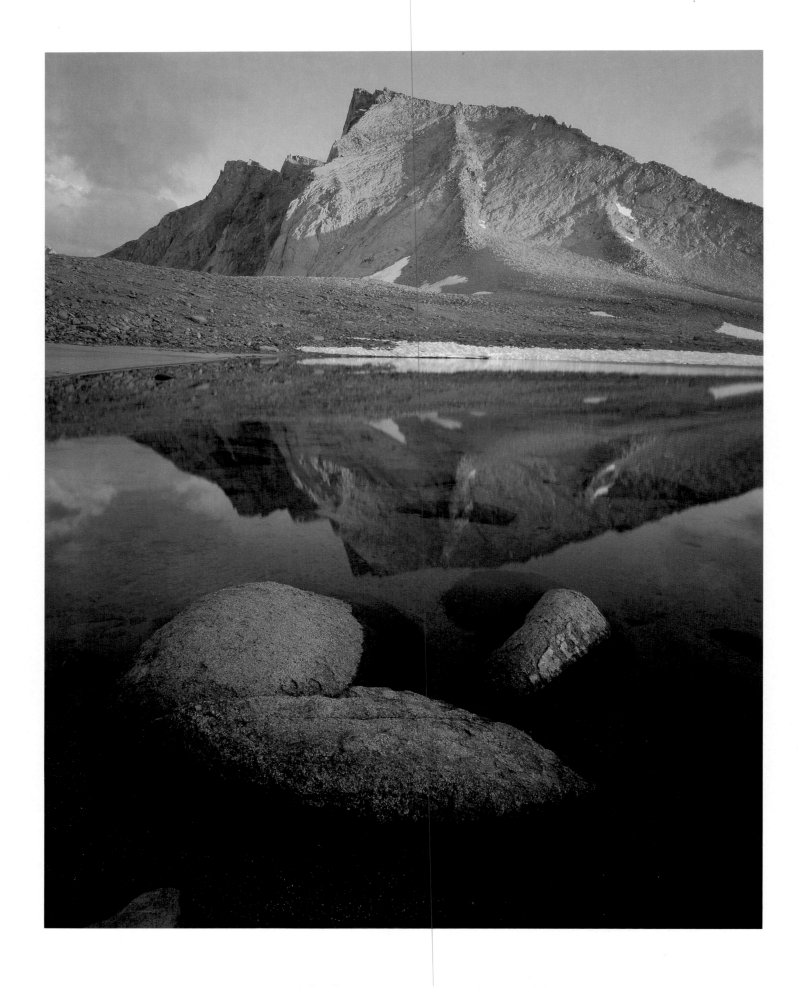

Mount Tyndall reflection, Sequoia National Park, California

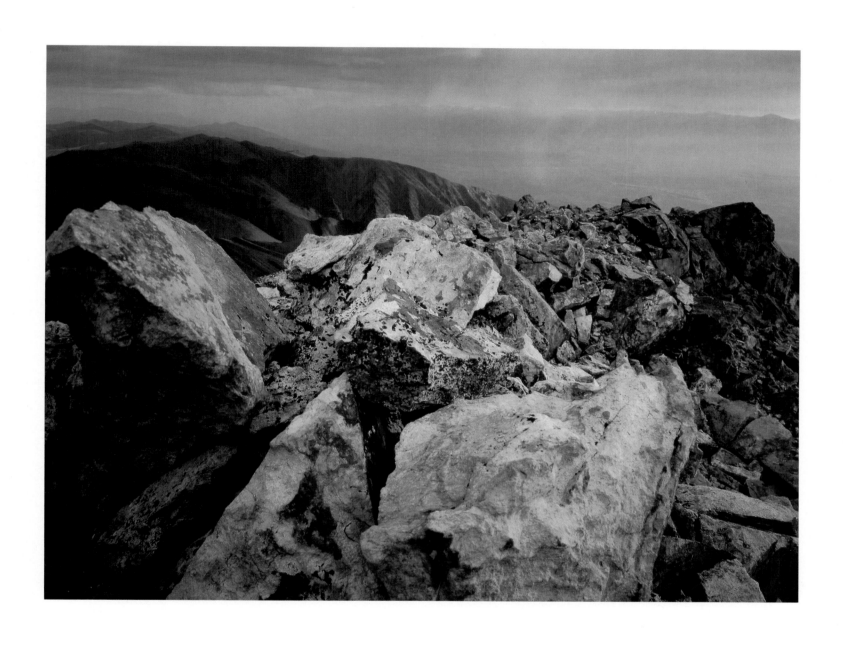

Jumbled toprock on White Mountain, White Mountains, California

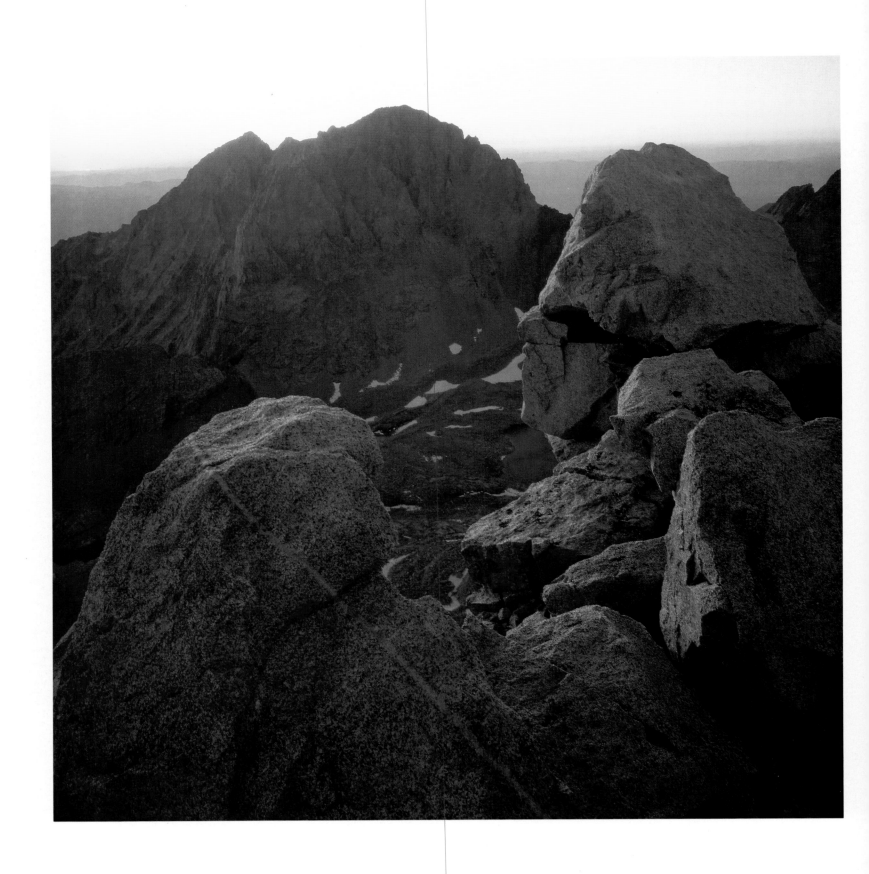

Mount Williamson, John Muir Wilderness, Sierra Nevada, California

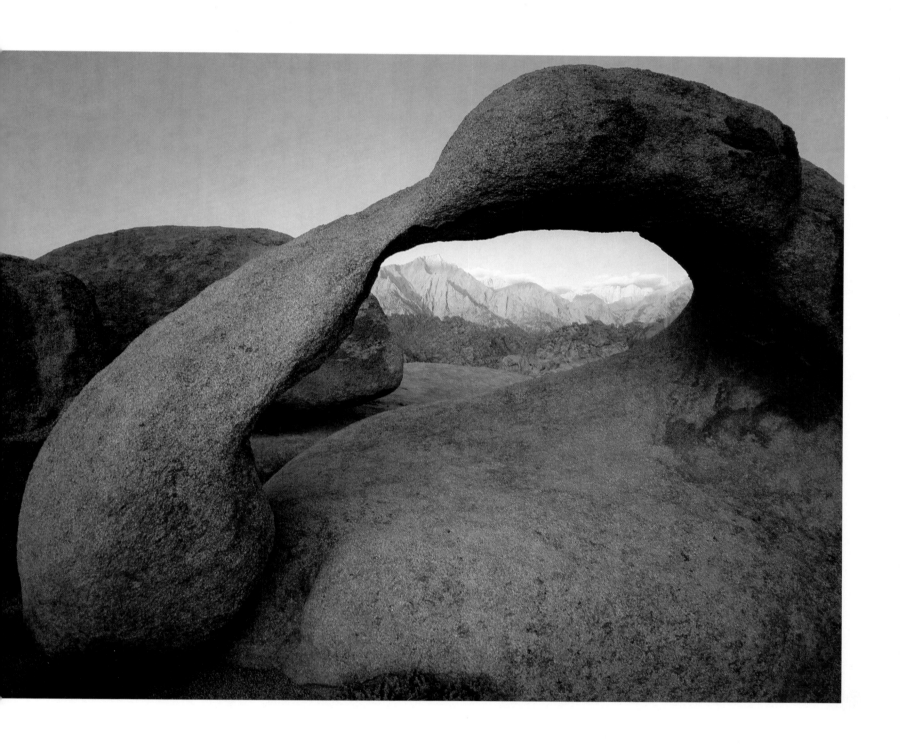

Granite arch form, Sierra Nevada east side, California

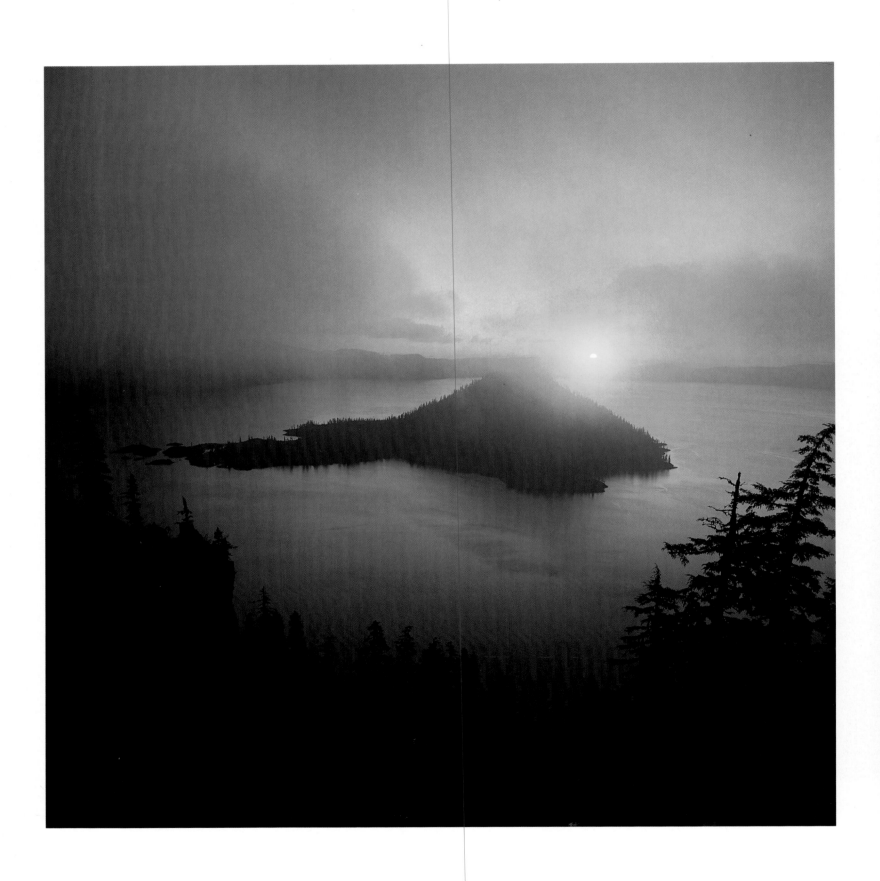

Dawn fog and Wizard Island, Crater Lake National Park, Oregon

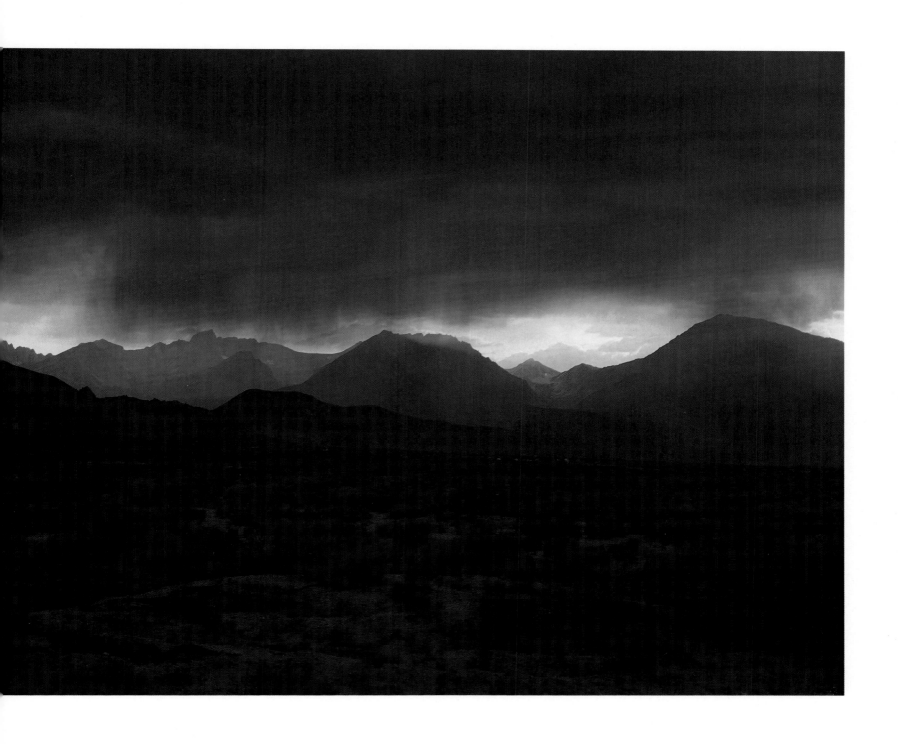

Summer storm, eastern slope of Sierra Nevada, California

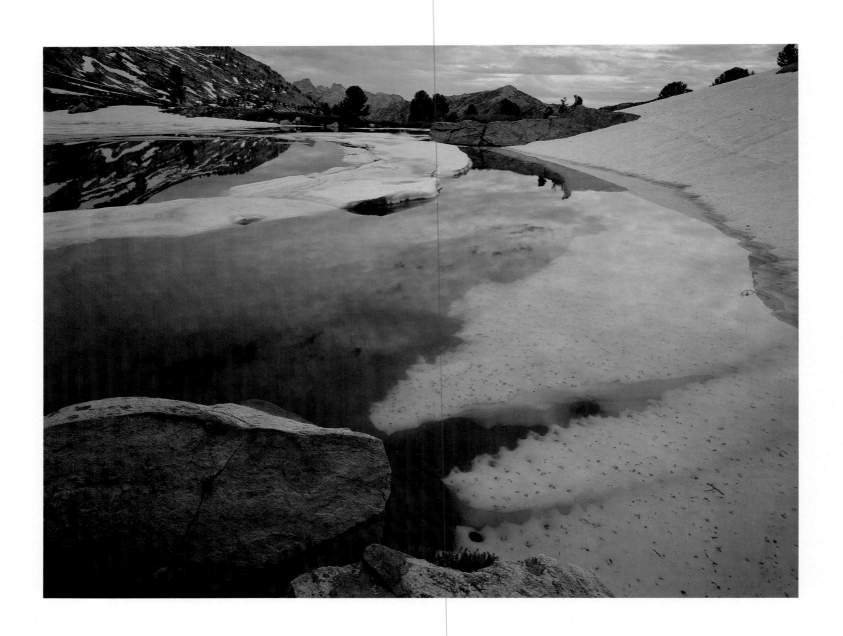

Above: Ice flows in Lamoille Lake, Ruby Mountains, Nevada

Right: Minaret Peaks, Minaret Wilderness, Sierra Nevada, California

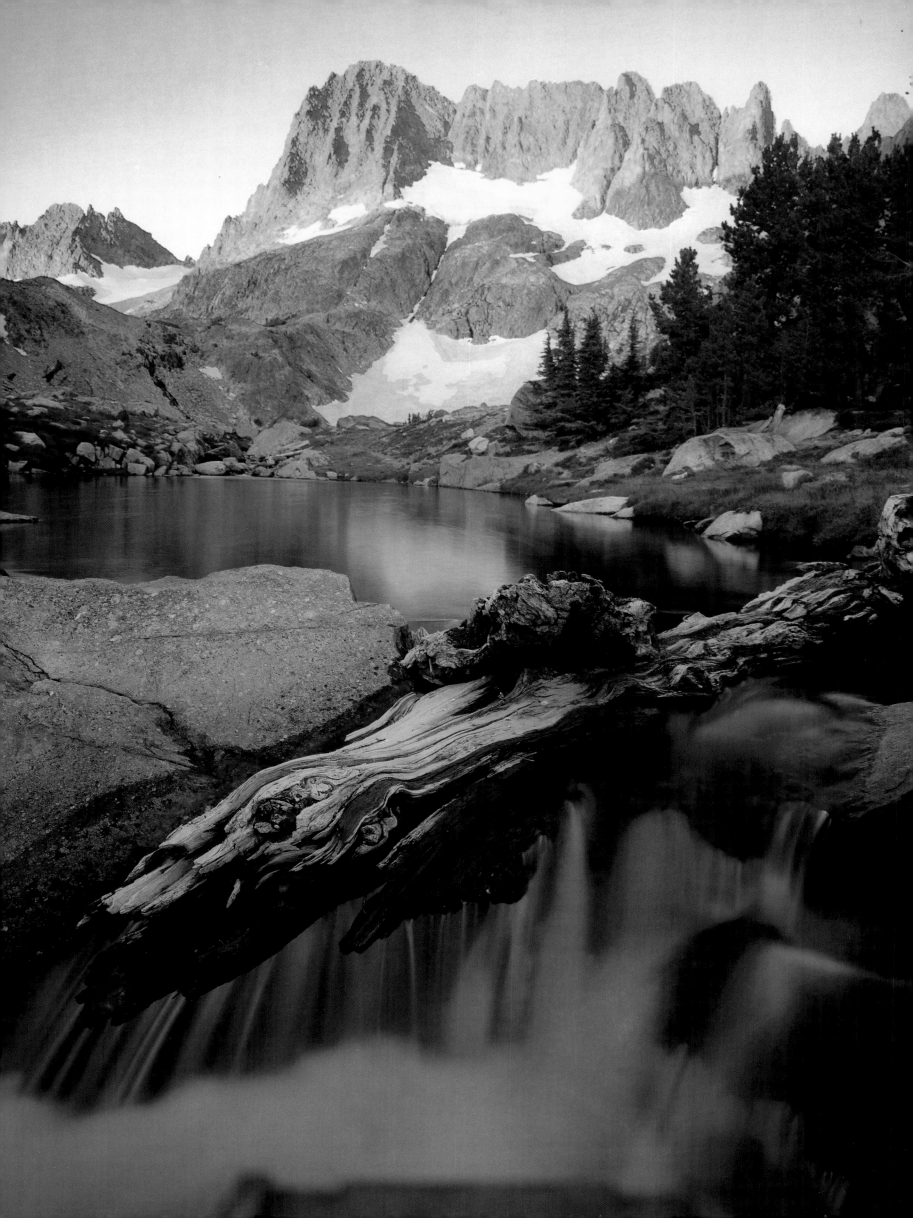

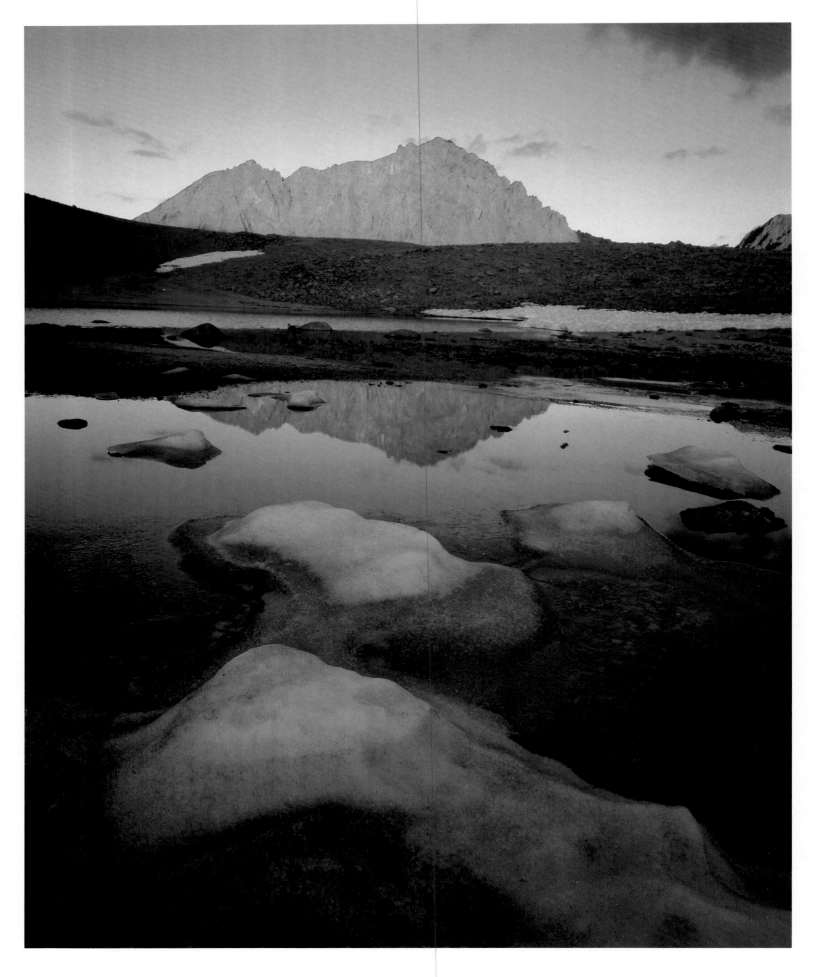

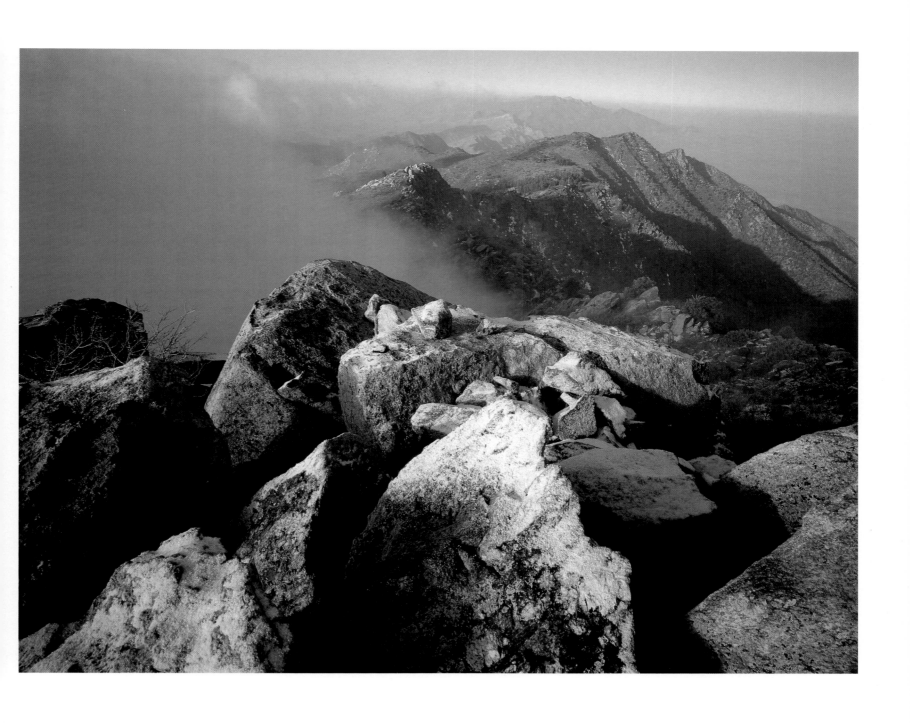

Left: Mount Williamson, John Muir Wilderness, Sierra Nevada, California

Above: Virgin Mountains toprock, Paiute Primitive Area, Arizona

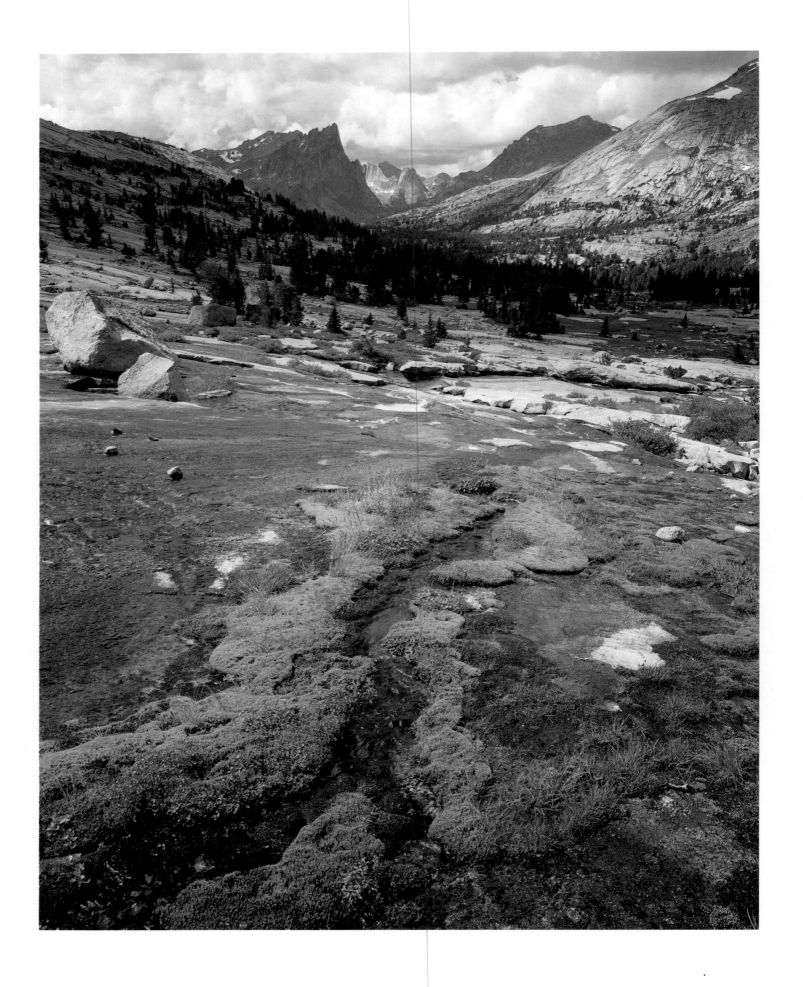

Cirque of Towers, Bridger Wilderness, Wind River Range, Wyoming

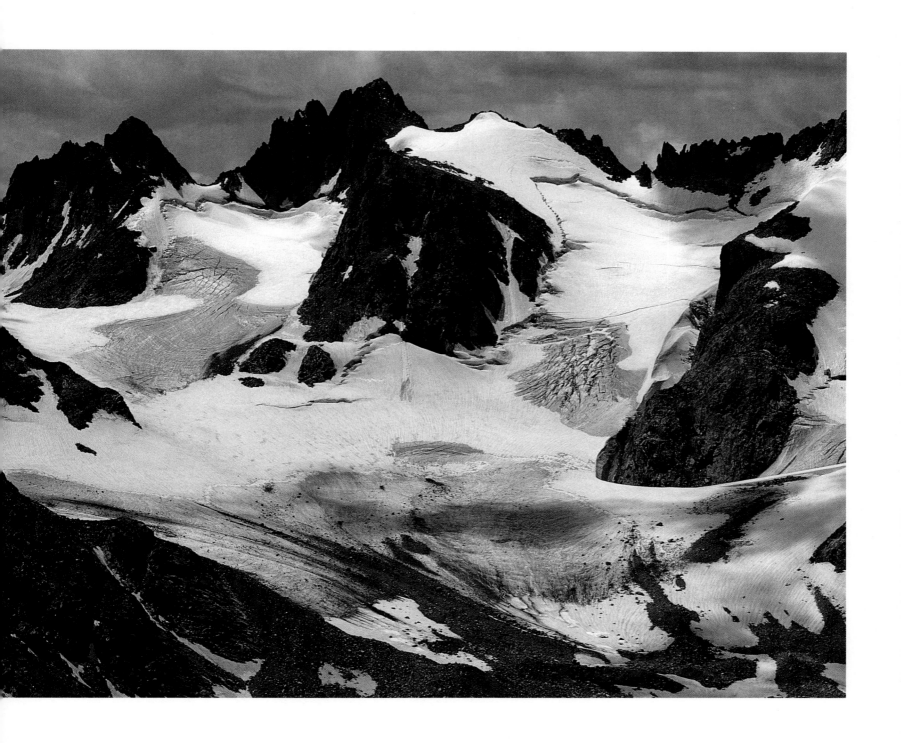

Dinwoody Glacier, Fitzpatrick Wilderness, Wind River Range, Wyoming

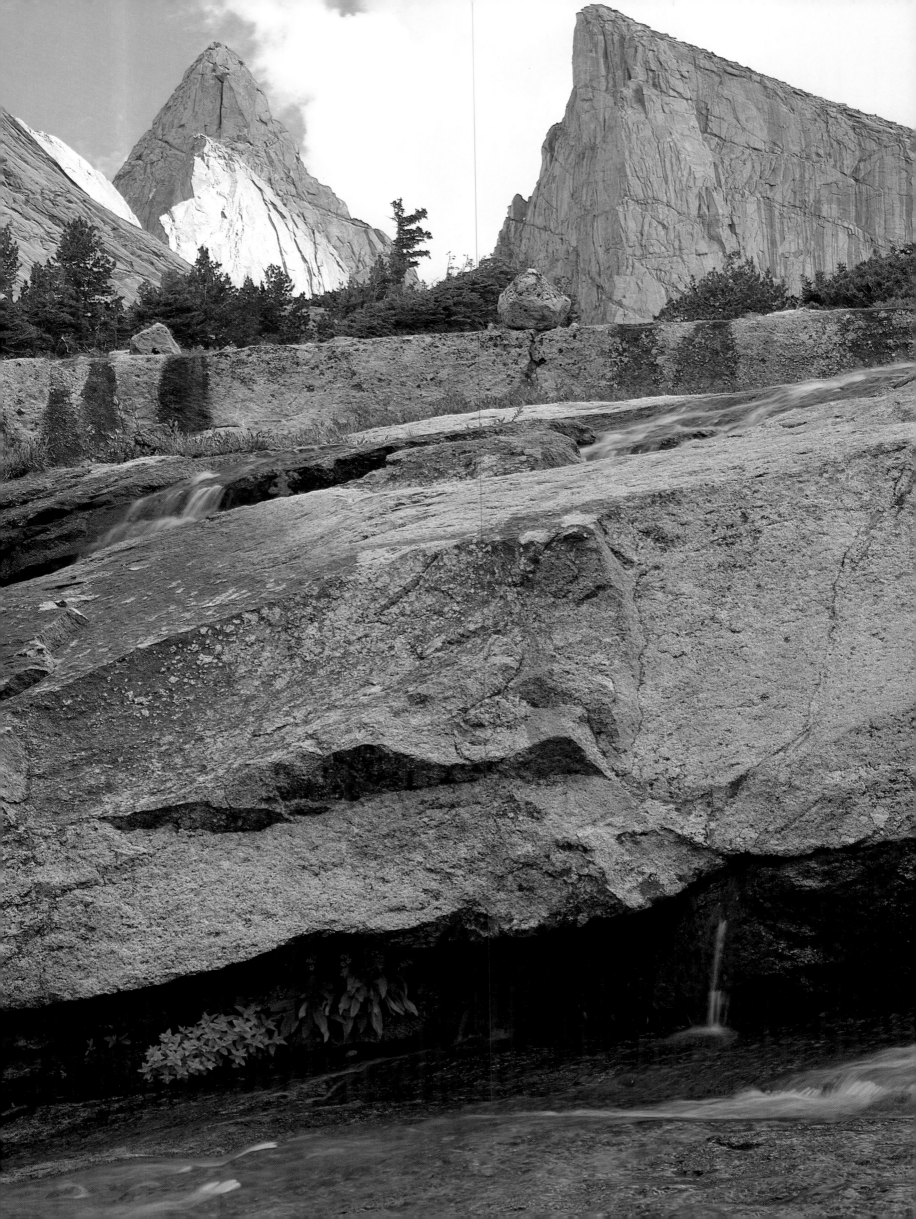

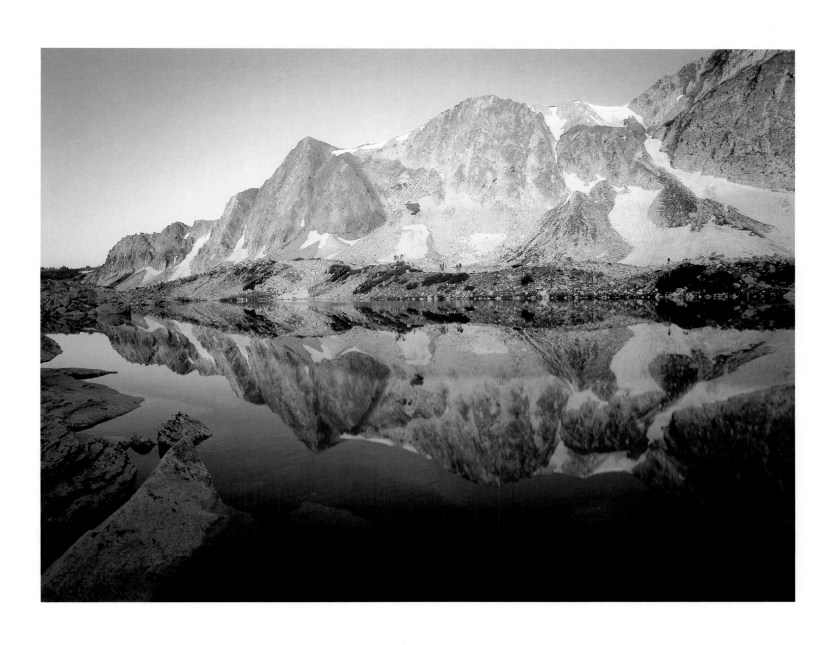

Left: Granite ledges below East Temple Mountain, Bridger Wilderness, Wind River Range, Wyoming

Above: Dawn reflections of Medicine Bow Range, Wyoming

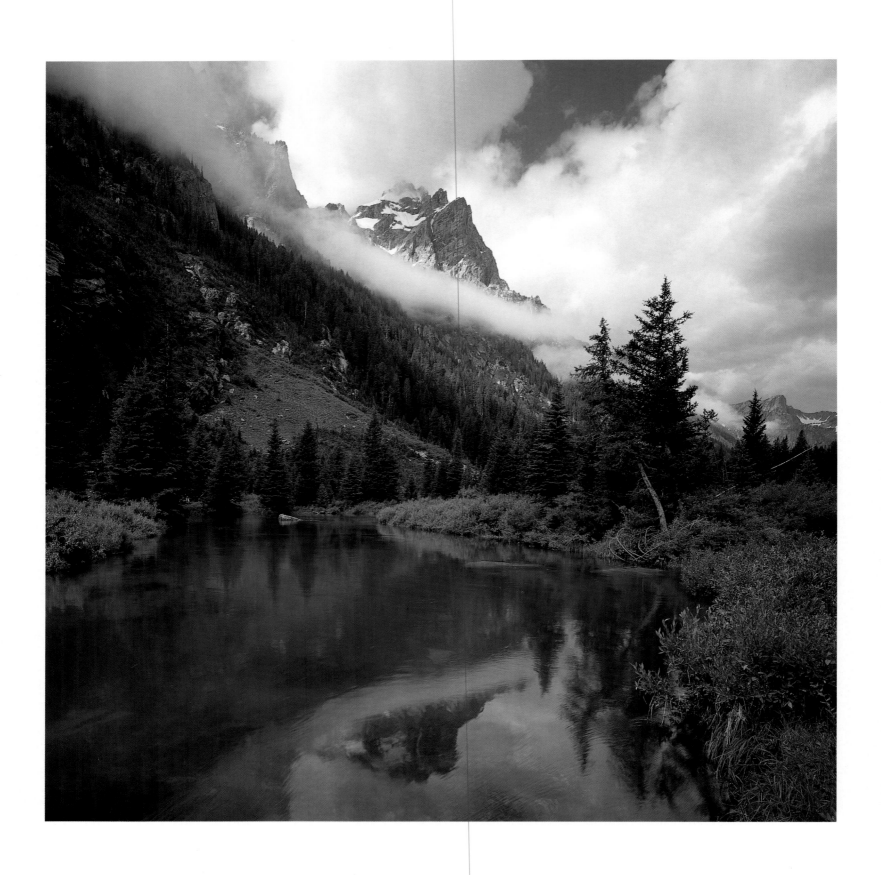

Mount Owen reflections, Cascade Canyon, Grand Teton National Park, Wyoming

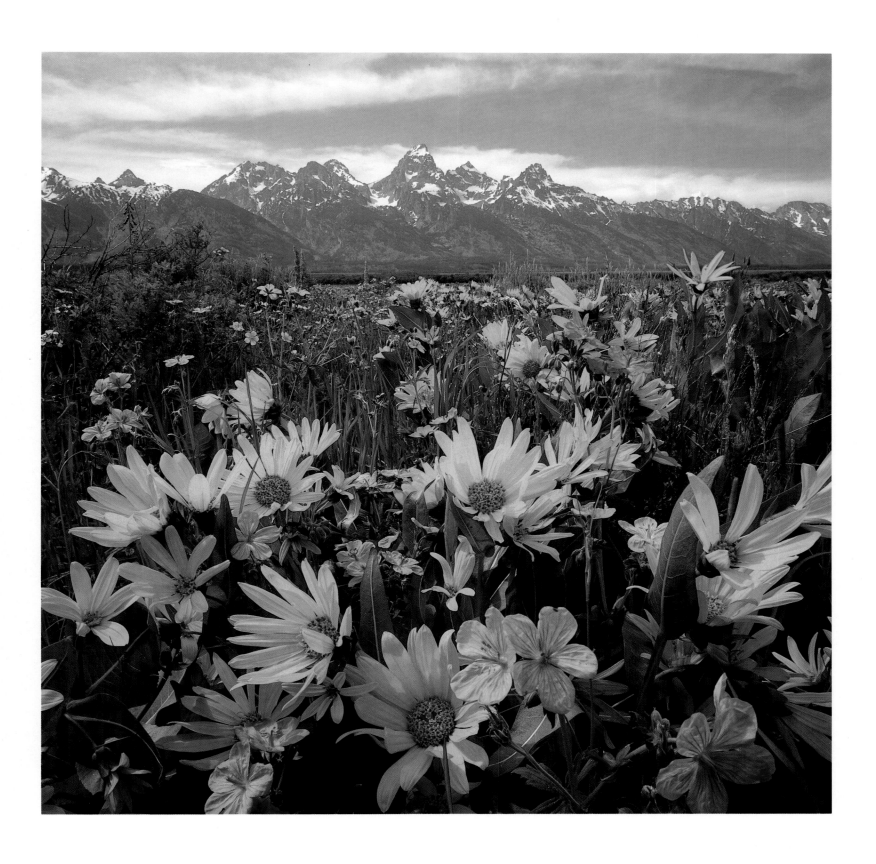

Summer flowers in Jackson Hole, Grand Teton National Park, Wyoming

Malpais lava flow and Mount Taylor, New Mexico

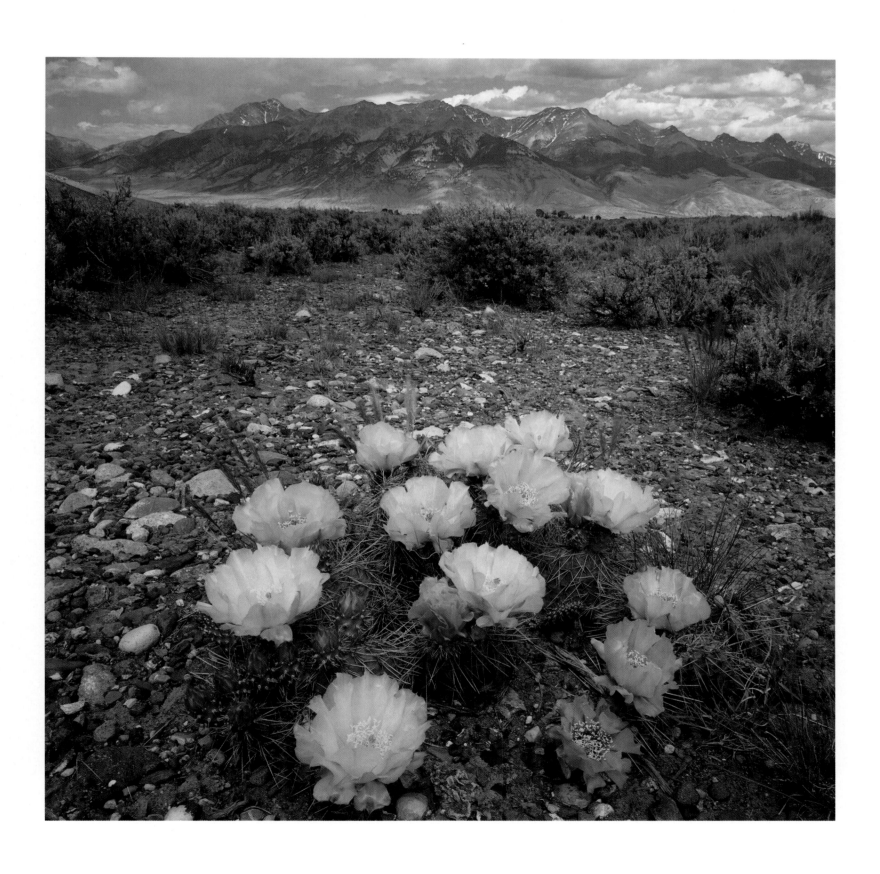

Borah Peak and prickly pear cactus, Lost River Range, Idaho

Forests

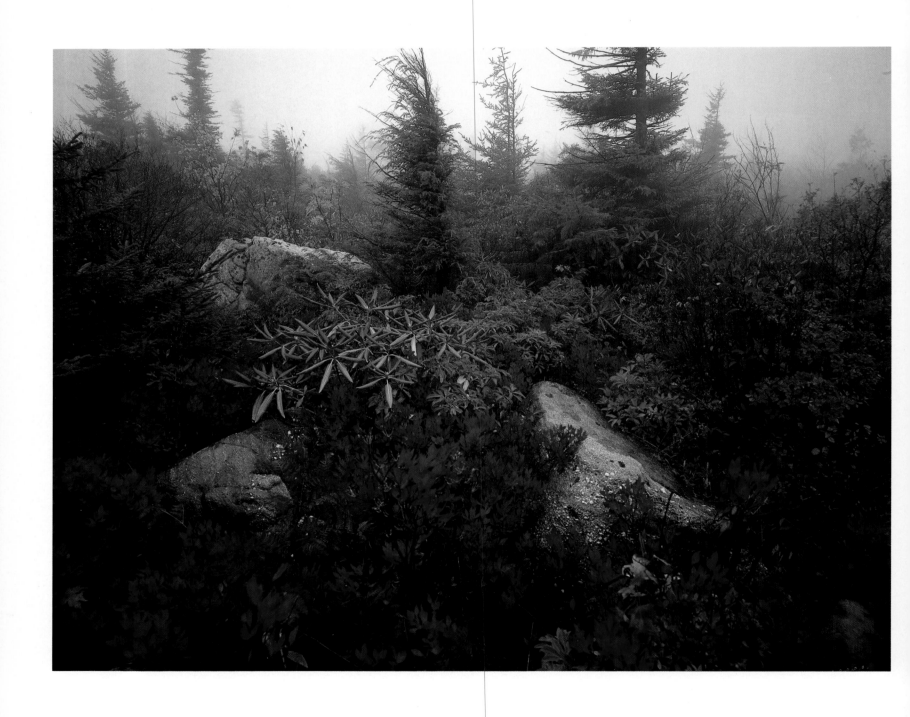

Alpine autumn, Dolly Sods Wilderness, West Virginia

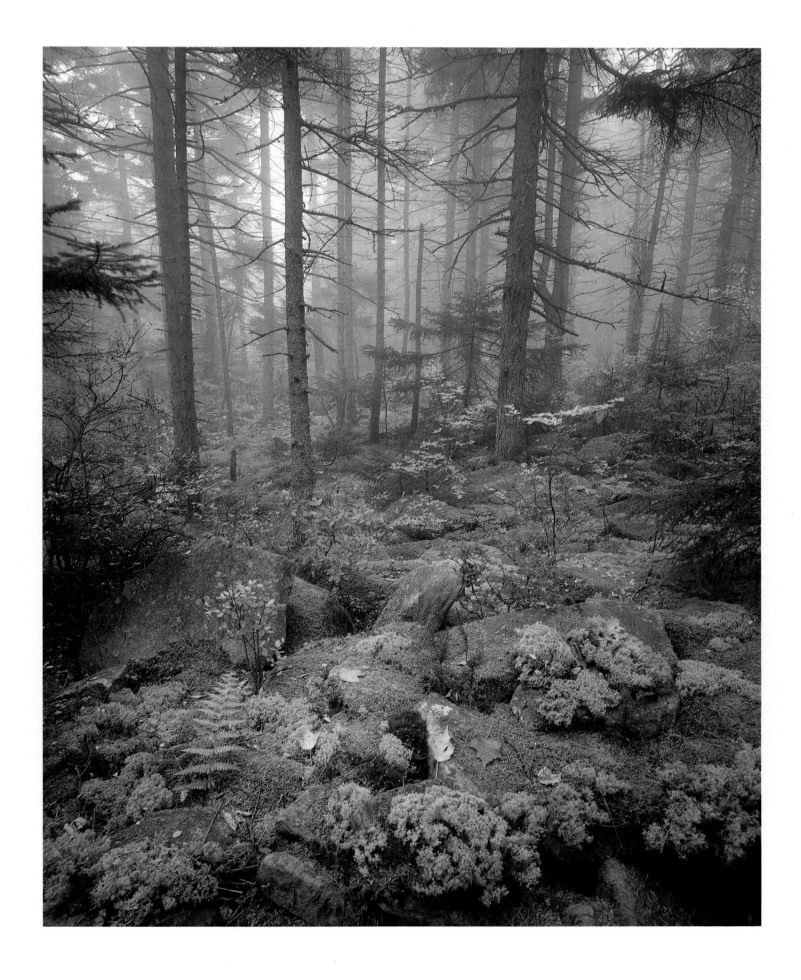

Mosses and spruce forest, Spruce Knob, West Virginia

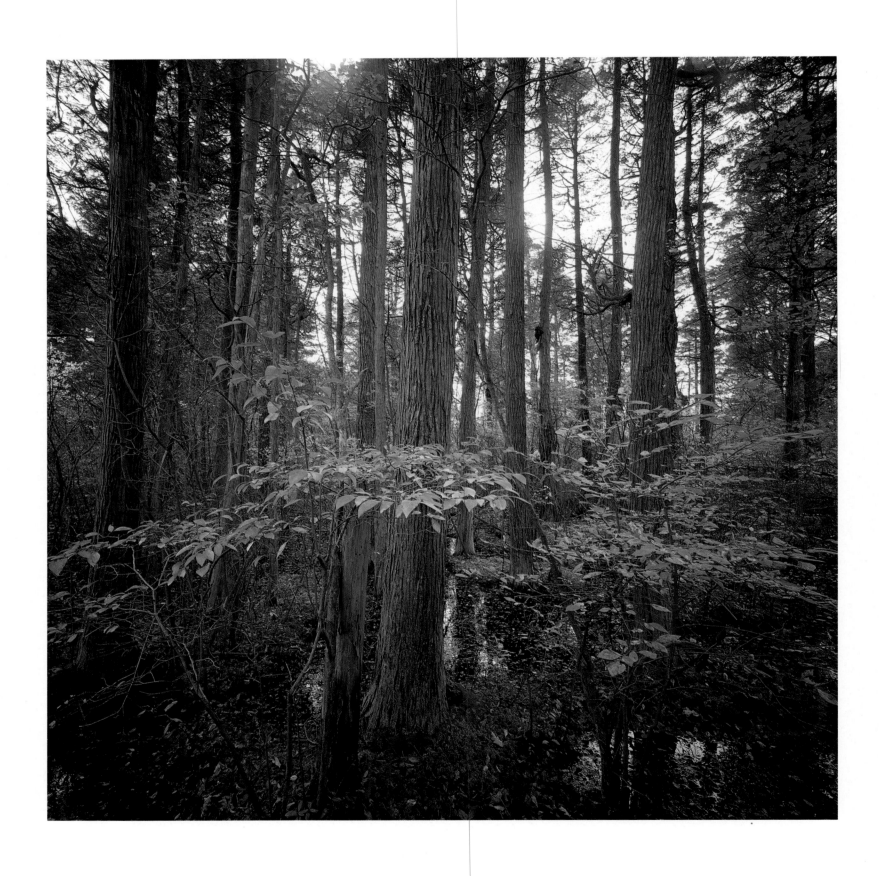

White Cedar Swamp, Great Swamp Preserve, Rhode Island

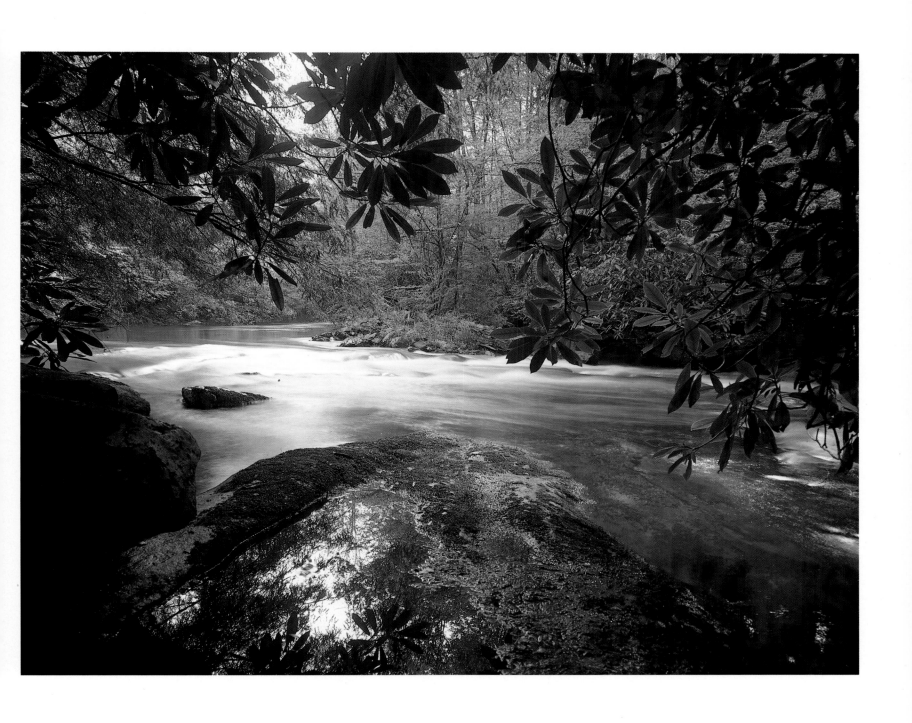

Upper Nantahala River, Nantahala National Forest, North Carolina

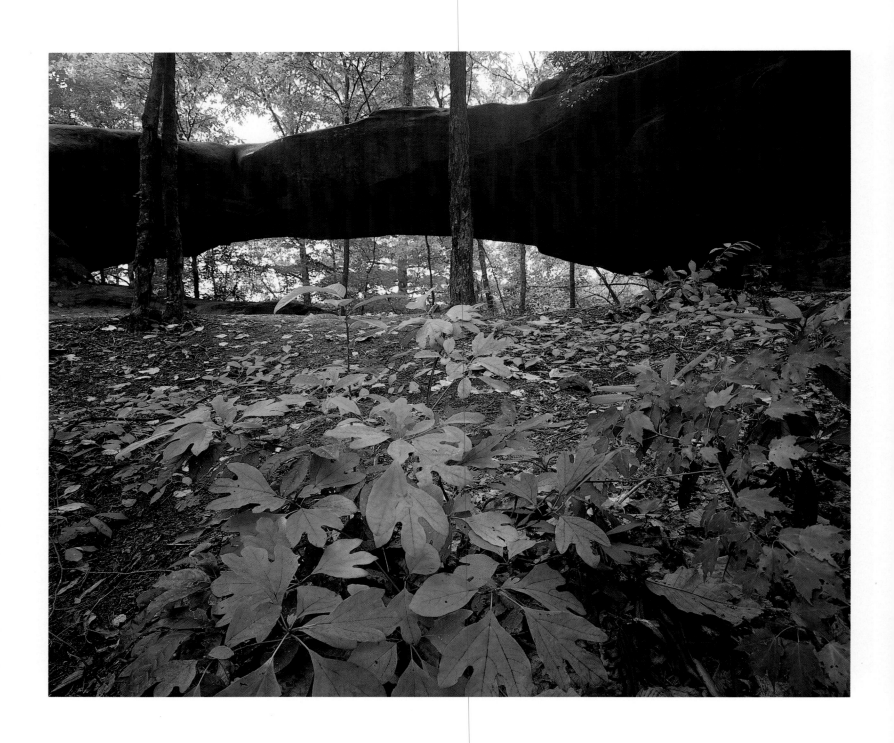

Above: Span of Princess Arch, Red River Gorge, Kentucky

Right: Spruce and reindeer moss in Round Glade, Cranberry Glades Preserve, West Virginia

Following Page: Maple and hemlock, Great Smoky Mountains National Park, Tennessee/North Carolina

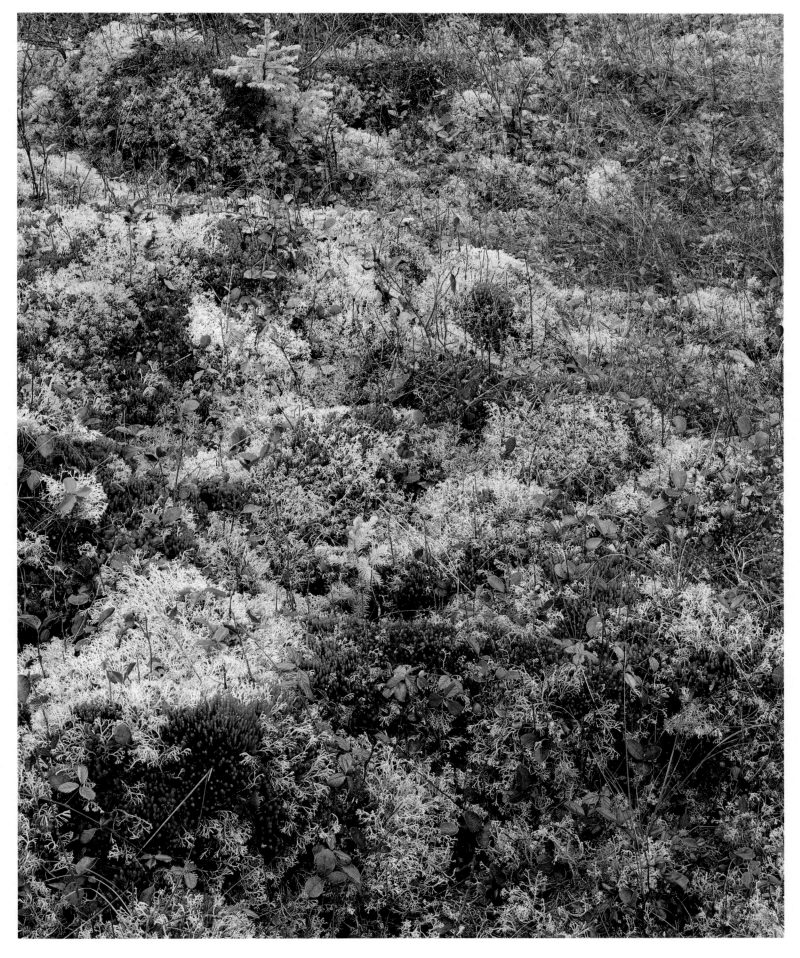

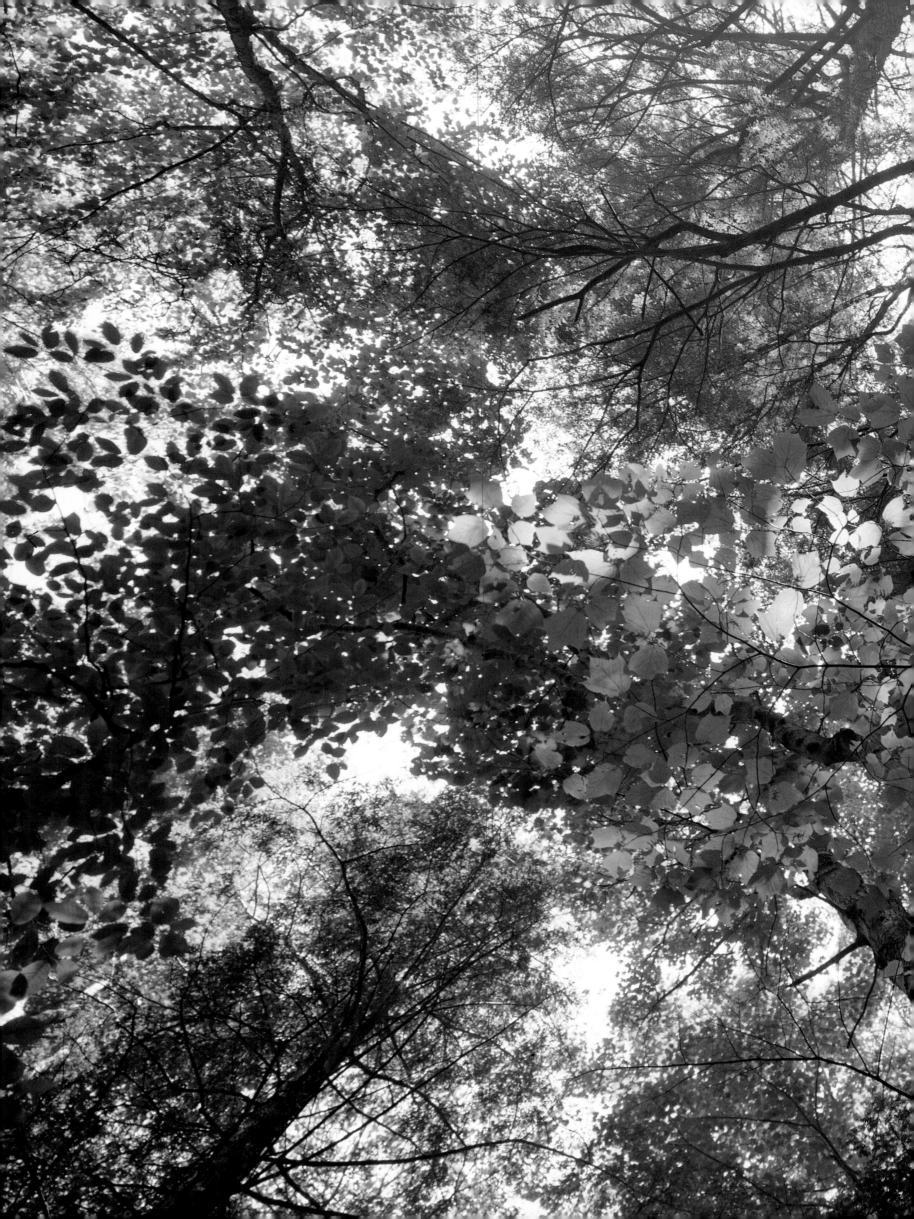

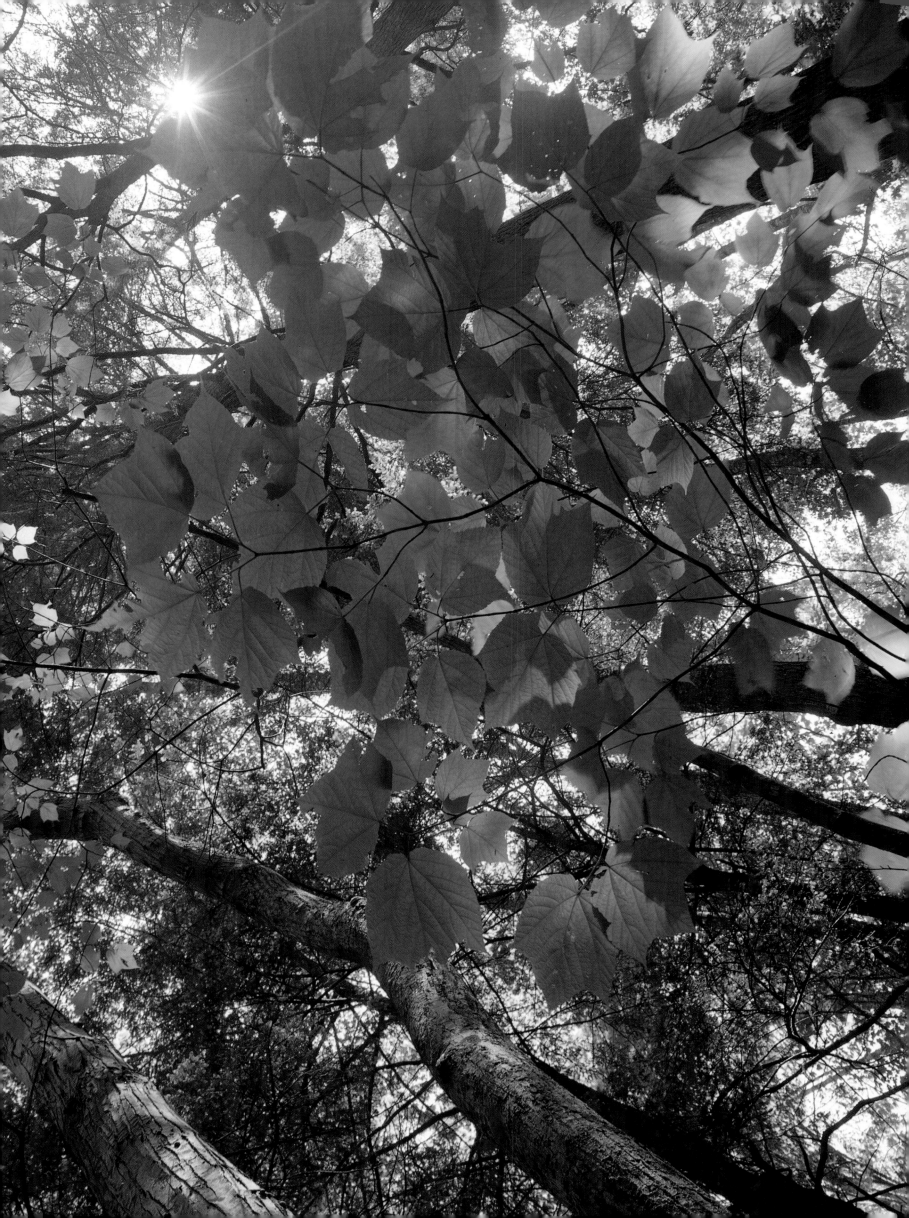

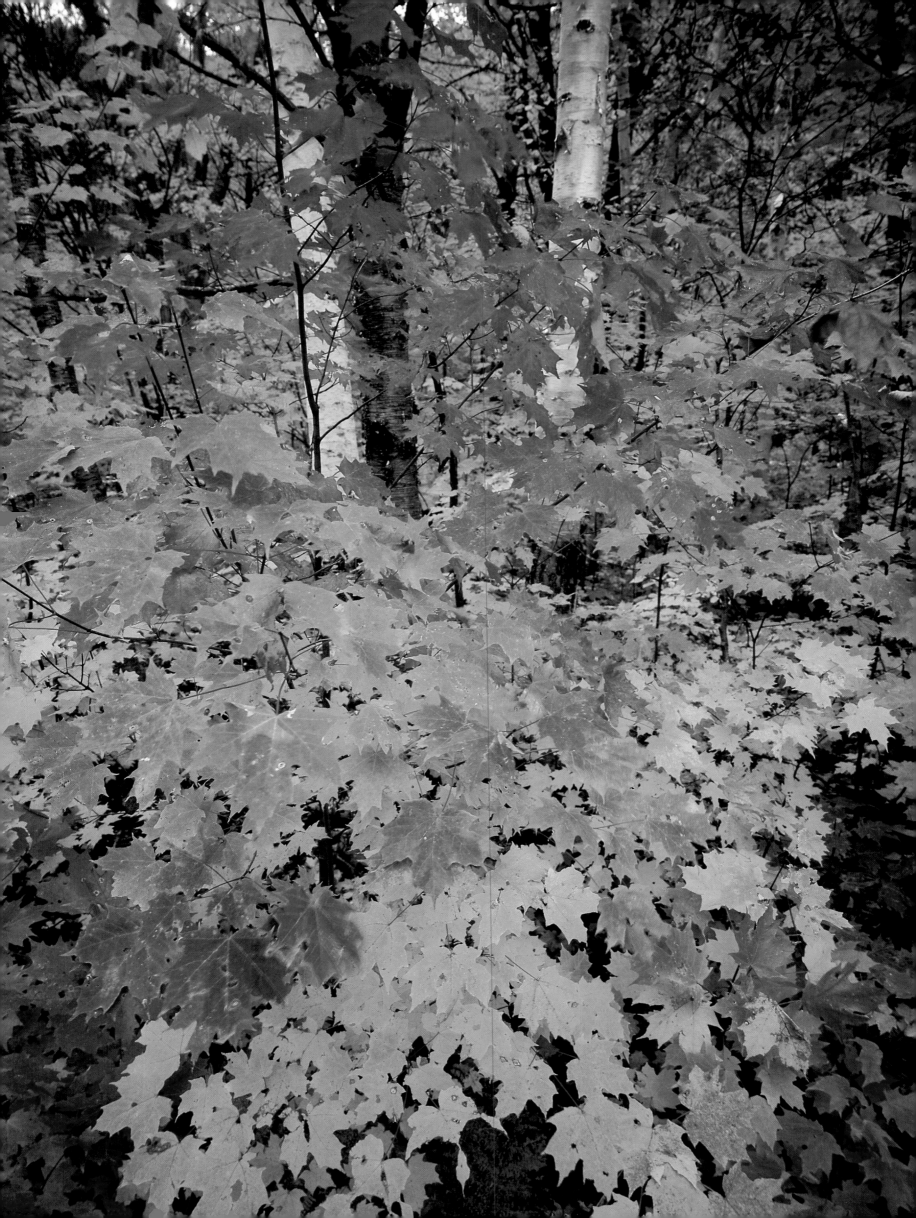

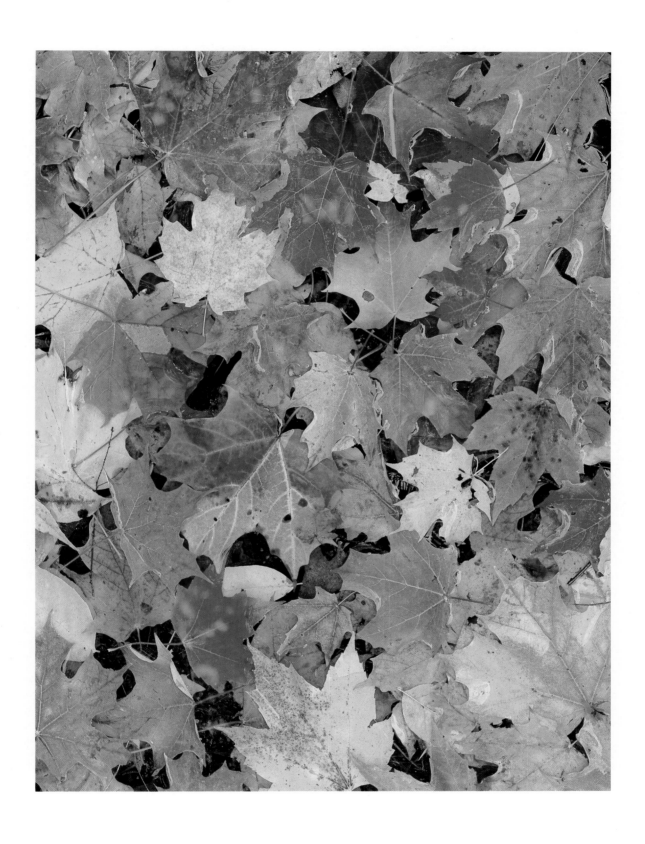

Left: Maple and birch in Ausable River Gorge, Adirondack Mountain Park, New York

Above: October leaves, Adirondack Mountain Preserve, New York

Above: Pine and hardwood forest, Neches Bottom Unit, Big Thicket Preserve, Texas
Right: Magnolia and sassafras on oak forest floor, Turkey Creek Unit, Big Thicket Preserve, Texas

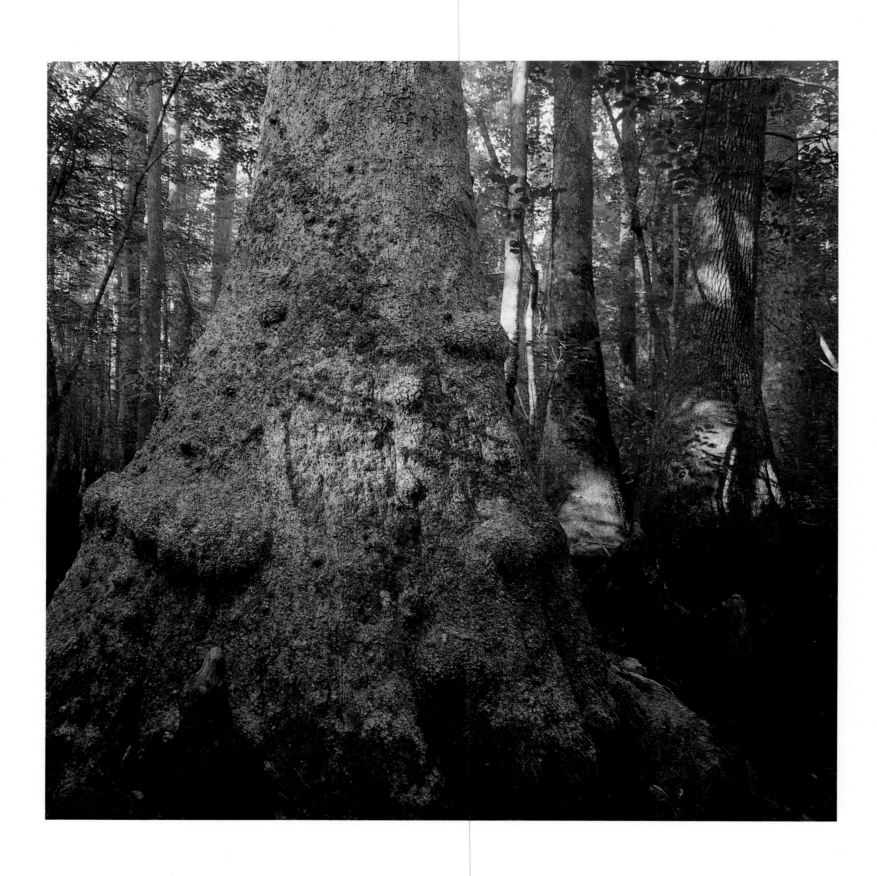

Large tupelo bole, Four Holes Swamp Preserve, South Carolina

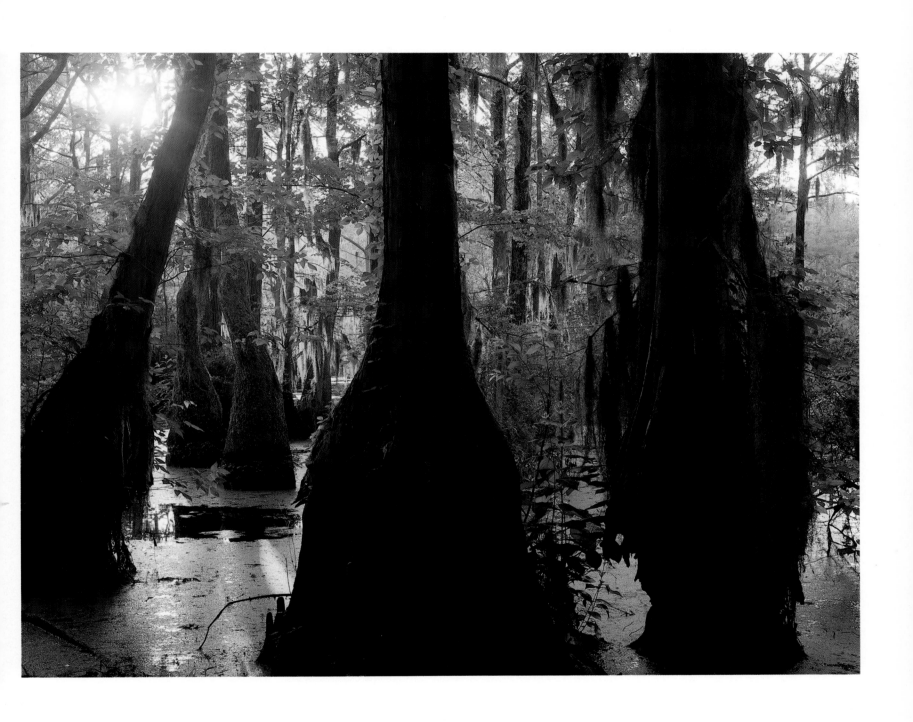

Cypress and tupelo, Merchants Millpond State Park, North Carolina

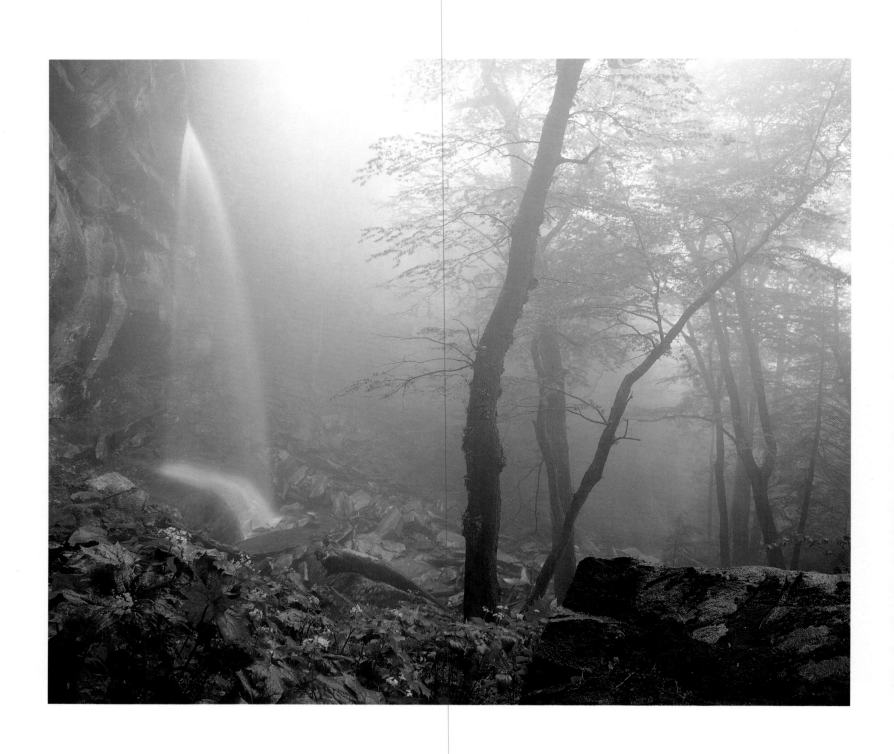

Rainbow Falls, Great Smoky Mountains National Park, Tennessee/North Carolina

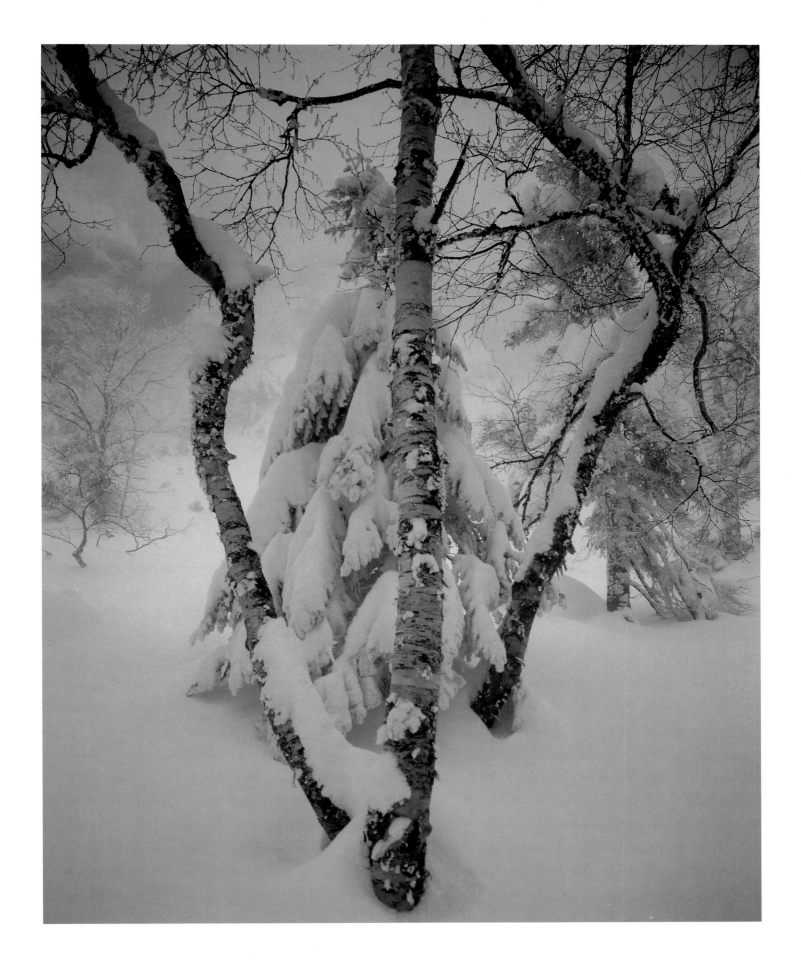

Birch and spruce, Mount Mansfield, Green Mountains, Vermont

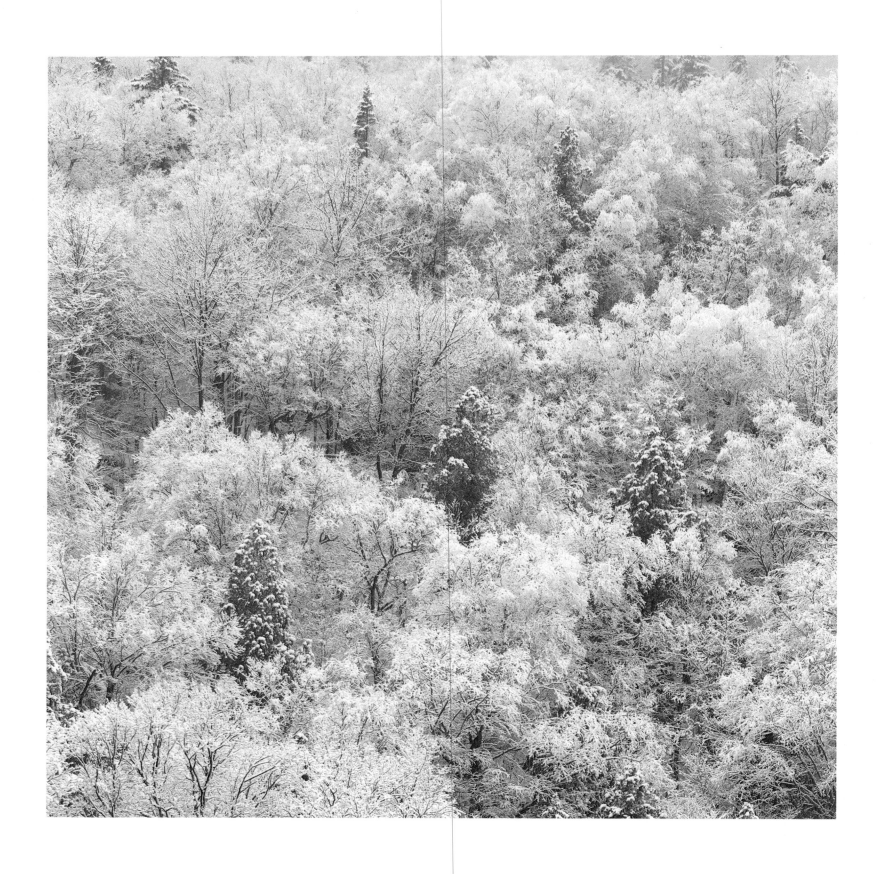

Winter frosting on Whiteface Mountain, Adirondack Mountain Preserve, New York

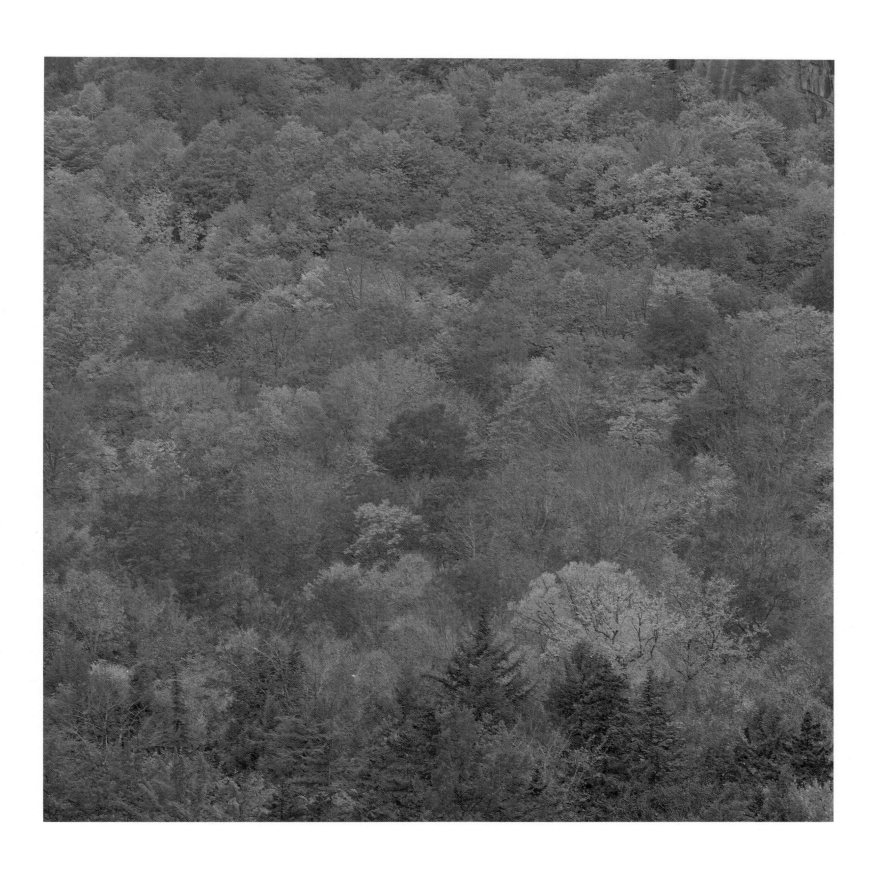

Autumn hues, Green Cliff, White Mountains, New Hampshire

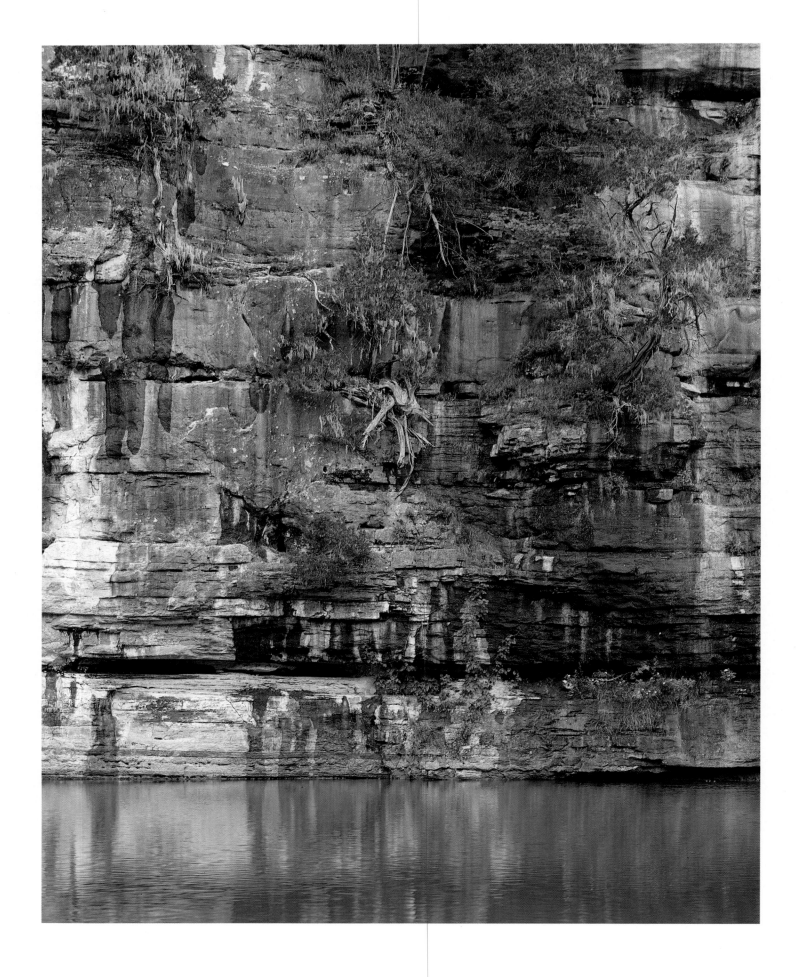

Limestone-Painted Rocks, Buffalo National River, Arkansas

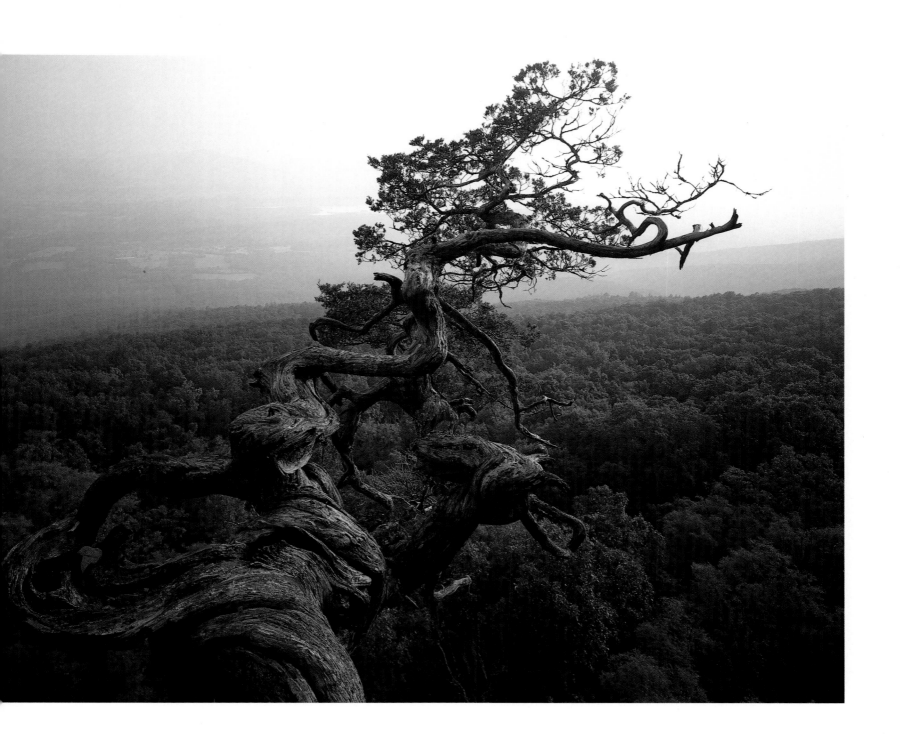

Cedar at rim's edge, Mount Magazine, Quachita Mountains, Arkansas

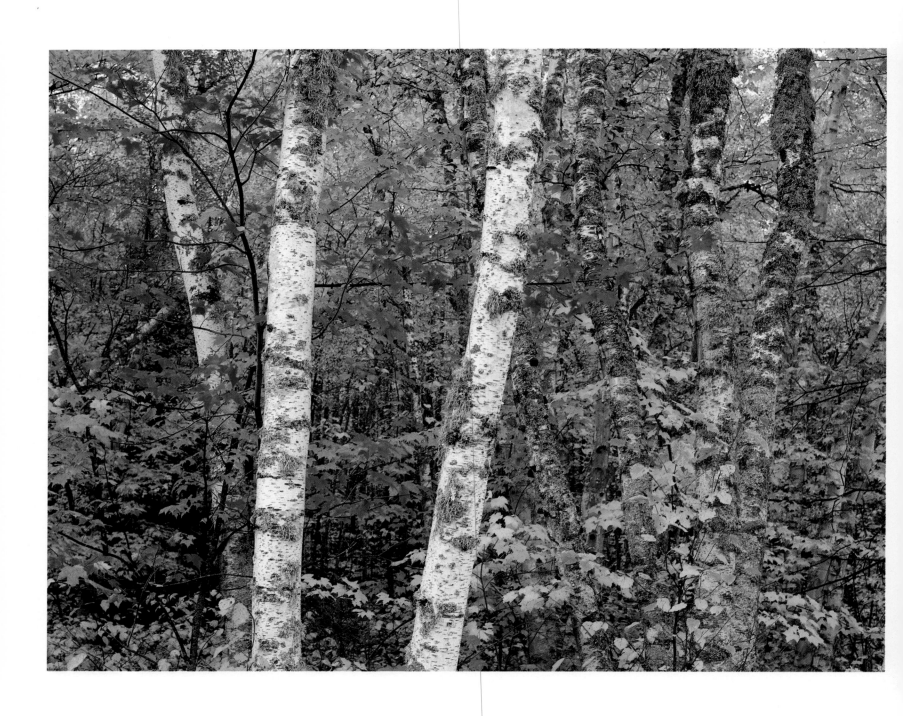

Above: Northwoods birch and maple, Voyageurs National Park, Minnesota

Right: Maple and birch forest, Voyageurs National Park, Minnesota

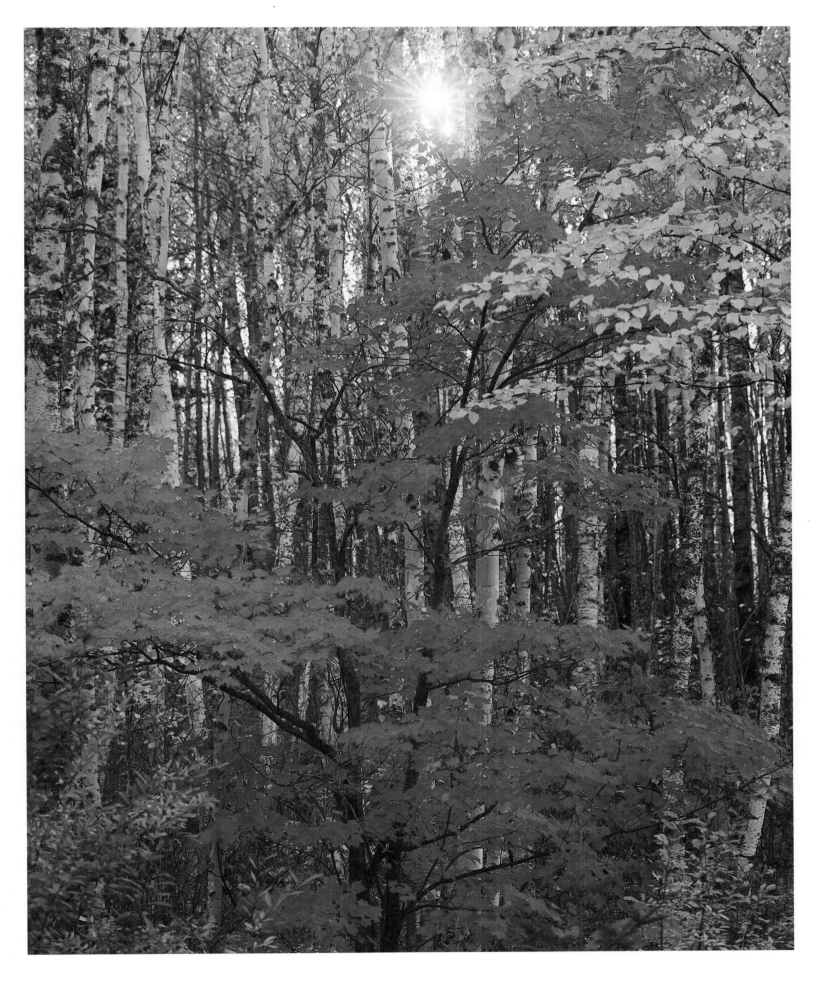

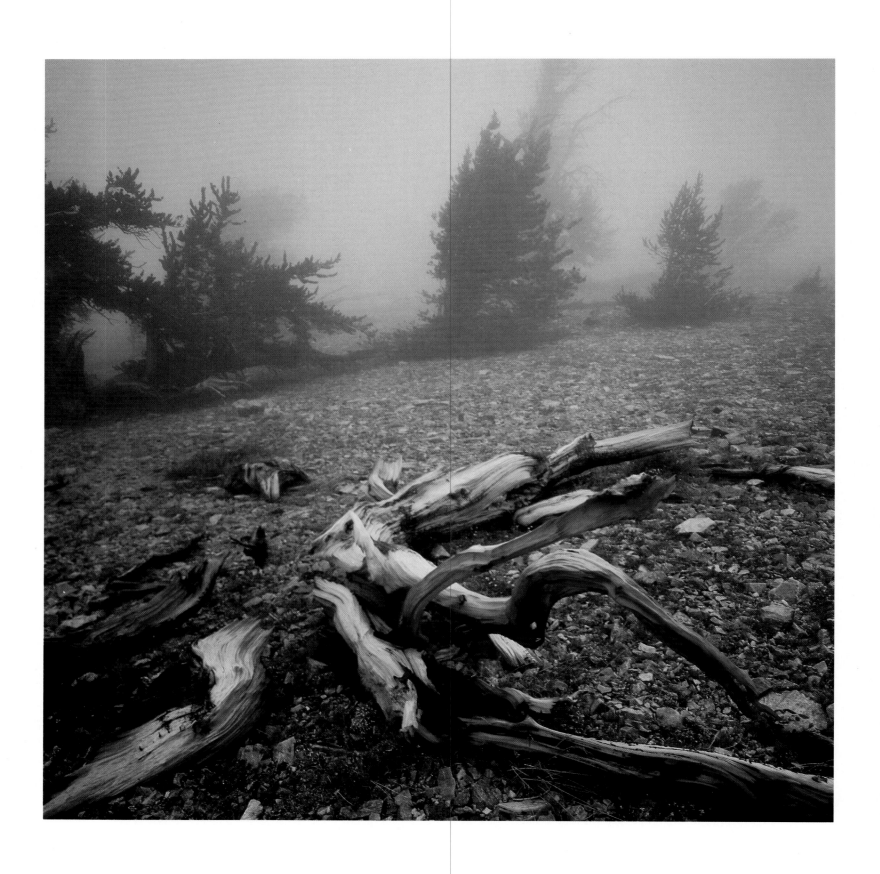

Bristlecone pine fragments, Moriah Table, Snake Range, Nevada

Lace lichen on oak, Santa Lucia Mountains, California

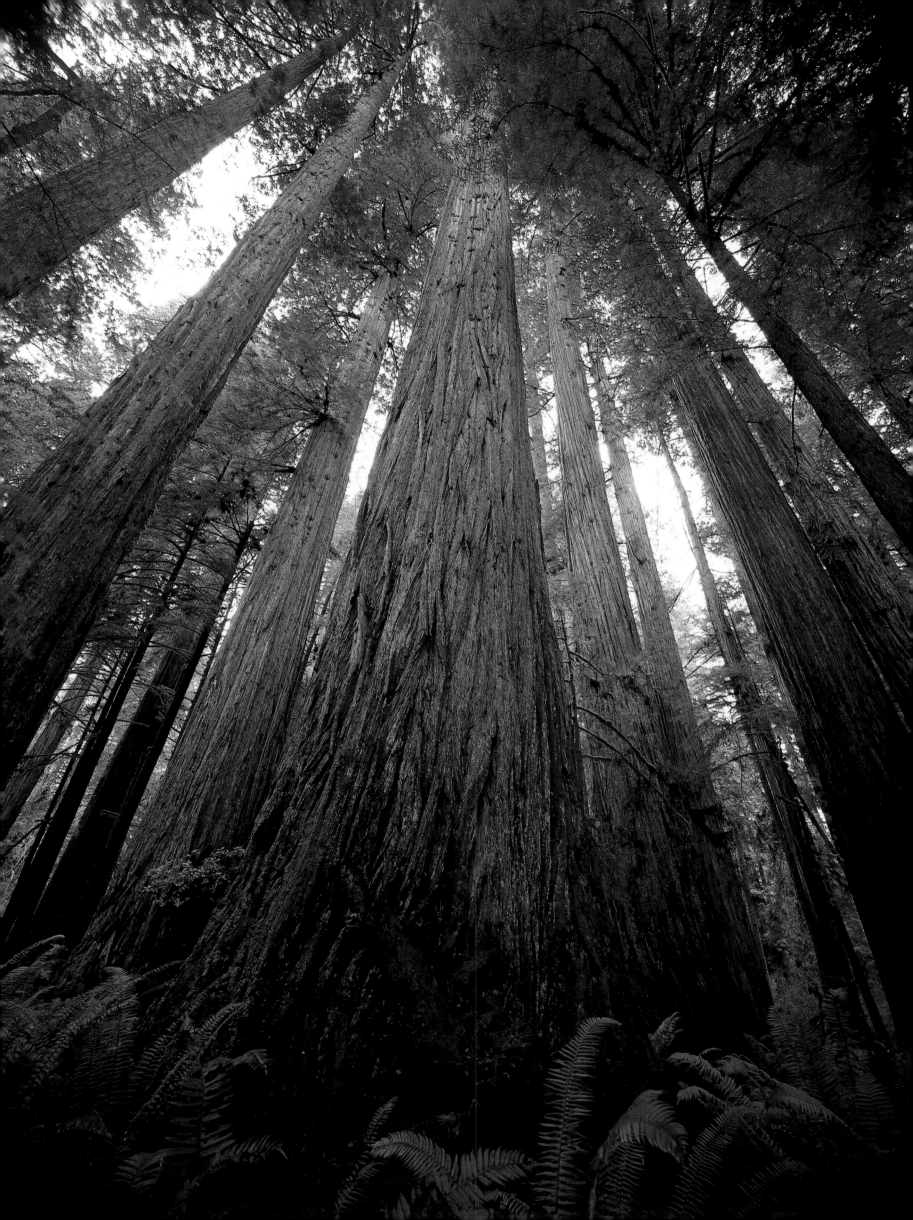

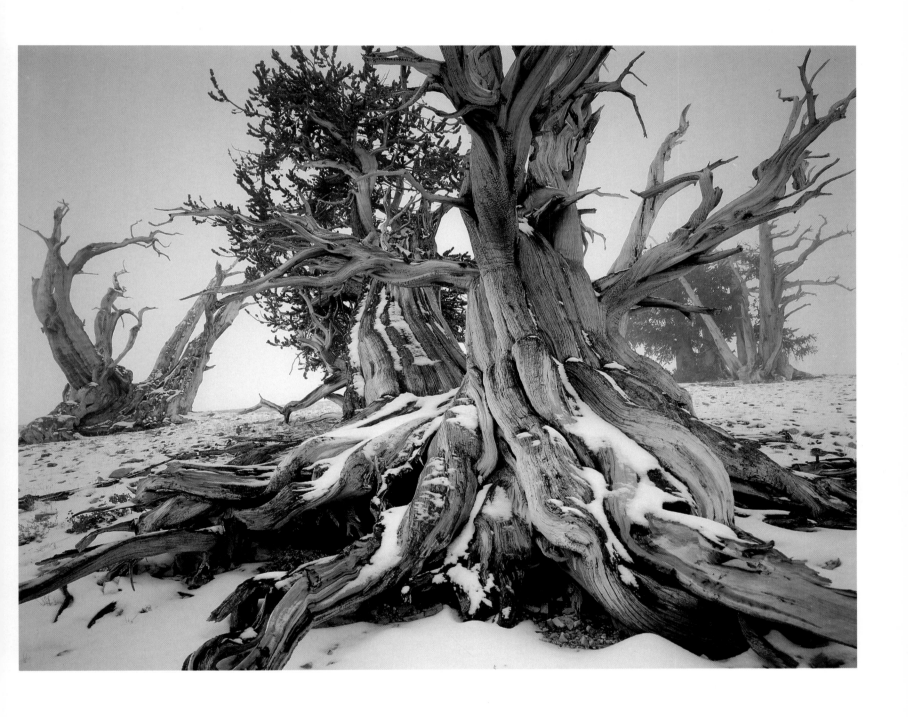

Left: Sequoia sempervirens, Jedidiah Smith Redwoods, Redwood National Park, California

Above: Bristlecone pines, White Mountains, California

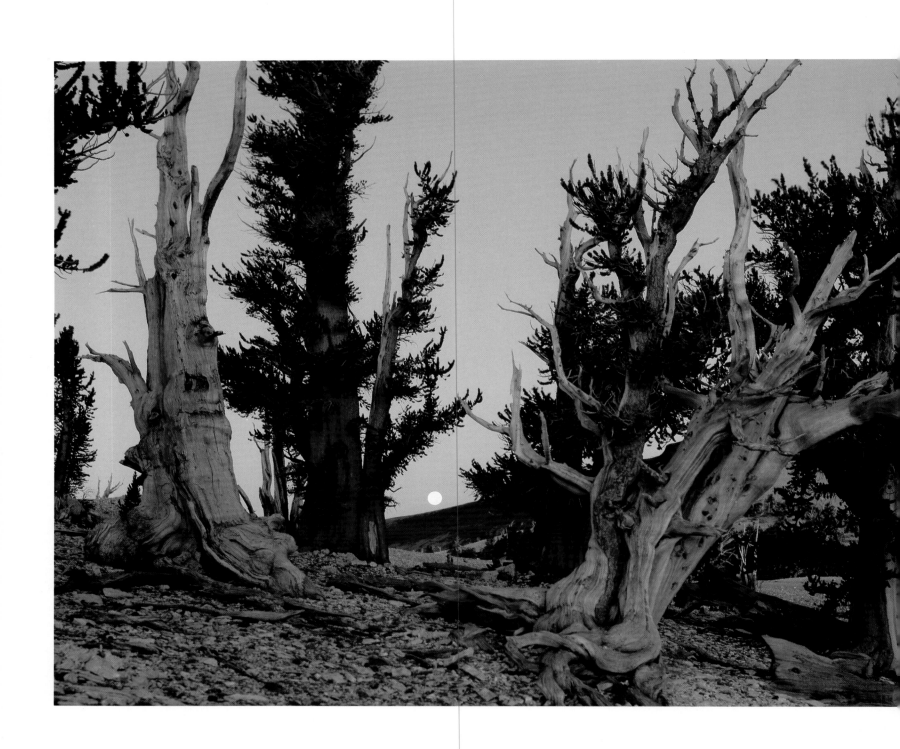

Moonset and bristlecone pines, White Mountains, California

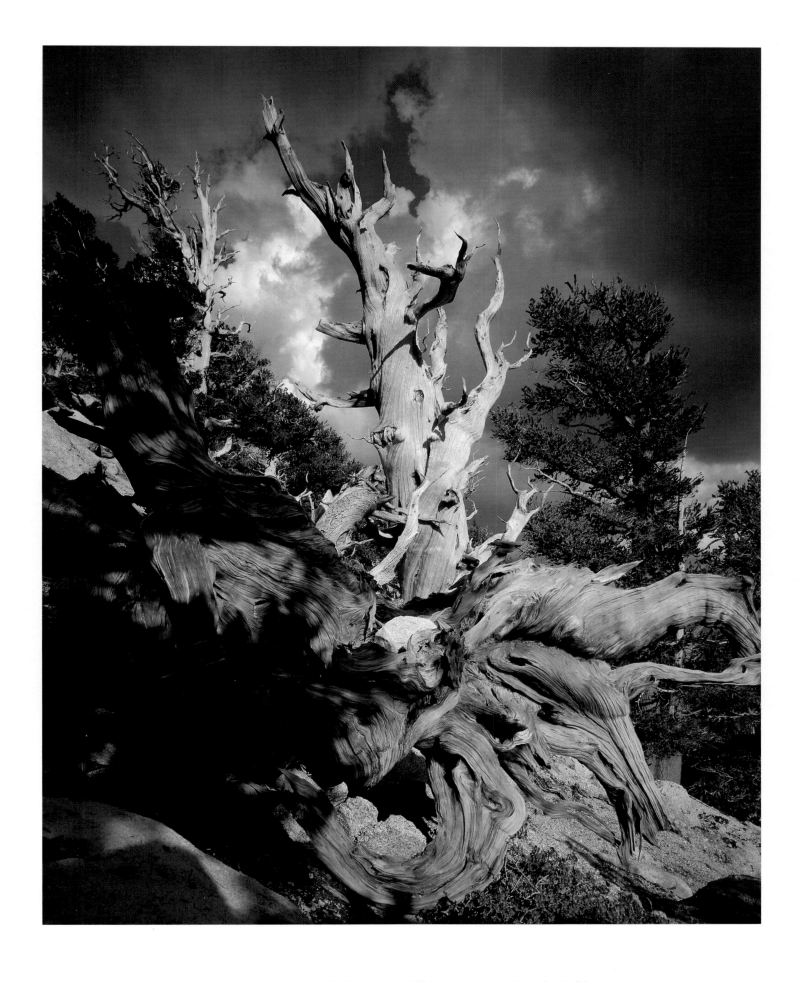

Sculptured foxtail pines, Golden Trout Wilderness, Sierra Nevada, California

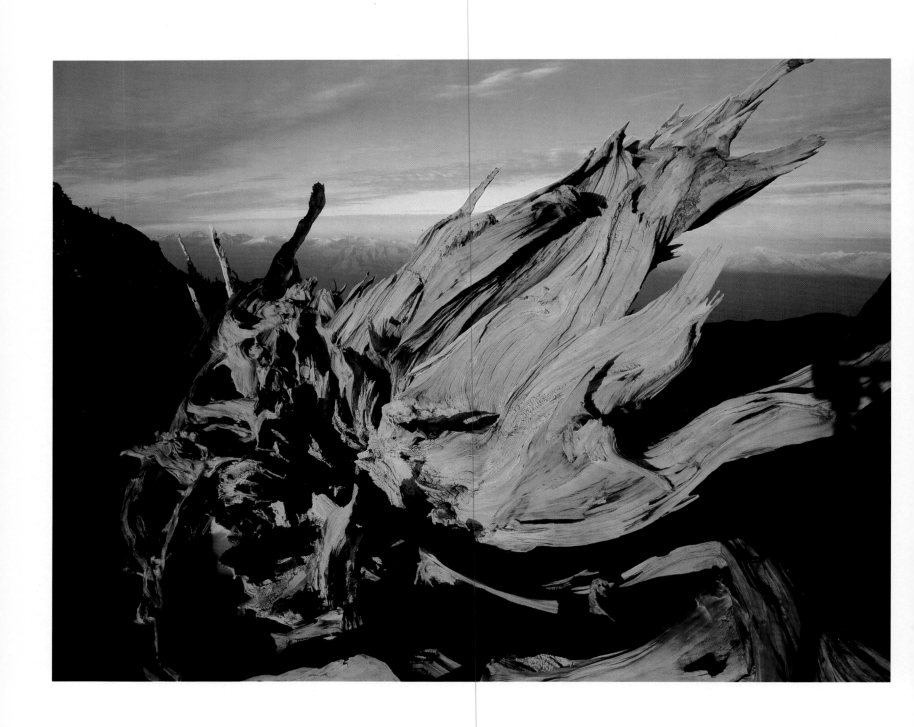

Upturned bristlecone pine, White Mountains, California

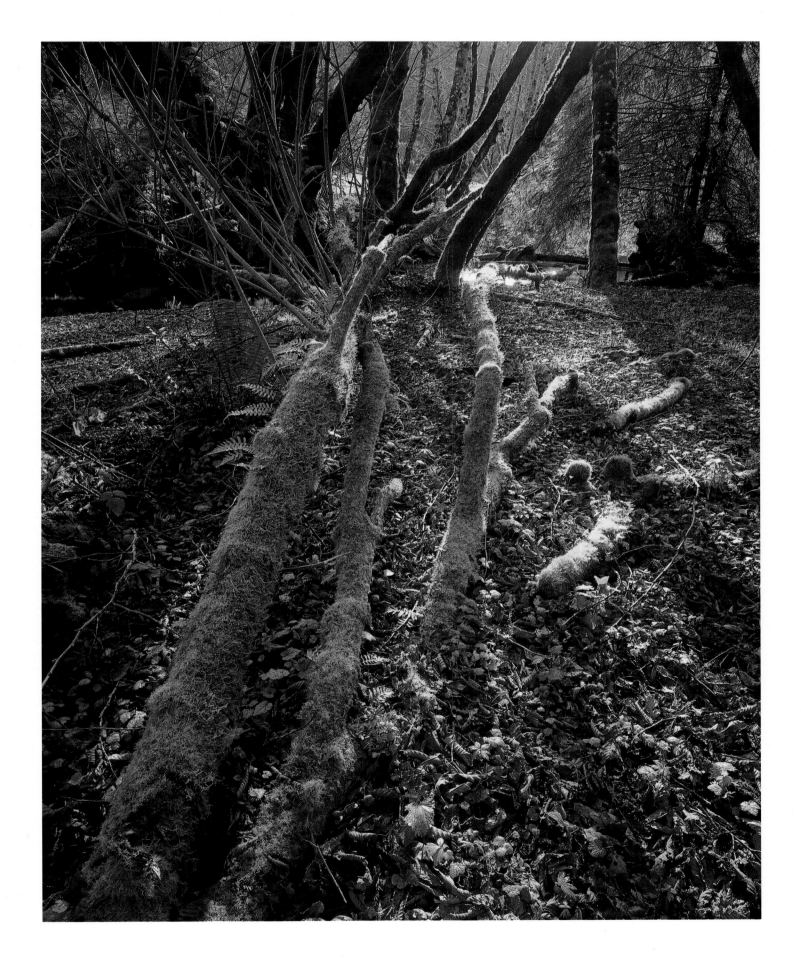

Fallen maple along Hollow Tree Creek, Mendocino coastline, California

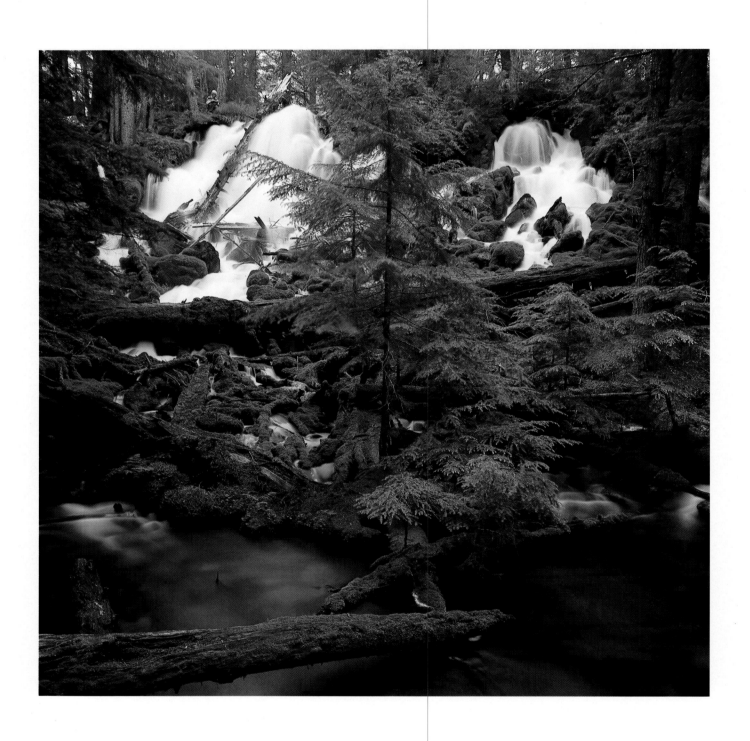

Clearwater Falls on North Fork of Umpqua River, Cascade Range, Oregon

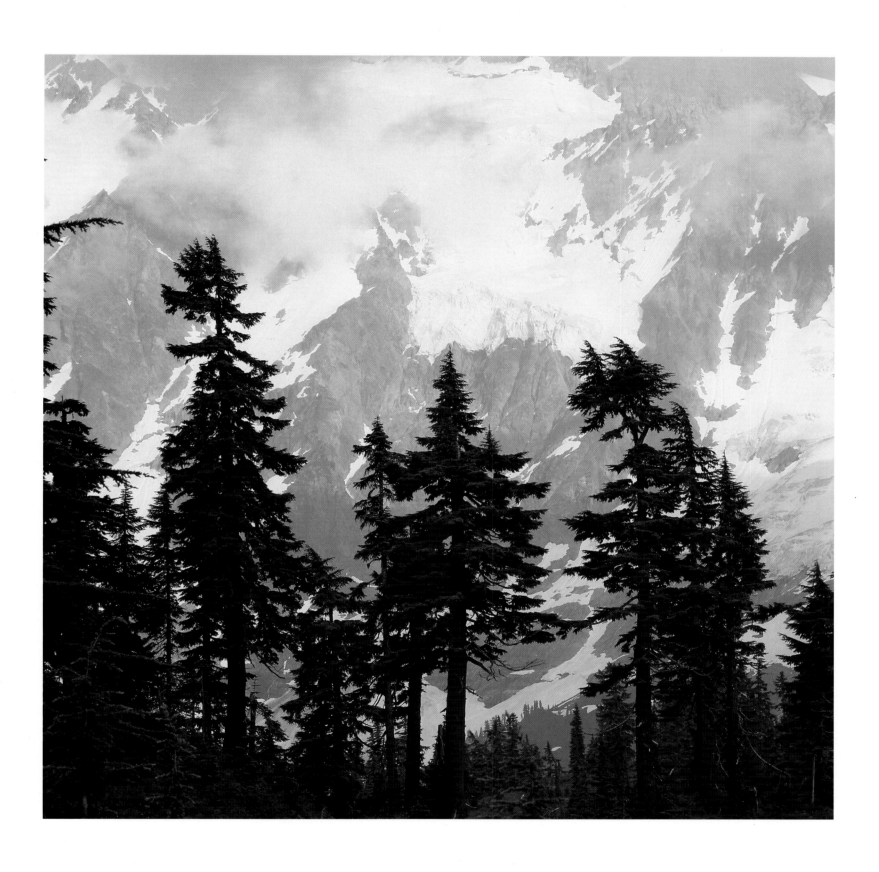

Hemlock and glaciers of Mount Shuksan, North Cascades National Park, Washington

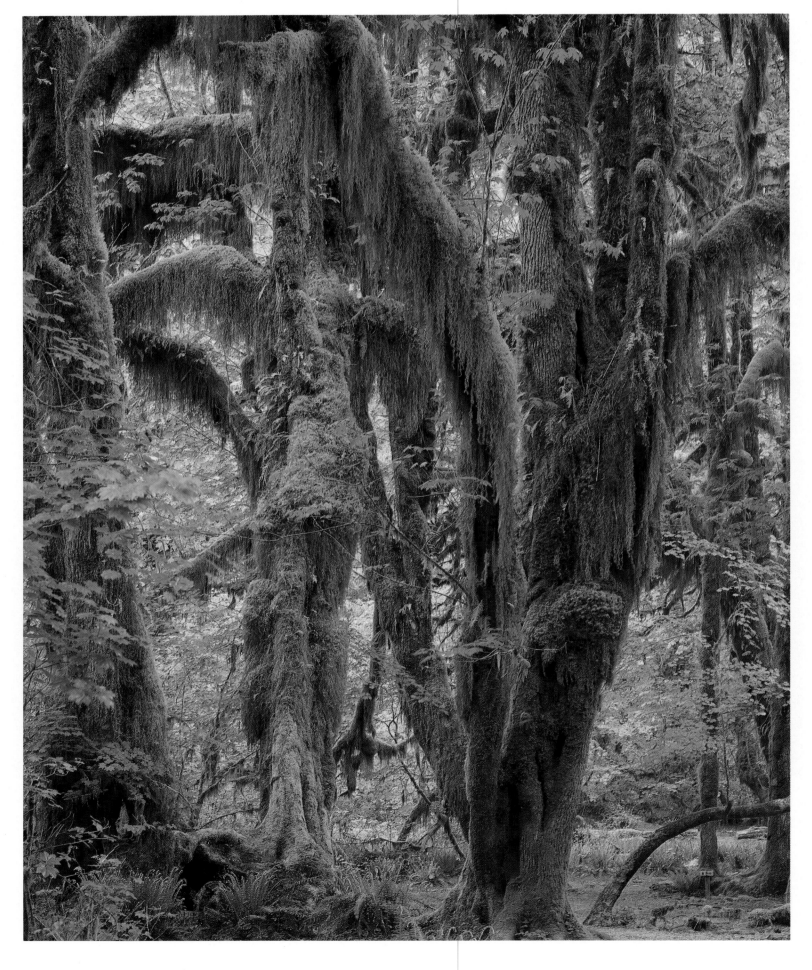

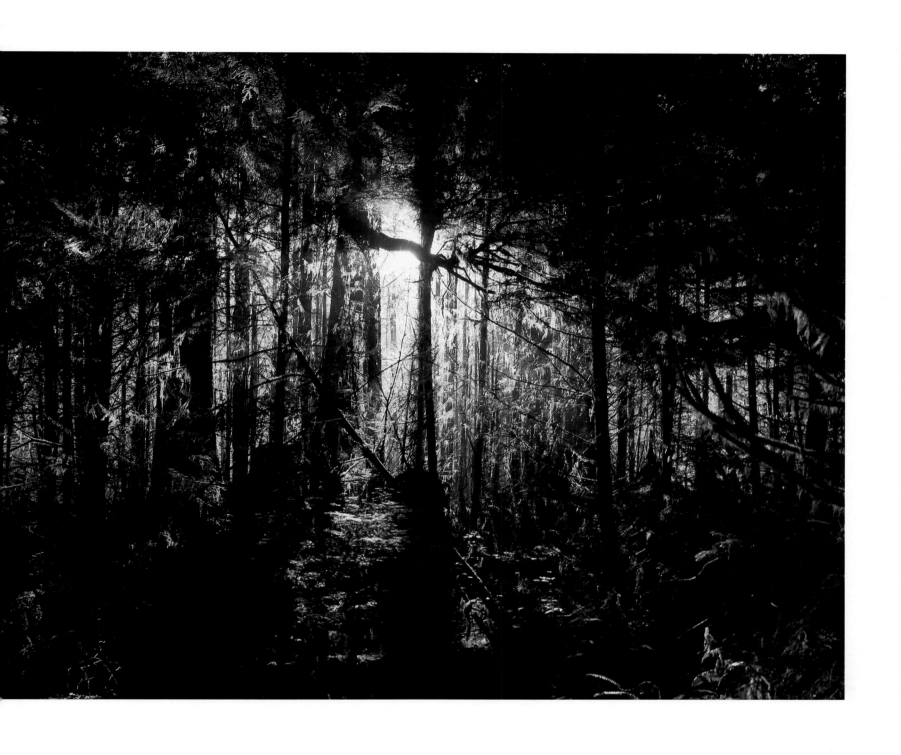

Left: Moss-draped maple in Hoh Rain Forest, Olympic National Park, Washington

Above: Coastal forest interior, Nemah River, Washington

Grasslands

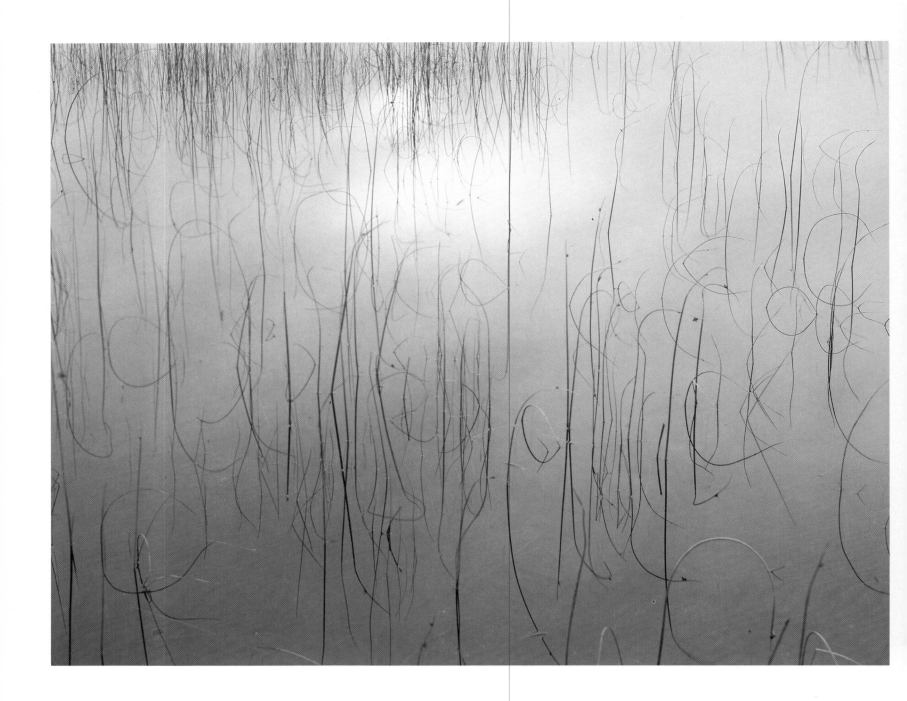

Rushes, Wilderness State Park, Lake Michigan, Michigan

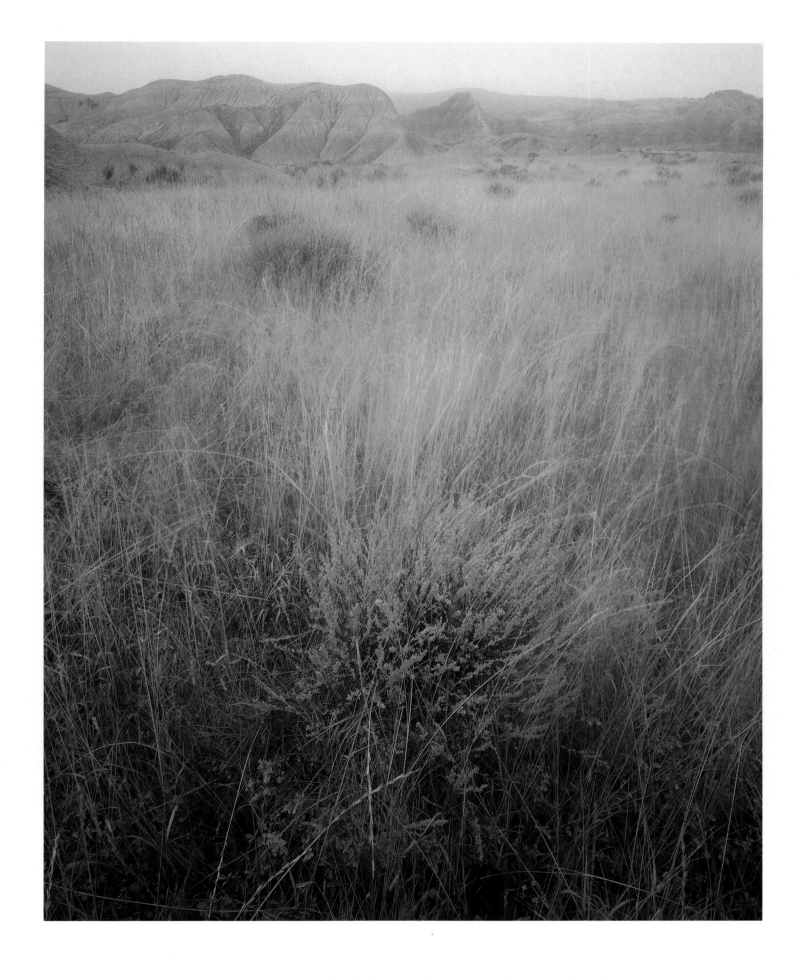

Sage and grasses, Toadstool Geologic Area, Oglala National Grasslands, Nebraska

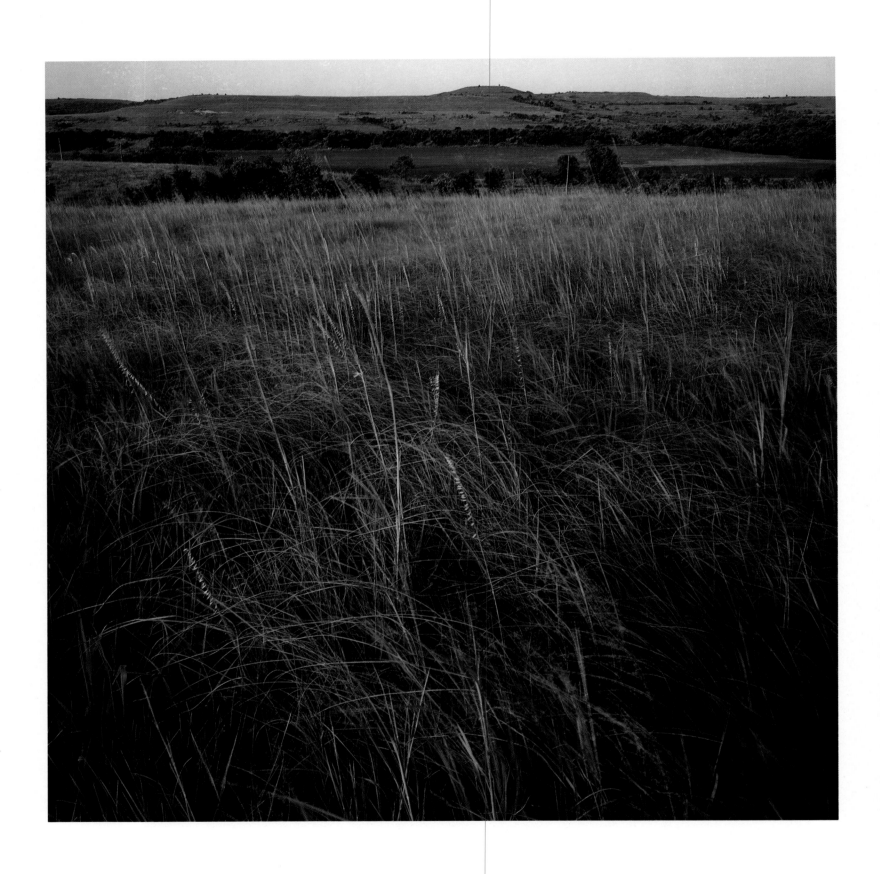

Summer grasses, Flint Hills Preserve, Kansas

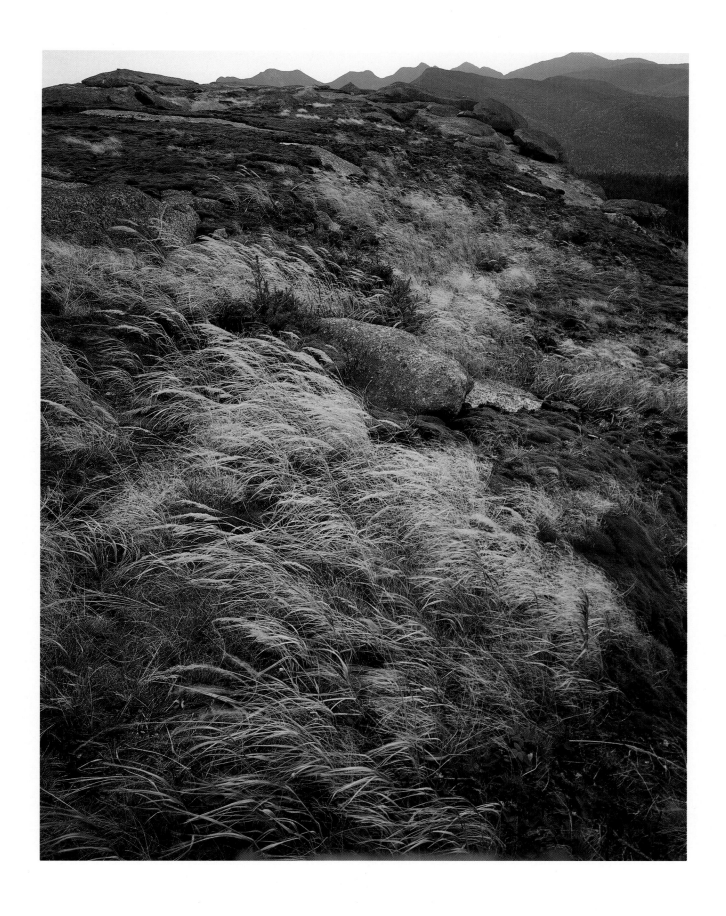

Alpine grasses atop Cascade Mountain, Adirondack Mountain Preserve, New York

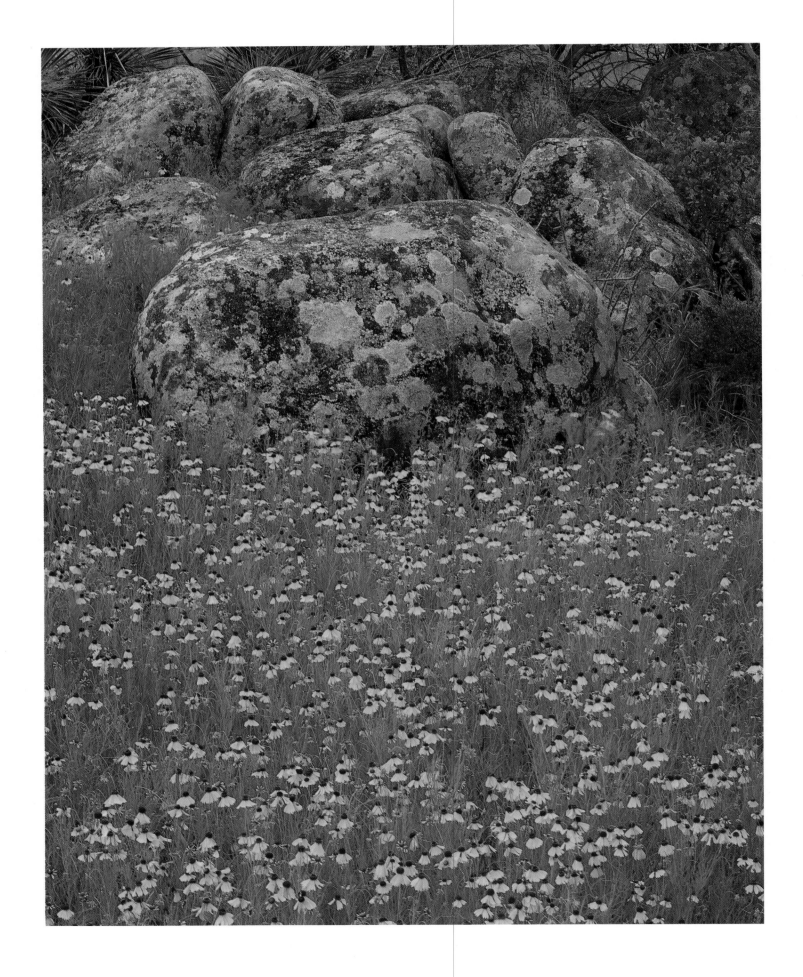

Coneflower with boulders, Llano Uplift, Enchanted Rock State Park, Texas

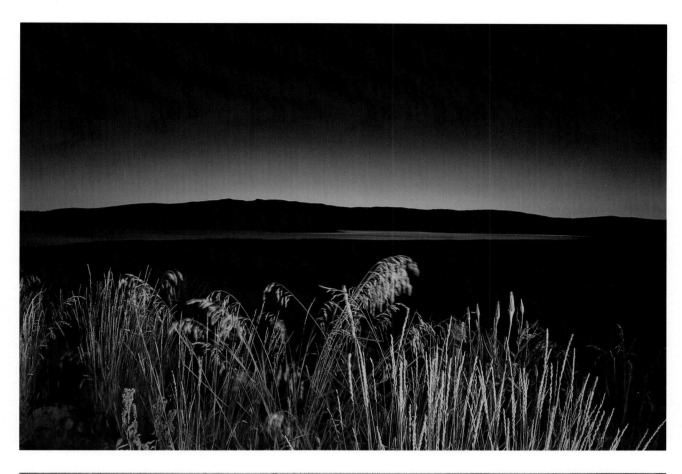

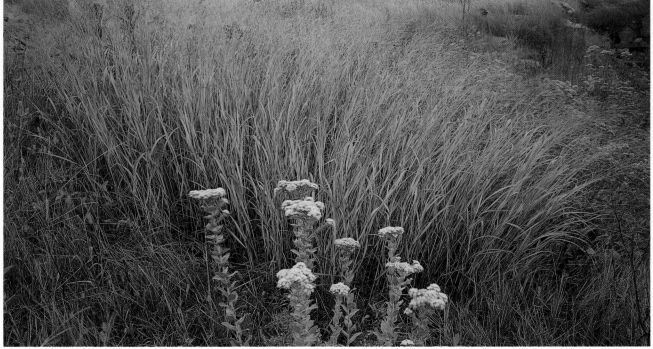

Top: Big Lake and Mount Baldy, White Mountains, Arizona

Bottom: Sandreed grass and goldenrod, Blue Mounds State Park, Minnesota

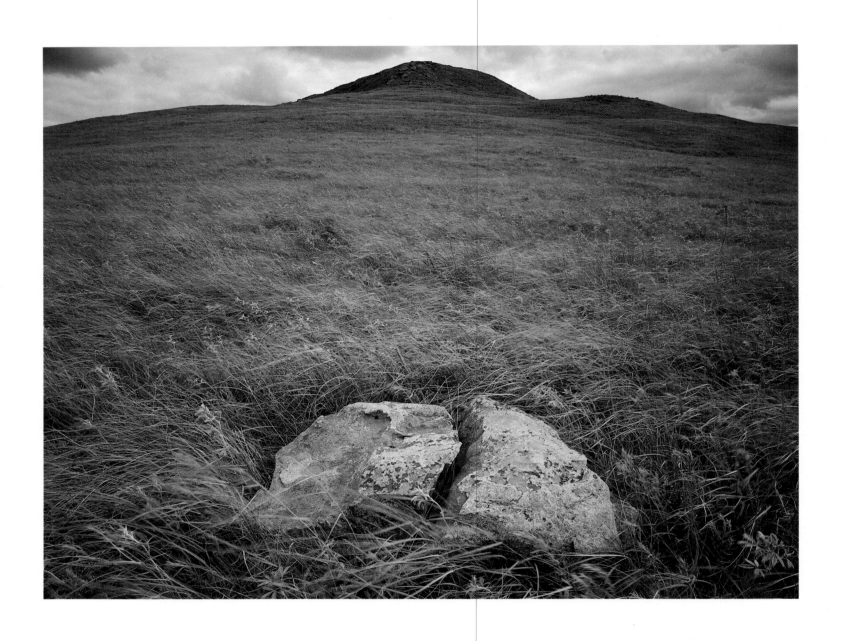

Above: High plains, Grand River National Grasslands, South Dakota

Right: Canadian rye, Niobrara River, Agate Fossil Beds National Monument, Nebraska

Following Page: Autumn grasses, Toadstool Geologic Area, Oglala National Grasslands, Nebraska

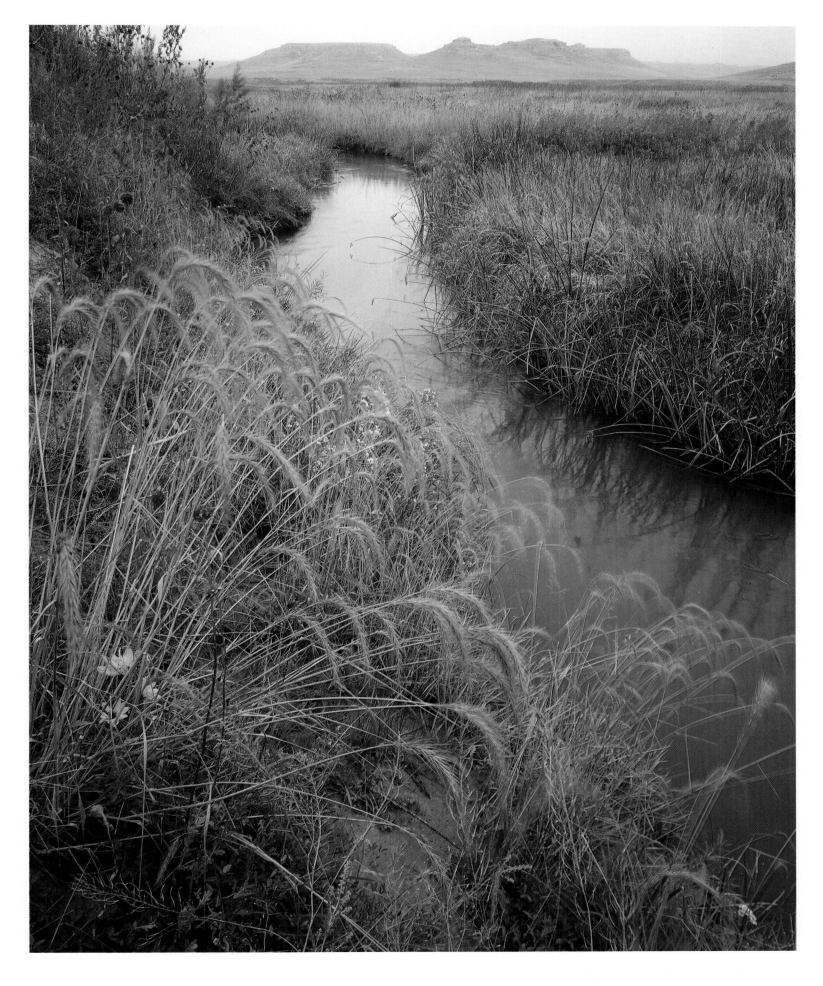

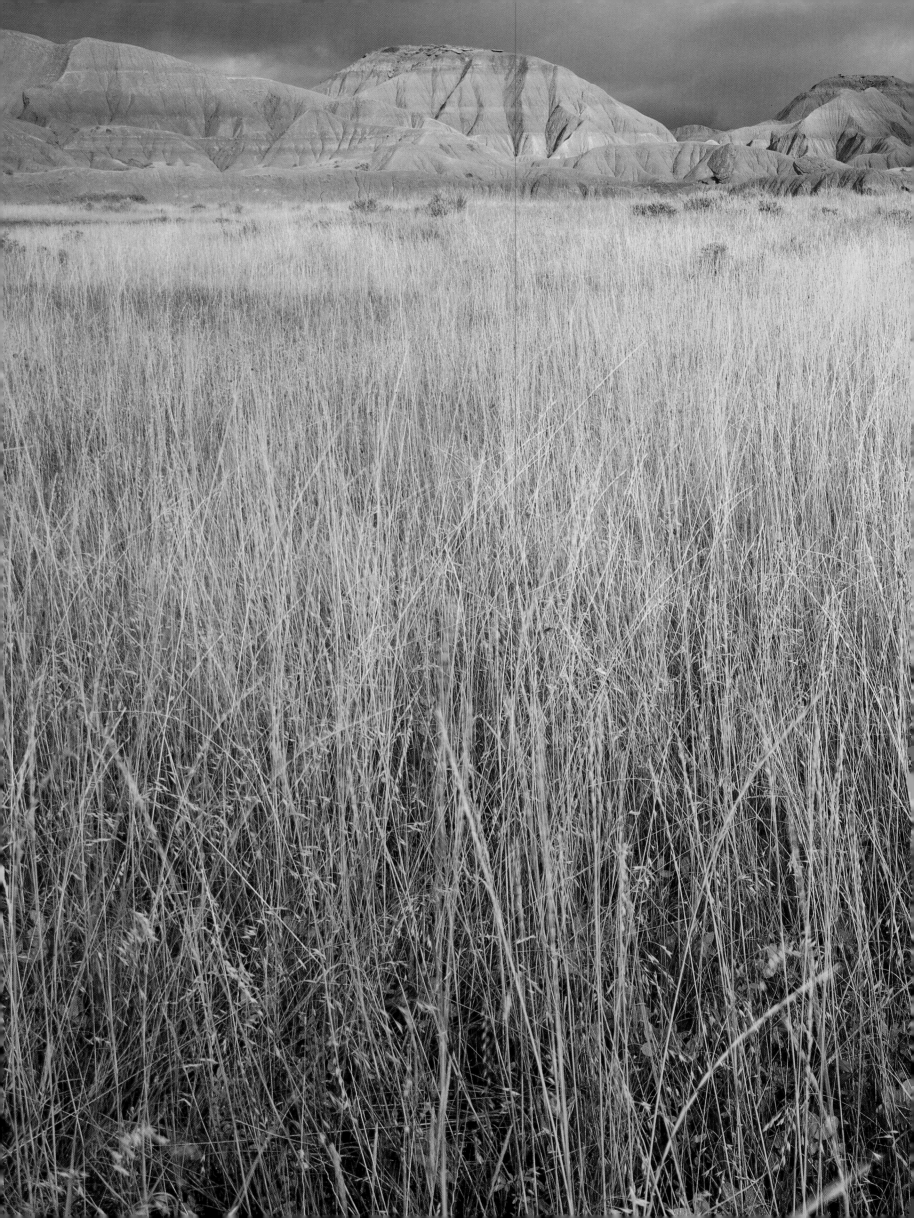

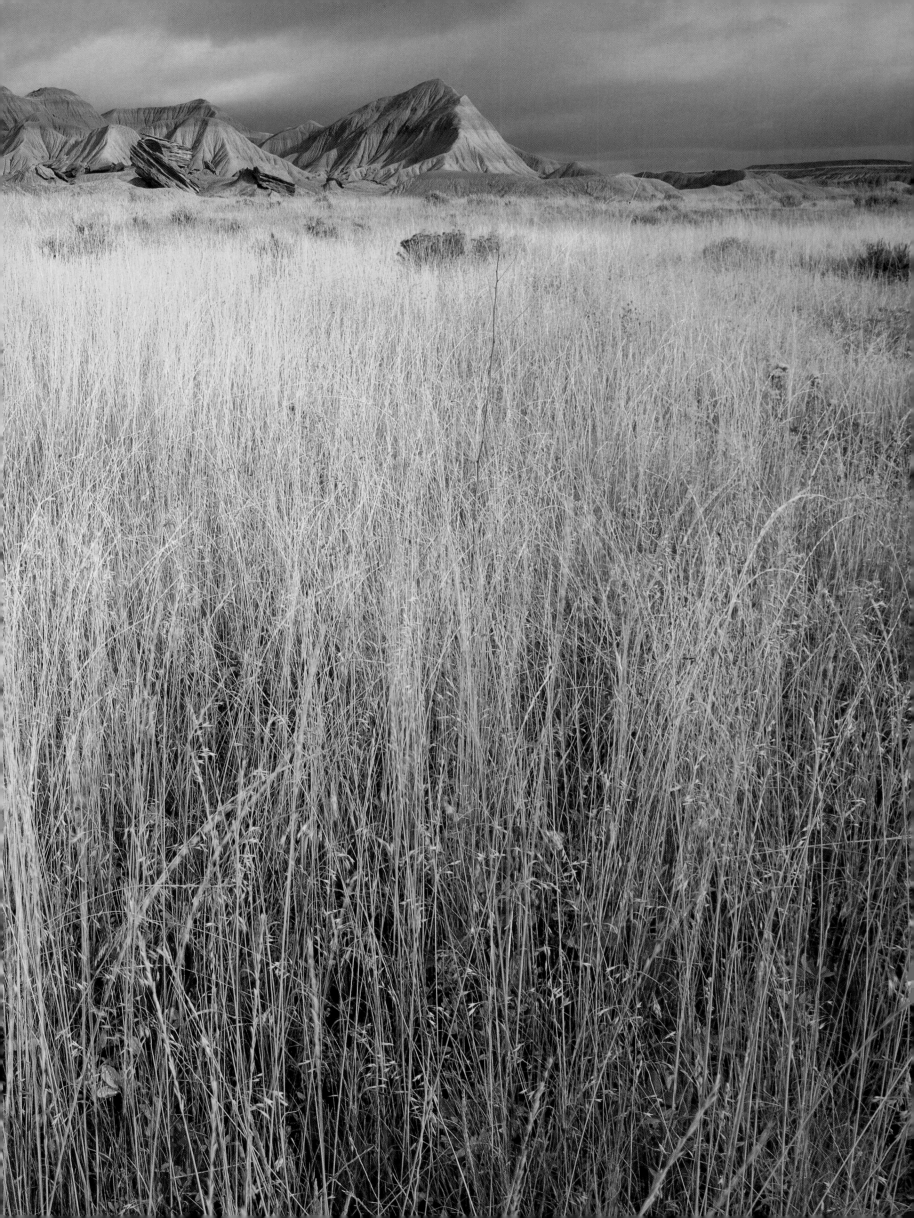

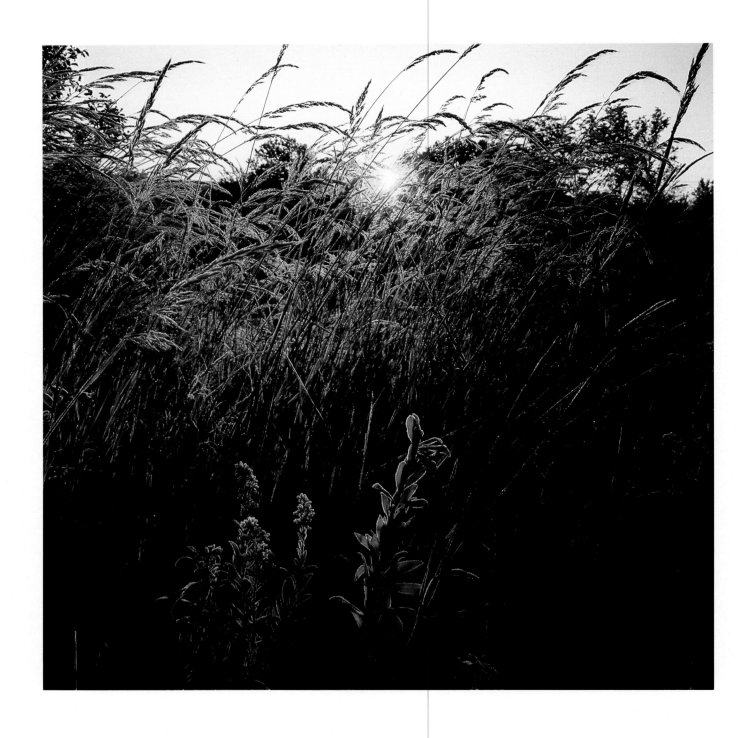

Above: Frosted sunrise, Tallgrass Prairie Preserve, Kansas

Right: Switchgrass, tallgrass prairie along Mississippi River, Missouri

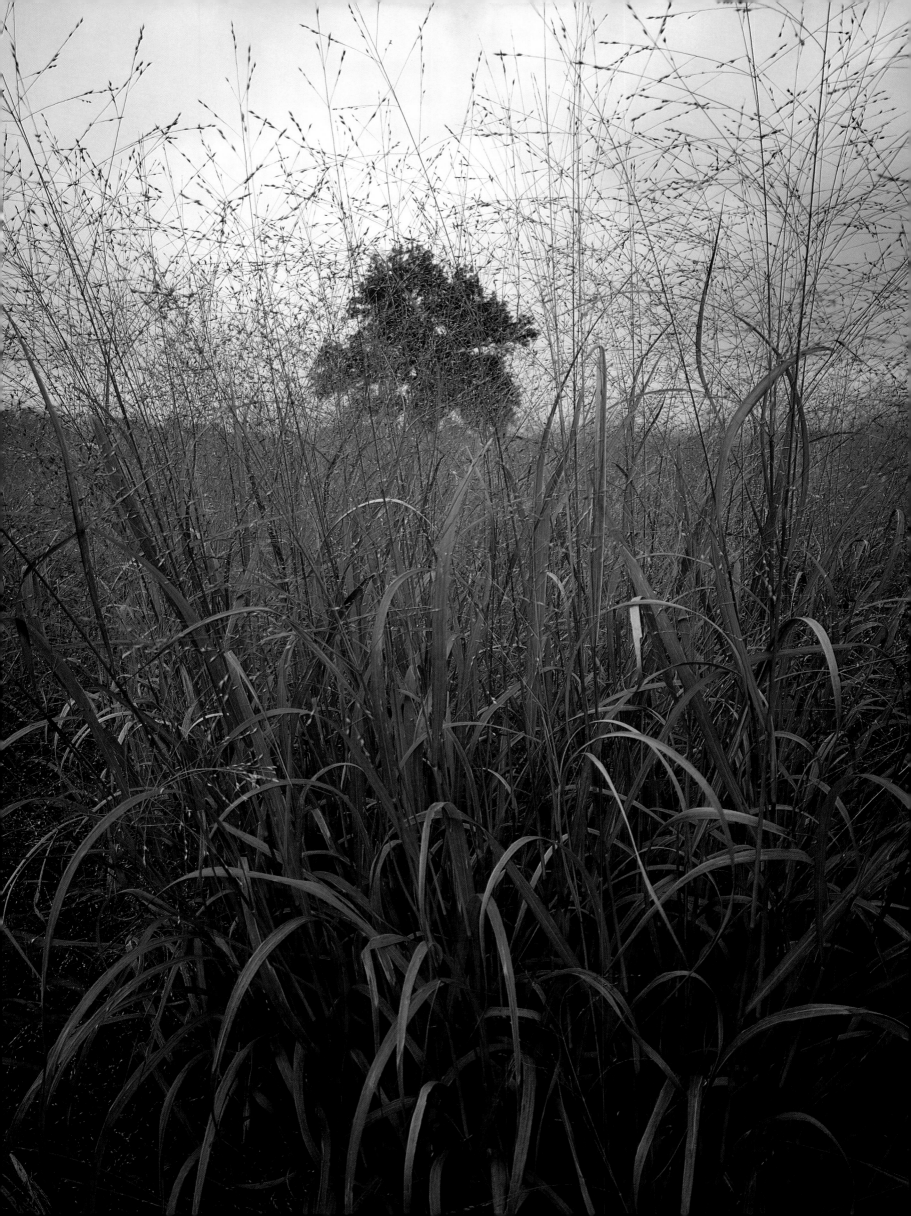

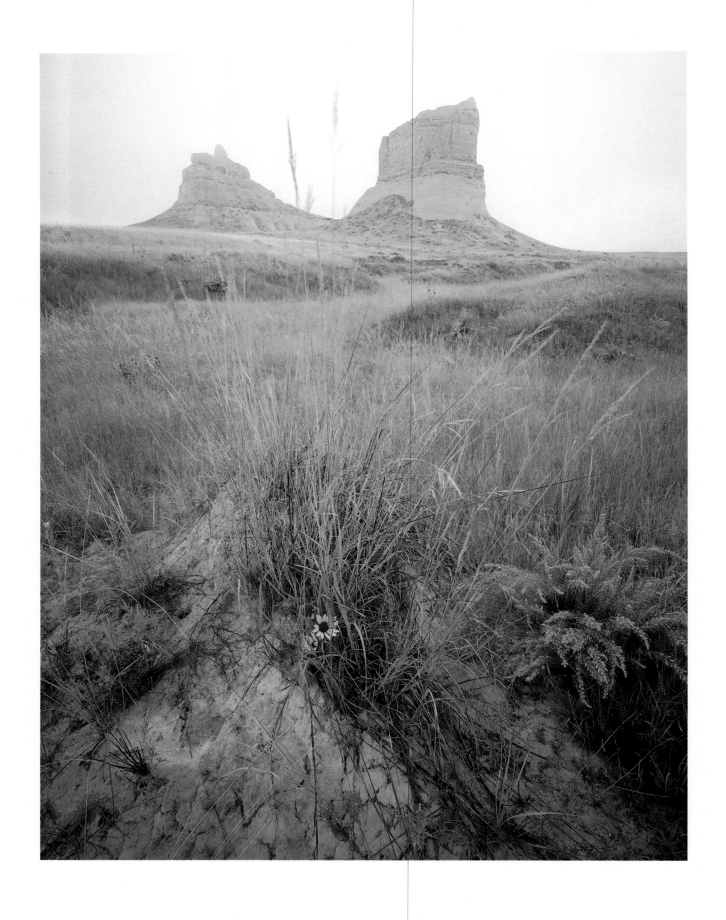

Above: Jail and Courthouse Rocks, North Platte River, Nebraska

Right: Chimney Rock and grasses, North Platte River, Nebraska

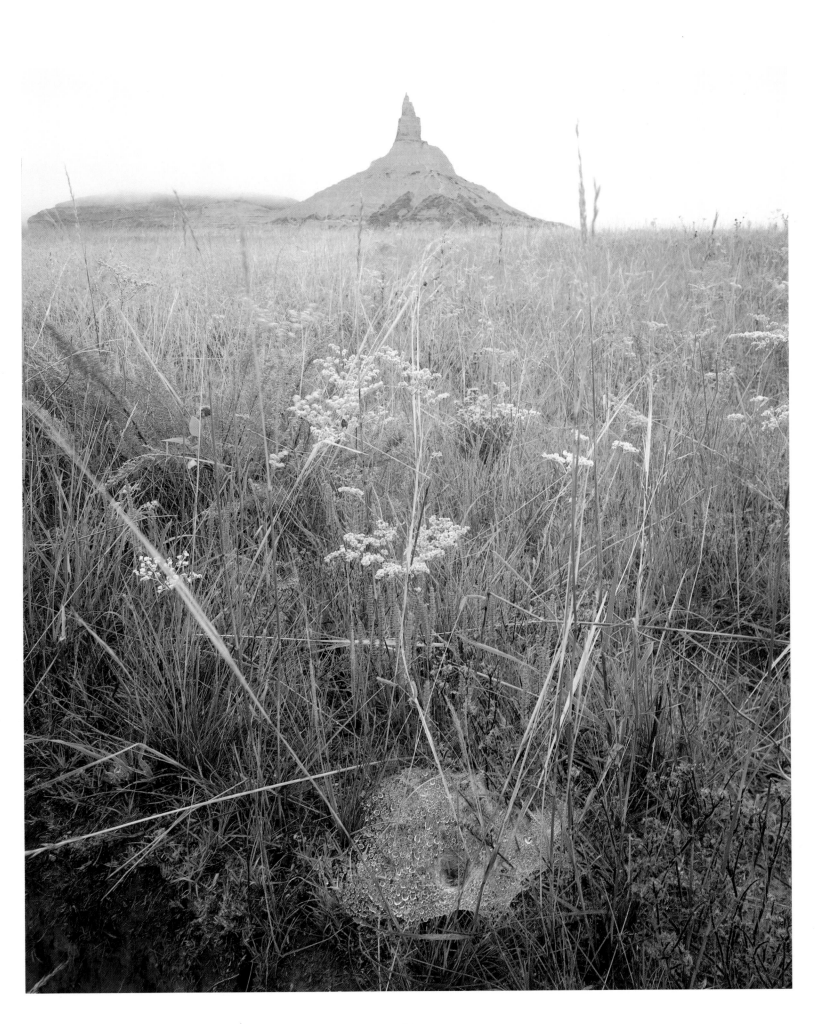

Autumn prairie of switchgrass and maple, Pine Barrens Preserve, New Jersey

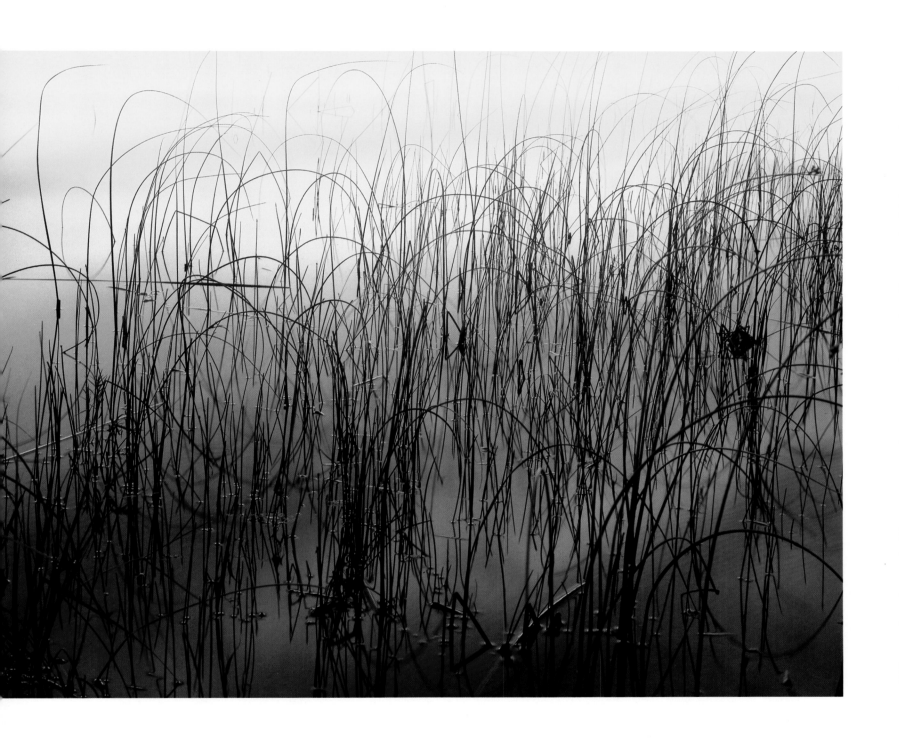

Rushes in dawn caligraphy, Nicolet National Forest, Wisconsin

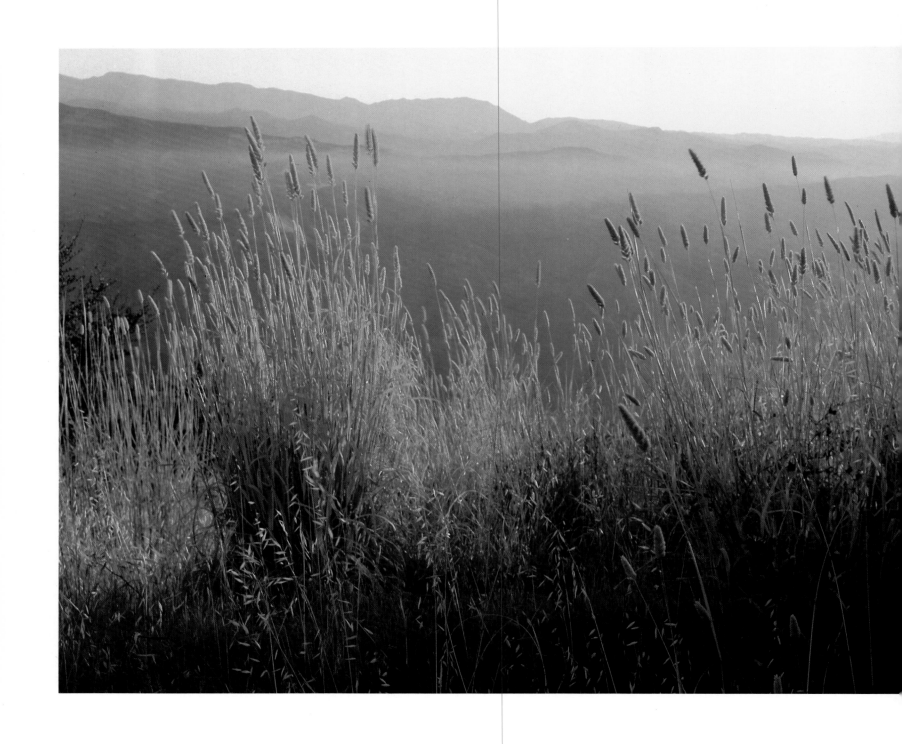

Above: Morning grasses, San Rafael Mountains, California

Right: Fog-shrouded Pacific Ocean, Santa Ynez Mountains, California

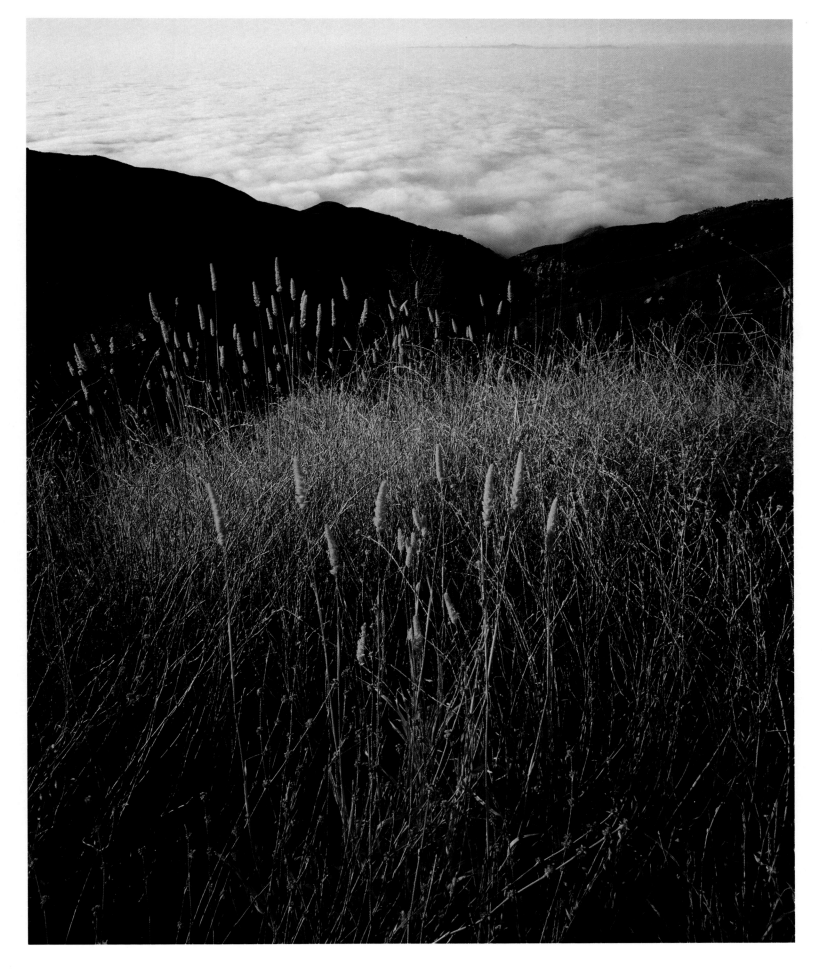

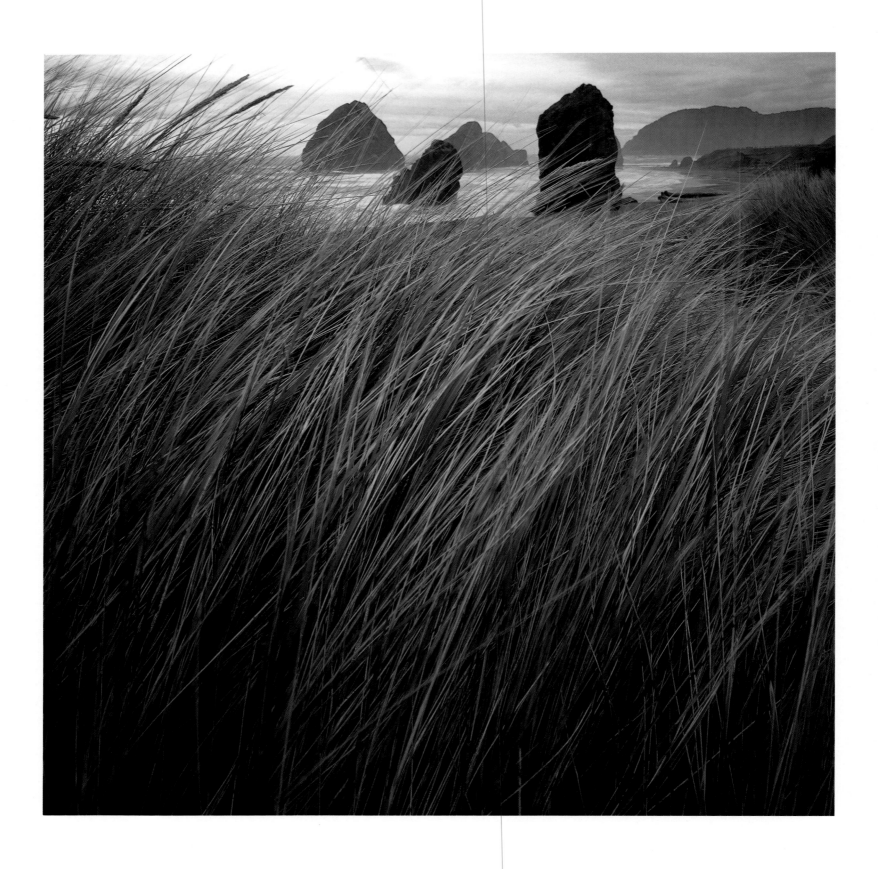

Dune grasses with seastacks, Cape Sebastian, Oregon

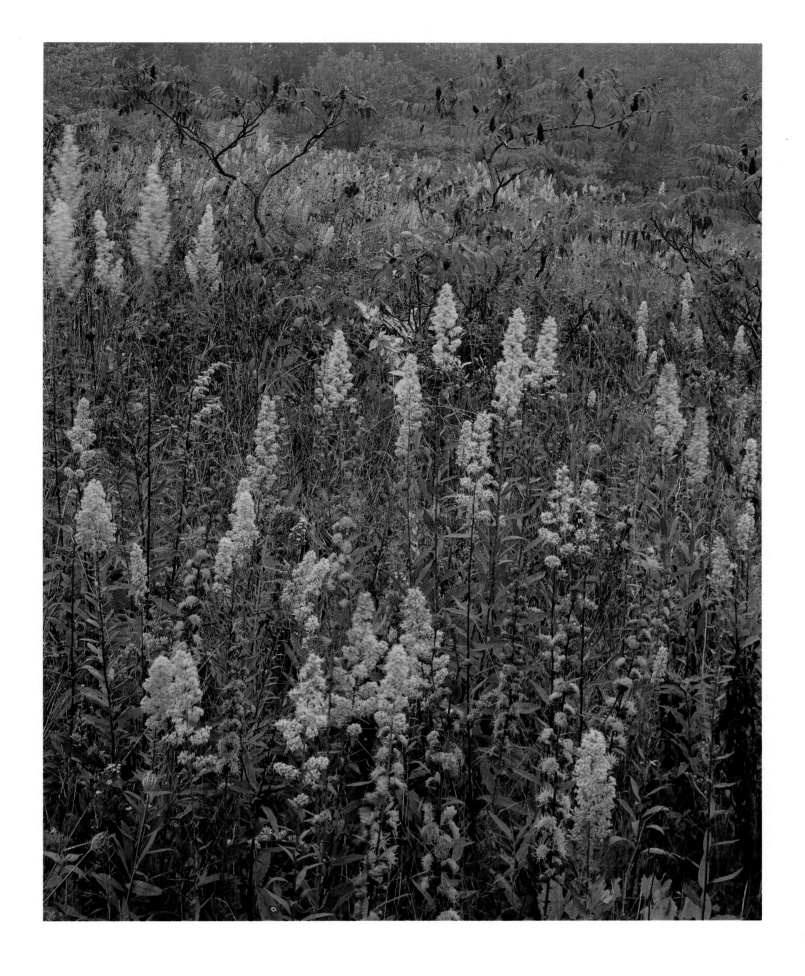

Blazing star, golden rod, and sumac in open prairie, Kipp State Park, Minnesota

AMERICAN LANDSCAPE
By T. H. Watkins
An Excursion into History, Memory, Imagination, and Fact
PART ONE

I. THE MOUNTAINS

I looked with awe at the ground I trod on, to see what the powers had made there, the form and fashion and material of their work. This was that Earth of which we have heard, made out of Chaos and Old Night. Here was no man's garden, but the unhanselled globe. It was not lawn, nor pasture, nor mead, nor woodland, nor lea, nor arable, nor waste-land. It was the fresh and natural surface of the planet Earth, as it was made forever and ever

—Henry David Thoreau, *The Maine Woods*

Not all the drama on this continent of ours has been human. All but maybe three million of the earth's 4.6 billion years has been a history witnessed by no creature sophisticated enough to write down what it has experienced or in some other way contrive to pass its testimony on to future generations. But the earth itself can tell the story when we learn how to read it, and nowhere is the drama better told than in the mountains of the American landscape.

I thought I knew mountains. I grew up with them after all. Every morning from my home in Southern California I could look out my bedroom window and see the long, serrated blue line of the San Bernardino Range between Mount San Antonio on the west (Mount Baldy, we called it) and Mount San Bernardino on the east, all of this part of the mountain system that separates northern California from southern California—into two separate countries, some would say. By climbing to the top of my backyard elm tree, I could look east up the San Bernardino Valley to San Gorgonio Pass, through which the hot, violent breath of the *Santa Ana* would

howl down out of the Colorado Desert at least once a year, testing friendships, dissolving marriages, increasing the workload at police stations and the county sheriff's office. The pass was bracketed on the north by its namesake, Mount San Gorgonio, and on the south by Mount San Jacinto rising like a great, breaking wave above the elegant hamlet of Palm Springs. These were *real* mountains—San Antonio, San Bernardino, San Gorgonio, San Jacinto—all of them more than ten thousand feet in altitude, their topmost crags covered in snow all year, and I could legitimately feel some kinship with the characters in James Ramsey Ulman's *White Tower* (one of my favorite books in childhood) as they struggled against the bitter challenge of the Alps. Sitting on the makeshift platform I had cobbled together high in the branches of the tree, I could peer toward San Gorgonio and by squinting just so turn it into a kind of Matterhorn.

In later years I would come to know parts of the Sierra Nevada, the White Mountains of New Hampshire, the Colorado Rockies, the Appalachians of central Pennsylvania, the Great Smokies of Tennessee and North Carolina. So I could consider myself well-mountained. But while I had seen much, I had understood little.

I learned this not long ago while traveling by train from Chicago to Seattle along the old Great Northern route, the last vestige of railroad tycoon Jim Hill's nineteenth-century dream of empire. For twenty-four hours we had rattled hellbent across the high plains of northern Minnesota, North Dakota, and Montana, but as the late afternoon came down on the country near the end of the second day, the train progressively slowed and began to strain toward Marias Pass and the Continental Divide. It was early spring, and the weather was not especially good, though there had been little

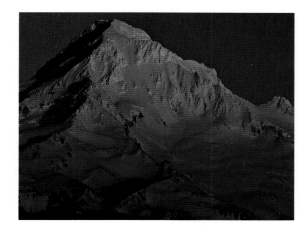

rain. There was plenty of snow on the ground, however, and it thickened the higher we climbed. The overcast lowered, too, until the landscape all about was enveloped in a thin mist that cast a milky screen over everything we saw.

Then the mountains of Glacier National Park began to present themselves, rising from the north like ghosts in the mist, the snow on their shoulders too deep and white to blend entirely with the fog, the black edges of exposed rock etched sharply against the muted sky. One after the other they came into sight as the train twisted through Marias Pass and up the canyon of the Middle Fork of the Flathead River: Mount Henry, Grizzly Mountain, Summit Mountain, Snowslip Mountain, Soldier Mountain, Rampage Mountain, Church Butte, Mount St. Nicholas, Riverview Mountain, Eaglehead Mountain, Loneman Mountain. I knew from my maps that these were just the peaks of the southern border of the park, that farther north—out of sight, but their presence almost tangible, like a weight on the mind—were other, even higher mountains rising along the course of the Going-to-the-Sun Highway almost into Canada. But these before me would do: I was safely encapsulated in my train compartment, but I could *feel* those mountains through the glass of my window, almost smell the snow and the stone. The book in my lap was forgotten; so was my reservation in the dining car. I sat transfixed for perhaps two hours, until the darkness closed down and shut the giants out.

What were those mountains teaching me that I had not known before? They spoke at an elemental level, eloquent stone bearing testimony to an unwitnessed past, the brute drama of continental history. Non-human history. Pre-human history. In Thoreau's words, Chaos and Old Night given form.

And this is the story I think they told—or at least part of it:

After the Big Bang of 4.6 billion years ago, a cloud of gas and dust coalesced, began to rotate, acquired density and a spheroid shape. It was a molten ball, and to its surface floated the lighter elements out of which it was made, silicon and aluminum. These cooled and coagulated, became the planet's ancestral rock, gathered into the first continents, enormous islands in the molten flux. Volcanoes began to bubble and spurt, surrounding the globe with gasses that formed an atmosphere, and in that atmosphere water condensed and began to fall, creating oceans. The floor of the oceans hardened into enormous unstable plates split by rifts through which flowed lava from the planet's still-molten interior.

There was an extraordinary amount of moving around and about among all these planetary elements for hundreds of millions of years. Something over a billion years ago, the land mass that would become today's North America settled down long enough to be ground into from the northeast by an unidentified land mass which jammed ocean bedrock up and into the continental surface, building mountains and giving birth to a frenzy of volcanic activity, with consequent deposits of lava over wide areas. The two land masses remained locked in this violent embrace for perhaps three hundred million years, then drifted apart, the separation accompanied by more volcanic disruption, mountain-building, and the spilling of much lava again. A couple of hundred million years of erosion then wore most of the great mountains down to gentle nubbins, filling the interior valleys with sediment. Not the Adirondacks in New York State, however. Either because some subterranean force kept shoving them higher than erosion could tear them down (and may still be doing so), or because the great collision had given them an extra layer of rock, or because a succession of volcanic intrusions lifted them higher than the surrounding country, the Adirondacks remain prominent, relics of the original continent. While erosion and sedimentation combined to smooth most of the still-young continent, the sea came and went over much of the land several times, laying down its own deposits of trillions of tiny, dead sea creatures that became layers of limestone. Slowly, the continent began to assume something of the form it has today, complete with a shallow shelf on the East and West coasts created by sedimentary deposition. Laurentia is the name scientists have given this ancient forebear of North America.

A few thousand miles to the southeast, on the other side of the Atlantic's predecessor sea, another great continent lay abuilding. This one, named Godwanaland, comprised most of what is now Africa. Maybe five hundred million years ago, Godwanaland started drifting northwest, and 450 million years ago it plowed into the eastern coast of Laurentia, its own continental shelf sliding over Laurentia's shelf and slamming into the land above the sea with implacable force. When Godwanaland finally tore itself away, it may have left pieces of itself behind; this, at least, is one current theory many geologists now use to explain the fossilized anomalies they find within the American continent's eastern rocks. More important to our discussion here, the power of Godwanaland's collision simply crumpled the land, raising old and

sedimentary rocks together into enormous folds that ran all the way from what is now northern Maine to what is now the middle of Georgia. These were the Appalachian Mountains, including the individual segments called the Great Smokies, the Blue Ridge, the Alleghenies, the Poconos, the Catskills, the Green Mountains, the White Mountains, the Presidential Range, and so on up to Mount Katahdin in Maine.

Not that the Appalachians are all of a piece; precious little in geology ever is. The mountains north of the Connecticut River Valley (formed as a great rift when Godwanaland and Laurentia pulled apart) are of a considerably different character. Accompanied by extensive volcanic and subterranean activity, they apparently began to rise even before the collision itself, and while there is evidence that Godwanaland shoved them farther west, there is not much to indicate that any significant folding took place. It is likely that these mountains are still building, being raised by pressures from below. In any case, they are more crudely and sharply sculpted than those of the south, and generally higher; at 6,290 feet, Mount Washington in the Presidential Range is the highest peak east of the Black Hills and north of 6,684-foot-high Mount Mitchell in the Great Smokies. It is also the windiest spot on earth, a never-matched 231 miles-per-hour having been recorded there.

The Appalachians, their northern peaks and gorges cut and polished by the frozen masses that crept over them during the various ice ages, their southern reaches shaped more by wind and rain and therefore softer and rounder to the eye, were North America's first mountains—or at least the first to survive into human time. Close behind them, and created in much the same way, apparently, are the Ouachitas, which run southwest from Arkansas into Oklahoma. These folds in the earth were jammed together when either the hump of South America or the Yucatan Peninsula ground into Laurentia from the south during another variation on the continental collision theme, this one occurring perhaps 300 million years ago. North of the Ouachitas, some little-understood internal force lifted up a wide plateau in Arkansas-Missouri, after which the well-understood forces of erosion carved the tangled maze of mountains and hollows that we know today as the Ozarks. About eight hundred miles northwest of the Ozarks, another great blister on the land—a gigantic dome of granite known as a batholith—rose up through the High Plains a hundred

million years ago and was worn away to the mountainous complex we call the Black Hills.

The same forces that thrust the batholith of the Black Hills into sight probably created the backbone of the continent as well—the Rocky Mountains. This jumble of upthrust rock, marching from south to north through the states of New Mexico, Colorado, Utah, Wyoming, Montana, and Idaho—and above that all the way through western Canada—gives character to the interior landscape of America. Even its names have an outsized power: the Sangre de Cristo and San Juan mountains, the Sawatch Range, the Front Range, the Never Summer Mountains, Mount of the Holy Cross, the Park Range, the Laramie Range, the Medicine Bow Mountains, the Uintah Mountains, the Sierra Madre, the Elkhead Mountains, the Bear River Range, the Wind River Range, the Owl Creek Mountains, the Grand Tetons, the Gros Ventre, Wyoming, Aspen, and Caribou ranges, the Centennial, Big Belt, Pioneer, and Beaverhead mountains, the Absaroka Range, the Lost River Range, the Sawtooth Range, the Salmon River Mountains, the Clearwater Mountains, the Cabinet Mountains, the Salish Mountains, the Sapphire Mountains, the Garnet Range, the Lewis and Clark Range, the Swan Range, the Flathead Range . . .

The Southern and Central Rockies were born of the Laramide Revolution, a geological movement that began about eighty million years ago when the Farallon Plate, one of the earth's constantly-moving crustal formations, slid under the western coast of the continent and began to push the Colorado Plateau in a northeasterly direction. This movement put enormous pressure on the land ahead of it, compressing, folding, cracking, and shoving around the layers of sediment that had been laid down over the eons as deposits from ancient inland seas, with much of the crumpling accompanied by the molten bubbles and spurts of volcanism. The land also began to rise as all this was happening, thousands and thousands of feet, an uplift that probably continues. In many areas, subsequent erosion has worn away all the sedimentary rocks to expose billion-year-old stone in peak after peak rising in jagged magnificence all along the Front Range through Colorado and Wyoming: Mount Evans, Longs Peak, Clarks Peak, Pikes Peak, Castle Peak, Medicine Bow Peak, Wind River Peak, Grand Teton, Fremont Peak . . .

This is high country defined and absolute, pieces of Thoreau's "unhanselled globe" exposed to the sight of man and the work of

the elements. To stand on the upper reaches of country like this is one reason people risk so much in the art of mountain-climbing. Gene Fowler, who grew up in the Colorado Rockies, understood some of this and caught it in *Timber Line*:

If you scale a peak crowned by an acre or so of tableland, you will encounter amazing paradoxes. You have climbed through a violence of upthrusting winds—mostly from the east—which have endeavored to hurl you from crag to ravine; then suddenly you win the flat summit and stand in an area so calm as to be uncanny. The nearby gale, mounting a corkscrew to heaven, rockets past your peak to wrestle with the stars. And it is a vastly impressive experience to stand in the calm zone, hearing the unruly cry of the great wind, and with never a whisper of it straying through your young hair. At timber line you become Olympian.

The drama continued in the Northern Rockies, though the forces that gave them birth came from a slightly different direction—and possibly two directions. The one that geologists are reasonably certain about came from the northwest, where another crustal plate slid under the continent, creating the pressures that folded, broke, and raised up the land to the east, creating the ranges of northern Idaho and northern Montana—including the phalanx of peaks that had risen out of the mist to greet me with their awesome presence in Glacier National Park. One particularly interesting phenomenon that distinguishes these mountains is the presence of huge sheets of sedimentary rock that did not shatter or fold appreciably as they were shoved east; instead, they simply rode up and over other formations on their journey, and today their exposed edges can be seen in splendid long escarpments like the Garden Wall in Glacier National Park or the Chinese Wall in the Bob Marshall Wilderness.

But the Northern Rockies also are distinguished by the presence of very large granite batholiths that have been jammed up through the surrounding country. One of these, the Idaho Batholith, is 250 miles in length and a hundred miles across at its widest point and underlies most of Clearwater, Nez Perce, Bitterroot, Payette, Salmon, Boise, Challis, and Sawtooth national forests. No one seems to know for certain how these enormous intrusions took place, but as Walter Sullivan reports in *Landprints: On the Magnificent American Landscape*, some geologists think that the Northern Rockies were squeezed into existence from both ends:

They envision the rim of the original North American landmass diving under the newly acquired structures to the west, producing great compression along what became the northern Rockies. In this regard James W. H. Monger of the Geological Survey of Canada sees the westward-moving continent "ploughing into the accumulated, semi-consolidated 'mush' to the west (which may have been travelling south to north across its bow)." There is considerable evidence that the edge of the previous continental basement now lies under the mountains just west of the Rocky Mountain Trench.

While east is east and west is west, quite often the twain *do* meet, even merge—at least in the world according to geologists. The West Coast collision that produced at least some of the Northern Rockies also created what we now call the Cascades, a broad reach of mountain country that runs south through most of the western half of Washington and Oregon, then curves southeast across a large chunk of Northern California. Violent country. When Mount St. Helens swelled like a great bubo on the land, then blew off the top of its head in 1981, it was acting out a continuing tale. This section of America is part of the ring of fire that curves up and around the Western Hemisphere from Japan to Mexico, a rim of earthquake and volcanic eruption where the forces that have been with the earth since its cosmic coagulation still express themselves in no uncertain terms. They have already built volcanic peaks to be reckoned with—Mount Spickard, Mount Logan, Mount Olympus, Glacier Peak, Mount Rainier, Mount Hood, Mount Shasta, Lassen Peak, among others—and the processes continue as the North Pacific Plate and the Pacific Plate slowly grind against each other, their energy shaping the land and occasionally threatening to obliterate its human presence.

Even farther west, the Coast Ranges that rise from northern Washington and run three-quarters of the way down the California coast are largely the result of the same earth-moving process—but with variations. The Klamath Mountains of the northern California-southern Oregon coast, for example, are such a jumble of geological coming and going that nothing is exactly where it should be. David Rains Wallace writes in *The Klamath Knot*:

There is hardly a mountaintop in the Klamaths that didn't start at the bottom of something. The gigantic white trapezoid called Marble Mountain began as a deposit of limy

ooze under the Pacific. The red peridotite hulks of the Kalmi-opsis were originally ocean floor and planetary mantle, beneath the limy ooze. The granite peaks of the Trinity Alps began deep in the continental crust. And what is at the bottom of the deep gorges that run below these peaks, so far below that peaks are invisible from gorges? In many places one finds twisted humps of black rock called pillow basalts which originated as lava flows from underwater volcanic action. . . . This can seem very upside down to someone used to associating lava flows with the tops of volcanoes.

By comparison, the Sierra Nevada, the last great range in the lower 48, appears almost sedate in its composition. From rolling, climbing foothills that border California's great central valley on the east to the sharp-tilted escarpment that looms over western Nevada, the Sierra Nevada is a straightforward block of stone first pushed up and out by pressure from the Farallon Plate. These mountains are granite, for the most part, shaped on their eastern reaches into serrated peaks like Mount Whitney, at 14,495 feet the second-highest point in the United States (Mount McKinley in Alaska is higher). It is in the Sierra, too, that the most spectacular evidence exists of the work that glaciers have done in almost all of America's mountains during the two million years of the Ice Age epoch. Just west of a line of peaks rising ten, eleven, twelve, and thirteen thousand feet above sea level, lies the glorious trench called the Yosemite Valley, where inch by gravid inch glaciers once carved out an incomparable landscape, something which the continent's European settlers could not have imagined and probably would not have believed had they been told.

We are still in the Ice Age epoch, and unless we have permanently heated up the atmosphere with our fluorocarbons and hydrocarbons and other effusions, the ice will come again to shape and polish the mountains. And the mountains themselves, most of them, will still be building, the ancestral rock of the earth being pushed forever higher even as ice and wind and precipitation tear it down and carry it to the sea. I suppose that was what those mountains in Glacier National Park were telling me. They seemed to be physically moving, you see, tortuously creaking up out of volcanic steam as they rose above me and the train from which I watched. An illusion, of course, but a powerful one, a living reminder that the story of mountains is not done, nor is the making of the American landscape.

II. THE FORESTS

And so, at dawn, on the twenty-sixth day of April,
Just over four months from London,
They sailed between Cape Henry and Cape Charles
And saw the broad Chesapeake, and the wished-for shore.
—Stephen Vincent Benet, *Western Star*

There is no denying the mythic power that trees hold over us. The ancient Greeks populated the Hellenic woods with hundreds of spirit gods, creating votive figurines and statues to represent them and placing them here and there in the forest; the spot chosen was sanctified by their presence. The ancient Celts of the British Isles worshiped the old oaks of England and made cathedrals of their groves, and even today, among village folk in the Cotswolds or the forested valleys of Wales, you can find those who still believe that willow and birch trees harbor spirits that are not made entirely of cellulose. Knowing this, perhaps we can begin to understand something of the power of the presence that awaited those Europeans who first ventured here.

The American continent was first a comely odor, and the odor came from trees. It was perfume, like something out of Old Araby; it promised to validate dreams, and dreams, after all, were what had driven men and women to cross the dark Atlantic in the first place. The Jamestown settlers had smelled it before making landfall off the coast of Virginia in the spring of 1607; it was a good time of year, the best time of year for that country, and the odor, permeated with new life, promised much. Three springs later, aboard the pinnace *Deliverance*, British adventurer William Strachey caught the same odor off Cape May, and it was strong enough for him to record the occasion in a letter home. A little after midnight on May 27, 1610, he wrote, the crew of the *Deliverance* "had a marvelous sweet smell from shore. . . which did not a little glad us." The gladness did not long survive their arrival at Jamestown, for this tiny outpost in the Virginia tidewater country showed the ravages of what was called "The Starving Time." Out of three shiploads of gentlemen and laborers who had been sent to the New World by the London Company to dig for gold and establish British dominion, only thirty-eight were still alive in 1610. Disease, sunstroke, malnutrition, and sporadic Indian raids had killed the rest. It would take them ten years to acquire some

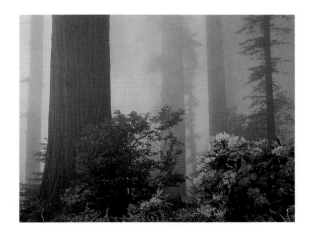

immunity to New World fevers and to learn the arts of survival well enough to prosper—to learn to plant American corn, which grew readily, rather than good British wheat, which would not; to catch fish; to capture and domesticate wild turkeys; and to hunt the lovely whitetail deer for their flesh and skins. By then, too, they had learned to travel into the forest only in well-armed groups.

For it was the forest, the forest whose promising odor had been their first knowledge of the continent, that was their challenge and their terror. Certainly the Pilgrims who established Plymouth Colony in 1620 had found it so. They had been bound for the better country of Virginia, but early winter storms had driven them off course and they put in on the shores of Massachusetts instead. It was November and bleak, cold as only New England can get, the kind of chill that turns the marrow damp, and in the freezing mists the dark forest shouldered down to the very edge of the sea. Everywhere they turned, their historian, William Bradford, remembered, they could see nothing

> but a hideous and desolate wilderness, full of wild beasts and wild men. . . . Neither could they, as it were, go up to the top of Pisgah to view from this wilderness a more goodly country to feed their hopes; for which way soever they turned their eyes (save upward to the heavens) they could have little solace or content in respect of any outward objects. For summer being done, all things stand upon them with a weatherbeaten face, and the whole country, full of woods and thickets, represented a wild and savage hue.

They had no idea, these settlers north and south. They stood on the narrow coastal fringe of the continent and feared the wilderness they could see for themselves without knowing yet how deep that wilderness lay on the land and how deeply it would affect them as a people to go into it, take hold of it, conquer it—or how much it would take *out* of them to do so. To know this it might have been enough to drive most of them back to their beginnings.

Imagine those pinpricks of settlement at the edge of the continent, the sharp-tipped palisades, the raw, windowless buildings, the few pallid squares of cleared land, the trickle of ragged humanity armed with blunderbusses and Elizabethan pikes, peering westward, wondering. Now imagine cameras above each of them panning upward and outward from them, higher and higher, revealing the land that lay to the west and the forest covering it, the ancestral forest old as the passing of the last ice age, older than the

Indians, those other immigrants who had come by land bridge from the Asian continent, a wilderness of trees that spilled for a thousand miles into the American interior, clear to the Mississippi River, not yet even an outlandish rumor to the settlers . . .

Think of the arboreal names: from the northern tip of the country and curving west by southwest through what was already known as New England into what would become known as the mid-Atlantic states, stands and mixtures of balsam fir, white spruce and red spruce, white, yellow, and black birch, the red and the sugar maples, beech trees, hickory trees, the Atlantic white cedar and the eastern red cedar, the white pine and pitch pine, the chestnut, black, white, scarlet, and scrub oak, the black cherry tree, the sassafras tree . . . Out in the shallow valleys of the Ohio and its tributaries crowd maple-beech and oak-hickory forests, while up in Michigan and Wisconsin and Minnesota white pine forests darken the oceanlike shores of the Great Lakes . . .

In the south, fanning out from the tidewater country and dipping down into the Florida peninsula, spread Virginia pine, shortleaf pine, and table mountain pine, eastern hemlock, yellow buckeye, silverbell, basswood, white ash, the tuliptree, the sumac tree, the persimmon tree, the holly tree, tupelo and sweet gum, magnolia and laurel, longleaf, slash, and loblolly pine, red oak and live oak, southern white cedar, cypress, yellow poplar, black locust . . . In the Great Smoky Mountains alone are all of the above and more, 130 individual tree species; in southern Florida are few of the above, save for wet forests of slash pine and bald cypress . . .

As the cameras of our mind move ever higher above the coastal fringe of north and south, the two images blend into one, and we can now see beyond the Mississippi, into the prairie and plains provinces (unwooded except for two great islands in the sea of grass—the Ozark Plateau with mixed oak-hickory stands, the Black Hills with ash, elm, bur oak, paper birch, Ponderosa and lodgepole pine), then into the southern, central, and northern Rockies, where the forest comes into its own again, covering more than one hundred million acres in a dark mantle pierced only by the naked rock of the peaks above timberline . . . The names, moving south to north, from lowland to highland: cottonwoods, piñon pine, juniper, lodgepole pine and Ponderosa pine, spruce-fir and Douglas fir, aspen, western white pine, yellow pine, white-bark pine, western red cedar, mountain hemlock, tamarack, alpine larch, subalpine fir, alder and dwarf birch . . .

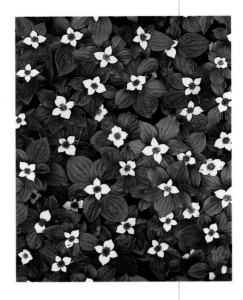

Higher still, and the Columbia Plateau, the Great Basin, and the Colorado Plateau reveal themselves, the arid core of the western land, where the forest bursts out again only in patches and pockets on the highest ranges—quaking aspen and mountain-mahogany, juniper, limber pine, piñon pine, subalpine fir... The cameras keep moving, up, up, the Sierra Nevada and Cascade ranges rise into sight, and with them the forest that once spread unbroken from Canada to the California Desert—Engelmann spruce, western hemlock, Oregon white oak, Douglas, grand noble, Pacific silver white, Shasta red, and subalpine fir; lodgepole, white, sugar, and Ponderosa pine; black and canyon live oaks, bigleaf maple and western larch, incense cedar and black cottonwood; bristlecone pines, the oldest living things on earth; giant sequoias, the largest living things on earth... And finally we see the coast ranges, with Douglas fir again, but also madrone, tan oak, Coast oak, California bay laurel, bigleaf maple, Monterey and Coulter pines, and the coast redwoods, the tallest living things on earth—until the last of the continental forest plunges down to a tracery of surf at the shore of that other great sea, the Pacific.

In all the European experience there had never been such a wilderness, such a plenitude and variety of trees. We became, from the outset, a nation of wood products—barrel staves and ship timbers, roof trees and wagon axles, horse collars and pully blocks. We used wood as it had never been used before, and what we did not want to use we cut and burned away in order to raise up something we did want to use, like corn. As we grew from those anemic patches of settlement on the eastern shore into a spreading civilization, something new upon the earth, we went through the original forest like a scythe through brittle wheat. Dyan Zaslowsky summarized it in *These American Lands*:

> Colonial expedience became a national industry in the years of growth that followed the War of Revolution, and in a continuing climate of abundance, the forests fell as the industry moved. First through New England, then into the Adirondacks and Catskills of New York and Pennsylvania, south into the Appalachians, through the Blue Ridge Mountains and the Great Smoky Mountains, clear to the edge of Florida. Up into the old Northwest, where Michigan lost its original forest in a single lifetime, where the old forests of Wisconsin were cut, rough-sawn into billions of board feet of unfinished lumber, packed together into rafts the size of football fields, and floated down the rivers to market. By the turn of the century the industry had jumped the continent to the West Coast, first to California, where the coast redwoods and the sugar pine of the Sierra fell to the saw and the donkey engine; then to Oregon and Washington, where spruce and Douglas fir disappeared into the holds of coastwise lumber schooners; then back to the interior of the continent, to the Rocky Mountains, through Colorado, Wyoming, Montana, and Idaho, where another industry consumed wood to timber its mines and build its boom cities.

In its scope, in the amount of wood taken, and in the swiftness of its passage, there was nothing in human history to compare with the decades of this astonishing assault on the natural world.

We did not annihilate the forest in all its forms; that would have been more than even the slightly deranged energy of the nineteenth century could have accomplished. But we did it damage, real damage, particularly in the eastern third of the continent, where the loss of valuable watershed finally inspired a twitch of common sense. This was the Forest Reserve clause of the General Revision Act of 1891, which empowered the president of the United States to withdraw from public use—logging being the principal use—forested areas of the public lands. Under the provisions of this act, presidents Benjamin Harrison, Grover Cleveland, and Theodore Roosevelt created a total of 148 million acres of forest reserves, the heart of today's National Forest System which was rounded out to its present 191 million acres by purchase provisions in the Weeks Act of 1911 and the Clark-McNary Act of 1924.

So the great eastern forest began to heal itself, or much of it anyway, a humid climate and good soils letting the trees come back. Not all of them, and not in such profusion, ever; second growth is always a poor second to the virgin growth that preceded it. The maples, hemlocks, beeches, and other hardwood species never did regain their old prominence and in some areas of the East disappeared altogether. The forest no longer stretched unbroken to the Mississippi—no more could it be said (as it often was) that a squirrel could travel from Maine to Missouri by leaping from branch to branch.

Yet you can still find the resonance of that old forest, some sense of the somber mystery that once lay over the land, the presence

that had driven the Pilgrim fathers to such dark agitation. You can feel it in the breeze while walking in a grove of spruce in Baxter State Park, Maine, or through preserved old-growth hickory and beech in Heart's Content, Pennsylvania, the urban sprawl of the Northeast Corridor a distant memory. Or you can find it farther west, in the rare stands of virgin white pine left in northern Michigan and Wisconsin, relics of the Great North Woods, the place of legend. Or down in the Great Smokies, where the rolling old mountains are draped with the tatters of mist and the understory growth is an explosion of life. Or in the seeps and bogs of the last of the bottomland forest in the lower Mississippi Valley, where the cypresses are hung with the graygreen wraiths of the fungus called Spanish moss. In places like this you begin to understand what Richard Lillard meant in *The Great Forest*: "Unlike Europe, the wooded continent was prediction, not chronicles, it was dreams, not traditions." Uncertainty mixed with hope here on the edge of the old forest.

While you can even now catch a hint of the forest's emotional power in the still-wooded portions of the East, you must go west to learn something of its sheer immensity, the awesome spread of life that must have momentarily struck dumb those who, in the words of James Bryce, "first burst into this silent, splendid Nature."

In October of 1985, I had the privilege of being flown over much of Payette National Forest and the Salmon River Mountains of Idaho in a small plane, covering perhaps a thousand square miles in a few hours. The forest below—spruce, tamarack, lodgepole pine, and yellow pine for the most part—was a little ragged in places. Logging had been going on in this country for more than a century and was still going on—a fact about which local and even national conservation groups have had quite a lot to say. Logging roads crisscrossed many slopes, ugly piles of slash lay strewn over old clearcut areas where second growth could do little but struggle weakly toward life in the loose, granitic soils of these mountains. It was a fairly depressing sight, much of it.

And yet. . .and yet, beyond the clearcut patches and slash piles and logging roads lay the forest, the somber forest, sprawling over ridge after ridge after ridge to the haze of the far distance in all quarters of the compass—north to the Clearwater Mountains, south to the Sawtooth Range, east to the Beaverhead Mountains, west to Hells Canyon on the Snake River, a continent of trees within the continent. At one point in the flight we seemed at the very heart of it all, cruising no more than two hundred feet above the slopes, and the entire world was suddenly trees and mountains, a rolling shadow over the land, the ultimate forest, the endless forest, impenetrable, forbidding, impersonal, implacable.

It was a sobering, vaguely troubling experience, the sort of thing that can cause you to fall back on cliché: *It all made me feel so insignificant.* Not quite true, though; not insignificant so much as cut off, barred from any true understanding of the full dimensions of life on this cooling cinder we call earth. In its very depth and scope, the forest below me seemed beyond my comprehension, representative of a mystery too large for my experience to define. It was a place where monsters could abide—and maybe that was how the original settlers had felt when they looked upon the ancestral forest with the heaving Atlantic at their backs.

It is better to be in it than above it or outside it, for when it is properly approached the forest is a place of welcome. The mystery is real enough, and in some ways is indeed incomprehensible in an intellectual sense, but it also calls up wonder and a powerful sense of connection, of contact with all the life that trembles there. I was reminded of this a few months after my Idaho trip, when I walked with a new friend through second-growth rain forest he owned on Vashon Island in Puget Sound. The island had been almost completely logged over a couple of generations ago, and throughout the three acres of my friend's plot were the moss-covered stumps of the old Douglas fir, spruce, and western hemlock that had been sliced away; ferns now sprouted from their bases, and seedlings from other species had taken root in the soft, soil-like surface of their rotting tops. But even the second growth was impressive, thick, dark, green, the sun slanting through the branches to take the morning chill from this spring day. The smell was dank and rich, the odor of life, kin to the "marvellous sweet smell" that had come to the voyagers of the *Deliverance*. Standing there, I began to feel again the stirring of recognition that must have operated in earlier peoples, a racial memory about which I have written before in another time, another context: *Are we Druids, then to find seeps of knowledge in moss and rock, epiphanies in sun-seeking trees? Perhaps. Our bones are older than we know, and if we bring to our worship the schemata of science or the inductions of poetry more often than we do the blind torches of ritual, the truth that hides in the dims of a forest is no less elusive—and quite as necessary . . .*

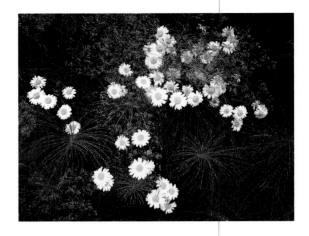

Be very still and listen, now. Something is happening here. Above, the dry twitch of a leaf, the complaint of a moving branch; below, the wet serpentine probe of a root, the busy conversation of the soil; somewhere, the chattering of a rill, the implicated noise of a standing deer. A saraband is made, is moved, is orchestrated . . .

Production, consumption, transformation, conversion—stone into soil, soil into tree. The dance is the elemental given form, the orchestration the chemistry of life. Earth, air, fire, and water: they are gathered here in a boil of creation, molecules coupled into chains of being, sap and sinew, root and brain. History written in a Hemlock's veins

III. THE GRASSLANDS

> Grass is the forgiveness of nature—her constant benediction. . . . Forests decay, harvests perish, flowers vanish, but grass is immortal. Beleaguered by the sullen hosts of winter, it withdraws into the impregnable fortress of its subterranean vitality, and emerges upon the first solicitation of spring. . . . Its tenacious fibers hold the earth in its place, and prevent its soluble components from washing into the wasting sea. It invades the solitude of deserts, climbs the inaccessible slopes and forbidding pinnacles of mountains, modifies climates, and determines the history, character, and destiny of nations.
>
> —John James Ingalls in *Kansas Magazine*, 1872

One of the reasons forests have acquired mythic presence may well be that they are something relatively new in the human experience. From the earliest hominids of five million years ago through *Homo erectus* of two million years ago to *Homo sapiens* of two hundred thousand years ago, the human animal learned the arts of survival in a grassland environment. It was not until about fifty thousand years ago that the species acquired both the numbers and the technology that enabled it to spread out into environments foreign to its history—and in these new environments begin to build the history that lies at the heart of our present civilization. For millions of years, the first and most pervasive sound that came to every human child must have been the conversation of the wind soughing through endless fields of grass.

It is quite a sound. I was a good deal more than a child when I first heard it as those ancestral humans must have heard it, but it impressed itself on my memory almost as if I, too, had just been born into it. I had spent the previous two days exploring the tangled gulches and canyons of the Black Hills of South Dakota, then set out in the morning for Miles City, Montana. It was a spectacular late-September day on the High Plains; clouds the size of Australia drifted in great piles across a sky so deeply blue that it seemed possible to feel it trembling at the edge of outer space, while on both sides of Highway 59 the hills rolled gently away to the knife-edge horizon, an ocean of buffalograss, blue grama, and bluestem wheatgrass rippling like silk in the wind. When my stomach announced that it was noontime, I pulled off to the side of the road somewhere near the confluence of the Tongue River and Pumpkin Creek, turned off the engine, opened a can of beer, and manufactured a raw cheese-and-rye sandwich out of a bag of groceries purchased back in Belle Fourche.

And listened. After having heard for several hours the sturdy hum of my car's engine, I suppose I had expected a kind of silence. But the air was alive with sound. Birdsong, of course: a mockingbird's catalogue of territorial imprecations, the fluting of meadowlarks, and broken notes and piping I could not identify. But most of all the wind, playing the grass as if it were an instrument, a whole section of instruments, an entire orchestra. The sound was constant but varied in pitch and tone, and it took only a little stretch of the imagination to pick out tenor and bass notes, chording and counterpoint, even a rhythmic click and rustle, like a drummer putting the whisk to his cymbals.

After a while, I got out of the car, climbed gingerly over a sagging barbed-wire fence, and walked out into the land, the grass whipping around my knees. I stopped on a small rise and let it all wash over and around me, the sound and movement of the wind surrounding me, seeming to come from all points of the compass simultaneously, enclosing me within a kind of vortex. The sensation was enhanced by the setting—360 degrees of uninterrupted horizon, against which the edge of the sky came down like the rim of a bowl. Standing there on that spot, turning slowly, it was both exhilarating and vaguely unnerving to feel so completely exposed to the elements and to what at moments seemed to be the music of the earth itself; it was hard not to feel as if I were somewhere near the center of the universe—or at least the solar system.

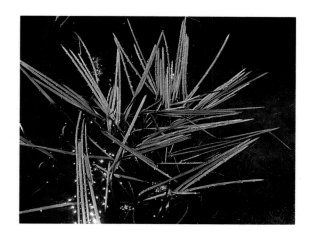

Well. The grasslands of North America have a way of inspiring that kind of anthropocentrism and overweening self-drama; when you are the tallest living thing for many miles around it gives your presence a certain weight that is not experienced, say, when you are standing under the beneficent limbs of a great sugar pine in the middle of a forest in the southern Sierra or looking up at the crown of a redwood. That afternoon I was in the heart of the northern portion of the extraordinary spread of grassland that sweeps down from Canada and through much of the states of Montana, North Dakota, South Dakota, Wyoming, Nebraska, Kansas, Colorado, Oklahoma, New Mexico, and Texas. Taken as a whole, this wide belt of territory is called the Great Plains, and it encompasses nearly a quarter of the entire American landscape.

A good part of our history as a nation was acted out here, too. Most of the Great Plains lies west of the hundredth meridian, where the annual rainfall averages less than twenty inches. When he led an exploring expedition into this country in 1820, its semi-arid condition persuaded Major Stephen Harriman Long to dub it "The Great American Desert" and to dismiss it forever as a candidate for civilized settlement. "In regard to this extensive section of the country," he gloomily reported, "we do not hesitate in giving the opinion, that it is almost wholly unfit for cultivation, and of course uninhabitable by a people depending upon agriculture for their subsistence." Better to leave it to the ubiquitous pronghorn, the prairie dogs, the black-footed ferrets, the coyotes, the ferruginous hawks and golden eagles, the enormous herds of buffalo that blackened the earth to the horizons during their 1,500-mile migrations north-to-south and back again every year, and to the Indians who had based a life and culture on them.

We didn't, of course. The buffalo were systematically eliminated and the Indians subdued after a generation or so of bloody skirmishes. The railroads laid track west, leaving behind them the spoor of railhead communities. Cattle were driven up from Texas to feed and fatten on the rich shortgrass of the Northern Plains, and the cowboy, the "hired man on horseback," attached himself to the national psyche, never to be pried loose. Homesteaders crept out beyond the hundredth meridian, praying, as the politicians had promised, that rain would indeed follow the plow, planted their corn and their wheat, broke their backs and often their hearts, and built a life that endured. Only a little over a century after Major Long had proclaimed the land to be useless for such purposes, we

had brought so much cultivation to the Great Plains that a good part of them blew all the way east to Washington, D.C. Drought had combined with overgrazing, overcultivation, and poor cultivation to produce the Dust Bowl of the Great Depression. But the airborne dirt that wafted east on the jetstream in the early 1930s acted like a kind of goad on the Congress and the administration of President Franklin D. Roosevelt, who brought forth both the U.S. Grazing Service (now the Bureau of Land Management) in the Department of the Interior and the Soil Conservation Service in the Department of Agriculture. Over the next thirty-five years, the reclamation work of these two admirable federal institutions would go a long way toward making it possible for me to stand and admire the way the wind walked through a stretch of preserved native grassland in eastern Montana in 1971—and in a few places I could do much the same today. The Great Plains are by far the most extensive spread of grassland country still found in the United States, although many of the original grasses have long since given way to the cultivated grasses—corn, barley, wheat, and alfalfa, for instance. But they are not the only grasslands left, nor even the most various. Virtually every part of this continent contains pockets, patches, and sometimes square miles of native grassland, stubborn survivors of a time when the wild grasses ruled everywhere that mountains, deserts, and forests did not. Grasses form the third largest family of flowering plants—only the orchids and the asters possess more individual species—largely because they are tough enough to flourish in environments hostile to other forms of plant life and because their productive seed crops can be dispersed easily and widely by the wind and the movement of birds and animals.

In places like Great Meadows National Wildlife Refuge in Massachusetts and Saltmeadow National Wildlife Refuge in Connecticut, you can still wade through marshy cordgrass meadows that are healthy remnants of those in which the first New Englanders pastured their cattle. Out in California's San Luis National Wildlife Refuge in the San Joaquin Valley, you can stand in a one thousand-acre block of Pacific bunchgrass, Idaho fescue, bluebunch wheatgrass, California needlegrass, and pine bluegrass—one of the largest remaining portions of the original California Prairie whose spring and summer wildlflowers once filled the Great Central Valley with a frenzy of color from the Coast Range to the foothills of the Sierra Nevada. In the Gila Mountains of eastern Arizona

there are stretches of undisturbed semidesert grasslands reminiscent of the days when the grama grasses, dropseeds, three-awns, and tobosa grass of the Southwest fed enough cattle to produce such greed-ridden conflicts as the Lincoln County "War" of New Mexico and the cheap thuggery of killers like Billy the Kid, while over in the Lyndon B. Johnson National Grassland of Texas enough of the various shortgrass types have been preserved to illustrate how the Southern Great Plains could support such outsized enterprises as the King Ranch. Up in Southern Idaho, mantling the hills above Little Jacks Creek Canyon, Indian ricegrass, bluestem wheatgrass, needle-and-thread, and Sandberg bluegrass can still be found in a healthy mix with the sagebrush biome typical of the northern Great Basin, fighting off the invasion of cheatgrass—a vigorous, velvety foreigner that has draped itself over much of the Great Basin West like a shroud and driven out native species. In the mountain meadows and alpine grasslands of Washington, Oregon, and California—many of them still used for the summer grazing of cattle and sheep—the native bluebunch wheatgrass and other grasses are punctuated by an explosion of color from wildflowers—asters, lupines, cinquefoil, calypso, alpine pyrola, Indian pipe, Indian paintbrush, pentstemon, monkey-flower, lady's slipper, and the narrowleaf and roundleaf sundews, among many others.

A world of grass that survives in spite of the worst we can do to it. Overgrazing in the West continues to be a major problem, and if the situation falls short of that which darkened the skies of Washington, D.C., during the Great Depression, it still bears watching. It is worth the effort, for grass remains the necessary link in an ancient chain, as described by Kansas Senator John James Ingalls in 1872:

The Primary form of food is grass. Grass feeds the ox; the ox nourishes man; man dies and goes to grass again; and so the tide of life, with everlasting repetition, in continuous circles, moves endlessly on and upward, and in more senses than one, all flesh is grass.

"But," Ingalls went on to add, "all flesh is not bluegrass. If it were, the devil's occupation would be gone." He was speaking, with all due reverence, of one of the species found in tallgrass prairie, a type of grassland that deserves special celebration here, for it holds a special place at the heart of our history, as well as a special brand of beauty.

In its original form, the tallgrass prairie fanned out from western Ohio through Indiana, Illinois, Missouri, Iowa, and Minnesota, then on into portions of eastern North Dakota, South Dakota, Nebraska, Kansas, and Oklahoma before it entered country with less than twenty inches of rain a year, dribbled off into mixed-grass prairie, and then disappeared altogether into the high plains farther west. There were four hundred thousand square miles of it, more than 250 million acres of rolling green prairie, interspersed here and there by maple, beech, oak, and hickory groves that were kept at bay by periodic wildfires—which prevented the spread of trees even as they nurtured healthier regrowth of the prairie grasses and forbs. After nearly two hundred years in the forests and woody river valleys of the eastern seaboard, clearing the fields and forests, building their towns and cities, colonists and pioneers finally had adjusted themselves to the demands of the new continent. Or so they thought. After the War of the Revolution ground to a close and settlers began to spill across the Appalachian Plateau and down the river valleys to the west in ever-increasing numbers, they discovered that they would have to learn to live all over again in the midst of yet another environment almost entirely alien to the European experience—the prairie.

It nearly unnerved many of them. Certainly, this was true of the pioneers who people James Fenimore Cooper's 1827 novel, *The Prairie*. A group of westward-bound settlers, they did not find much to their liking:

From the summits of the swells, the eye became fatigued with the sameness and chilling dreariness of the landscape. The earth was not unlike the ocean, when its restless waters are heaving heavily, after the agitation and fury of the tempest have begun to lessen. There was the same waving and regular surface, the same absence of foreign objects, and the same boundless extent to the view Here and there a tall tree rose out of the bottoms, stretching its naked branches abroad, like some solitary vessel; and, to strengthen the delusion, far in the distance appeared two or three rounded thickets, looming in the misty horizon like islands resting on the waters As swell appeared after swell, and island succeeded island, there was a disheartening assurance that long and seemingly interminable tracts of territory must be passed, before the wishes of the humblest agriculturalist could be realized.

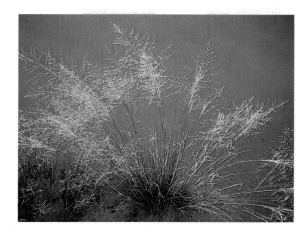

Not really. Beneath the rolling grassland of that ostensibly dreary landscape lay the sod, and beneath the sod lay some of the richest soil on the face of the planet. It was made rich by the nutrient cycle established by all the grasses—the big bluestem or "turkey-foot," which grew higher than a tall man's head in many places; Indian grass, nearly as tall; sloughgrass, a. k. a. prairie cordgrass, a. k. a. ripgut, so-called because of the tough, knife-like edge of its leaves; little bluestem, shorter by far than its cousin, the big bluestem, but increasingly dominant the farther west the prairie rolled; and, depending on climate, elevation, and latitude, a mix that included prairie dropseed, needlegrass, June grass, porcupine grass, sideoats grama, Canada wild rye, slender wheat-grass, switch grass, and Kentucky bluegrass, the latter designed, Senator Ingalls insisted, as "the final triumph of nature, reserved to compensate her favorite offspring in the new Paradise of Kansas for the loss of the old upon the banks of the Tigris and Euphrates."

In all, about one hundred and fifty individual species of grass were represented in the rich biome of the tallgrass prairie—not to mention the flowers which provided a succession of blossoms from spring through autumn: alumroot and shooting star, hoary puccoon and Canada windflower, lupine and lobelia, pasque-flowers and purple avens, cornflowers and prairie cat's-foot, spi-derwort and bird's-foot violets, dozens more. The roots of the grasses, flowers, and other plants embraced to form an as-tonishingly compact tangle of fibers and dirt known as sod, which throughout the prairie country was carved out of the ground like brick and used to build houses until the humble agriculturalists could afford to import lumber. That very sod had stood in the way of prosperity until the invention of the mouldboard plow and the polished steel share, which provided a tool sharp and durable enough to cut though the surface to the black soil that lay waiting, so fecund and moist with humus that a farmer could mold it in his fist and smell the life contained within it. More and more of them did precisely that, until by 1842 Senator Henry Clay of Kentucky could memorialize a new breed:

> Pioneers penetrate into the uninhabited regions of the West. They apply the axe to the forest, which falls before them, or the plough to the prairie, deeply sinking its share in the unbroken wild grasses in which it abounds. They build houses, plant orchards, enclose fields, cultivate the earth, and raise up families around them.

Indeed. Over the next century, the orchards, enclosed fields, and reared-up families spread with splendid energy. Corn, wheat, barley, oats, and soybeans replaced the big bluestem and the ripgut and most of the other grasses, and today there are only about one hundred and fifty thousand acres of American tallgrass prairie left. In the appendix to his 1982 book, *Where the Sky Began*, a lovely and loving account of the history, natural history, and present condition of the tallgrass prairie, John Madson lists 177 sites, ranging in size from the one-acre Queen Anne Prairie of McHenry County, Illinois, to the thirteen thousand-acre Colvin Prairie of Eddy County, North Dakota, in which remnants of the original prairie can still be found, protected to a greater or lesser degree by city, county, and state governments, by private indi-viduals, and by such organizations as the Nature Conservancy—which has probably done more than any other group to preserve some of the most representative sites, including the seven thou-sand six hundred-acre Samuel H. Ordway Memorial Prairie in South Dakota and the eight thousand six hundred-acre Konza Prairie of the Flint Hills in the northeastern corner of Kansas.

It is in the Flint Hills region—which runs several hundred miles north to south through much of eastern Kansas and Oklahoma—that the largest concentrations of tallgrass prairie remain. And it is in this area that a resurgent preservationist movement hopes to establish a sixty thousand-acre Tallgrass Prairie National Park. Most of the land in question, however, is privately owned, and the ordeal of creating a national park out of a patchwork of privately-held individual plots will doubtless be long and difficult—just as fifty years ago, when a similar process brought forth Great Smoky Mountains National Park. If the movement succeeds, it will pro-vide future generations with some powerful sense of an original landscape that once inspired not just a fearful uncertainty, but the kind of awe expressed by Thomas Morris upon his first exposure to the Illinois prairie in 1791:

> Soon after we came into extensive meadows; and I was assured that those meadows continue for a hundred and fifty miles By the dryness of the season they were now beau-tiful pastures, and here presented itself one of the most delightful prospects I have ever beheld; all the low grounds being meadow, and without wood, and all of the high grounds being covered with trees and appearing like islands; the whole scene seemed an elysium.

Deserts

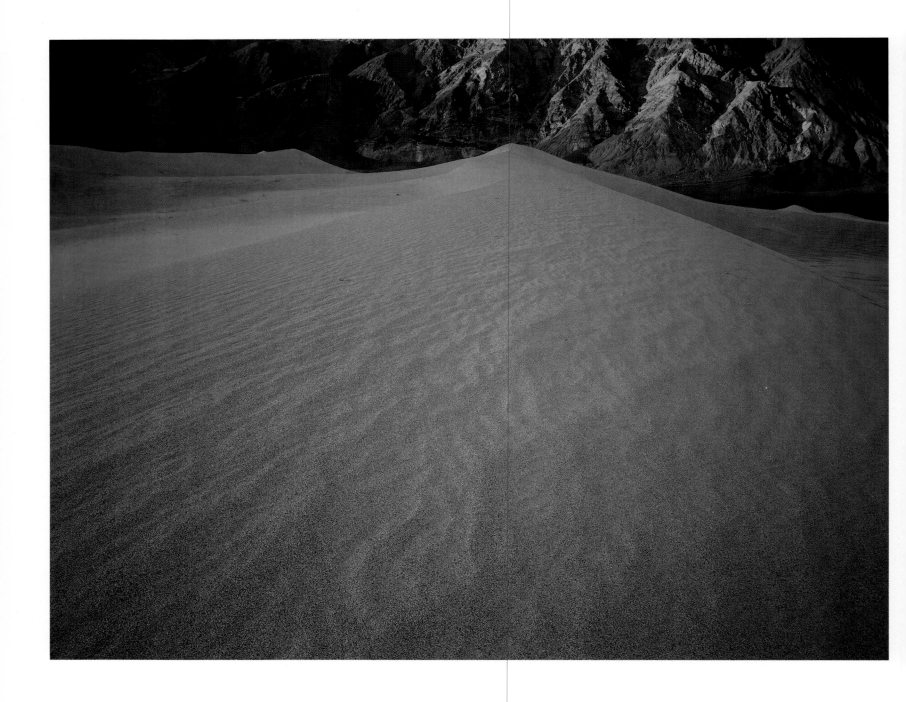

Dawn light, Saline Valley Dunes, Mohave Desert, California

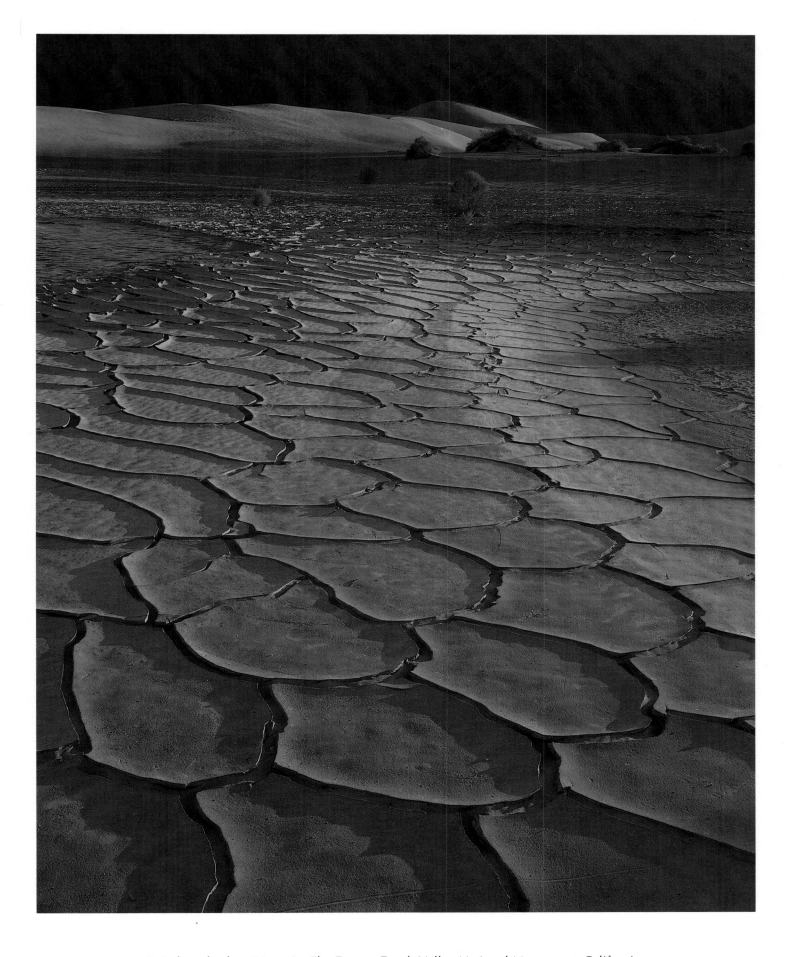

Dried mud cakes, Mesquite Flat Dunes, Death Valley National Monument, California

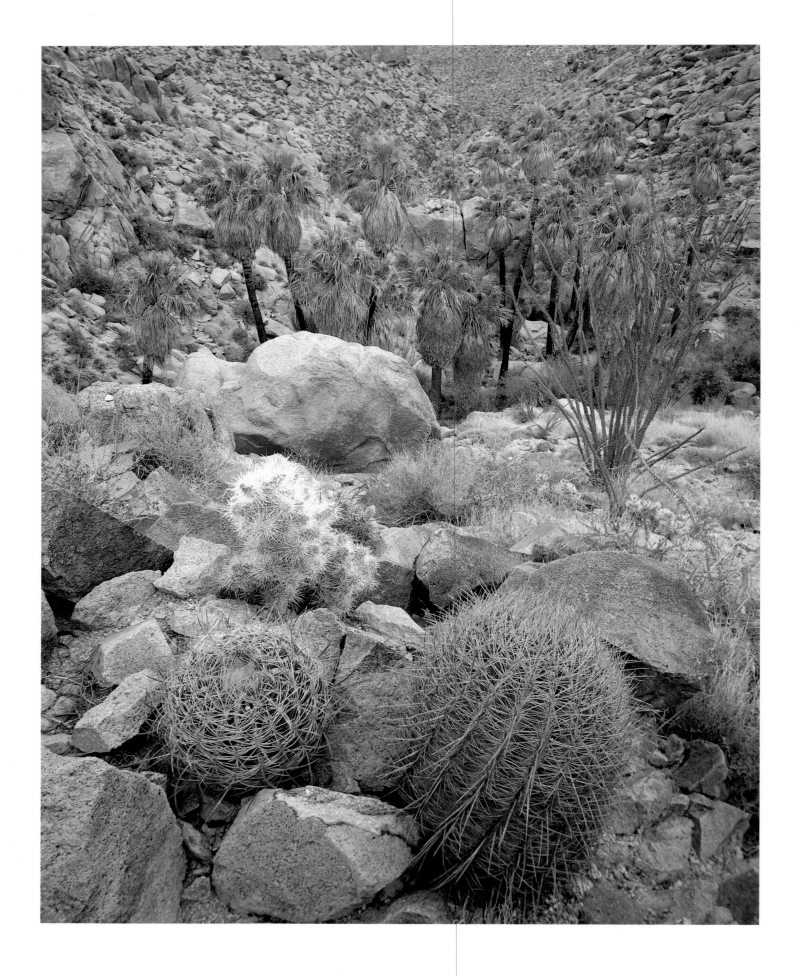

Lost Palms Oasis, Joshua Tree National Monument, California

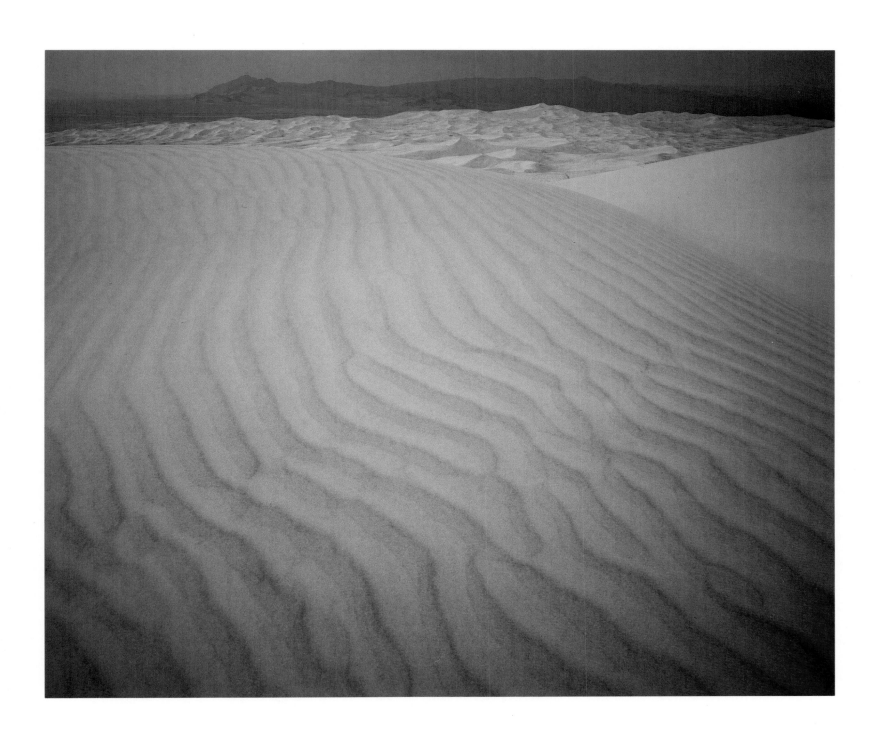

Kelso Dunes Preserve, Mohave Desert, California

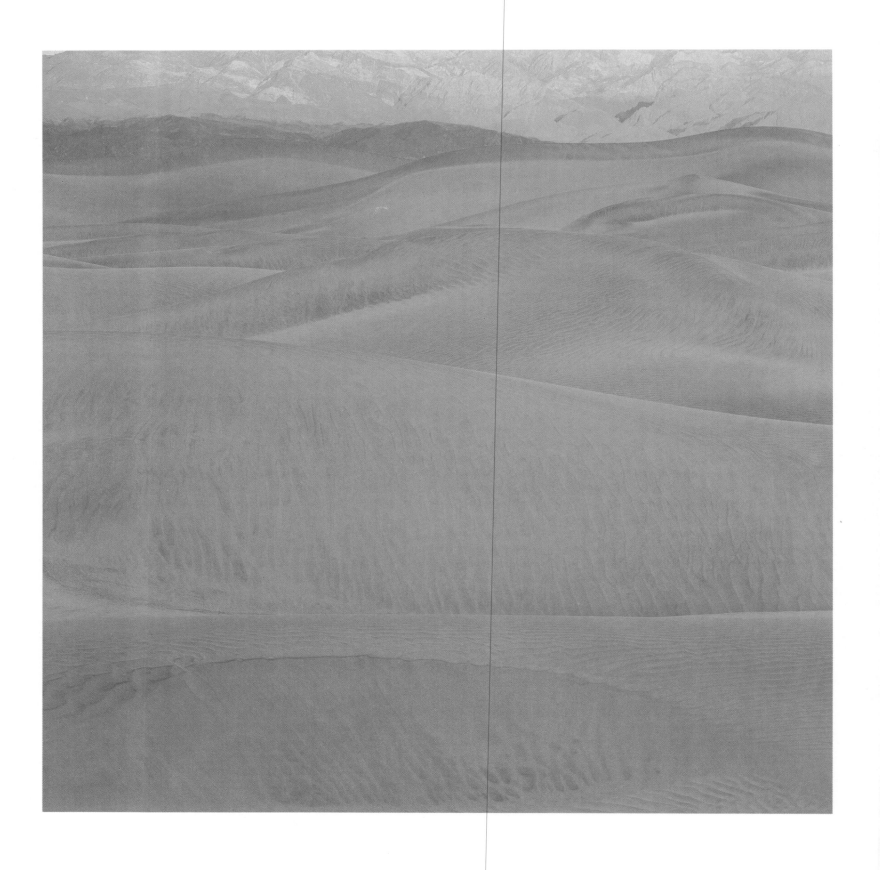

Above: Dune ridges and Cottonwood Mountains, Death Valley National Monument, California

Right: Beavertail cacti and Kelso Dunes, Mohave Desert, California

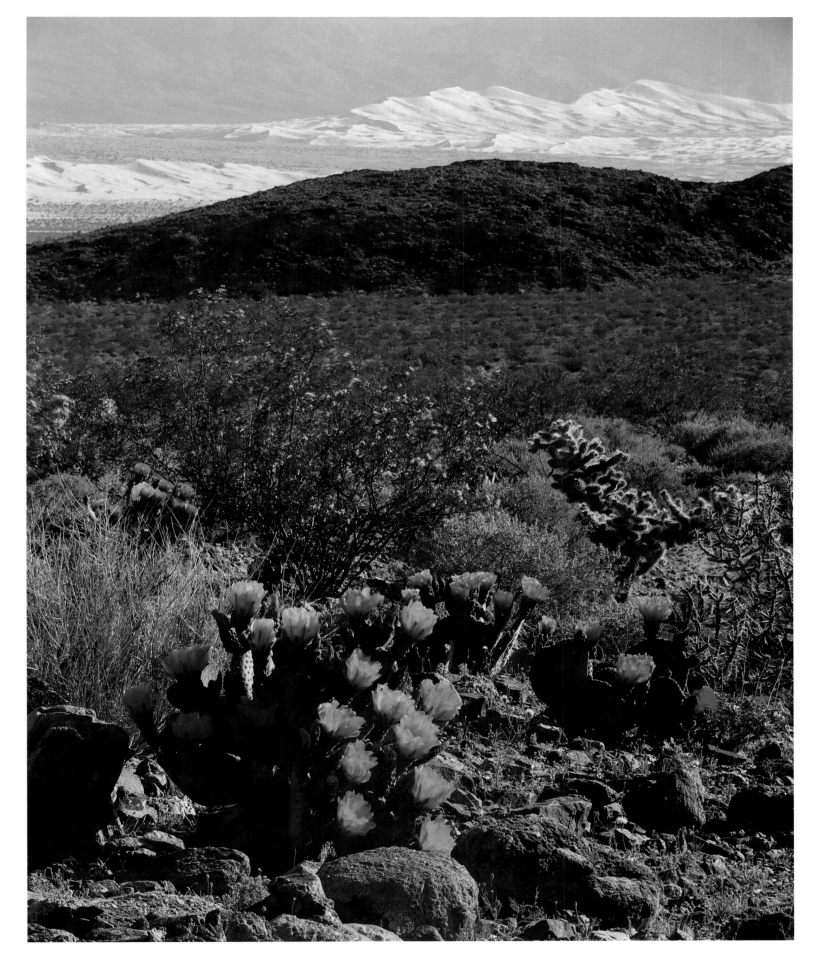

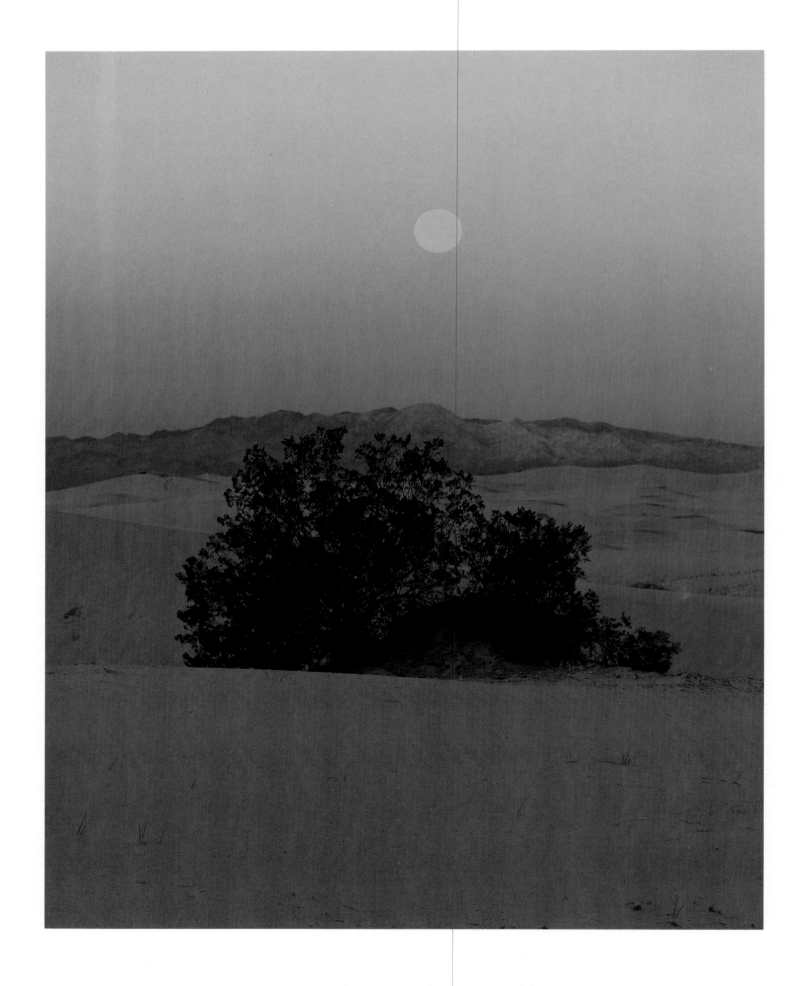

Moonset over Kelso Dunes, Mohave Desert, California

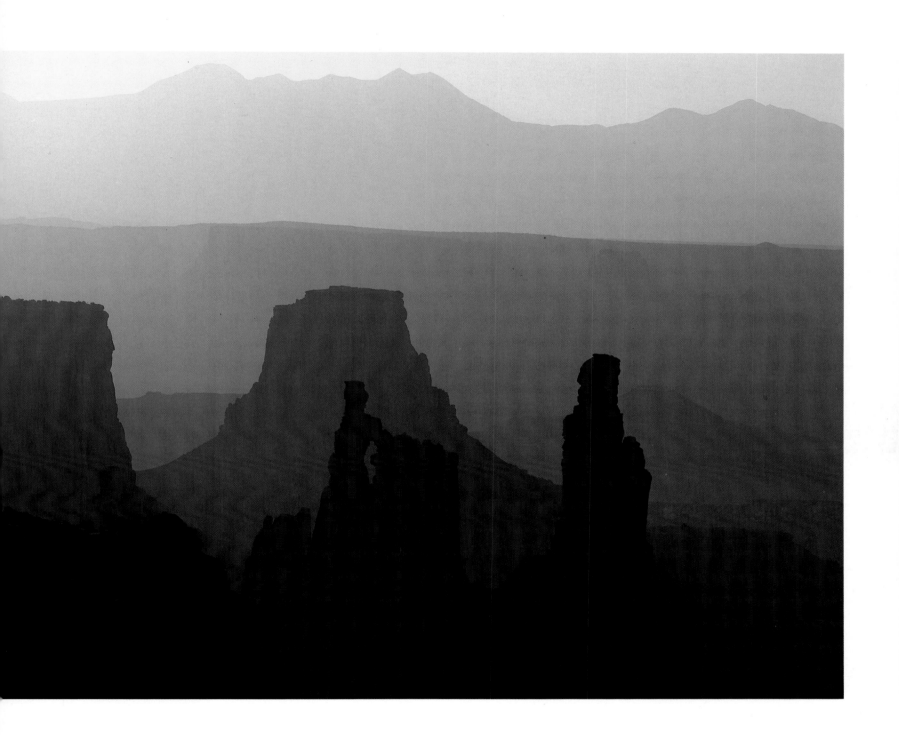

Washerwoman Arch and Sierra La Sal, Canyonlands National Park, Utah

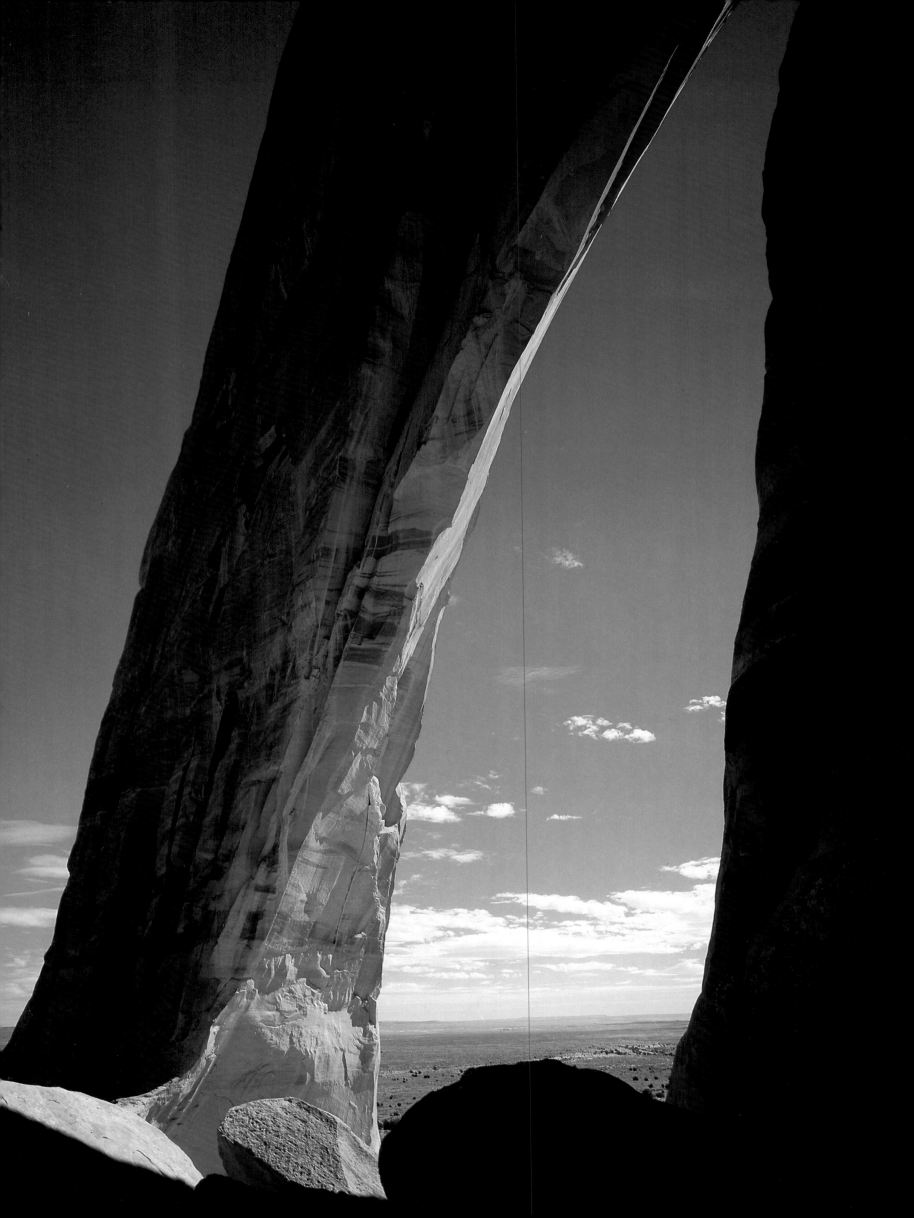

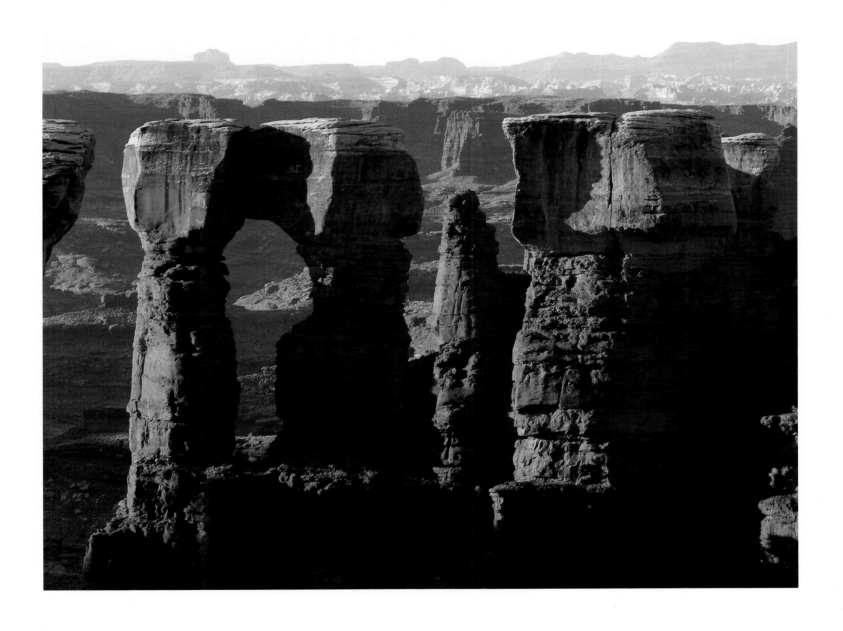

Left: Arch, White Mesa, Arizona

Above: Sandstone forms, White Rim, Canyonlands National Park, Utah

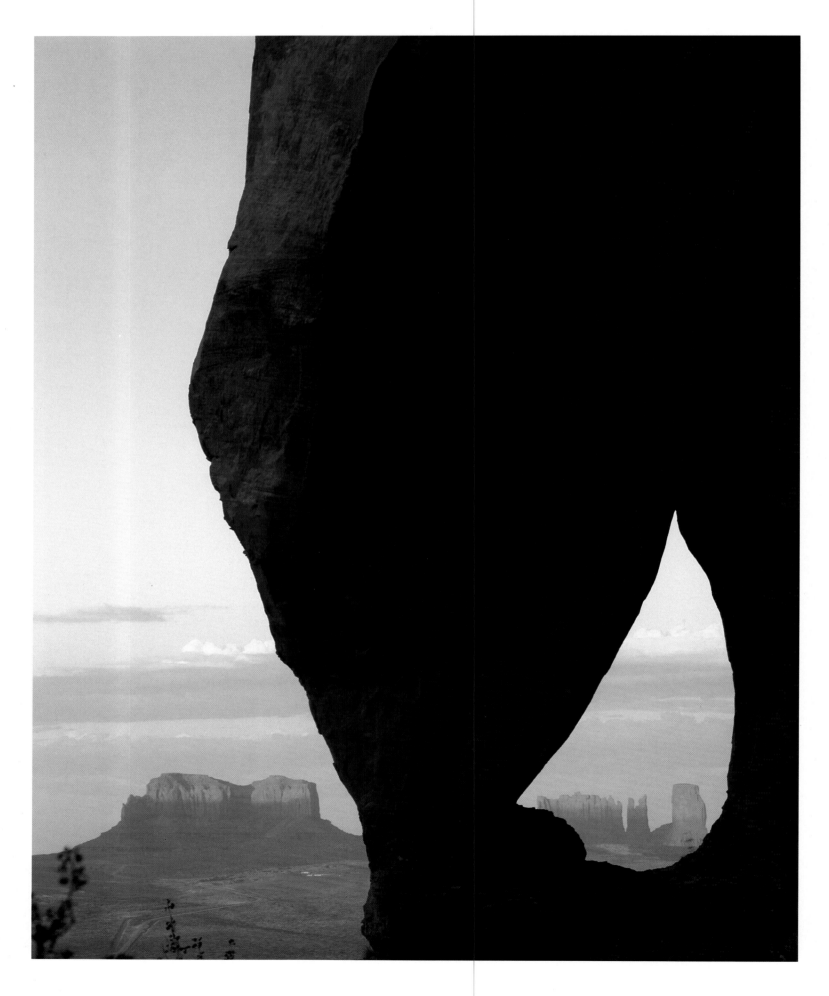

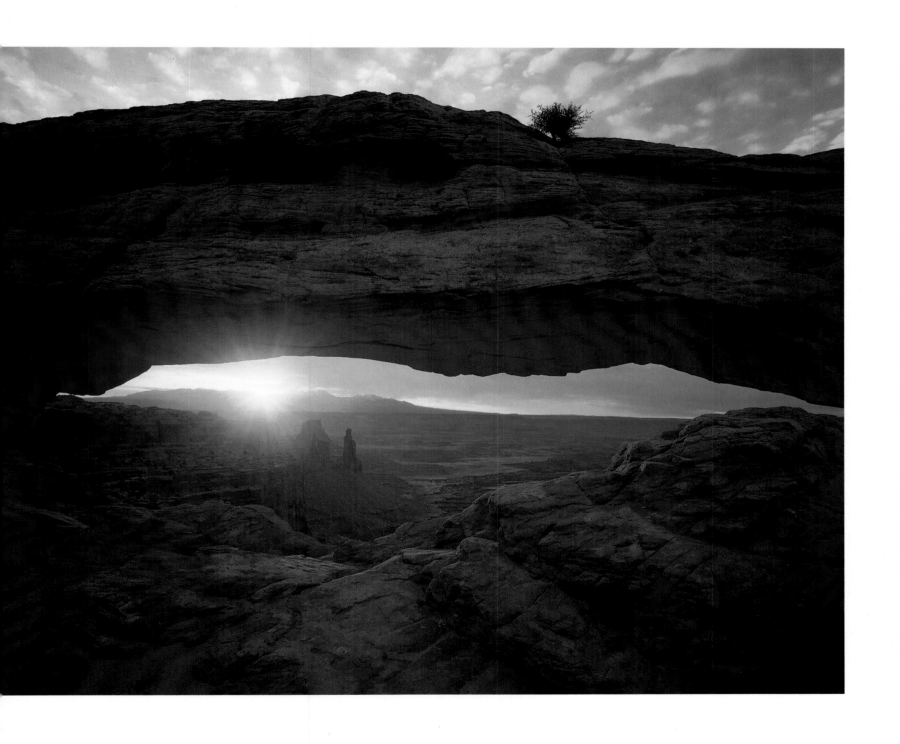

Left: Monument Valley sandstone forms, Arizona/Utah

Above: Mesa Arch and Sierra La Sal, Canyonlands National Park, Utah

Overleaf: Pink limestone erosion forms, Bryce Canyon National Park, Utah

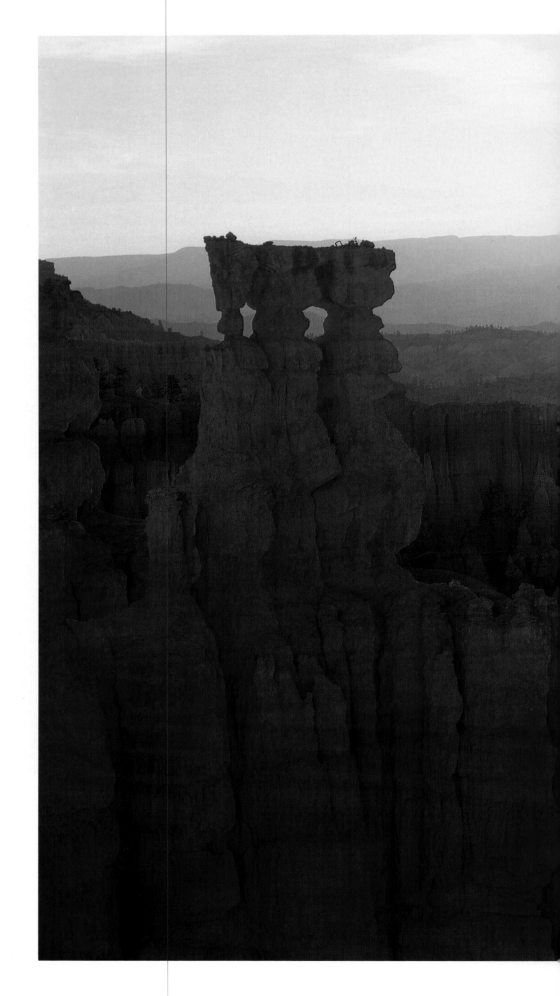

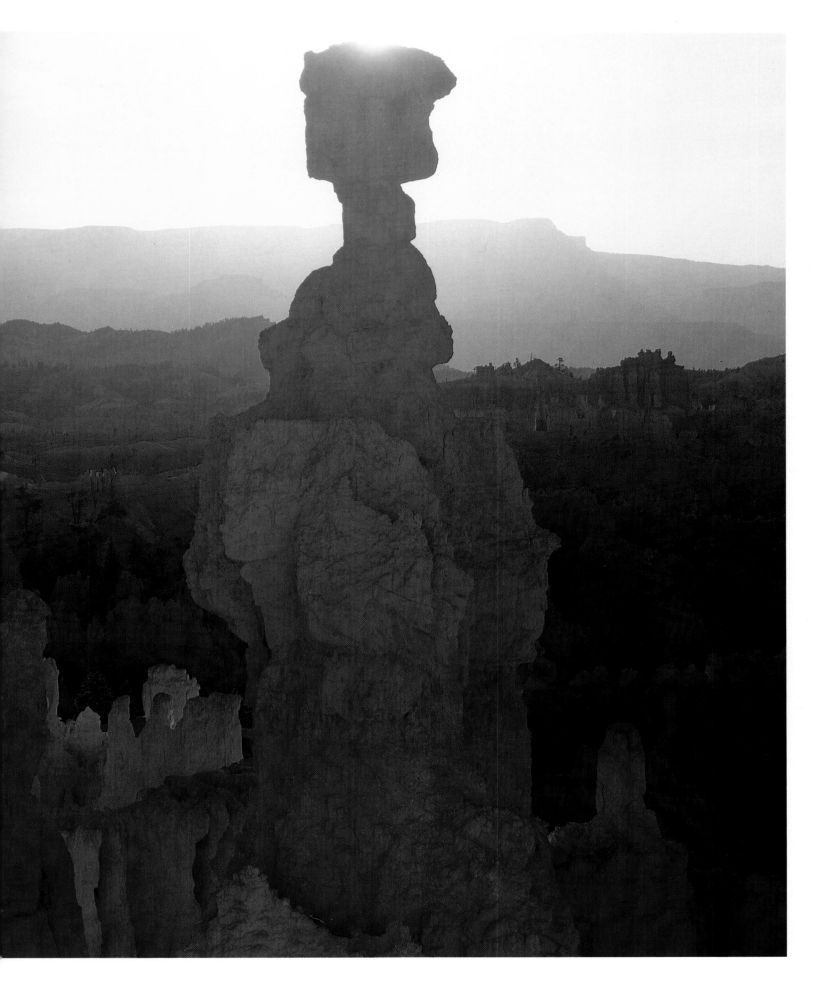

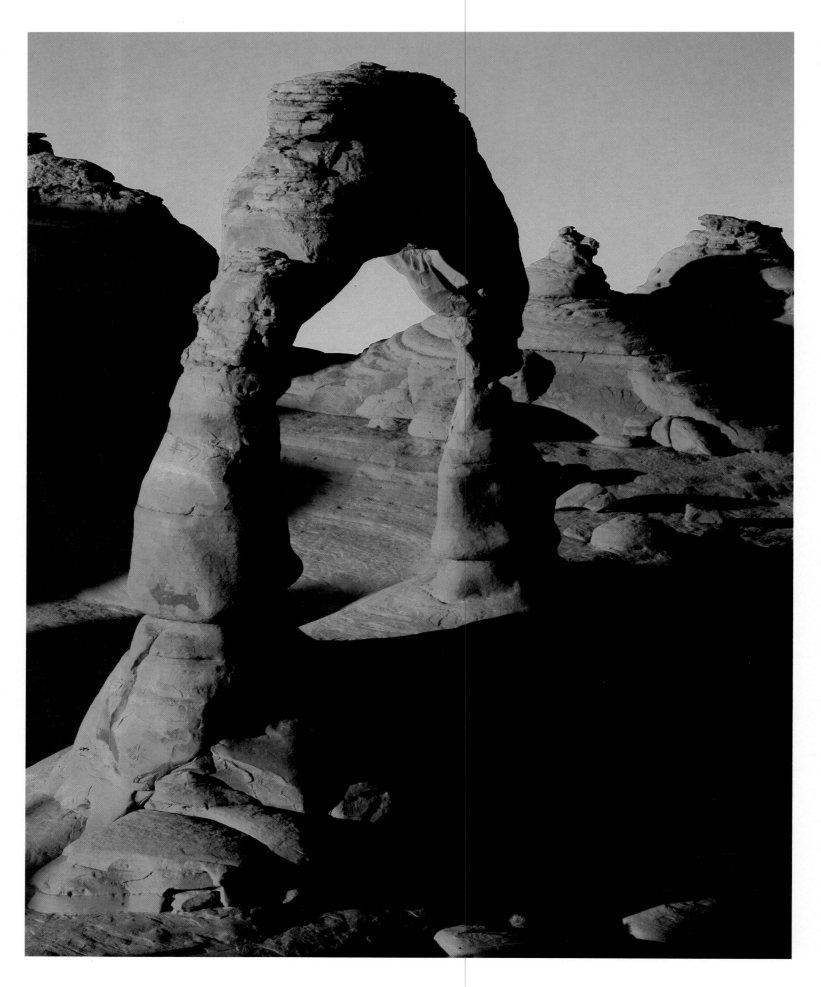

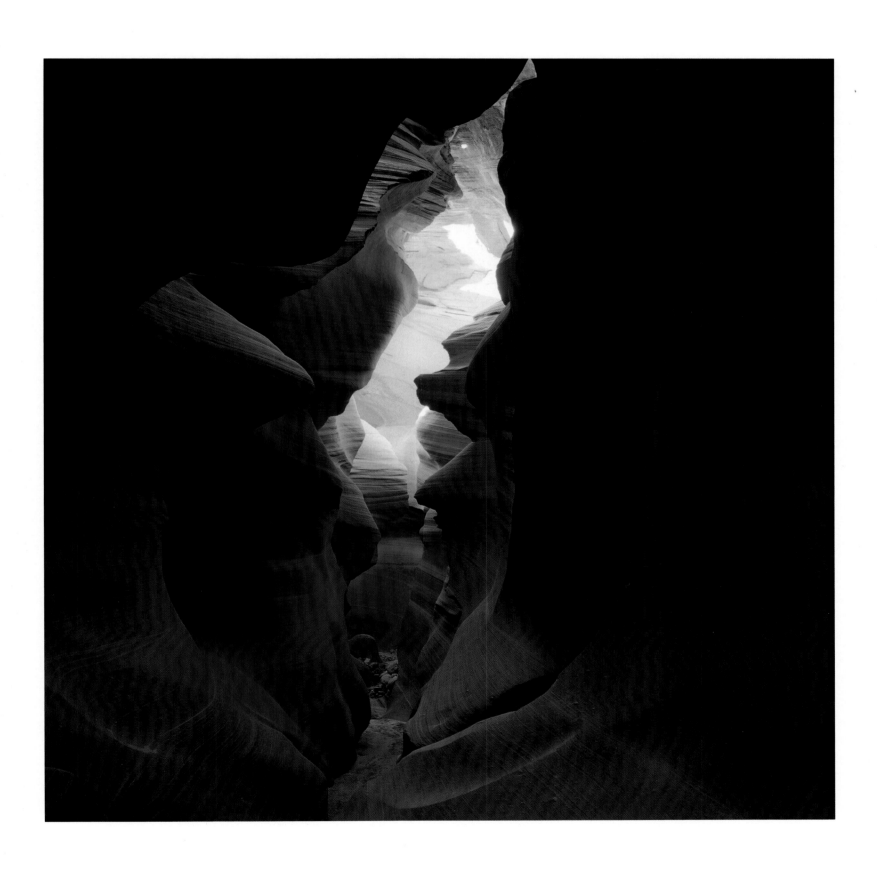

Left: Evening at Delicate Arch, Arches National Park, Utah

Above: Inner slickrock, slot canyon, Glen Canyon National Recreation Area, Arizona/Utah

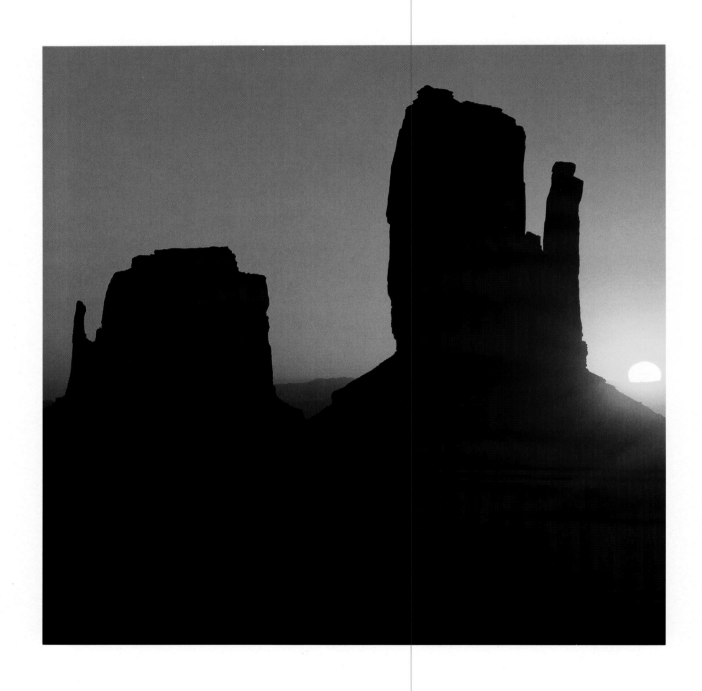

Above: Mitten Rocks silhouette, Monument Valley, Arizona/Utah

Right: Cascading dunes and Yeibichei Rocks, Monument Valley, Arizona/Utah

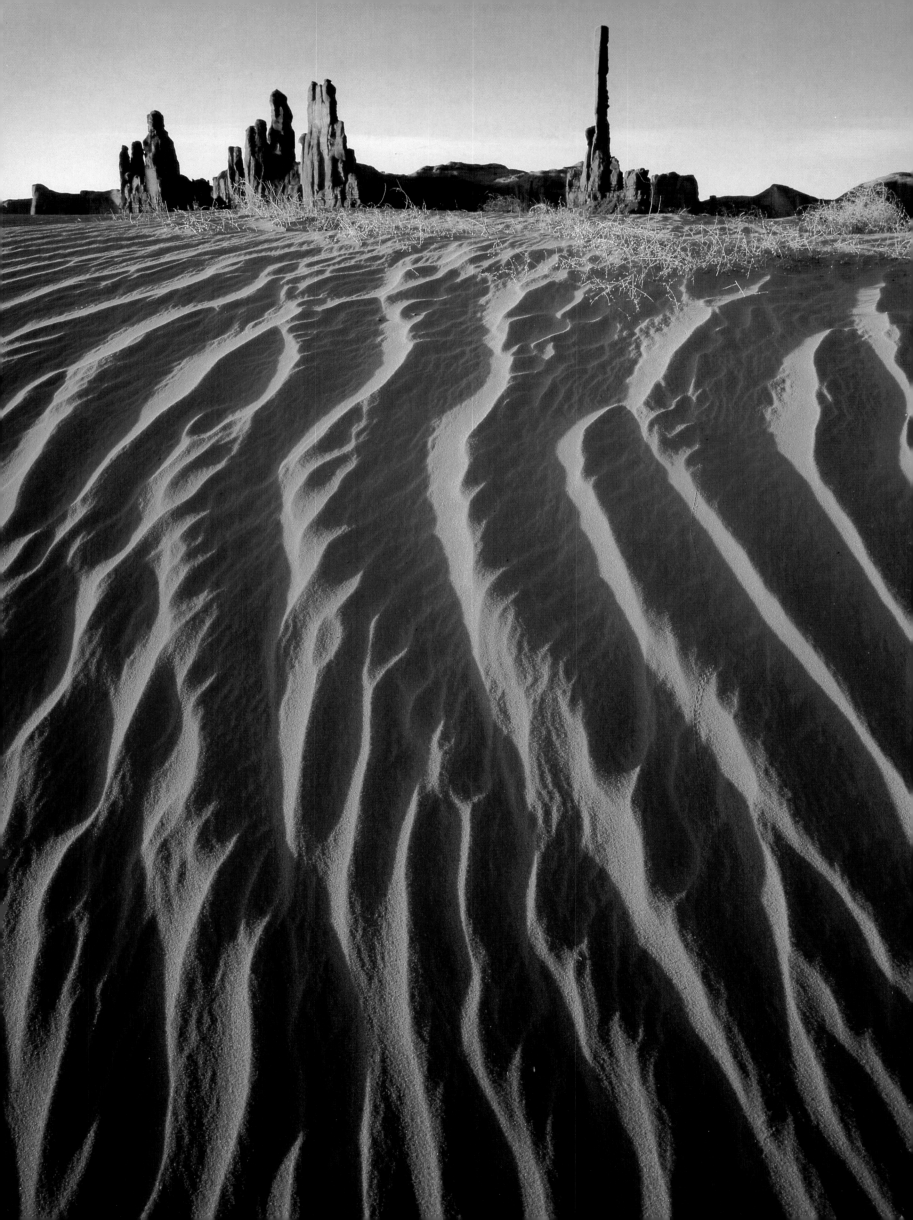

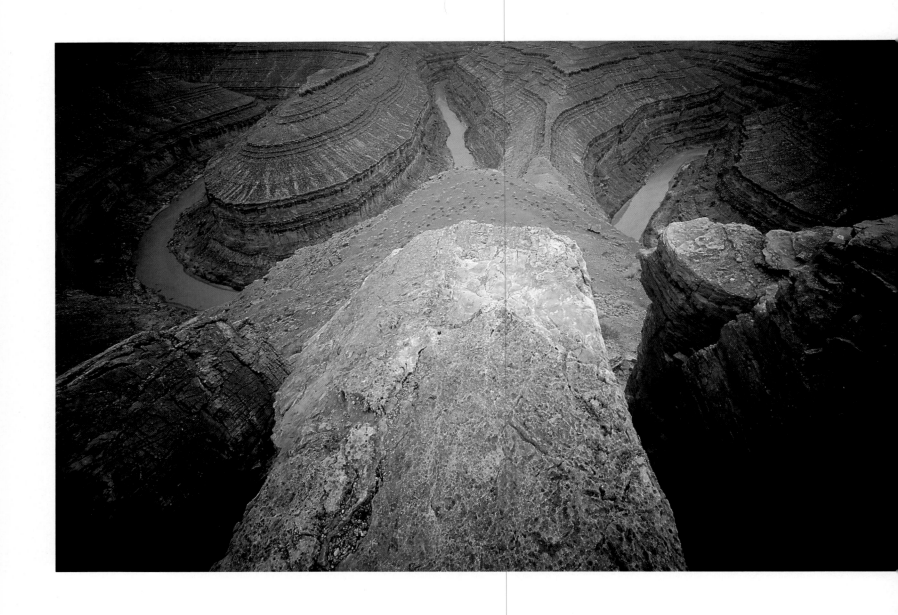

Goosenecks of the San Juan River, Utah

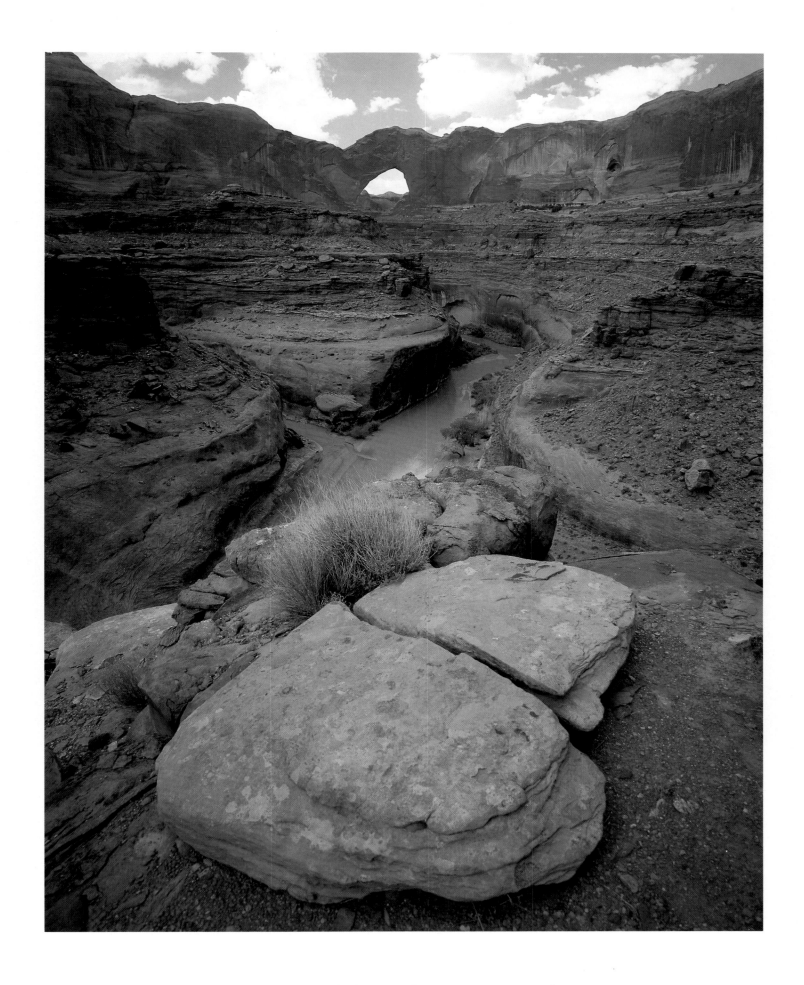

Stevens Arch above Escalante River Canyon, Utah

Desert ridges, Chiricahua Wilderness, Arizona

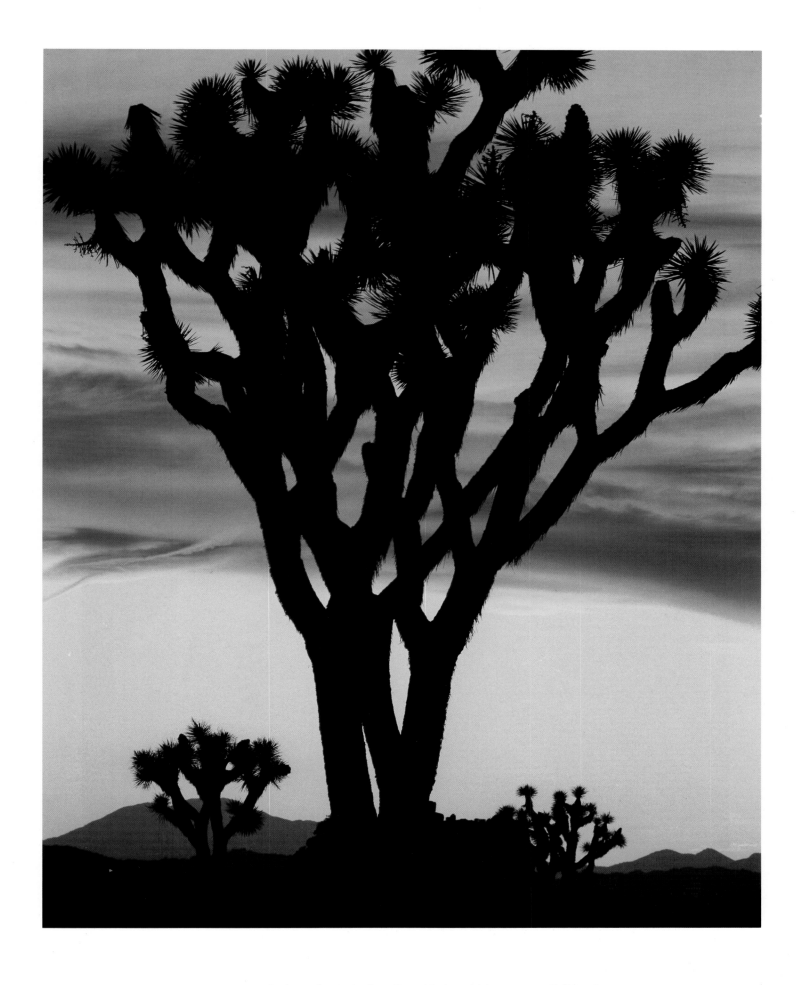

Joshua plants, Joshua Tree National Monument, California

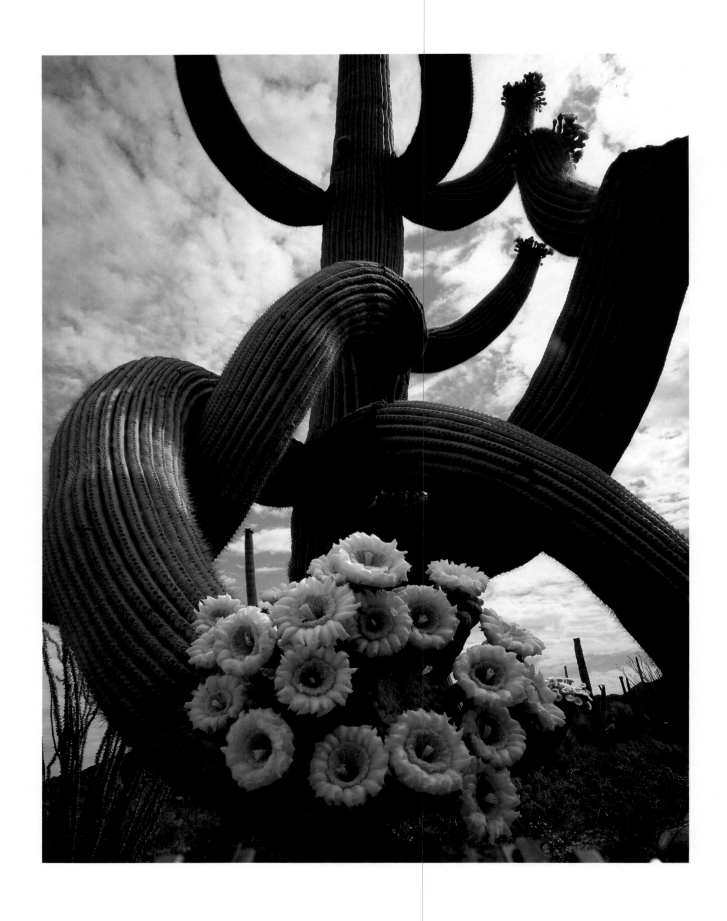

Blooms of saguaro cactus, Saguaro National Monument, Arizona

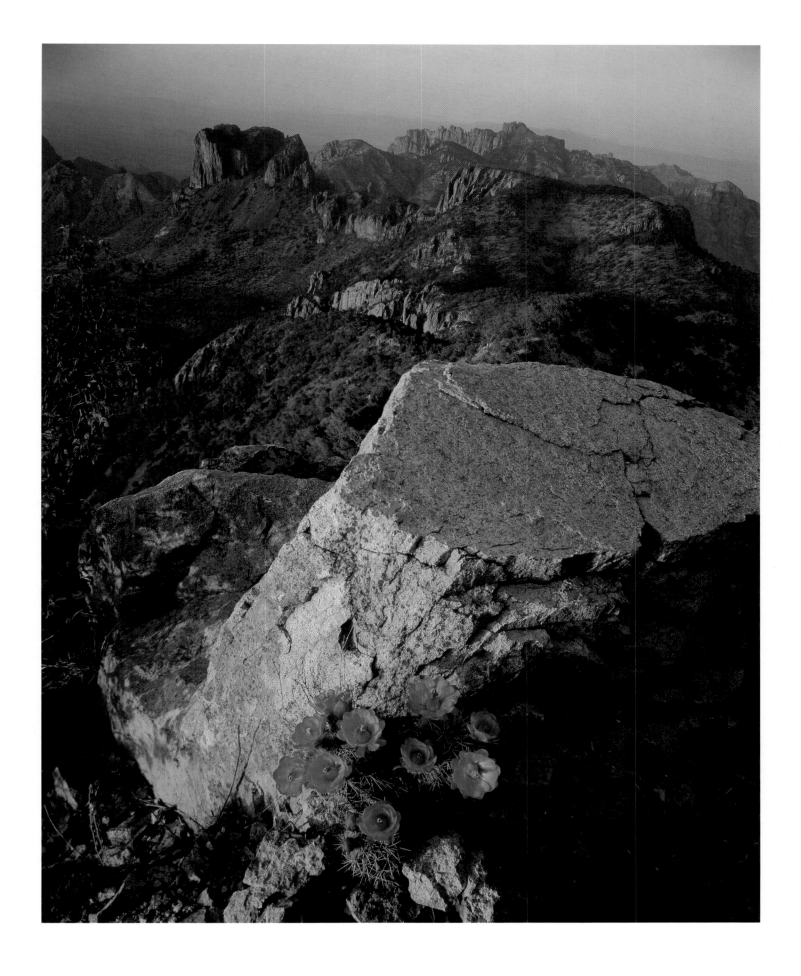

Claret cup hedgehog cactus on Emory Peak, Big Bend National Park, Texas

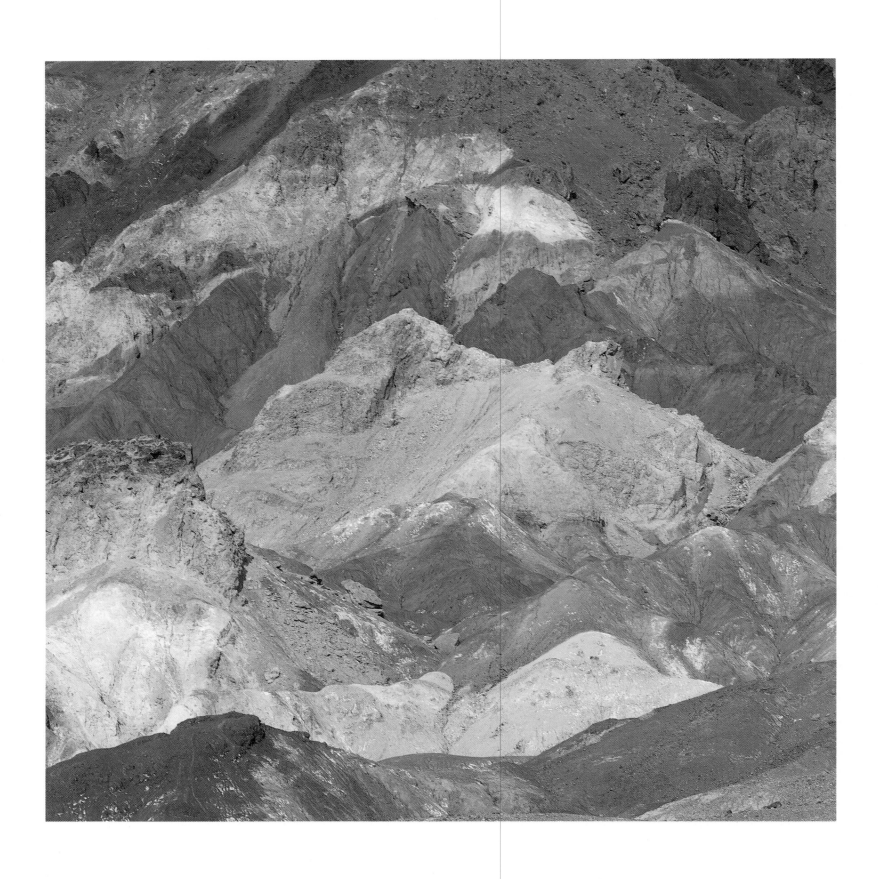

Above: Volcanic hues of Artists Palette, Death Valley National Monument, California

Right: Caprock and clay, Bisti Badlands Wilderness, New Mexico

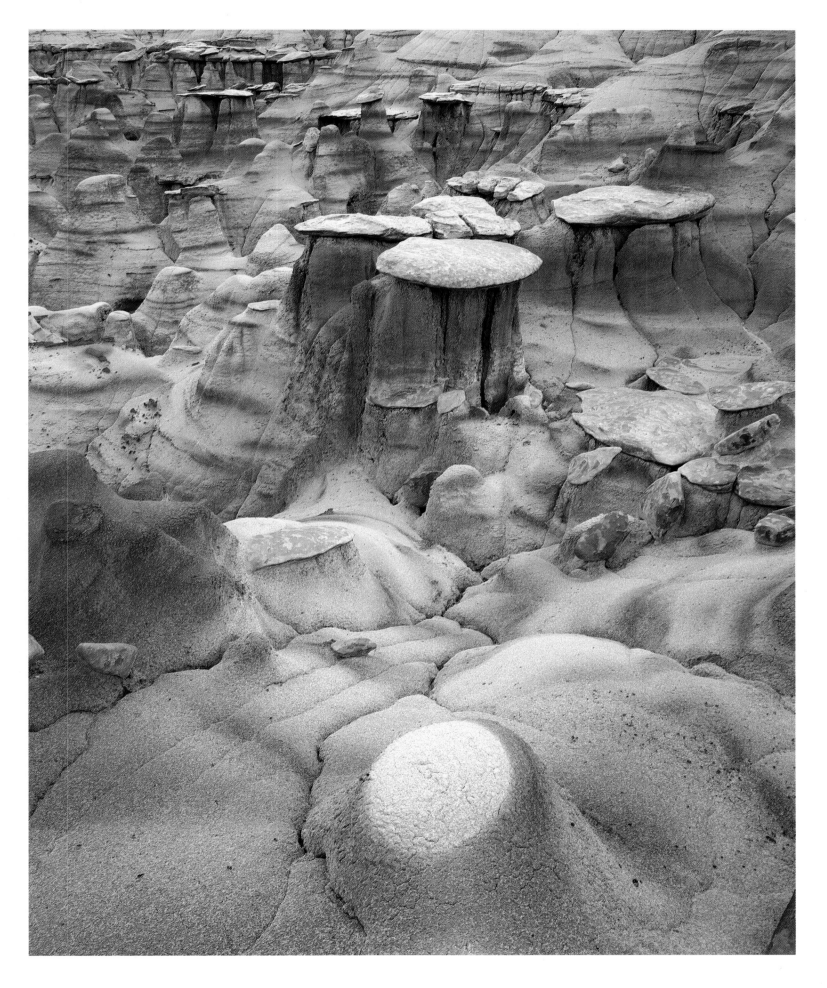

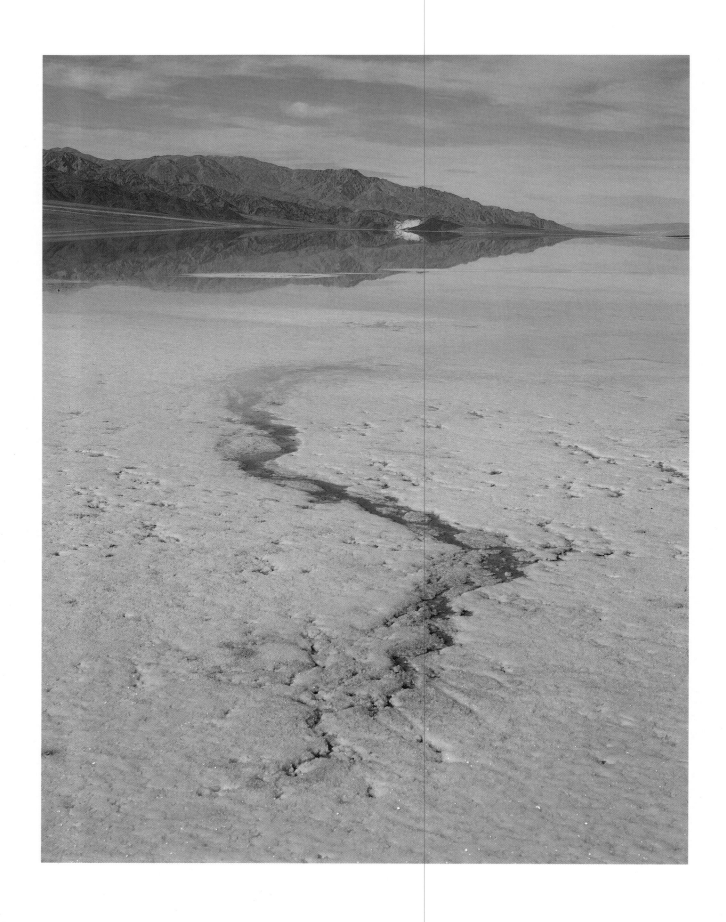

Above: Badwater salt playa, Death Valley National Monument, California

Right: Blue ridges of Grand Canyon National Park, Arizona

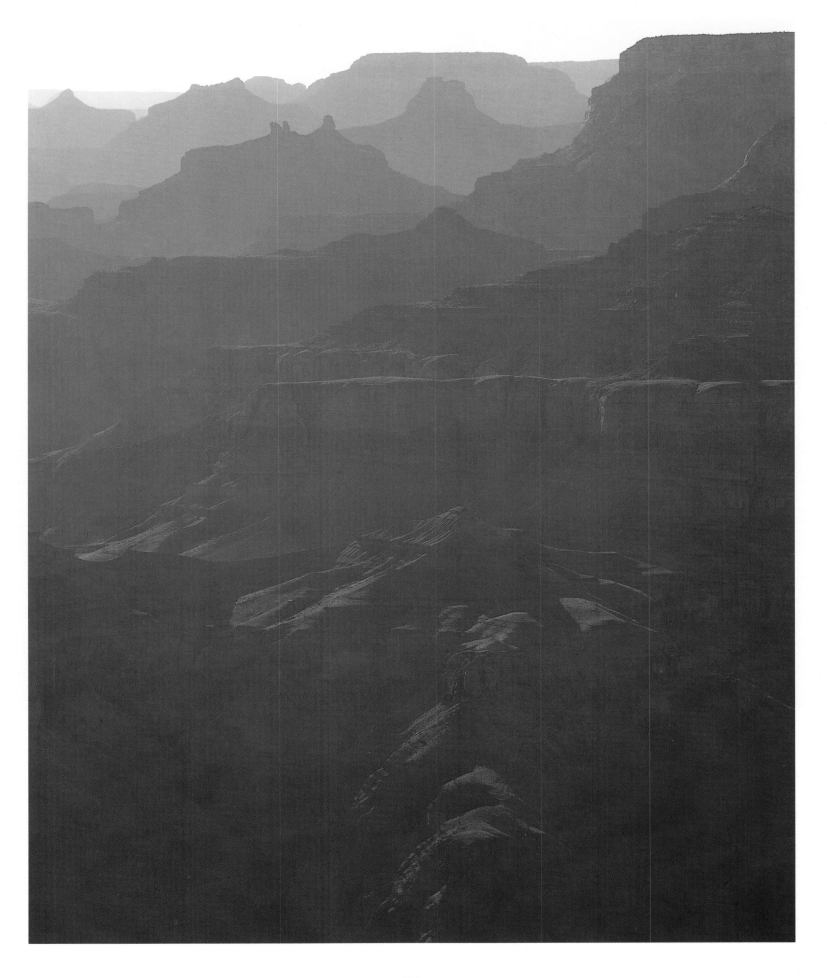

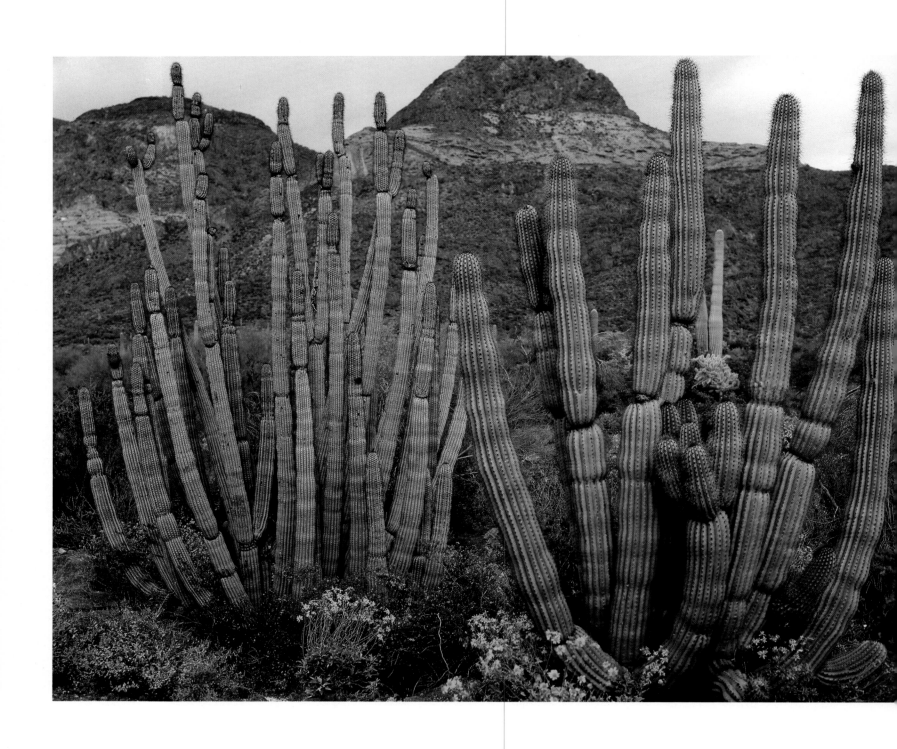

Above: Organ pipe cacti, Organ Pipe Cactus National Monument, Arizona

Right: Great Salt Lake Playa, Utah

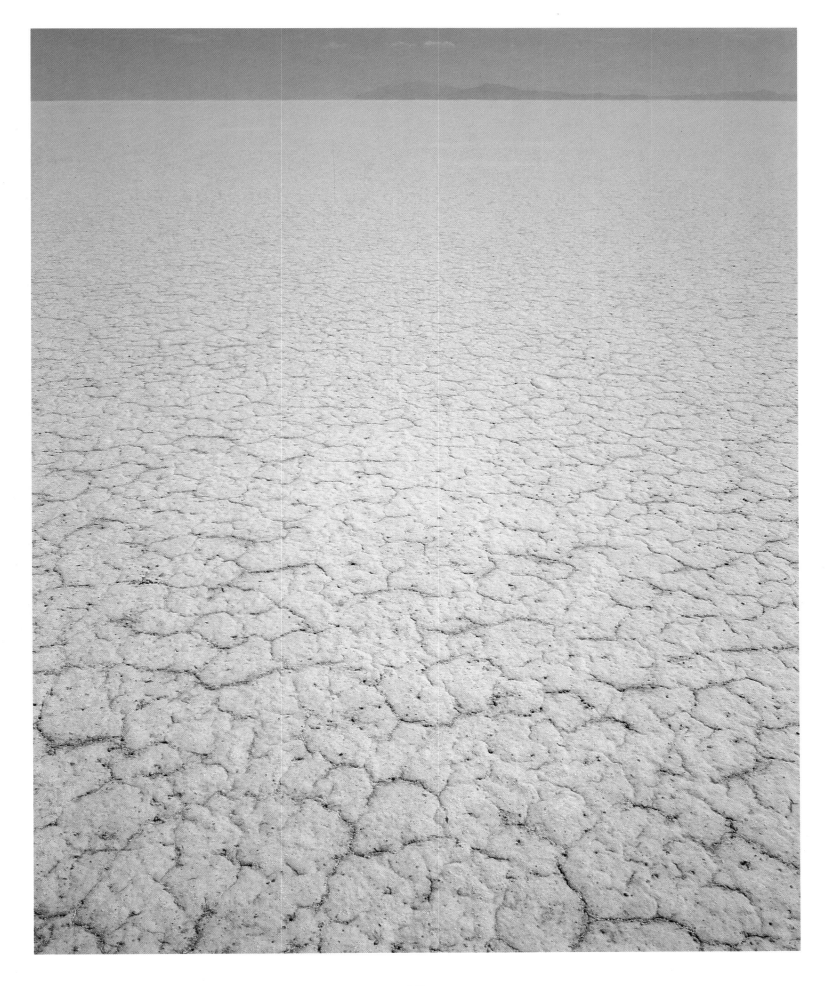

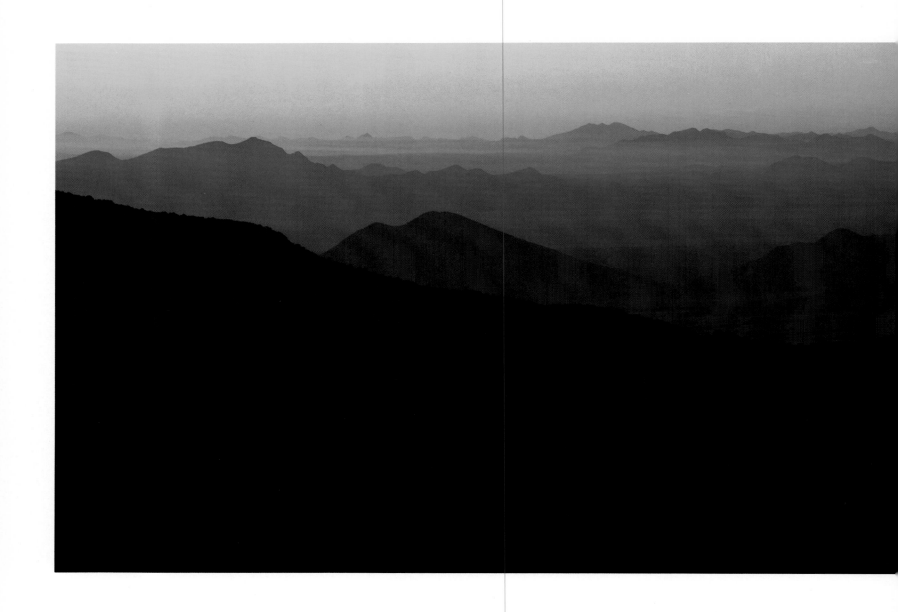

Desert ridges, Chiricahua National Monument, Arizona

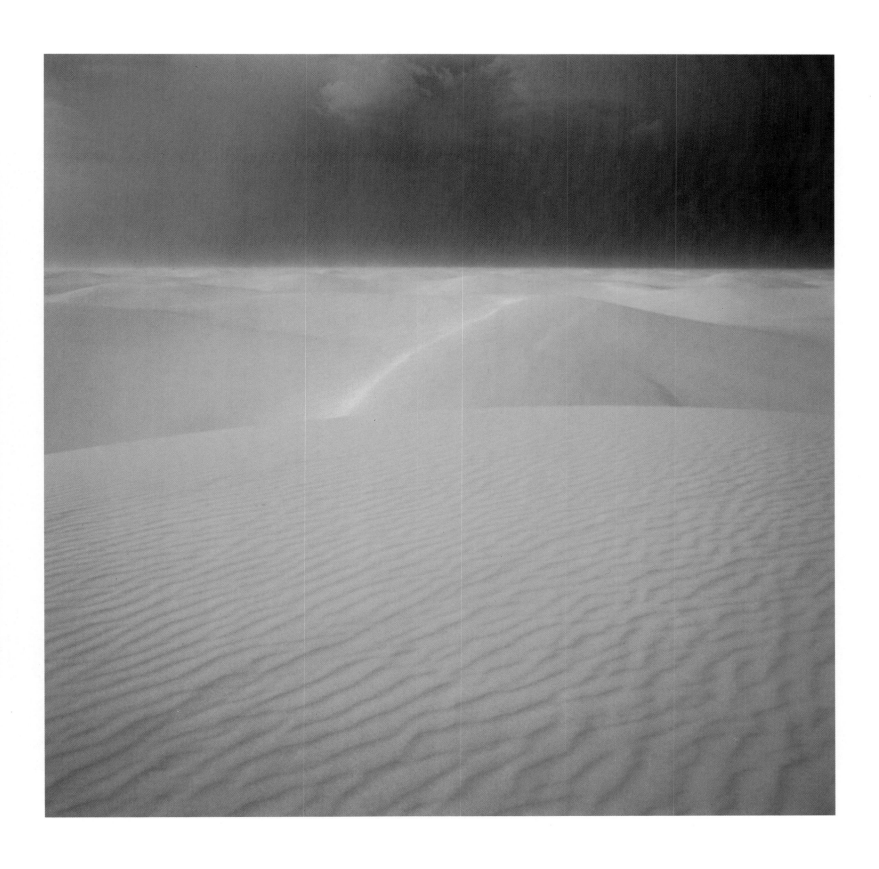

Approaching storm, White Sands National Monument, New Mexico

Wetlands & Rivers

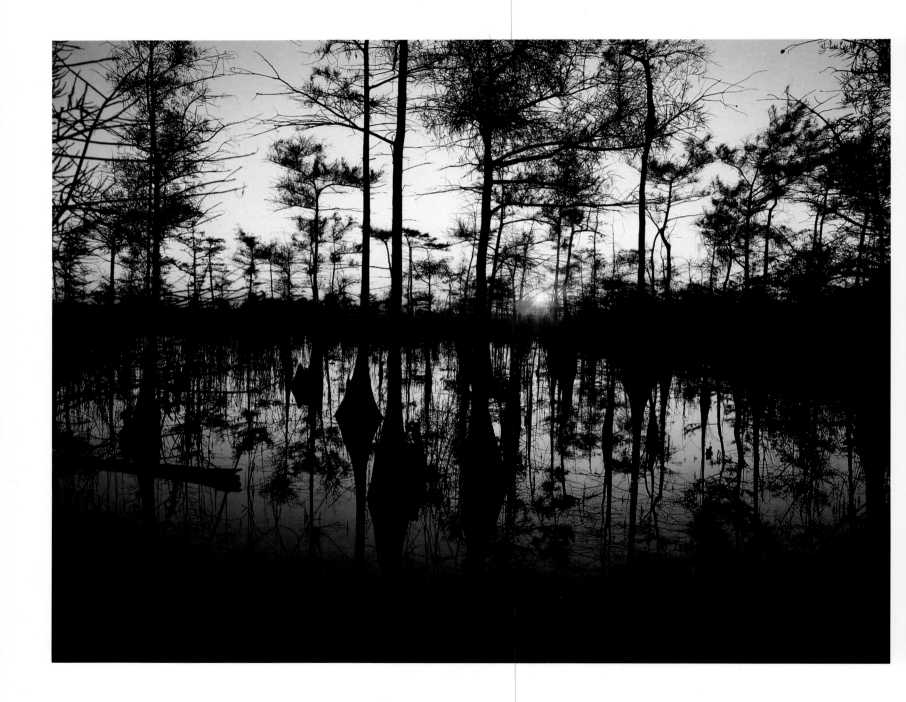

Dwarf cypress in Sweet Bay Pond, Everglades National Park, Florida

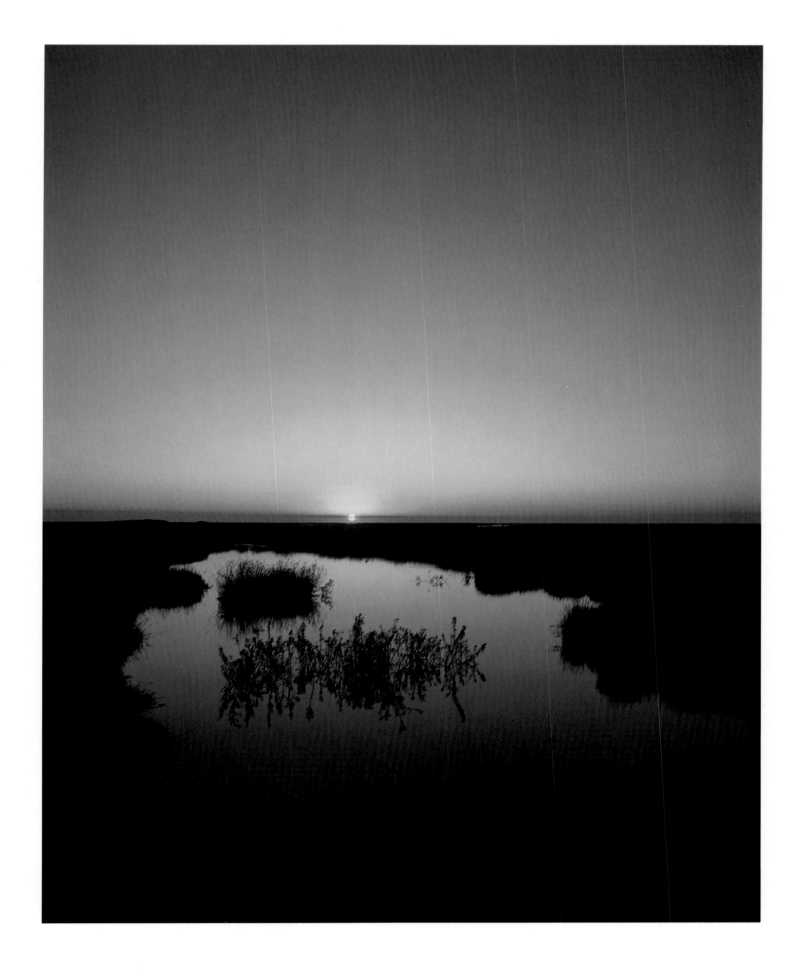

Gulf Coast estuarial pool, Copano Bay, Texas

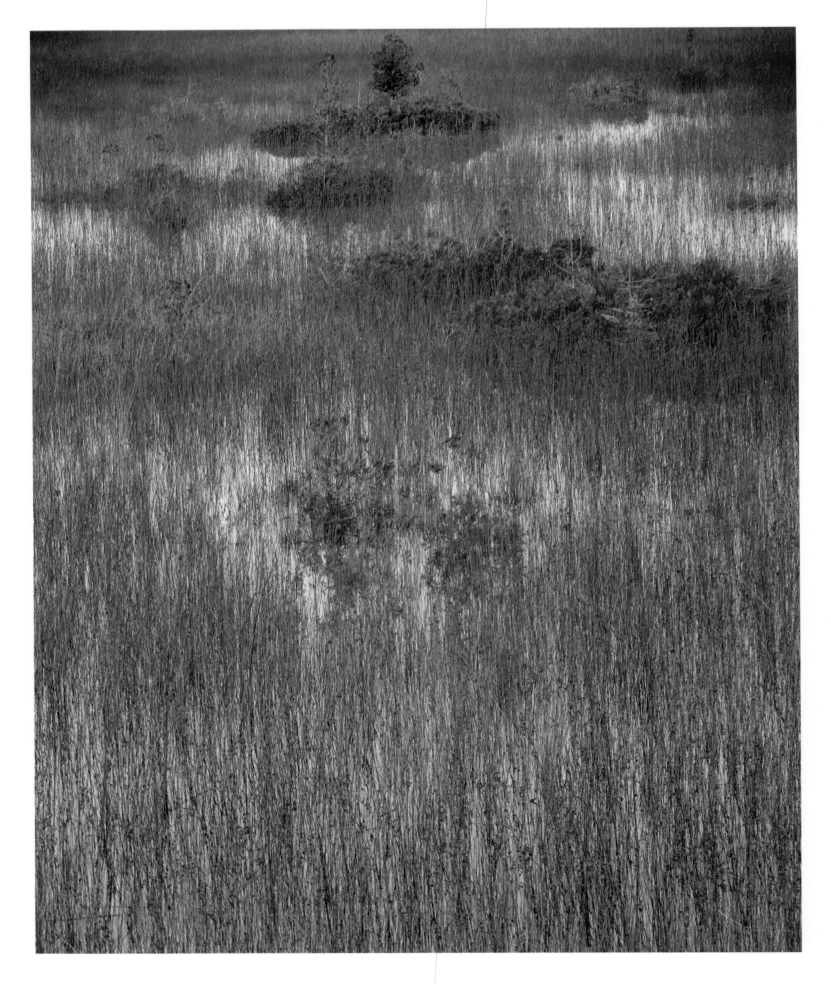

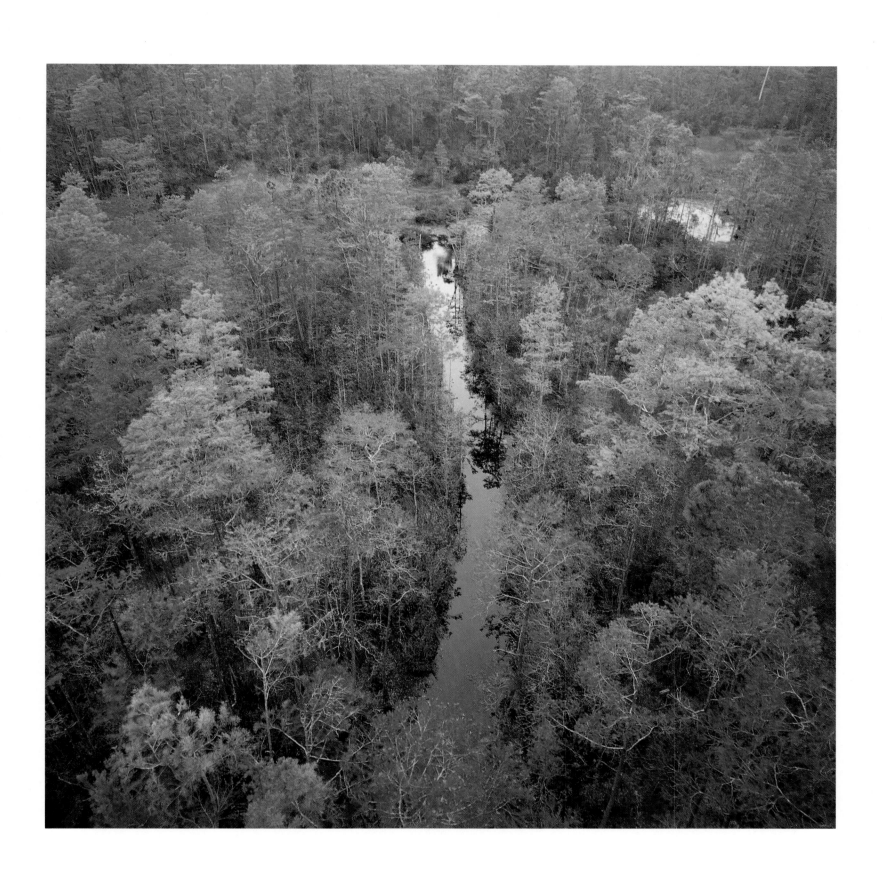

Left: Autumn marsh at Lake Michigan's edge, Upper Peninsula, Michigan

Above: Pond cypress in autumn, Okefenokee Swamp National Wildlife Refuge, Georgia

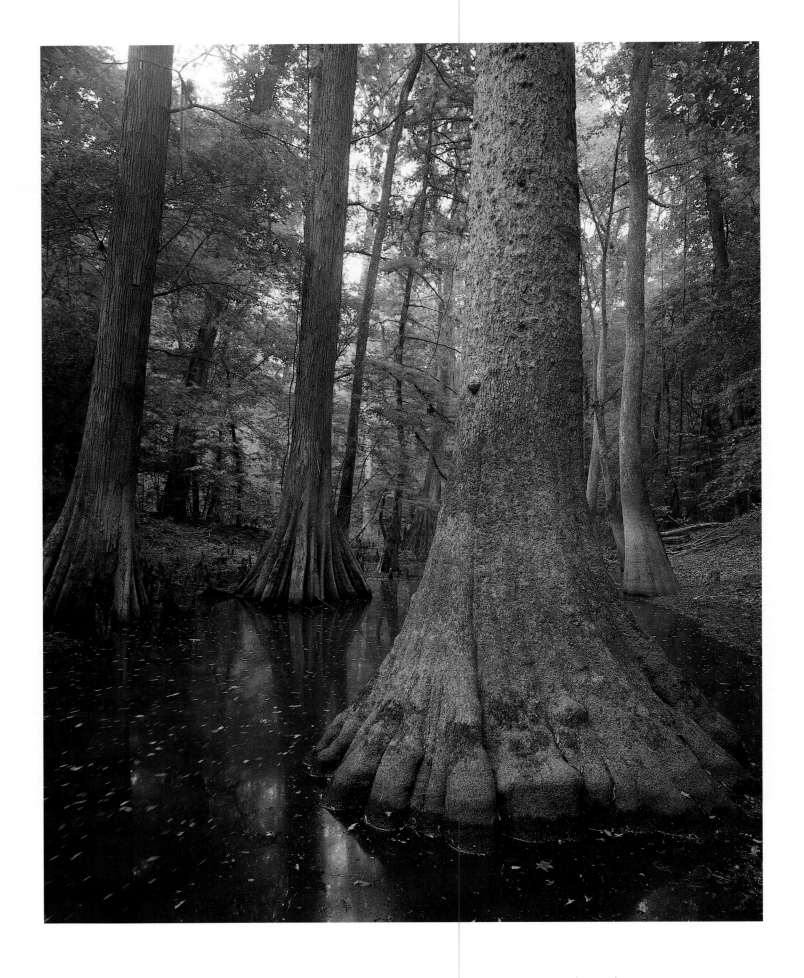

Tupelo and bald cypress, Congaree Swamp National Monument, South Carolina

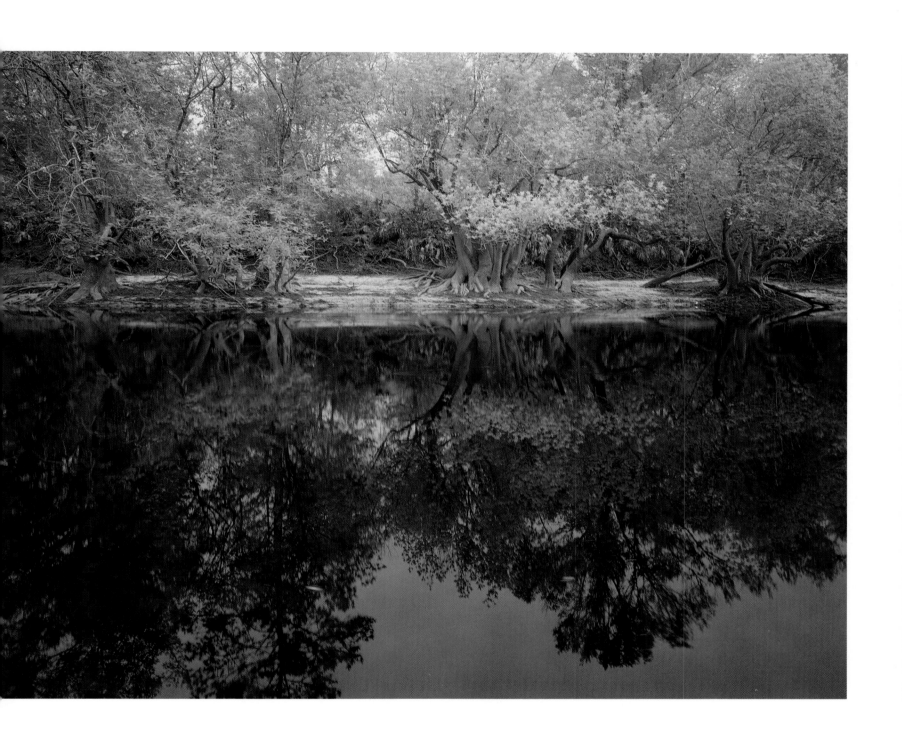

Ogeeche tupelo, Suwannee River reflections, Georgia

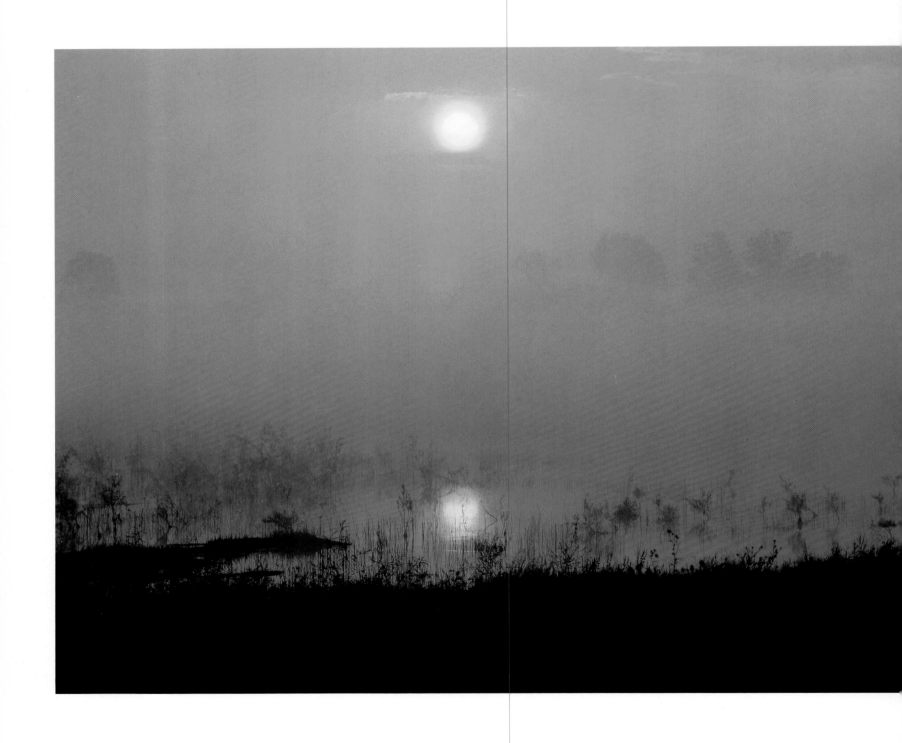

Morning fog over freshwater pond, Tupelo, Mississippi

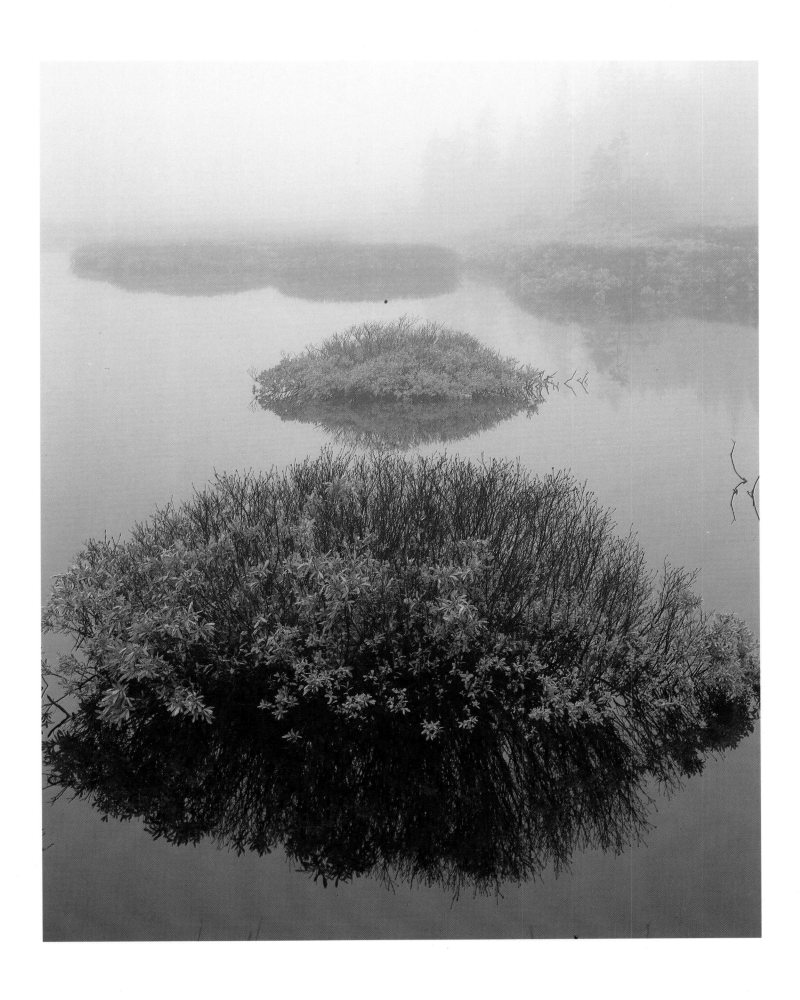

Willows and Seawall Pond, Big Heath, Acadia National Park, Maine

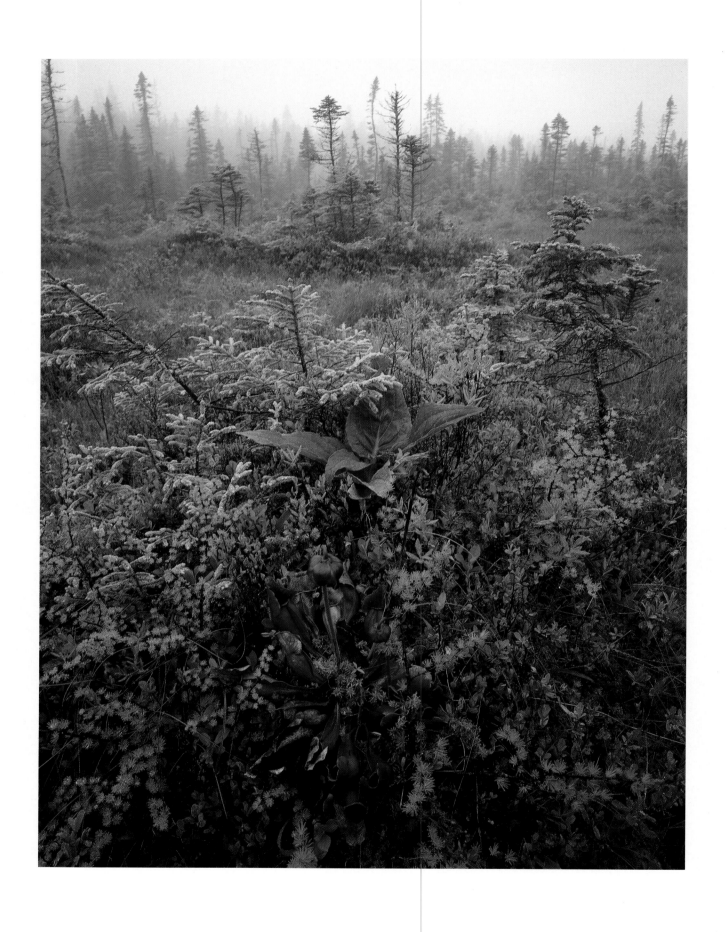

Coastal bog community, Big Heath, Acadia National Park, Maine

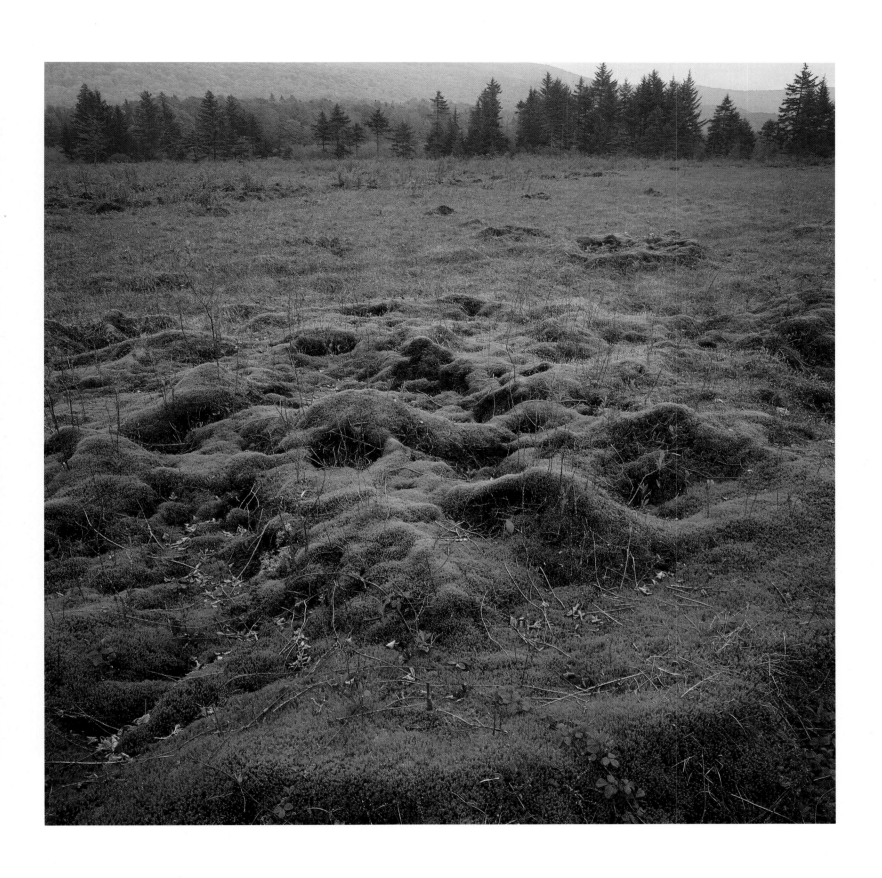

Sphagnum moss in Round Glade, Cranberry Glades Preserve, West Virginia

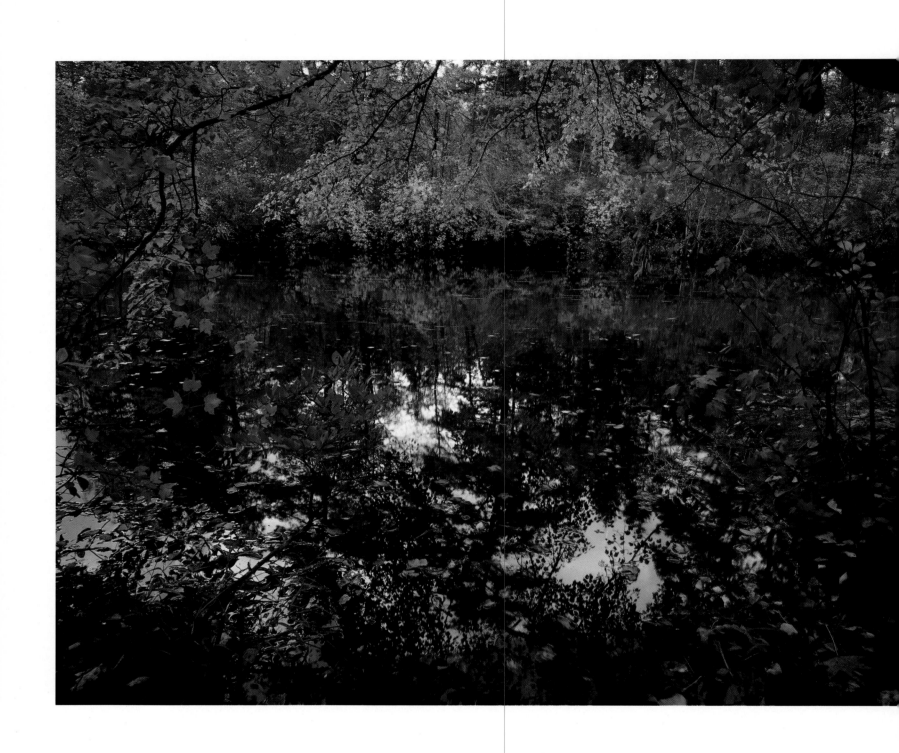

Autumn along Mullica River, Pine Barrens Preserve, New Jersey

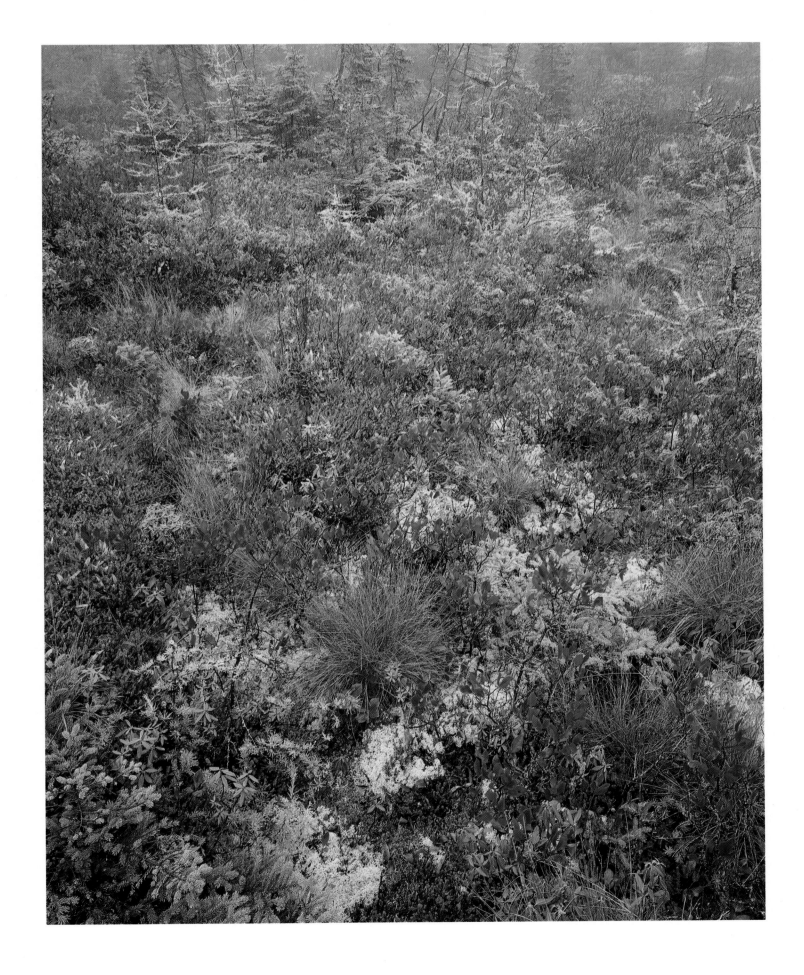

Autumn bog, Big Heath, Maine

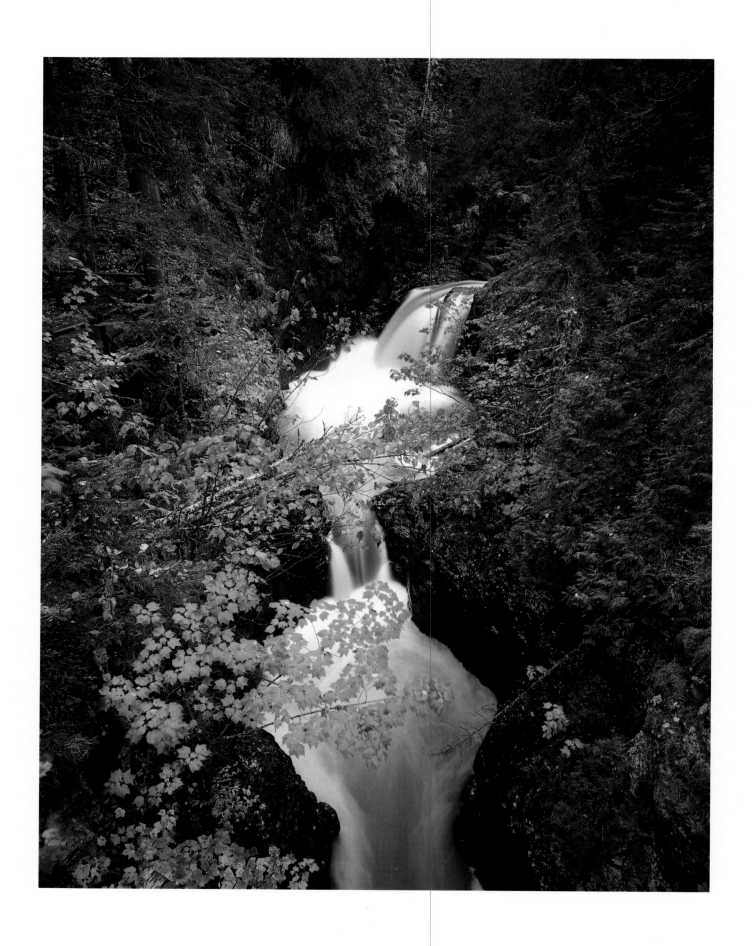

Cascade River State Park, Lake Superior, Minnesota

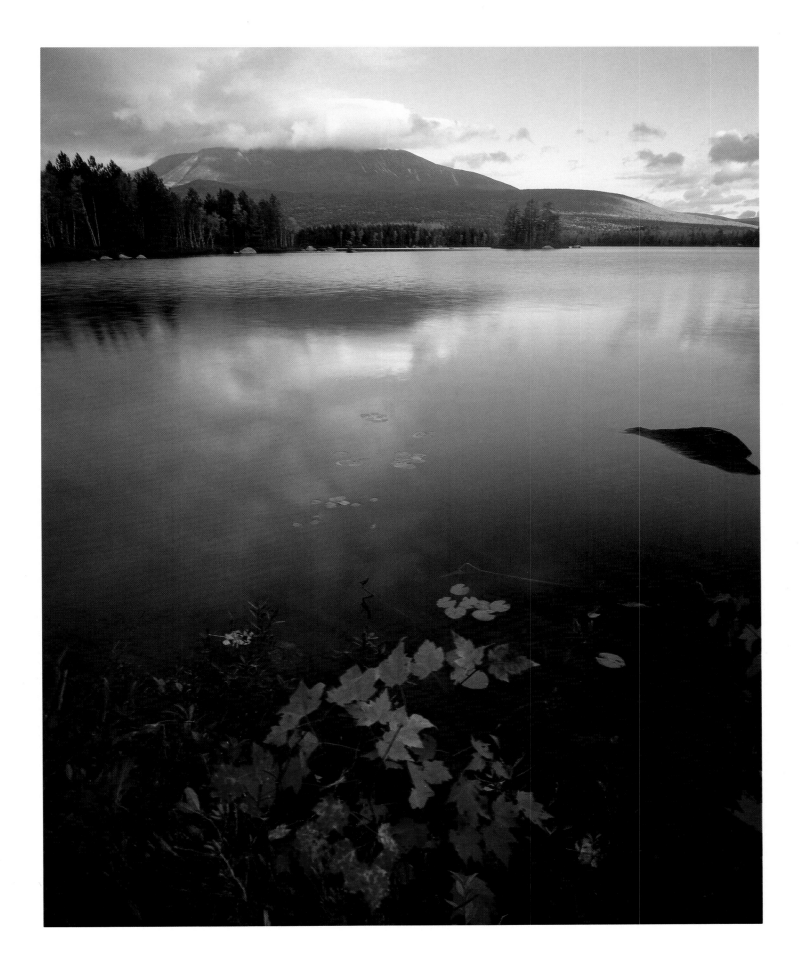

Mount Katahdin and Togue Pond, Baxter State Park, Maine

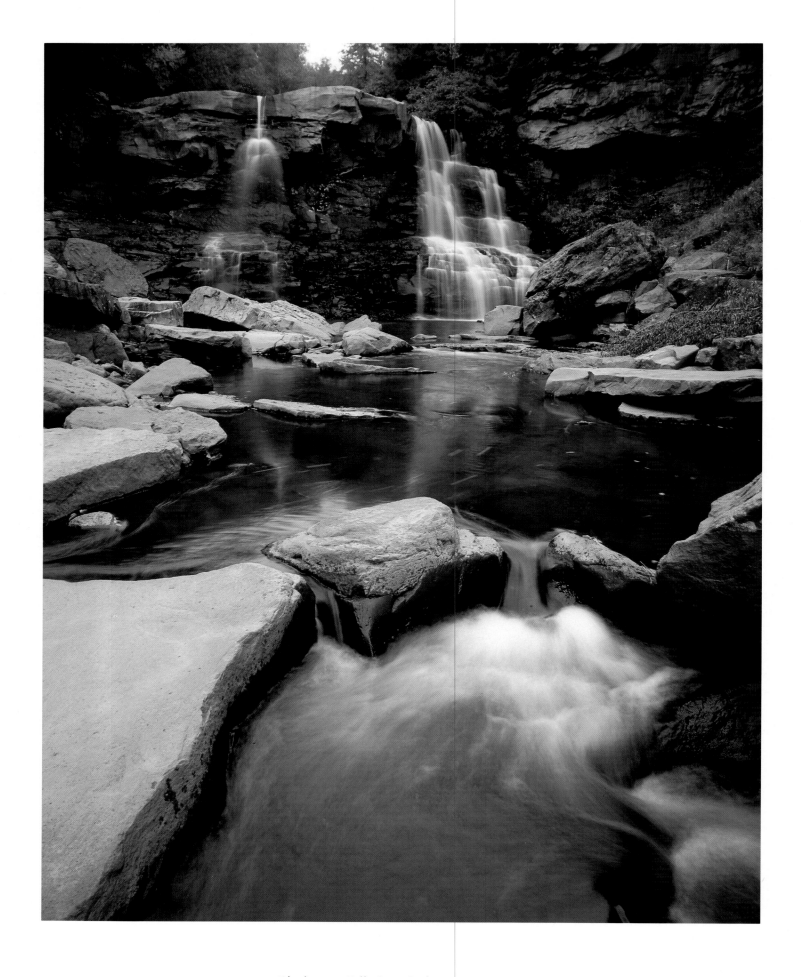

Blackwater Falls State Park, West Virginia

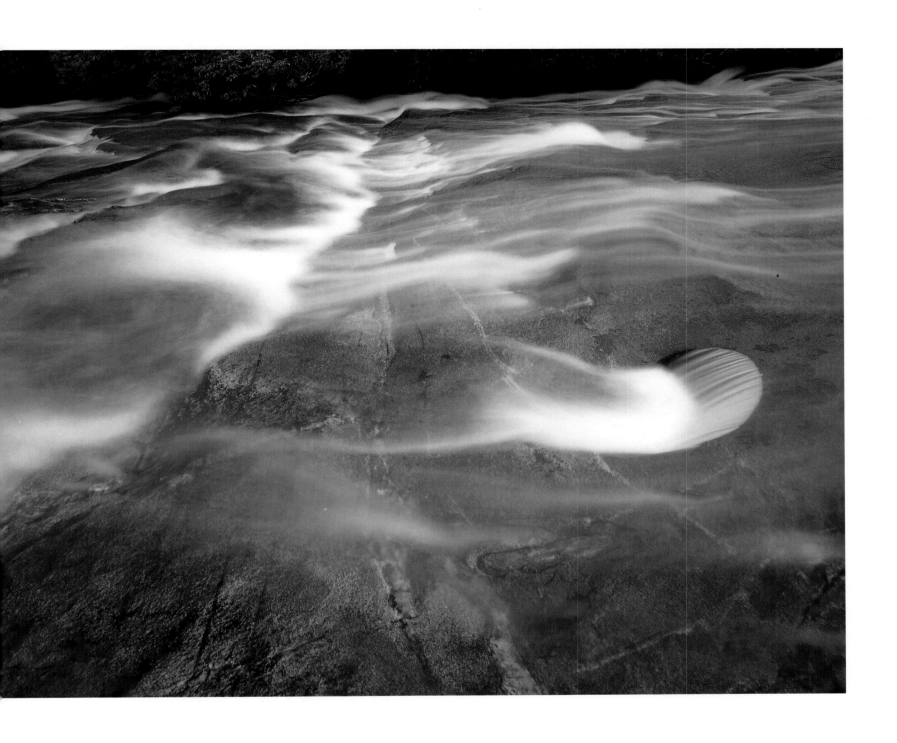

Flow at Sliding Rock, Looking Glass Creek, North Carolina

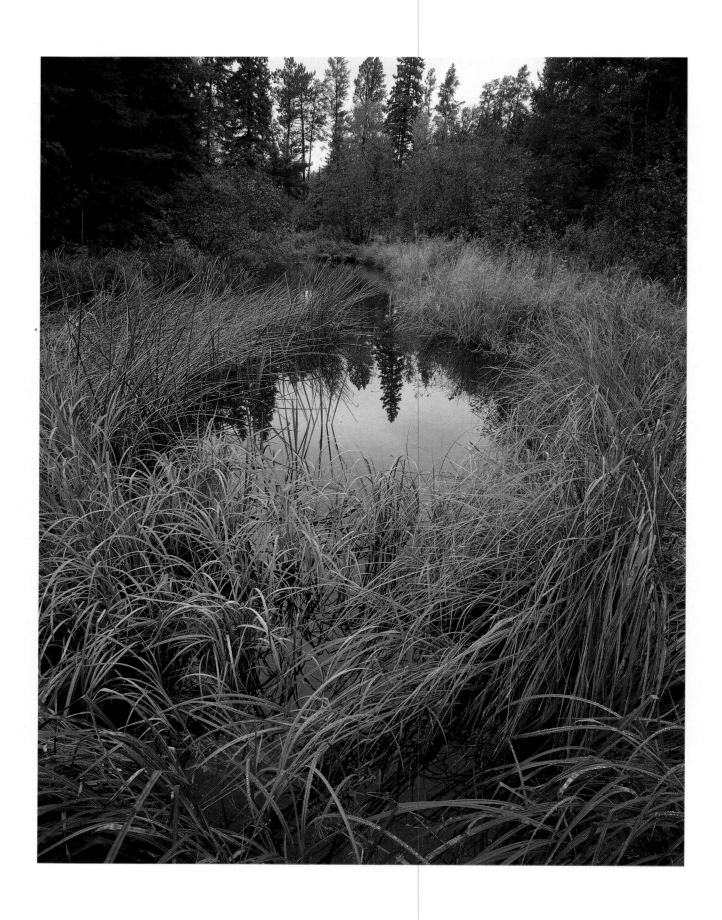

Headwaters of the Mississippi River, Itaska State Park, Minnesota

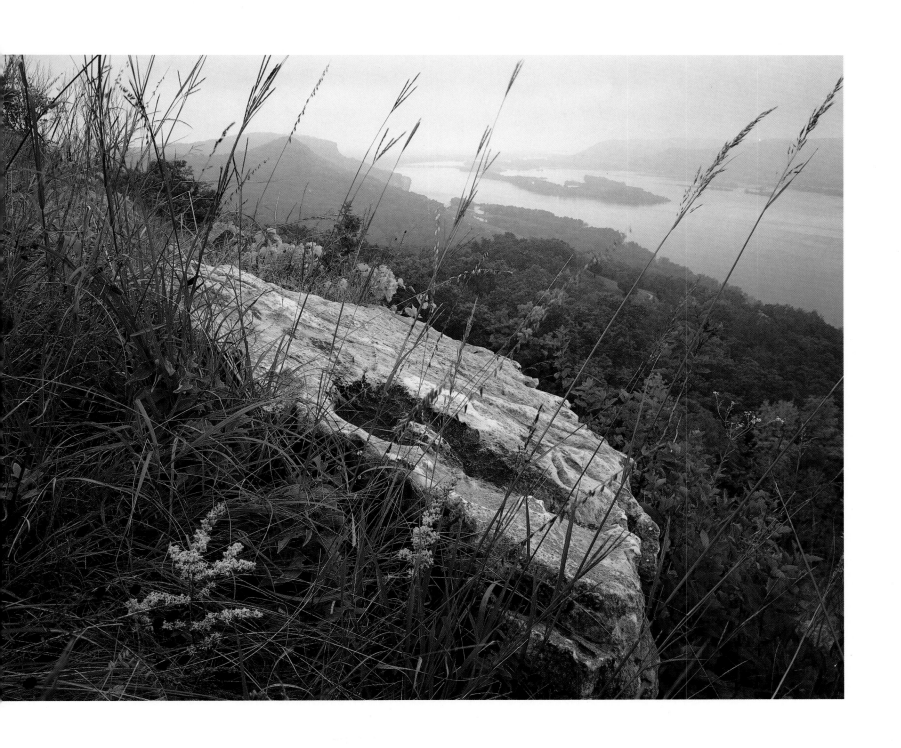

Mississippi River at Perrot State Park, Wisconsin

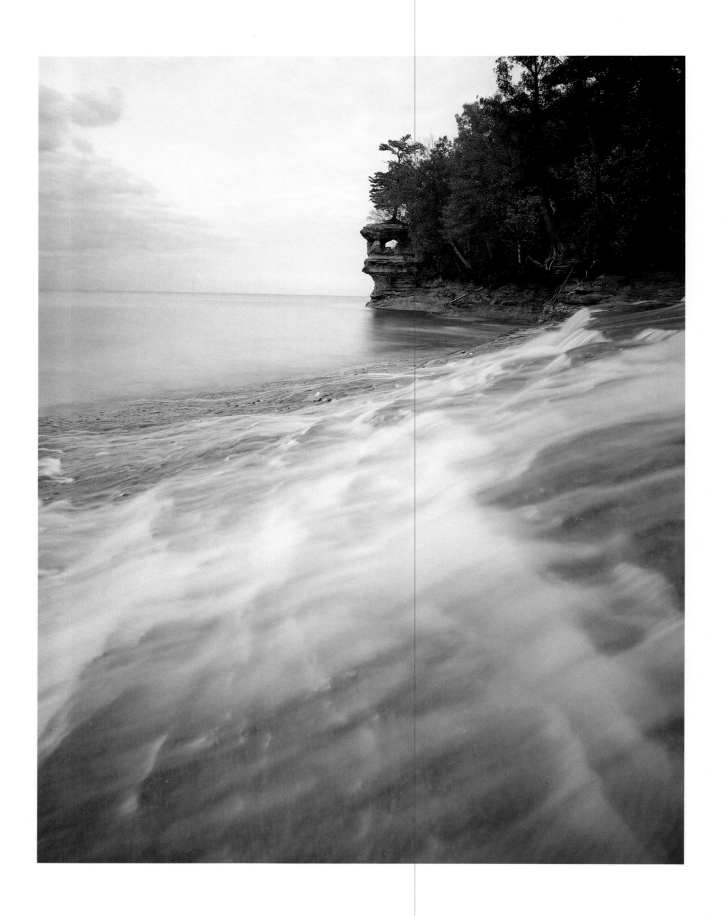

Chapel Creek joins Lake Superior, Pictured Rocks National Seashore, Michigan

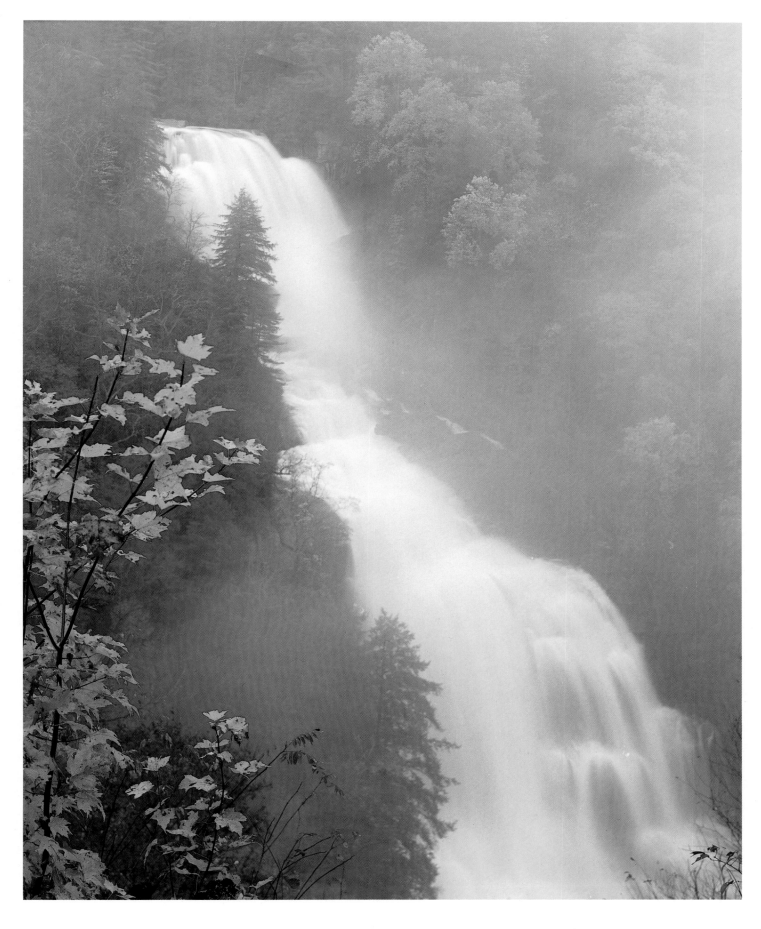

Above: Rain-swollen Whitewater Falls, Nantahala National Forest, North Carolina

Overleaf: Northwoods pool, Tahquamenon Falls State Park, Michigan

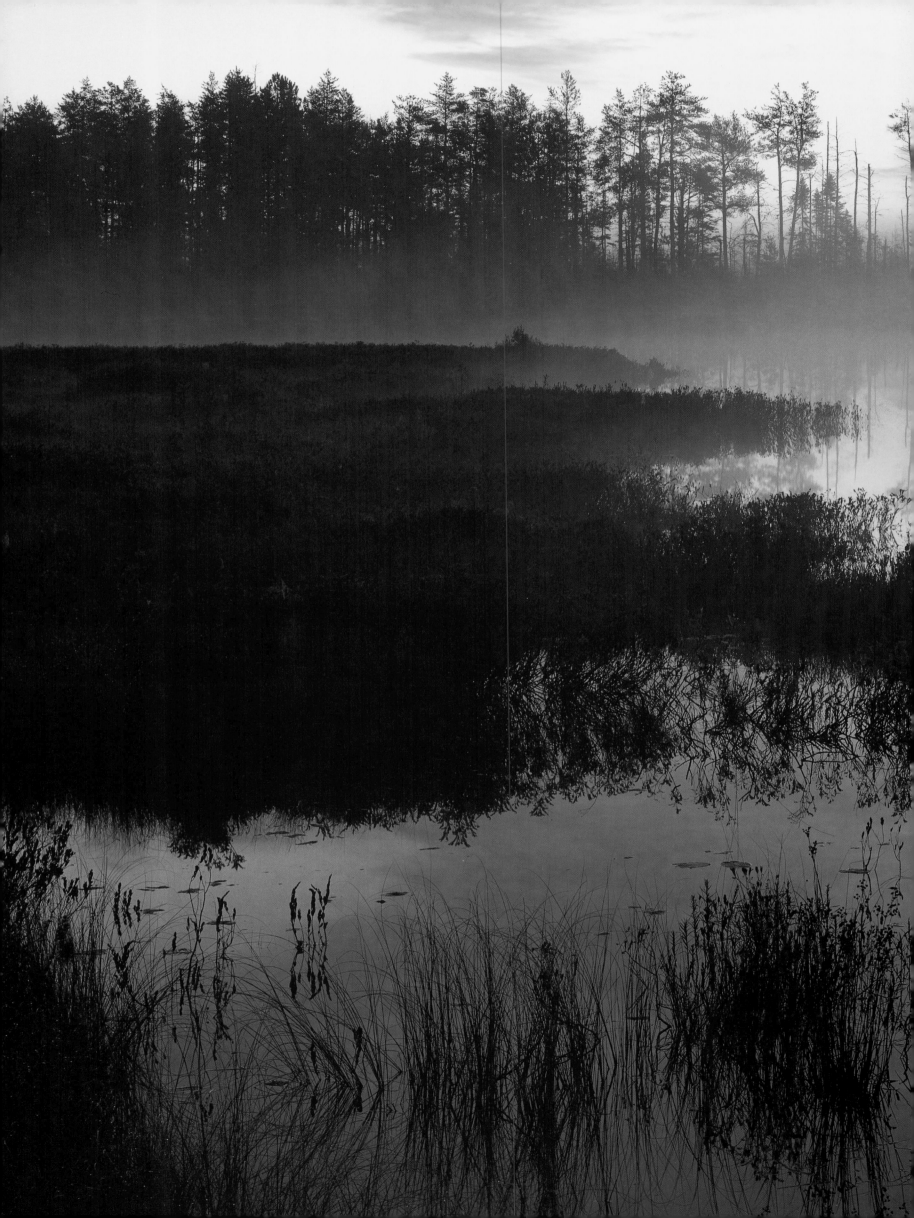

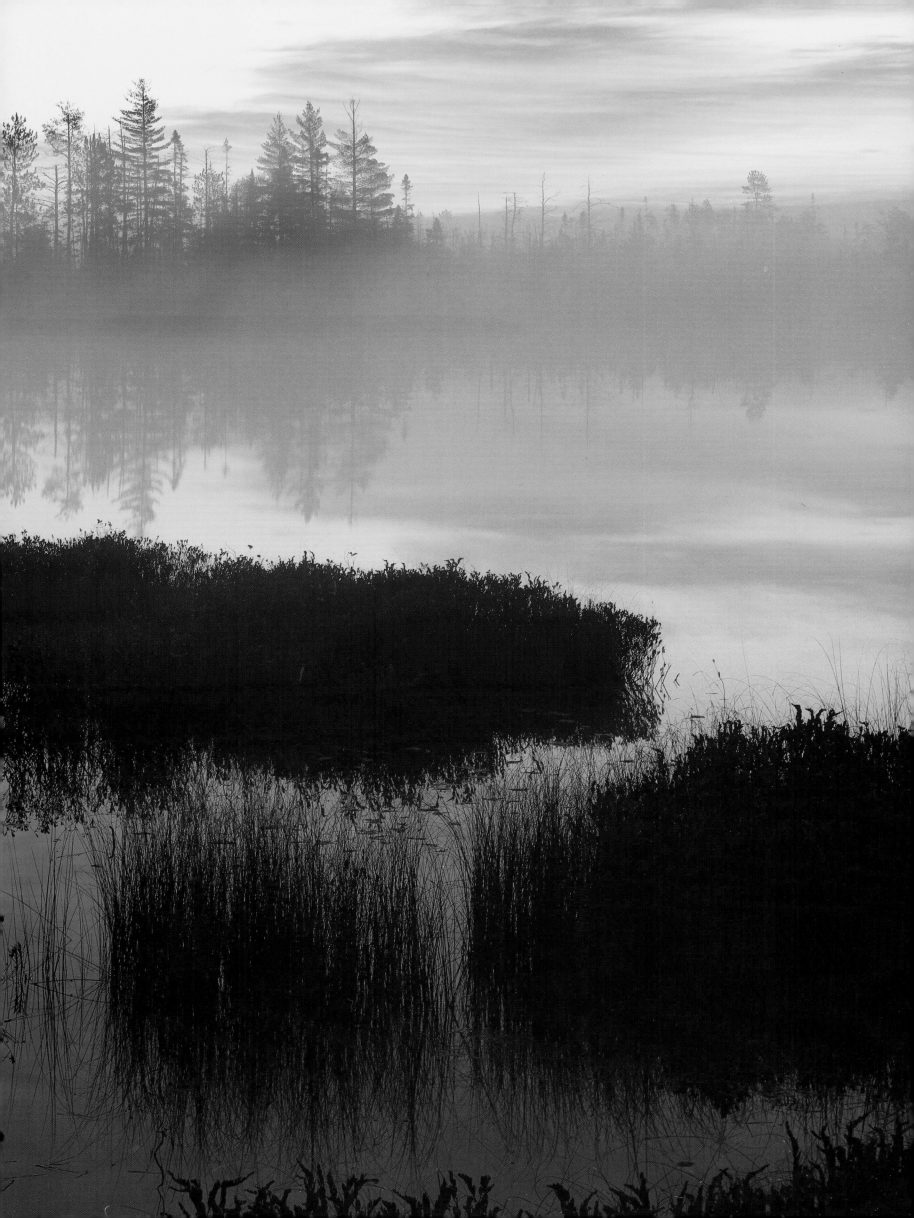

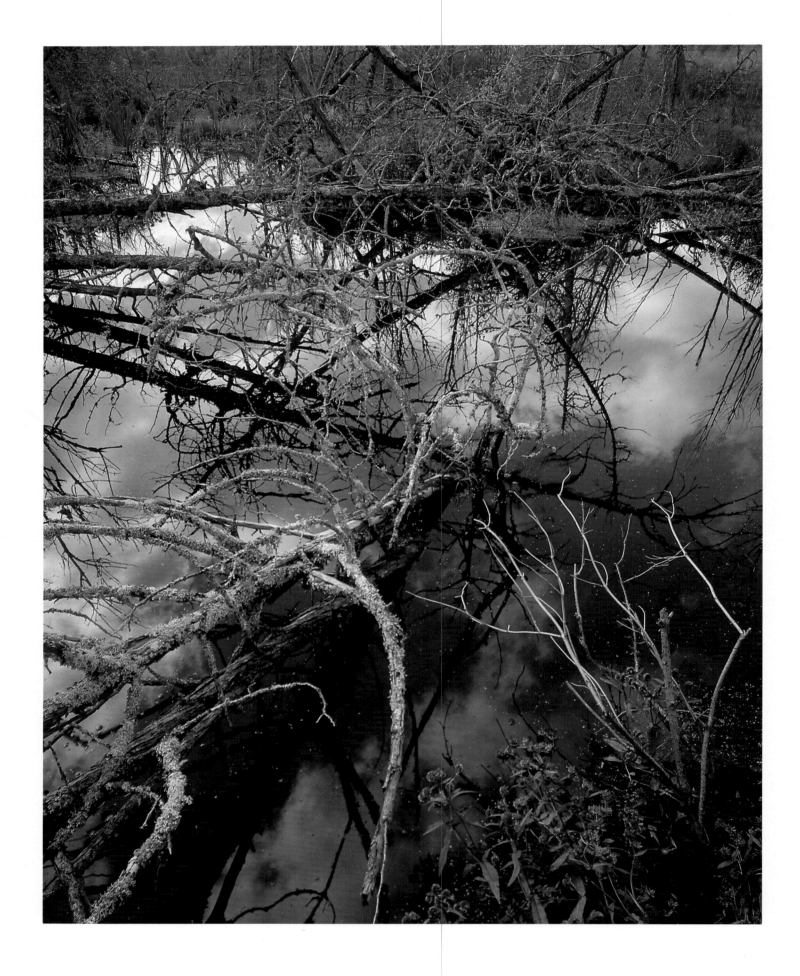

Moose Creek beaver pond, Boundary Waters Canoe Area, Minnesota

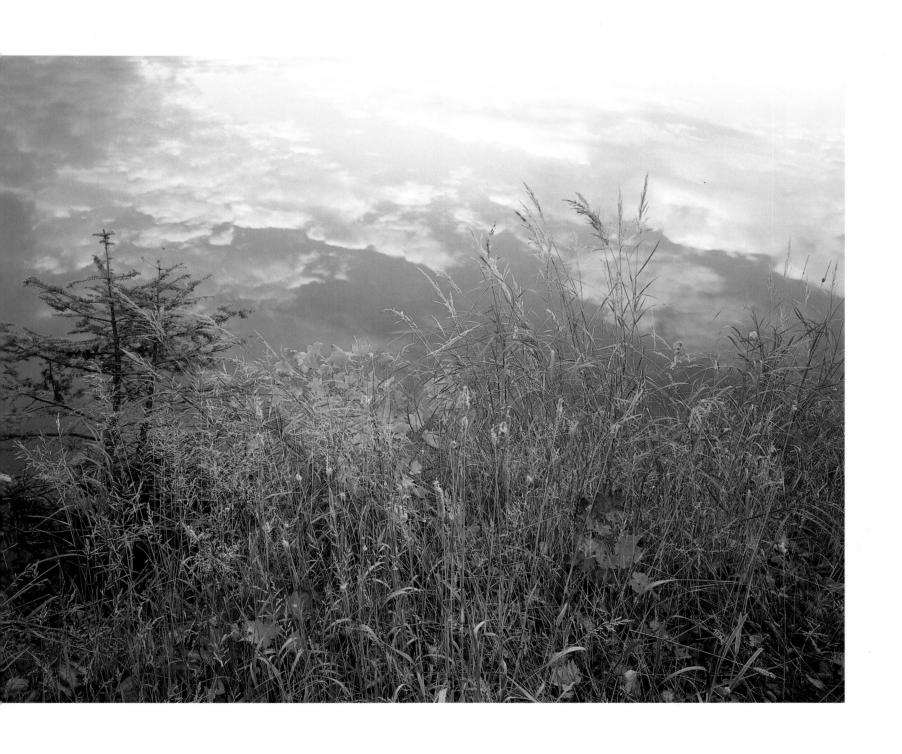

Reflections of autumn, Tahquamenon River, Michigan

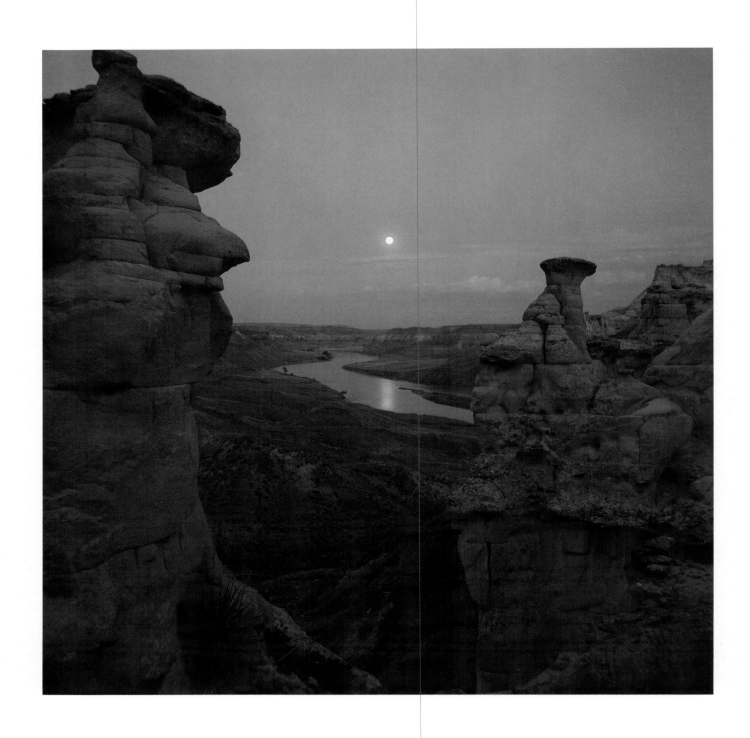

Above: Moonrise over Missouri River Breaks, Montana

Right: Tones of dawn along Lake Superior, Minnesota

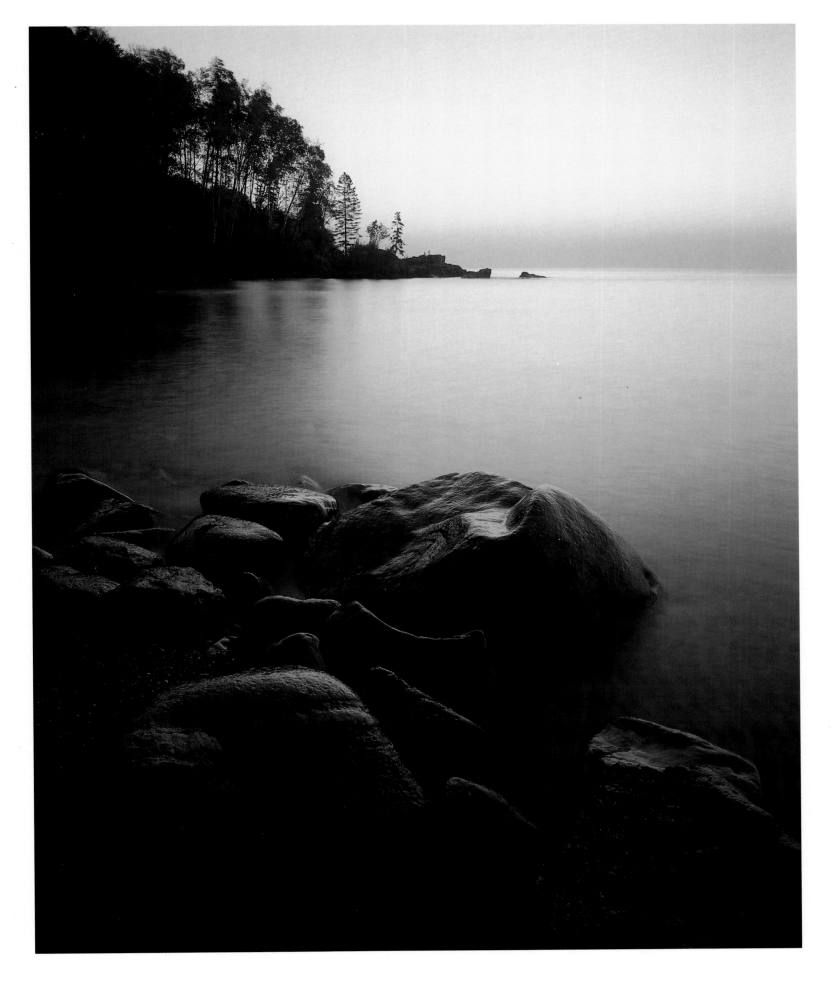

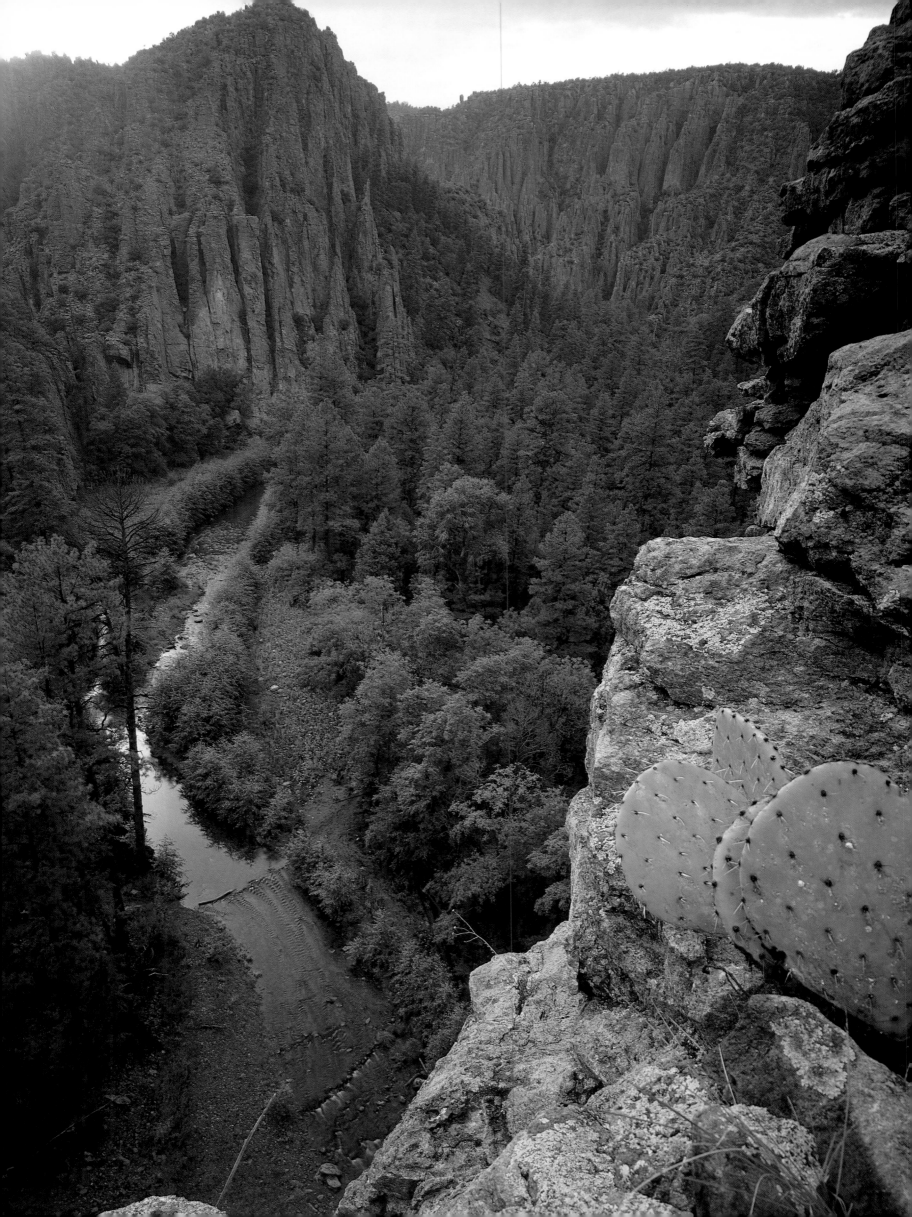

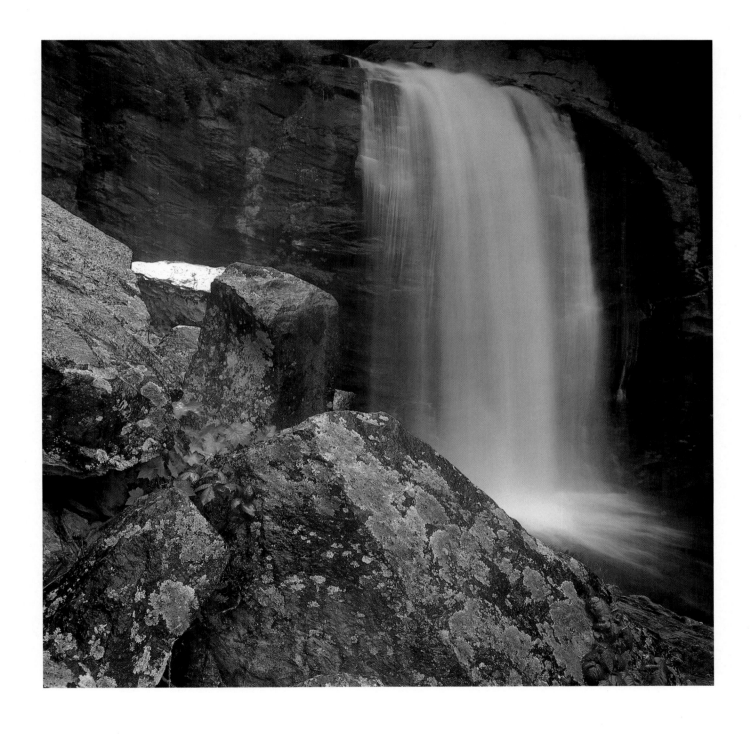

Left: Gila River West Fork, Gila Wilderness, New Mexico

Above: Looking Glass Falls, Nantahala National Forest, North Carolina

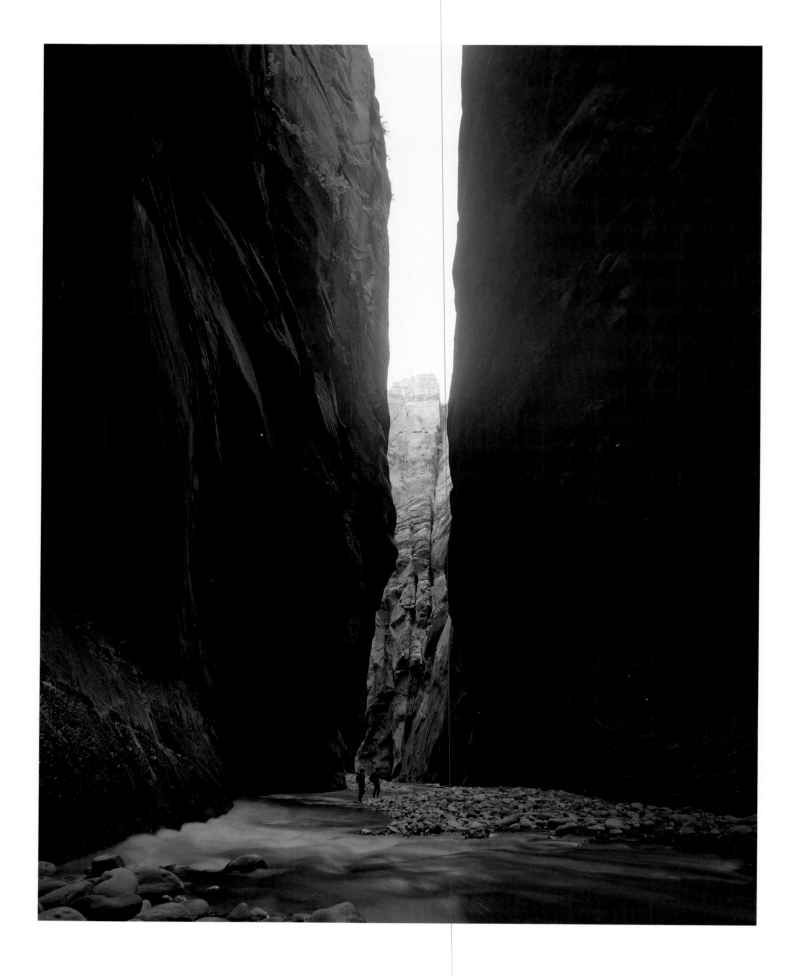

Virgin River Narrows, Zion National Park, Utah

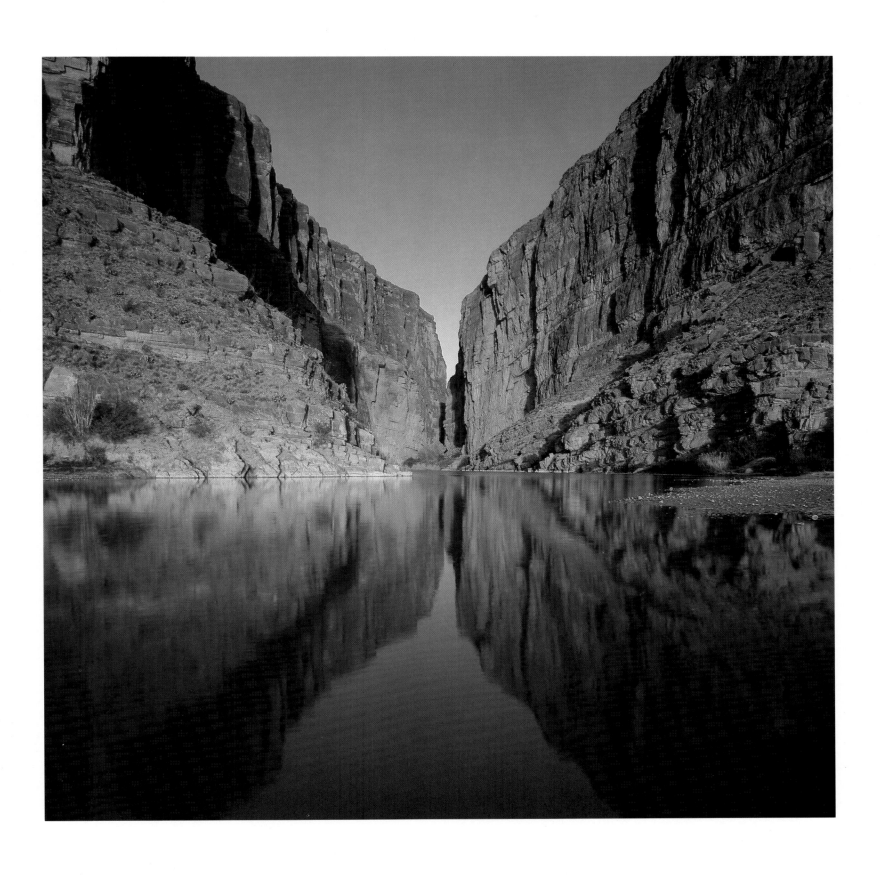

Santa Elena Canyon on the Rio Grande, Big Bend National Park, Texas/Mexico

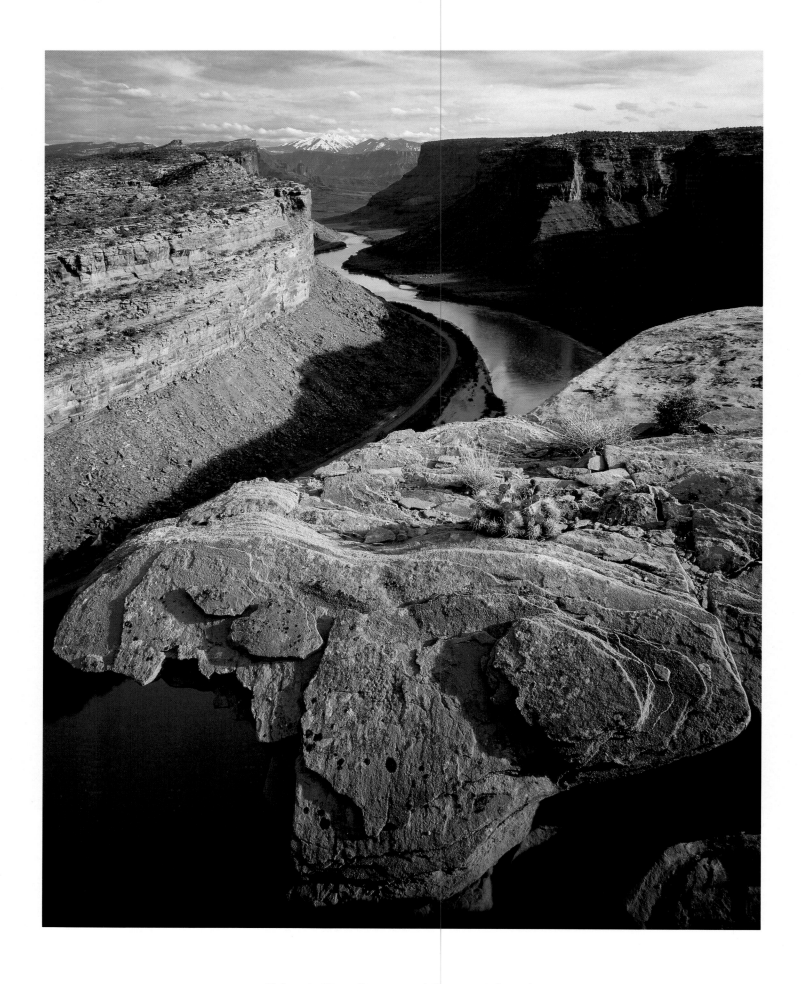

Colorado River Canyon and Sierra La Sal, Utah

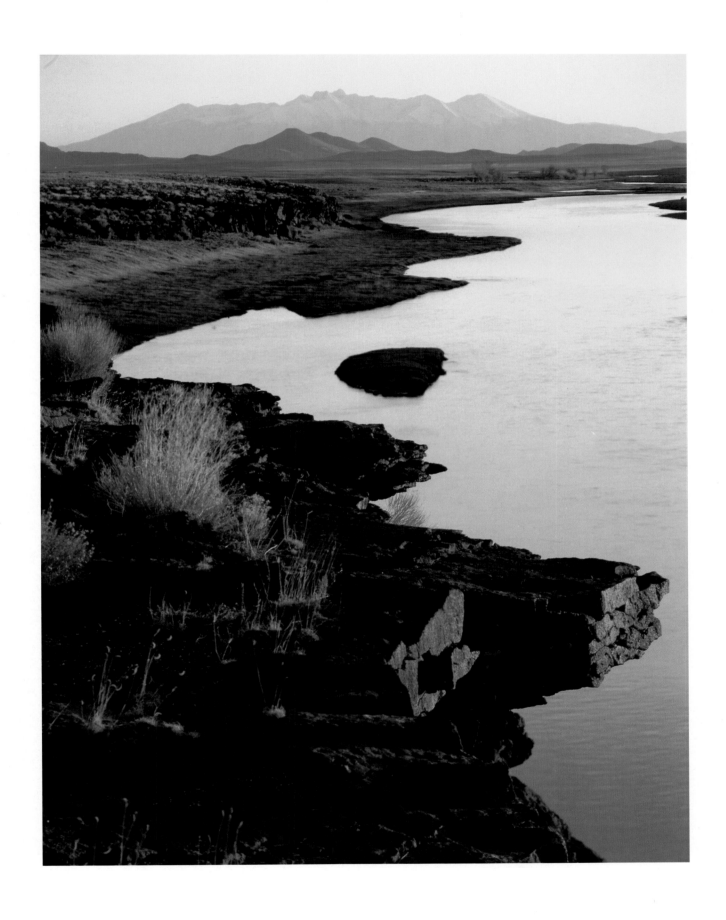

Rio Grande and Sierra Blanca, Colorado

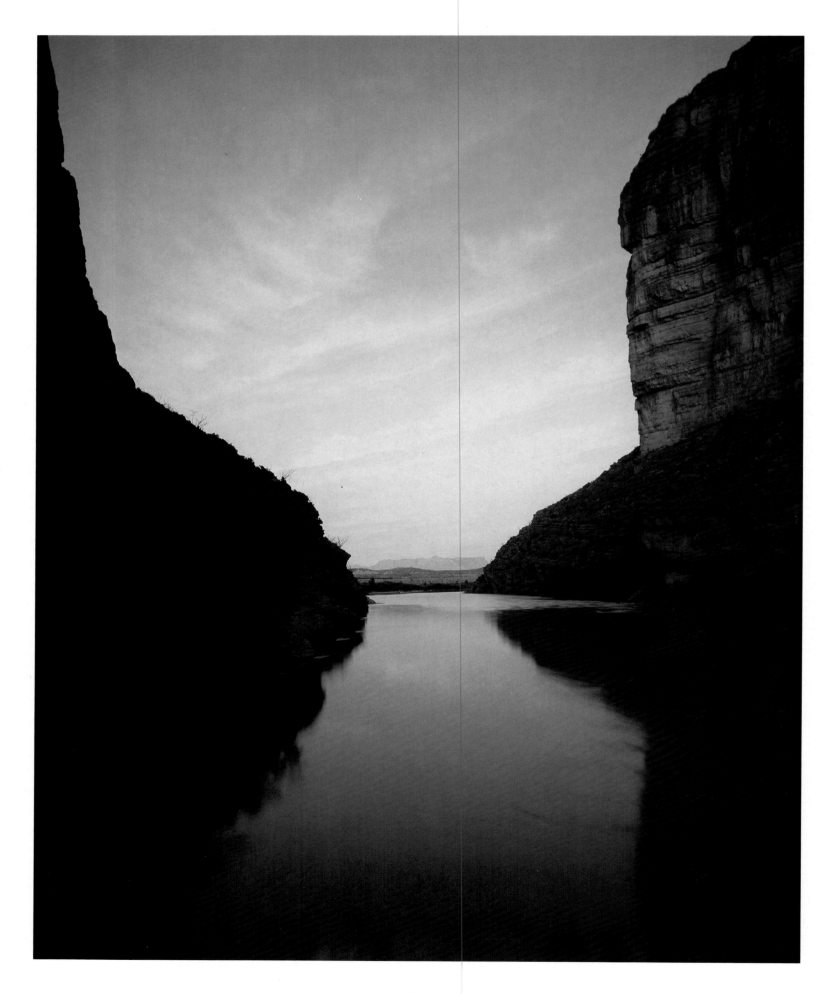

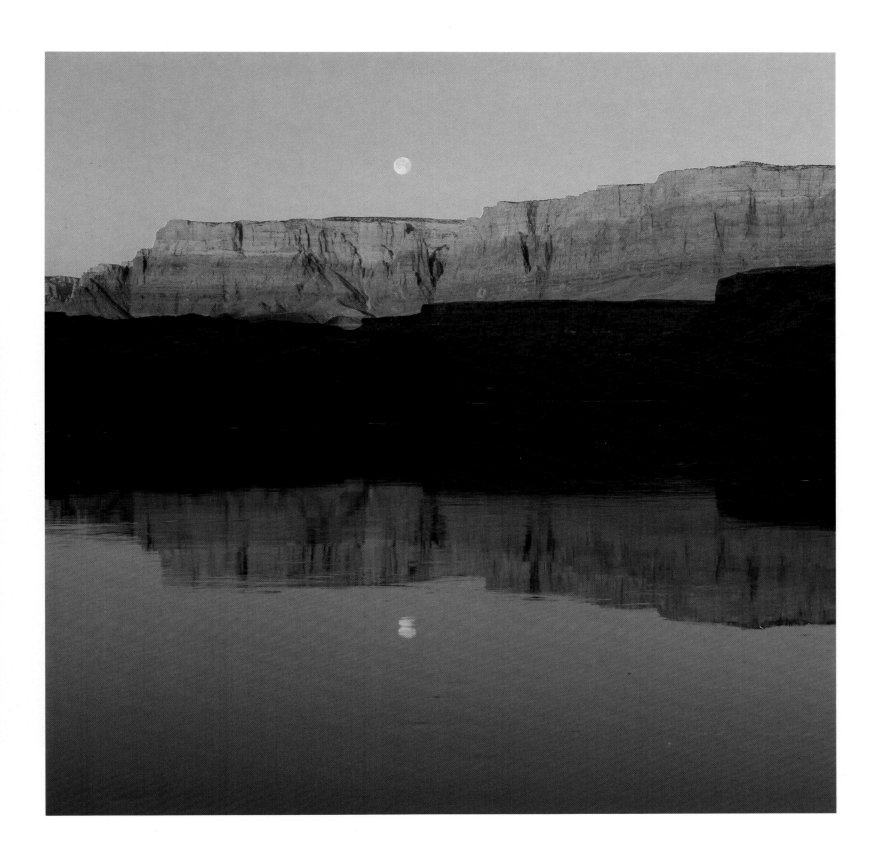

Left: Rio Grande in Santa Elena Canyon, Big Bend National Park, Texas

Above: Moonset reflection in Colorado River, Vermillion Cliffs, Arizona

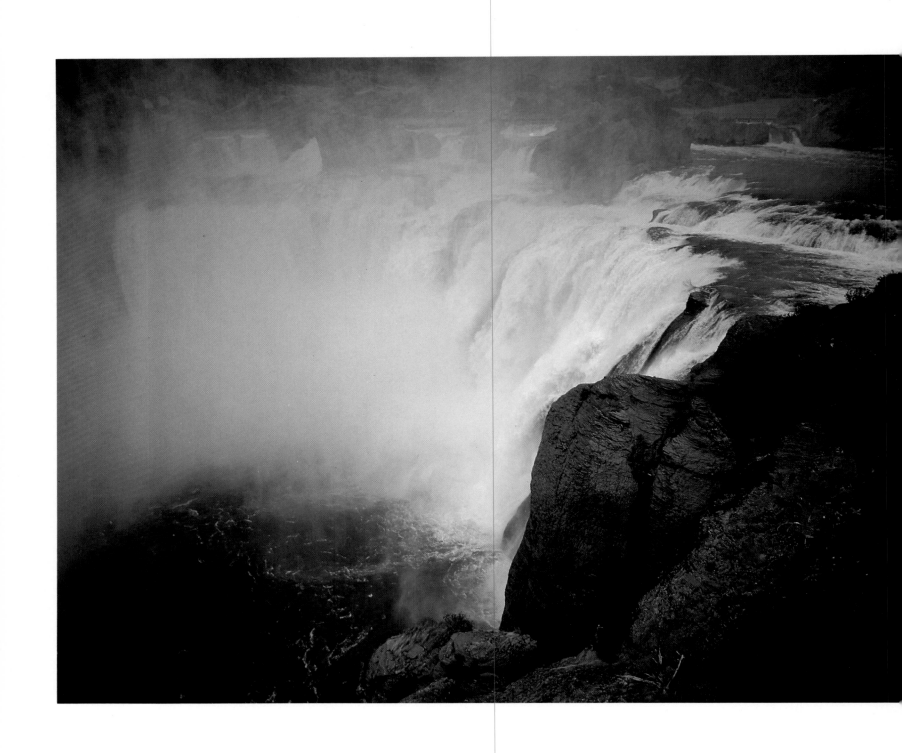

Shoshone Falls of the Snake River, Idaho

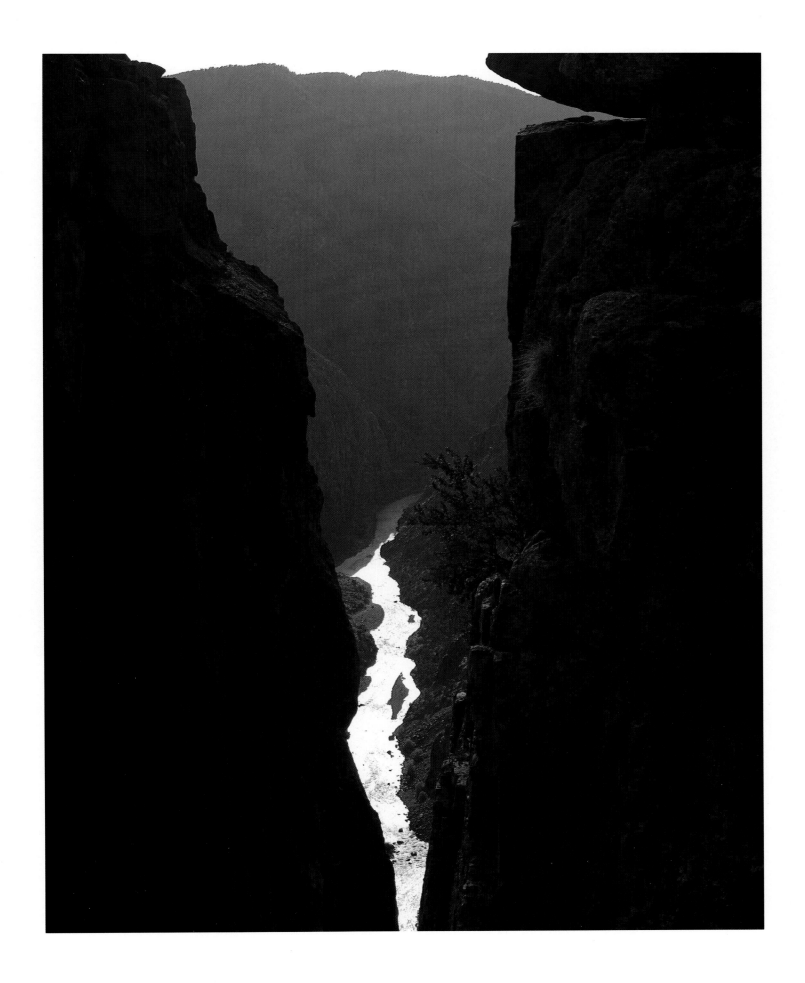

Black Canyon of the Gunnison River, Colorado

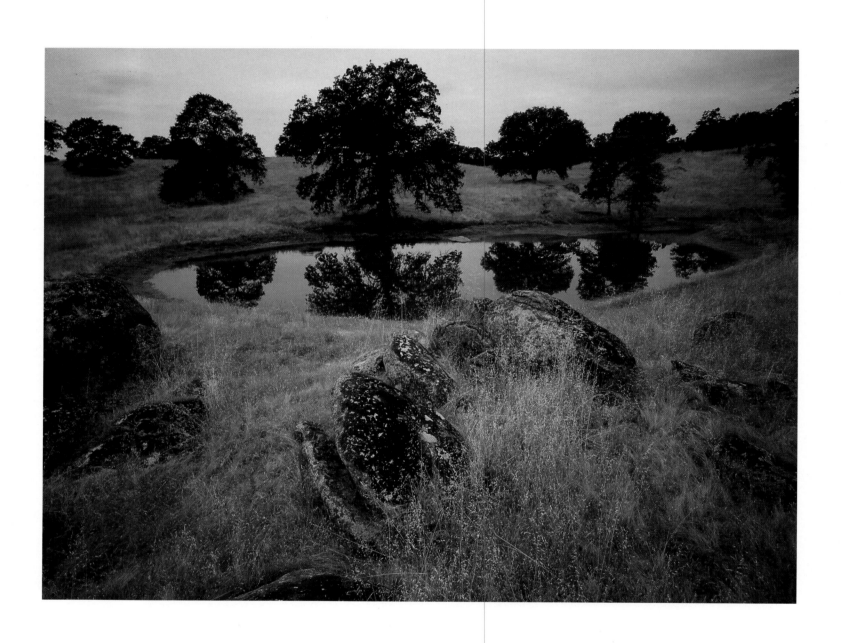

Vernal pool and live oaks, Mother Lode Country, California

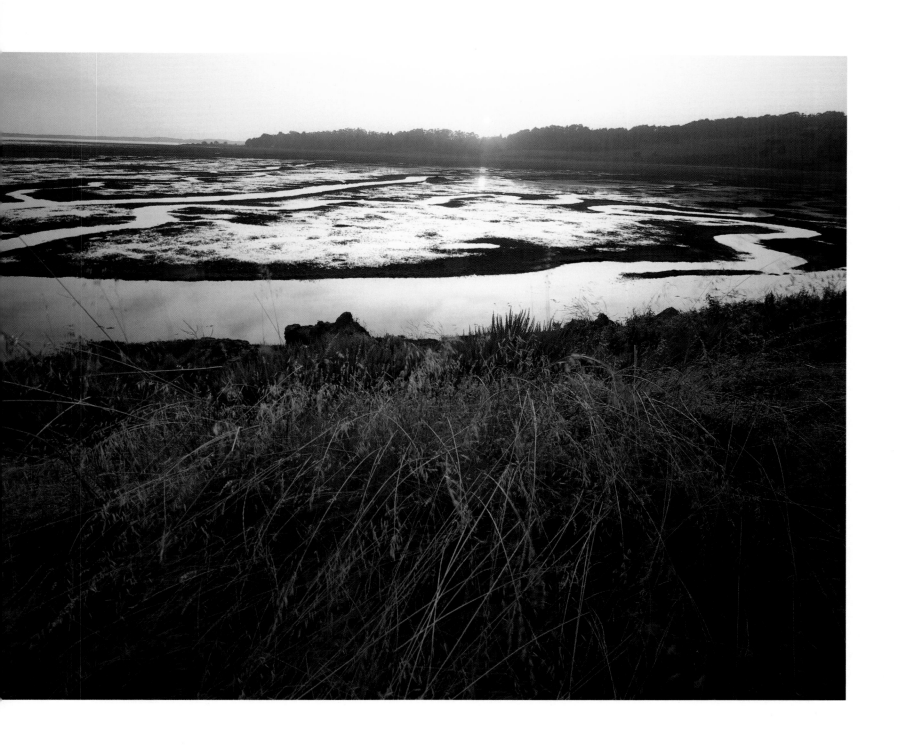

Los Osos tidal marsh, Morro Bay State Park, California

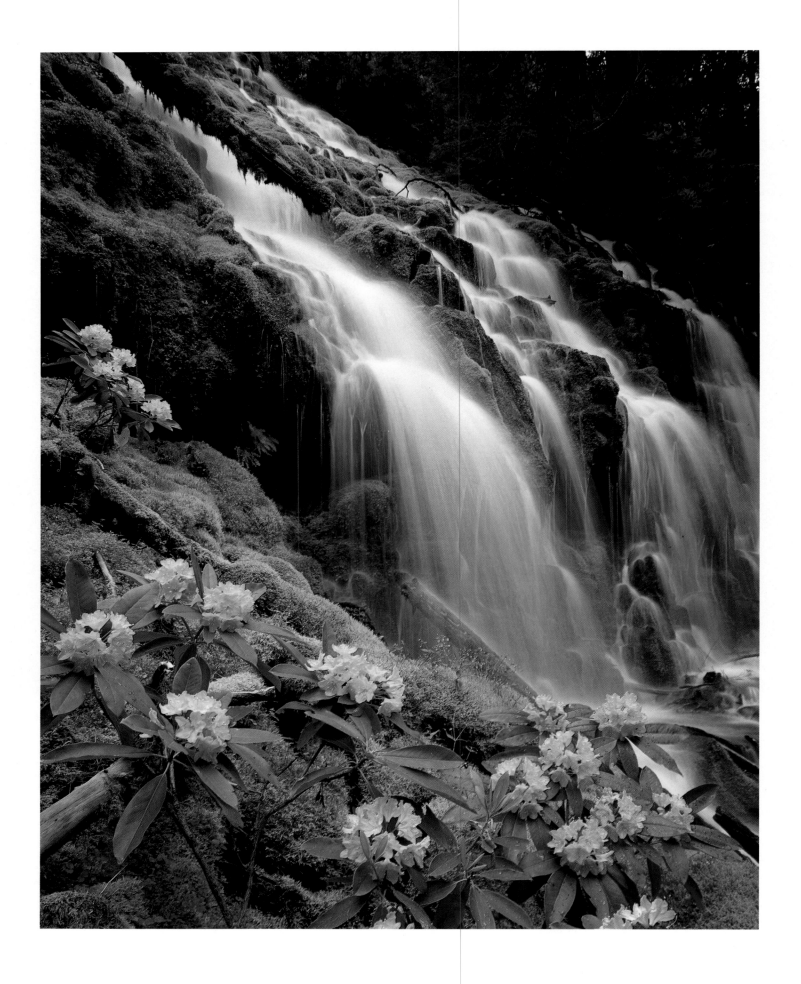

Upper Proxy Falls, Cascade Range, Oregon

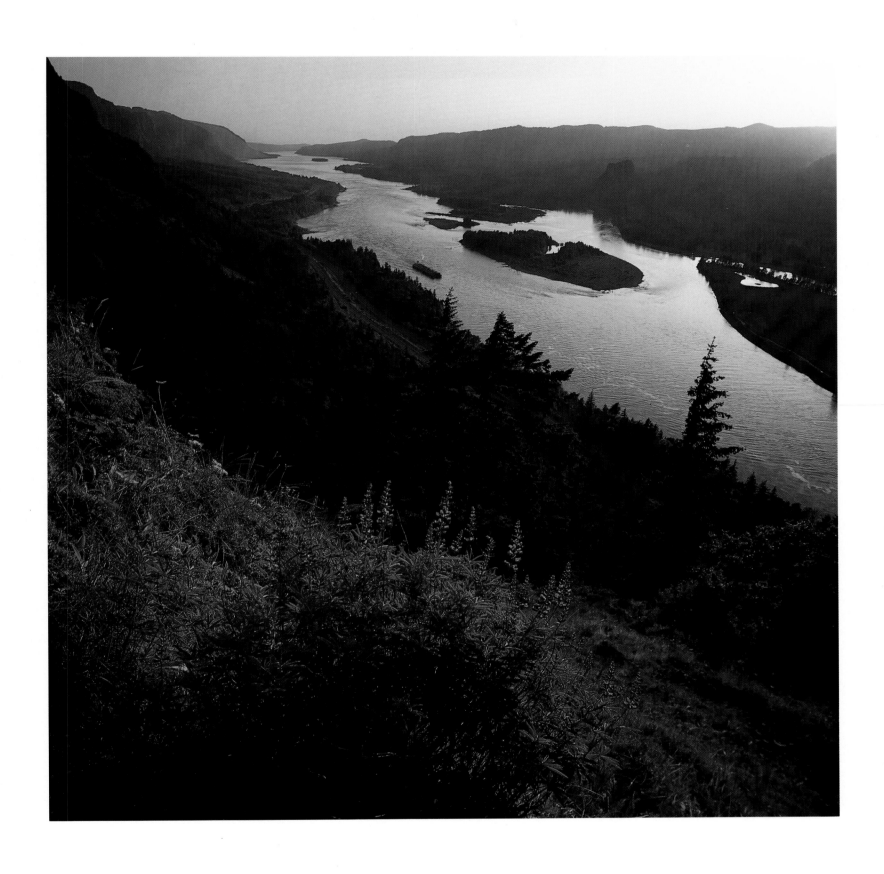

Columbia River Gorge, Oregon/Washington

The Excursion Continues
PART TWO

IV. THE DESERTS

> At night in this waterless air the stars come down just out of reach of your fingers. In such a place lived the hermits of the early church piercing to infinity with unlittered minds. The great concepts of oneness and of majestic order seem always to be born in the desert And there are true secrets in the desert. In the war of sun and dryness against living things, life has its secrets of survival.
>
> —John Steinbeck, *Travels with Charley,* 1962

From the beginning the desert has had a bad press. After all, when Major Long was looking for just the right phrase to describe the land that lay west of the hundredth meridian, he did not hit upon "barren wasteland" or "The Great American Desolation." He chose "The Great American Desert" in full confidence that his meaning would not be mistaken: he meant a place not only forbidding to look upon but hostile to life itself—the kind of wilderness in which even Christ could be tempted by Satan.

This is a pity, and I tend to take it personally. As noted earlier, I grew up in and about deserts and I still retain a desert heart. Desert has a kind of staying power in a person; I remember it, and it remembers me, and every return journey—to any desert—is a kind of homecoming. There is a lot to choose from, when I choose to go home again. This nation is blessed with four desert systems—five, if one counts the Colorado Plateau, which qualifies as at least semi-desert through most of its parts. Each, in greater or lesser degree, is different from the other, but all share the common attributes of desert: aridity, the relative scarcity of human populations, and with that a wilderness beauty that for diversity, complexity, space, form, and impact cannot be found anywhere else in the world. I am, pretty clearly, a desertophile, but I have the evidence to back up my passion.

Consider the deserts—the *great* American deserts:

First, the Chihuahuan. While three-quarters of this system lies between the Sierra Madre Oriental and Sierra Madre Occidental of Mexico, the remaining quarter covers enough territory in the United States to qualify as one of the country's major deserts: most of west Texas above the big bend of the Rio Grande and west of the Pecos, up into New Mexico in a kind of U-form around the southern tip of the Sangre de Cristo Mountains (themselves the southernmost expression of the American Rockies), then west as far as the southeastern tip of Arizona. In all, about forty-four thousand square miles, within which lie as various a collection of landscapes as you are likely to find anywhere. Begin with Big Bend National Park, into which the northern extension of the Sierra Madre Oriental pushes a jumble of peaks, some of them five, six, and seven thousand feet in height, and through which the Rio Grande has sculpted some of the deepest and most intricate canyons east of the Grand Canyon. Two hundred miles north-by-northwest, millions of years of moving water have eroded out of ancient limestone reefs the astonishing collection of caves embraced by Carlsbad Caverns National Monument. A hundred miles west of Carlsbad is White Sands National Monument, 228 square miles of gypsum sand dunes so brilliantly white that the reflected sun can be painful to the eyes, an ocean of sand on which the wind writes a different signature every day. Twenty-five miles north of White Sands are a hundred miles of ragged, hot, utterly bleak lava beds which the Spanish, who put their names on the land with precision, called *Jornada del Muerto,* "Journey of Death." A little over a hundred miles west of this moonscape blasted with heat is the Lower Box, a steep-walled redrock canyon

complex carved between the hamlets of Red Rock and Virden near the Arizona border by the Gila River, along whose banks at the canyon bottom is a verdant celebration of sycamores and willows and wildflowers, lush, supportive habitat for a wide variety of life, including as many as 265 individual species of birds.

The vegetation scattered over the Chihuahuan's gullies and outcrops, mountains, canyons, and intersecting fan-like alluvial plains, called *bajadas*, covers the spectrum from the inconspicuous to the absurd. Creeping across the desert gravel can be found the tiny filaree storksbill, whose half-inch blossom is a wink of pale lavender after a wet spring, or the even smaller creeper, the rattlesnake weed, whose almost invisible white flowers—less than an eighth of an inch across—can be discerned (with a great deal of attention) blooming from April to November. By contrast, the desert rosemallows, Mexican gold poppies, and the desert marigolds, each a celebration of bright yellow blossoms, are inescapable. Among the more outlandish items is the lechuguilla, an agave plant whose whip-like stalk rises in thin solitude as high as ten feet out of a cluster of pointed leaves a foot to two feet in length—slightly curving, graceful leaves that are as stiff as spikes and quite as dangerous, capable of piercing rubber tires and human hide with equal facility. The agave is redeemed, however, by the fact that it also is one of the most plainly useful plants found anywhere. Its fibers, stripped from the leaves, can be (and have been) used to make anything from sandals to fishnets, while various species can be (and most certainly have been) used to produce three of the most profound recreational fluids known to mankind—pulque, mescal, and tequila. Considerably less useful (or dangerous), but even more common to enormous portions of the Chihuahuan Desert is the soaptree yucca, which can grow to a height of twenty feet and looks for all the world like an unsuccessful palm tree on the top of whose huge asterisk of clustered fronds a flowered stalk juts up as if it were an afterthought.

The Chihuahuan is high desert, relatively speaking. Within the boundaries of the United States, its elevations range from a low of about one thousand feet along the Rio Grande to an average of 3,500 to 4,200 feet elsewhere. If its summers are quite as hot as one would expect of a desert, its winters are a good deal cooler. Not so with its desert neighbor to the west, into which the Chihuahuan noses briefly before becoming something else. That neighbor is the Sonoran Desert, one hundred and six thousand

square miles that cover most of Baja California, all of the northwestern plain of Mexico (bracketing the Gulf of California in the process), almost all of southern Arizona, and a portion of southeastern California. About a third of this expanse lies within the boundaries of the United States—and is itself divided by desert ecologists into two sections: the Lower Colorado River Valley and the Arizona Upland area.

Its two divisions are both subtropical desert, at once warmer, lower, and generally more moist (as deserts go) than the Chihuahuan. The Sonoran gets ten inches or so of rainfall every year in the winter and the summer months, hence its plant life is more diverse—not only in the number of species present but in the size of them. The Arizona Uplands, for example, is cactus country: the tiny fishhook cactus hiding under creosote bush and other shrubs; the stubby barrel cacti; the bush-like chollas—buckthorn, jumping, cane, pencil; senita cactus, prickly pear, and Desert Christmas, with their enchanting flowers amid the thorns; the fluted, graceful organ pipe; and the giant of them all, the saguaro, which can live for a hundred years or more and grow to twenty-five or thirty feet in height, its branches raised in supplication in so many calendars, postcards, coffee-table books, cowboy movies, and travel posters that it has long since come to symbolize all American deserts for those who have known none of them.

The Sonoran possesses a number of other distinguishing characteristics. Cabeza Prieta National Wildlife Refuge, for instance, eight hundred sixty thousand acres tucked into the southwestern corner of Arizona just above the Mexican border. Part of this Biblical stretch of desert wilderness was called the El Dorado Trail, a route over which thousands of goldseekers trudged on their way to California during the Gold Rush of 1849; the Spanish missionaries of the seventeenth century, working with colorful exactitude, called it *El Camino del Diablo*, "The Devil's Highway"—and the hundreds of American goldseekers who died here amid the scattered creosote bushes and bursage bore testimony to the accuracy of that description. Not many travel through here any more, which those who venerate this as essential desert consider just as well. Those who do come must obtain strict permits and sign waivers in order to enter the refuge from the U.S. Fish and Wildlife Service office in Ajo. For tramping about is not as easily done here as it is in, say, Parker River National Wildlife Refuge, Massachusetts. Cabeza Prieta lies within Luke Air Force Range and is subject to

gunnery and bombing runs from time to time, which can make things interesting not only for those humans in the wrong place at the wrong time, but for the resident desert bighorn sheep and the rare and endangered Sonoran pronghorn which use the refuge as part of their own range.

Over in the Sonoran's Lower Colorado River division lies the Salton Sea, in part the remnant of an enormous ancient body of water called Lake Cahuilla, formed when sediment carried south by the Colorado River piled up like a dam across the northernmost tongue of the Gulf of California. Over the millenia, the great lake slowly shrank until by the turn of this century it was little more than a fetid, salty pond lying isolated in the middle of a huge sink two hundred feet below sea level. At this point, the Colorado River flooded, the waters spilling into the sink to create the 350-square-mile Salton Sea of today. Winters here are mild enough to support a huge population of resident and migratory waterfowl: Canada geese, snow geese, pintail ducks and green-winged teal, coots, snowy egrets, avocets, gulls, and many other species. In the spring large flocks of stunning white pelicans can be seen wheeling in off the desert. Altogether, it is not the sort of thing one expects to see in a landscape that seems more appropriate to horned toads.

Above the Sonoran Desert, north by northeast through Arizona, southeastern Utah, southwestern Colorado, and northwestern New Mexico—one hundred thirty thousand square miles in all—is the Colorado Plateau. Since roughly two-thirds of this region receives more than ten inches of precipitation (mostly snow) a year, and since it contains many individual plateaus that rise above five thousand feet and mountains that exceed eleven thousand, the experts tell us that most of the Colorado Plateau cannot be called true desert. All right—but it will do until the real thing comes along. It was enough to strike poetry into the heart of Edward Abbey in *Desert Solitaire*:

> Light. Space. Light and space without time, I think, for this is a country with only the slightest traces of human history. In the doctrine of the geologists with their schema of ages, eons, and epochs all is flux . . . but from the mortally human point of view the landscape of the Colorado is like a section of eternity—timeless. . . .

Abbey's mention of the Colorado River was not casual; this country has largely been shaped by the Colorado and its principal tributaries—the Green, the Gunnison, the Dolores, the Dirty Devil, the Escalante, the San Juan, the Paria, the Virgin, the Little Colorado. More accurately, it should be said that the country *is* being shaped by the rivers, since the geological changes of all those "ages, eons, and epochs" are continuing in full force. These processes apparently began about 550 million years ago, when the first of many great inland seas laid down the first of many sedimentary deposits upon the bedrock of the earth's origin—limestone upon sandstone upon shale upon sandstone upon shale upon limestone, the layers accumulating over hundreds of millions of years, packed down solid by their own weight and the weight of the layers above them, mounting thousands of feet, eon by eon. Eighty million years ago, when the Laramide Revolution jammed the Farallon Plate under the southwestern part of the North American continent, the pressure from beneath caused all the sediments of the Colorado Plateau to rise, with relatively little fracturing or buckling. Anywhere from seven to twelve million years ago, a sudden increase in precipitation gave birth to a trickle of water that began a long journey from southwestern Wyoming toward the Gulf of California across the top of the plateau, which was still rising. The trickle became a stream and then a river carrying a powerful load of silt, which inexorably ground into the rising layers, the combined actions slowly revealing sheer, brilliantly colored walls of rock in canyons that grew deeper and more intricate with the passing epochs, as river after river joined its work to that of the Colorado.

The result has been country of surreal magnificence, unmatched anywhere else on earth, a landscape that has astounded, entranced, confused, and intrigued travelers ever since that day in 1540 when members of Coronado's New World Expedition first leaned gingerly over a cliff edge and looked deep into a canyon to spy a river they calculated could not be more than six feet across. The Indians they had encountered said it was more like "half a league," according to the expedition's chronicler, Pedro de Castañeda, and some of the men tried climbing down the canyon walls to find out:

> They returned about four o'clock in the afternoon, not having succeeded in reaching the bottom on account of the great difficulties which they found. . . . They said they had been down about a third of the way and that the river seemed very large from the place which they reached . . . and they thought the Indians had given the width correctly. Those

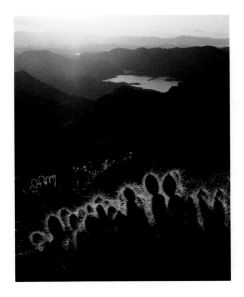

who stayed above had estimated that some large rocks on the sides of the cliffs seemed to be about as tall as a man, but those who went down swore that when they reached these rocks they were bigger than the great tower of Seville.

The canyon, of course, was the Grand Canyon, that awesome gash in the planet's hide, and it was five thousand feet deep at the point where they discovered it; the river was the Colorado, and if not "half a league" (one-and-a-half nautical miles) wide, it probably was at least three hundred feet from bank to bank. Like so much else those Spaniards were seeing for the first time, the Grand Canyon was difficult to assimilate; it still is for most who view it for the first time—it remains a blow to human perception, not quite believable. And it is only part—the biggest and most dramatic part, to be sure, but only part—of what the Colorado and its sister rivers have created. We are fortunate that the federal government has set aside some of the most important landscapes in the Colorado Plateau Province as a "Golden Circle" of parks and monuments: Grand Canyon National Park and Monument, Zion National Park, Bryce Canyon National Park, Rainbow Bridge National Monument, Natural Bridges National Monument, Capitol Reef National Park, Canyonlands National Park, Mesa Verde National Park, Arches National Park, Colorado National Monument, and Dinosaur National Monument.

From the armies of needlelike spires massed in Bryce Canyon to the enormous filagrees of curving stone in Arches, from the labyrinthian twists of the Green and the Yampa and the Dirty Devil (through canyons whose walls are as slick as finished cement and as splashed with color as a desert sunset) to the multicolored, stone monoliths of Zion, this is a world of rock and of what time, wind, rain, and rivers have done to it. It is quite impossible to stand in the middle of this explosion of geology and not wonder what relevance, if any, the human presence can possibly have in a world still being shaped by cosmic tools to a cosmic design.

If, in spite of its spectacular landscape, the Colorado Plateau is an uncertain candidate for classification as true desert, no one is likely to argue about the legitimacy of the Great Basin Desert. This is indisputable desert, primeval, powerful—and big: at one hundred fifty-eight thousand square miles, it is the largest desert system in the United States. It covers almost all of western Utah, large portions of southwestern Idaho and southeast Oregon, parts of northeastern and east-central California, and a full three-fourths of

Nevada. It is the largest single part of what geologists call the Basin and Range Province, that country between the Rocky Mountains on the east and the four hundred thirty-mile wall of the Sierra Nevada on the west, across which an evenly-spaced series of mountain ranges march like waves with the troughs of high valleys between them: the Wah-Wah Mountains, the Confusion Range, the Deep Creek Range, the Grouse Creek Mountains, the Goshute Mountains, the Schell Creek Range, the Egan Range, the Ruby Mountains, the Pancake Range, the Toiyabe Range, a dozen more.

Though it is part of a large complex, two points give the Great Basin Desert considerable distinction. The first is the fact that it is self-contained: the rivers, streams, and creeks that enter it from the mountains around it or originate from the mountains within it do not leave it—no water in the Great Basin ever makes it to the sea. Secondly, this desert is a land-o'-lakes—or was in the geological past. When the last glaciers melted, they created two huge inland seas that covered most of northern Nevada and northern Utah. The biggest of these was Lake Bonneville, at its largest almost as wide as Lake Michigan and more than a thousand feet deep. When it finally evaporated—or nearly so—perhaps ten thousand years ago, this great body of water left behind a number of remnants, all of them in Utah: Great Salt Lake, Little Salt Lake, Utah Lake, and Sevier Lake. Like the parent sea, most of these lakes are heavily-laden with concentrated salts and minerals; only Utah Lake remains comparatively fresh, since it has an outlet that drains into Great Salt Lake, while the rest trap and hold all their water. The sea also left behind an enormous *playa*, a flat, white bed of deposited salts that is probably one of the most sterile places on earth. This is the Great Salt Lake Desert, sixty miles across and a hundred miles long, lying like a cruel white burn on the land between Great Salt Lake and the Nevada border. The primary life-form of this stretch can be seen periodically in the southern portion called the Bonneville Salt Flats—human spectators of and participants in the technological goings-on at the International Speedway.

The second ancestral sea of the Great Basin was Lake Lahontan, which covered most of Nevada. It left its own remnant lakes, chiefly Honey Lake in northeastern California and Pyramid Lake and Walker Lake in Nevada, as well as equivalents of the Great Salt Lake Desert: the Black Rock Desert, ten miles wide and a hundred long spreading south from between the Jackson Mountains and the Black Rock Range of northwestern Nevada, and the forty-mile-

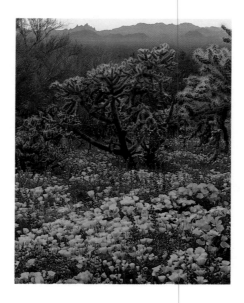

long Smoke Creek Desert fifteen miles north of Lake Pyramid. Even more effective reminders of the huge lake's presence in Nevada are the remarkable number of sinks and dry lake beds throughout the state, from Winnemucca Lake and the Carson Sink in the north to tiny Groom Lake and Yucca Lake in the south. There are twenty-four such dry lakes and sinks big enough to appear on most good-sized maps of the region, and hundreds more too small to qualify for cartographic immortality. Like the eleven varieties of sage-brush—big sagebrush, sand sagebrush, and black sagebrush chief among them—the sinks and dry lakes of the Great Basin are a kind of indicator species, demonstrating with a certain precision the kind and quality of this desert land.

Much the same can be said for the Mojave Desert, the last major desert system in the United States. It, too, has sinks and dry lakes scattered throughout its fifty-four thousand square miles, territory encompassing the southern tip of Nevada, the southwestern corner of Utah, the northern half of the California-Arizona border, and an immense portion of Southern California squeezed between the Tehachapi and Inyo mountains on the north and west, the San Bernardino and other Transverse ranges on the south, and the Colorado River on the east. In fact, because it sits smack between the Great Basin Desert to the north and the Sonoran Desert to the south, there are those who say that the Mojave has no individual character at all, but is a blend of both, a transition zone, a kind of geographic mongrel. I suppose a case could be made for this point, but not by me.

For this is my home desert, and to me it is forever unique. Born and reared up to something approaching manhood in San Bernar-dino, itself implanted on a semi-arid *bajada* spilling out of the San Bernardino Range, it would have been odd if I had not grown up knowing and loving this desert. It was less than an hour away through Cajon Pass, though it also could be reached by heading directly over the mountains through Lake Arrowhead or Big Bear Lake, or farther east by driving up through the Morongo Valley toward Twentynine Palms. My family, desert rats to the last man, woman, and child (and there were a lot of us), did it all the ways there were over a period of twenty years, and I became acquainted with parts of this desert generally unknown to the swarms of pilgrims who go streaking up today's Interstate 15 on their way to the stage shows and slot machines of Las Vegas. One was the Devil's Playground. In those days you safely reached it only by

letting the air out of your tires to soften them and keep them from sinking into the sand of what was loosely described as a "road" coming in off California State Highway 127.

The Playground—stygian irony is typical of names in the Mojave—lay just north of the Providence Mountains and the Eagle Mountains, and was itself not all that interesting, being a series of rolling, sandy hills covered sparsely by creosote bush and scattered thickets of mesquite. But just to the south lay the Kelso Dunes, one hundred sixty thousand acres of sand where individual dunes could reach five hundred feet or more and down whose slopes a small boy could roll, slide, and tumble with breathless abandon. Twenty miles west was the Mojave Sink, where the trickle called the Mojave River ended its uncertain northern journey down from Lake Arrowhead. In wet years, after a rainy spring and for a few weeks in the very early summer, the river was reborn here briefly beneath the shadow of three thousand two hundred-foot Cave Mountain. Vegetation sprouted along its sandy banks, shady spots appeared, the water chuckled among the stones of the wash, pools eddied, and the bright punctuation of dragonflies filled the air, while out on the desert proper a sea of sudden flowers sprang into being in purples and whites and blues and yellows—Apache plumes, great desert poppies, Southwestern thorn apple, white horse nettles, bladder sage, Mojave Desert star, and spreading fleabane, to name just a handful of the blossoms that gave sudden pattern to the desert floor. To crawl out of a sleeping bag still damp with dew next to that small, chattering river on such a summer morning was to experience the sheer newness of life with an intensity I have never known since.

The Mojave is replete with such exaggerated instances of life's dogged vitality. Take the Joshua tree. You will find it nowhere else in the world, and it is not what one has come to expect from a tree (it is, in fact, a variety of yucca). In 1844, explorer John Charles Fremont, who may have been the first non-Indian to see one, called it "the most repulsive tree in the vegetable kingdom." Perhaps yes, perhaps no; pioneering Mormons, sent out of Salt Lake City in the 1850s to establish a settlement somewhat nearer the ocean (they chose the site of San Bernardino, as it happened), found it somehow reassuring—its jutting, elbowed branches, tufted with spiky leaves at the end like open hands, reminded them of the patriarch Joshua leading his people into Canaan, and so they gave the tree this name. Its uniqueness was given more official

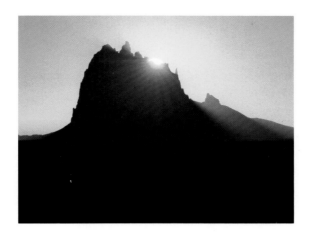

recognition in 1936, when President Franklin Roosevelt signed an executive order creating the five hundred sixty thousand-acre Joshua Tree National Monument, whose strange forest spreads out amid the creosote bush south of Twentynine Palms.

One hundred and fifty miles north, the Mojave offers perhaps the supreme testing ground for life's vigor: the two million acres of Death Valley National Monument. The valley from which the monument takes its name, six miles across at its widest point and seventy-five long, stretches between the Panamint Range on the west and the Amargosa Range on the east (two of the ranges typical of the Basin and Range Province), and provides a setting that might inspire Dante to touch up his version of the Inferno. All of it is below sea level, no point more so than a tiny sink called Badwater, which is 279.6 feet below, making it the lowest dryland spot in the United States. By contrast, Telescope Peak over in the Panamints tops out at more than eleven thousand feet.

More to the point, it is hot: during July, the average temperature is 116 degrees, and until a temperature of 136 degrees was recorded in the Libyan Desert, the 134 degrees once reached at Furnace Creek was the highest on record. It is dry: the average annual rainfall is 1.7 inches, and for two years out of every fifty, there is no rain at all. And it is saline, very saline: little Lake Manley, which exists only in the uncharacteristic wet years, is the remnant of another ancient lake that once covered the valley floor and washed up against the Panamints and the Amargosa Range; when that lake dried up, it left a mix of gravels and concentrated salts that went down for a thousand feet—one section, called the Devil's Golf Course, cracked into blocks and was then eroded by wind and water into a crumbling, dirty mix of yellow-white landscape that resembles what one might expect to see peering through a microscope at a litter of table salt and dry mustard.

The place, in short, is well-named. Yet even here on the valley floor, life not only abides but in a limited way flourishes. Even the purest salt flats support marginal communities of algae and fungi; on the perimeters pickleweed and saltgrass appear, and on the less saline soils the usual run of creosote bush, mesquite, shadscale, and arrowweed can be found. When it does rain, flowers, including primroses and poppies, can spring up here as in other parts of the desert—and the valley floor boasts a few plants unique to itself, such as the bear-poppy, a shrub whose blue-toned foliage is strung with long white fibers, or the wetleaf spiderling, whose leaves,

indeed, are always wet. In *Face of North America* (1963) Peter Farb noted that 160 species of birds had been recorded in the 550 square miles of the monument that lay below sea level—including herons, sandpipers, and snipe—and in the more recent (1983) *Sierra Club Guide to the Natural Areas of California*, John and Jane Perry report that 258 species have been checked off in the monument as a whole.

In the most demanding landscapes of all four American deserts, we do not find life locked out or conquered—merely challenged. And within the boundaries of that challenge we also can find, if we will take the time to look for them, all the shapes of life's beauty, tempered and illuminated.

V. THE RIVERS, WETLANDS, AND SHORES

What would the world be, once bereft
Of wet and of wildness? Let them be left,
O let them be left, wildness and wet;
Long live the weeds and the wilderness yet.

—Gerard Manley Hopkins, *Inversnaid*

In the Carlos Fuentes novel, *The Old Gringo*, an old man (journalist Ambrose Bierce) and a young American woman who are caught in the middle of a revolution are traveling across the Chihuahuan Desert in northern Mexico with a contingent of Pancho Villa's guerrilla army in 1913. In a profound and barren country that is alien to both of them, the thoughts of the old man and the woman turn to gentler landscapes:

Both Harriet and the old man were thinking of other, more opulent lands, of fertile, long, lazy rivers, of the splendor of waving wheat fields on land stretching flat as a tablecloth toward smoky blue mountains and gently rolling mountainsides covered with forests. The rivers: they thought especially of the rivers . . . a litany that rolled from their tongues like a current of lost pleasures in that dry and thirsty Mexican evening. Hudson, the old man said; Ohio, Mississippi, she answered from the distance; Missouri, Potomac, Delaware, the old man concluded: the good, green waters.

As this poignant moment from the novel illustrates, there is an odd sort of negative relationship between water and desert—it is the lack of water, after all, that is one of the definitions of a true

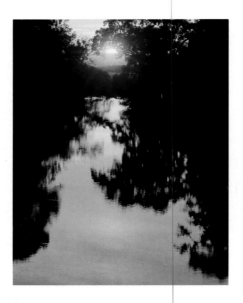

desert and probably the single most telling reason why we are apt to think of desert as anti-life. For we know in the deepest marrow of memory that all life—ourselves included—had its origins in the meeting of earth and water, and that it is in this meeting still that the potential becomes the real. It is our story that Loren Eiseley, the philosopher-scientist, tells in a powerful sequence of *The Immense Journey*, the imagined history of the fish that learned to walk at some moment in the dark time of life's beginnings on the planet. This exquisitely primitive creature, Eiseley says, probably lay still for a while at the edge of the pool of ooze from which it had crawled, blind but driven by the need to move; then it slowly began to scrape itself across the muck with its tenacious fins, jerking and squirming its way to another pool, then another and another, wriggling down the labyrinthian maze of geological history and biological evolution, crawling, finally, to become us.

Out of water, life. And so the old man and the woman stand in the desert, surrounded by implications of death, and think of good, green waters.

So do I now, remembering the waters I have known. As a desert brat, I could hardly have avoided being seduced by the magic of water. Not that there was all that much of it around the immediate neighborhood—except in years like 1938, when so much rain came all at once that it flooded out square miles of town and country, leaving our family stranded in a foot-deep sea of water until my grandfather came to rescue us in his high-wheeled old LaSalle. For the rest of the time there were only the odiferous little mineral sumps that leaked out of Tower Hill half a mile from my house, scummy ponds from which prodigious harvests of pollywogs could be made. Or the Santa Ana River—the description too ambitious for the reality—two miles from the house, a stream that was never more than fifteen feet across and a foot deep at this point on its sluggish, hundred-mile journey from the mountains to the sea, and in especially dry periods sometimes disappeared entirely. On rare family excursions, we sometimes drove clear across the desert to the Colorado, but even then that poor river was so completely dammed up that its lower stem was more like a series of thin lakes than a river—certainly not the roaring lion of a river that had carved out the magnificence of the Grand Canyon. It was many years before I had my first sight of a real river.

I had it standing on the banks of the Mississippi at a point just south of Cairo, Illinois, where the mighty Ohio spills its own flow into the Great River. Here was the essential Mississippi, "shining its mile-wide tide along" in the loving words of Mark Twain, carrying the silt and sludge and pollution from 1,234,700 square miles of interior America, fanning it out into the maw of the Gulf of Mexico. It was an immense and powerful thing to see for the first time, all this moving water, rippled with the muscles of an internal and immeasurable strength. Here was not merely the contradiction of desert, but its very antithesis, as wide an expanse of flowing, living water as any stretch of wind-sculpted sand dunes creeping up to the shoulders of Chihuahuan mountains. I have never since found reason to question the romance with which we have embellished the rivers of our history.

Those rivers have been numerous and important. The Mississippi: flowing 2,348 miles from Lake Itasca in northern Minnesota to the tentacled delta jutting into the Gulf below New Orleans, the most American of all the American rivers, its history mixed with that of four nations. It was discovered in 1541 by Spain's Hernan de Soto, who dreamed of a conquest of gold, but died on the river's banks in 1542 at about the same time that the men of Coronado's expedition were looking down on the Colorado from the rim of the Grand Canyon. The Frenchmen Louis Joliet and Pere Jacques Marquette ventured off on their epochal canoe trip down the Illinois and the Mississippi in 1673, letting the current take them farther downriver than anyone before them, clear past the mouth of the "Big Muddy," the Missouri, spewing its own load of mud and debris carried out of the West. Their countryman, Robert Cavelier, Sieur de La Salle, then took possession, standing at the mouth of the Mississippi and claiming its entire valley for the King of France in 1682. But the British snatched the valley from the French in 1763 by winning Queen Anne's War, only to have that new nation, the United States, take it away in 1783 and then manage to keep it in the Battle of New Orleans in 1815. Then followed the years of the river's glory, when armadas of keelboats and flatboats carried the produce and products of middle America to market, when the whistles of a thousand steamboats reverberated from St. Paul to St. Louis, from Cairo to New Orleans, giving a chorus of support to Mark Twain's conviction that a steamboat pilot was "the only unfettered and entirely independent human being that lived in the earth," before the bloody horror of Civil War closed in on the era like a great steel door, sealing it from everything but memory.

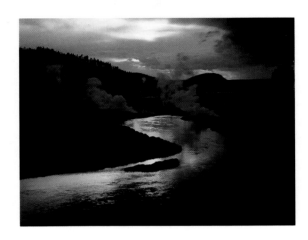

The Hudson: flowing out of Lake Tear of the Clouds in northeastern New York, discovered in 1609 by navigator Henry Hudson, who immediately concluded (as did all explorers who encountered rivers on the East Coast in that age) that the river was the legendary Northwest Passage that would lead him straight across the continent and on to the riches of Cathay; it didn't. The James: (another supposed Northwest Passage), first encountered by Captain John Smith and his bedraggled colonists in 1607 and along whose banks from Richmond to Hampton Roads there developed some of the most representative enclaves of the lush plantation life we call the Old South—a culture that ultimately destroyed itself with its kyphotic dependence upon the slavery of human beings. The Allegheny: tumbling out of the mountains of northern Pennsylvania to join the Ohio at what is now Pittsburgh; it was down the Allegheny that some of the first pioneers came into the Old Northwest after the War of the Revolution, and it was in its valley that a culture completely different from that of the James River grew up—an industrial culture of salt-making plants and finished lumber, coal mines and iron mines, rolling mills and steel plants.

The Ohio: whose flow provides part of the boundaries of Ohio, Kentucky, Indiana, and Illinois before merging with the Mississippi; whose black prairie soils supported yet another culture, this one coming very close indeed to Thomas Jefferson's dream of a republic of independent yeoman farmers, free people tilling free soil and building the edifice of Democracy. The Missouri: where the big dreaming called the westward movement can be said to have begun, the river that reached out 2,714 miles to drain the alpine slopes of the Rocky Mountains, the river that was a road for the long journey—the first true Northwest Passage—of Lewis and Clark in 1803 across the plains and mountains of a new possession called the Louisiana Territory. The Columbia: another of Lewis and Clark's "highways," rolling on to the Pacific Ocean through its magnificent gorge in what would become Oregon Territory. The Platte: "too thick to drink, too thin to plow," the first major western tributary of the Missouri, a wide, shallow river that came out of the mountains above Denver and along whose broad valley thousands of oxen-powered prairie schooners sent up billows of dust for two generations, their rolling wheels rutting the earth for nearly a thousand miles. The Rio Grande: in whose upper valley the Pueblo Indians have managed an uneasy co-existence with European cultures since the sixteenth century, their adobe villages,

their "cities made of earth," a perpetual reminder of earlier, haunted times when the desert sun glinted from the clustered helmets of conquistadores who came, saw, conquered, and did not understand. The American: a mid-sized tributary of the Sacramento in the great central valley of California, where one January morning in 1848 James Marshall saw something winking at him in the earth of a freshly-dug millrace, reached down to pluck it out, held it in his palm for a moment, then announced to his companions, "Boys, I believe I have found a gold mine!"

The rivers, unconcerned with all this human bustling, were about their work all the time, that work being the task of eroding the earth and carrying it bit by bit to the sea (except those rivers trapped in the Great Basin). And in the course of performing this work, the rivers have created landscapes of delicacy and power—the sheer, towering Palisades of the lower Hudson as it passes between New Jersey and New York; the enchanting dells of the Wisconsin River as it cuts a tortuous path through waferlike layers of sandstone; the oxbows and bayous of the lower Mississippi; the outlandish rock formations of the Missouri River Breaks in Montana; the tropical jungle-banks of the placid St. Johns in Florida; the semi-arid and sandy banks of the equally placid Niobrara in Nebraska; the Eleven Point tumbling and winding its way through the splendid maze of the Ozarks in Missouri; the Rogue plunging with headlong energy down the Klamath Mountains of the Coast Range in Oregon; all the gorges of the great western rivers—Hells Canyon on the Snake River, Black Canyon of the Gunnison, Grand Canyon of the Yellowstone, Marble Canyon on the Colorado (and of course the Grand Canyon), Labyrinth, Horseshoe, and Desolation canyons on the Green; the Rio Grande Gorge, the Columbia River Gorge, the canyons of the Owyhee, the Bruneau, the Gila, the Salmon, the Eel, the Trinity, the Feather. Placid or roaring with whitewater rapids, narrow or wide, shallow or deep, braided or straight as a canal, American rivers are a calligraphy on the land.

They have given us much, the rivers, and we have used them. They have been our highways and our sewers, our fishing grounds and our reservoirs. We have dredged them, rechanneled them, polluted them, and dammed them—some compulsive statistician has counted no less than fifty thousand big and little dams on the rivers of America (many of them so old they are no longer in use, of course). But we also have done something for the rivers, as well as to them, and done something for ourselves, as well. In 1968,

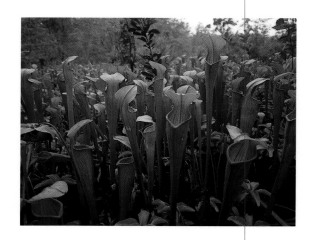

President Lyndon B. Johnson signed the National Wild and Scenic Rivers Act, legislation that recognized the rare and precious qualities of free-running rivers by providing for the protection and preservation of various stretches of various rivers of a wild or scenic character. These stretches cannot be dammed, nor can their banks be developed for commercial or residential purposes without careful planning and adherence to strict guidelines. In the case of many rivers, no development of any kind can take place. Today, more than seven thousand miles of sixty-two individual rivers are placed under the protection of the Wild and Scenic Rivers Act, with many more under consideration for eventual inclusion in the system. There is some assurance, then, that there will always be some parts of some rivers that will forever run free, continuing the prehuman task of transforming and transporting the land.

We have not done so well by the wetlands, and it is a singular pity that we have not. They have their own kind of delicacy and beauty to offer, and even a brooding power. But they are little-known and underappreciated, and thus too often plainly over-looked—or overwhelmed—by our civilization. Part of the problem is a matter of definition. Few people would have much difficulty identifying a boggy riverbottom sump or a swamp or a marsh as a wetland, but the term covers a good deal more spongy ground than that. Naturalist David Rains Wallace has addressed the ubiquity and antiquity of the wetlands idea as well as anyone:

> One could say that most of primeval North America was wetland, at some times, in some ways, even the desert, where cloudburst pools that may fill the flats once in a decade promptly produce fairy shrimp and spadefoot toads. A certain degree of wetland is normal wherever water is allowed to seek its unobstructed way and find its undepleted level. I've never been in a wilderness area where wetland wasn't a theme repeated with variations many times in a day's walk by springs, seeps, wet meadows, lake margins, floodplains, fault slips, hanging bogs, sinkholes.

Some people are fortunate enough not to have to worry about definitions. One of my best friends, a writer given to grumpy observations regarding nature and what humankind is doing to it, lives next door to a wetland. In fact, even though the five acres or so of this particular wetland are owned by the town in which he resides, you could even say it is his very own wetland, since he keeps a clear and constant eye on it and spends a good deal of time maintaining a public nature trail through it. The wetland is called Lonetown Marsh. It is situated in southern Connecticut, a region far better known for providing bedrooms for commuting worker bees from the clover fields of Manhattan than habitat for more primitive biotic communities. The marsh (though it would more accurately be described as a northeastern bog) is two or three feet deep, is surrounded on three sides by thick woods, and on the fourth is bordered by a narrow, paved road. It is not what you would call spectacular (few wetlands ever are), but it is a veritable caldron of wetland life—of pussy willows and spicebrush, swamp candles and fringed loosestrife, cowslips and golden ragwort; sweet flat, yellow flat, and horned bladderwort; turtlehead, lizard's tail, and pipewort. Mushrooms lurk beneath the shade of elderberry bushes, while yellow clusters of swamp marigold wave in the sunlight. Several species of newts and salamanders slither silently along the muddy bottoms, and leopard frogs, chorus frogs, and spring peepers turn the nights alive with ululations. A pair of great blue herons come here to nest regularly, crows infest the trees and bark at anything that moves, and on fall evenings, if you are very, very lucky, a band of Canada geese will curve down out of the sky in a dither of honking and settle for a while before resuming their annual migration south.

If I asked my friend to define a wetland, he probably would look at me as if I had lost my mind. There, he might say, right over there—*that's* a wetland.

Yes, it is. And so is a "pothole" in northern North Dakota, any one of thousands of ponds that dot the land just below the Canadian border, tiny bodies of water formed in the depressions left when the glacial ice began to melt thousands of years ago. They are hardly as lush with life as my friend's local bog in Connecticut—such northern climes do not promote lushness—but for the millions of geese, ducks, sandhill cranes, and other waterfowl that use them, these prairie potholes are utterly essential habitat—which is why the state of North Dakota is blessed with more national wildlife refuges than any state in the nation, including Florida, where Pelican Island was designated as the first wildlife refuge by President Theodore Roosevelt in 1903.

Pelican Island is not a wetland, but a good part of the rest of Florida can be said to be almost entirely wetland. The Everglades, a unique and capacious ecosystem, spreads south from Lake Okeechobee in a moist, slightly curving band one hundred miles

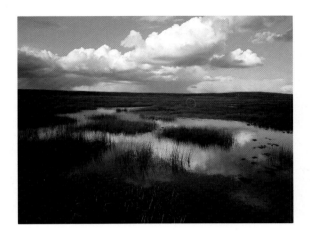

long and fifty wide, interrupted only by two of the major east-coast-to-west-coast highways, "Alligator Alley" (State Highway 84) and the Tamiami Trail (Highway 41)—together with some man-made canals, drainage ditches, holding dams, and other controlling works operated by the U.S. Army Corps of Engineers. With the exception of the highways—which can be escaped—most of this is unobtrusive. If you do not look for civilization's marks very hard, you can soon forget them entirely and be captivated, as I was when I first experienced it, by the horizon-wide expanse of this amazing place, a sea of bladderwort and duckweed, Jamaican sawgrass and hyacinth, featherfoil, louseworts, and orchids, a hundred other species of water-loving plants, and below all this rampant vegetation the moving, creeping water, a phantom lake that flows with almost inaudible gurgles and hisses and drips.

On the west lie the almost impenetrable gray forests of the Big Cypress Swamp, and the glades themselves are dotted throughout by tropical hammocks, strange, tangled islands of live oaks, gumbo-limbo trees, poisonweed, wild coffee, royal palm, strangler fig, and slash pine. Wildlife includes not only all the waterfowl common to most wetlands—egrets, herons, and the like—but a few rare species, like the snail kite, as well as marsh rabbits, round-tailed muskrats, white-tailed deer, and mink, while the more secretive Big Cypress Swamp harbors bobcats, black bear and the extremely rare Florida panther (an estimated thirty animals left), arguably the most beautiful wild creature on earth.

And then there are the alligators. Once seen, these survivors from the age of dinosaurs are not easily forgotten. The great naturalist William Bartram, traveling through Florida in the middle of the eighteenth century, reserved some of the most vivid writing in his famous *Travels* for the big reptile. Consider, he wrote,

the subtle, greedy alligator. Behold him rushing forth from the flags and reeds. His enormous body swells. His plaited tail, brandished high, floats upon the lake. The waters like a cataract descend from his opening jaws. Clouds of smoke issue from his dilated nostrils. The earth trembles with his thunder. When, immediately from the opposite coast of the lagoon, emerges from the deep his rival champion. They suddenly dart upon each other. The boiling surface of the lake marks their rapid course, and a terrific conflict commences. They now sink to the bottom folded together in horrid wreaths.

There are no alligators locked in death struggles in Bonnie Springs in southern Nevada, but these hot, bubbling seeps are a wetland nevertheless, and they provide the habitat for creatures almost as rare—though by no means so beautiful—as the Florida panther: several species of the genus *Cyprinodon*, the desert pupfish, some varieties no more than an inch in length, tiny, golden, scarce links in the complicated chain of life. There are no alligators in Oregon's Benson Pond, either, but this segment of Malheur National Wildlife Refuge is a wetland, too, and it is home to such wondrous creatures as the nocturnal black-crowned night heron, an elusive, hunch-backed bird whose raspy squawk is often the only sign of its presence, and the equally shy Virginia rail, who grunts and clicks while it skitters invisibly through the cattail marshland. Sometimes, though so rarely now that each visit is a kind of pageant, a bald eagle sweeps across the horizon.

Great Swamp in New Jersey and Tinicum Marsh in Pennsylvania, both completely surrounded by the urban sprawl of the Northeast Corridor; Fish Springs in the isolation of western Utah; Bosque del Apache, riparian wetland along the upper Rio Grande, where birds outnumber people; Rice Lake in Minnesota; Crescent Lake in Nebraska; Baskett Slough in Oregon; Red Rock Lakes in Montana; Hutton Lake in Wyoming; Panther Swamp in Mississippi; Okefenokee Swamp in Georgia; Parker River in Massachusetts . . . The wetlands are all around us—and all around us disappearing. Potholes, fens, bogs, marshes, swamps, pocosins, ponds, lakes, and riverine habitat are being used up for agriculture, industry, and urban expansion at the rate of anywhere from three hundred eighty thousand to four hundred fifty thousand acres every year. That is what the U.S. Fish & Wildlife Service's National Wetlands Inventory tells us. This is something to think upon while standing, say, in a boggy cordgrass meadow on the coast of South Carolina, watching the sun rise, its reflection beginning to glint redly from pondwater and to shine through the dewdrops hanging at the leaftips of forget-me-nots and monkey-flowers. This is a place that speaks of life, and in the air there is the taste and tang of salt, a reminder of the antiquity of the planet and of humankind's brief and vigorous history upon it, a message from the sea.

It is at the sea, in fact, that this personal celebration of the American landscape ends. The conclusion is logical enough. It is the sea, after all, that through evaporation and condensation provides the waters that make the rivers that have done so much to

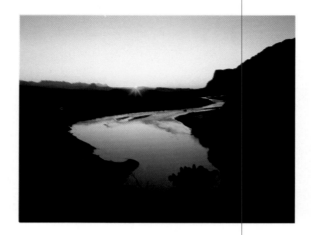

shape the interior continent, that provided the land-carving ice that once crept down from Canada, that, collected and absorbed, make the wetlands whose nutrients enrich the entire pyramid of life, from the bacterium to the biologist.

Land meets sea at the edge, but it is less an embrace than a collision. It is an old relationship, this encounter between the continental edge and the waters of the Atlantic, the Pacific, and the Gulf of Mexico. Ever since the original crustal plates first drifted together in the grinding alliance that made the continent, the sea has been doing its best to take it all back, the muttering, incessant rumble of its calm-weather waves nipping at the land with a deceptive gentility, the howling crash of its huge, storm-driven fists of water a more forthright statement of its intent. Measured in cosmic terms, it is not a contest that the land has any chance of winning, but while it continues, it provides us with a ringside seat to witness the most basic of all land-shaping processes: the implacable force of water.

And the continuing creation of some of the most compelling natural beauty to be found anywhere in the world. I suppose there are shores at the edges of other lands that are as beautiful. Given the abundance of meetings between land and water around the globe, it would be remarkable if there were not. But it would be difficult for any country to match the length and variety of America's shorelands. If you figure in all the bays, inlets, and estuaries, there are 28,673 miles of Atlantic shoreline, 17,141 miles of Gulf Coast shoreline, and 7,863 miles of Pacific shoreline—enough shoreline to be wrapped more than twice around the earth, if such a thing were possible. Along these extraordinary stretches of shore, the forces at work on these three continental edges have combined to produce variations on a theme. Begin at the northeastern tip of the country, where Maine confronts the North Atlantic. It is a ragged, wild meeting here, the land given its character by the work of glaciers as well as the sea. The ice came down out of the north on its most recent visit perhaps fifty thousand years ago, carving out river valleys between walls of more resistant rock and leaving long fingers of land jutting into the ocean—"heights o' land," as the folks of Maine call them. Offshore, remnants of former landlocked stone are now surrounded by the sea, ornamenting the coastline with thousands of islands and islets from West Quoddy Head to Casco Bay, among which the sea darts and surges with flurries of foam and much spectacular crashing.

South of Casco Bay, the meeting becomes more gentle, the lines of conflict less sharply drawn. Most of the East Coast of America rises from the continental shelf, which at this end of the continent is wide and comparatively shallow. The currents that move across the sloping shelf are gentle, allowing the creation of a complex system of sandy beaches and barrier islands—like the huge graceful hook of Cape Cod National Seashore curving into the ocean out of southeastern Massachusetts, or Fire Island off the coast of Long Island, Sandy Hook in New Jersey, and the long, snake-shaped spits of Assateague and Chincoteague islands off the coast of the Delmarva Peninsula (so named because it includes parts of Delaware, Maryland, and Virginia). At Cape Charles at the southern tip of the peninsula, ocean shoreline suddenly becomes bay shoreline with the enormous interruption of Chesapeake Bay, at four thousand square miles the largest estuary in the United States.

Below Albemarle Sound and Cape Hatteras, the coastline begins an inward curve almost four hundred miles long to Cumberland Island just above Florida—a stretch whose landscape alternates among such whitesanded shores as Myrtle Beach, tiny sounds and bays like St. Catherines Sound, and numerous broad, flat islands, including Parris Island in South Carolina, and Ossabaw, Blackbeard, and Jekyll islands in Georgia. By contrast, from its border with Georgia clear to its southern tip, the Atlantic Coast of Florida is a nearly unbroken tropical beachline, with almost no bays or major inlets and few islands—and one of the biggest of these, Miami Beach, is almost entirely man-made.

It is around that southern tip of Florida that the Gulf Coast begins, sweeping in a huge arc up the western edge of the state, curving west along its panhandle, past a piece of Alabama, the southern edge of Mississippi, and the boot-toe of Louisiana, then south along Texas to the Mexican border. The Gulf Coast has its own major estuaries—Tampa Bay, Mobile Bay, and Galveston Bay among them—its own barrier islands—Sanibel, St. George, Crooked, Dauphine, the Gulf Islands, the Chanadaleur Islands, Galveston, Matagorda, and the astonishingly slender Padre Island, more than sixty miles of sand, dune grass, and sea oats that curves like a whip from a point twelve miles south of Corpus Christi Pass all the way to Port Mansfield; all in all, a Texas-style barrier island.

But it is the coastal wetlands of Louisiana that give the Gulf Coast its most distinctive character. It is only about two hundred sixty miles as the great blue heron flies from Port Arthur, Texas, to

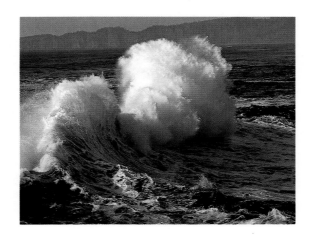

Slidell, Louisiana, but if you add up the actual shoreline, it probably would come to something closer to ten thousand miles, a bewildering complex of coontail grass and duckweed, bull tongue and wiregrass, roseau cane and wild sage; of alligators and cottonmouths, white-tailed deer, nutria, and muskrat. Forty percent of the nation's entire remaining marsh ecosystem is concentrated along this coast, as well as twenty percent of its estuarine waters. It is the winter home for millions of migratory waterfowl, including half a million blue and snow geese, and the permanent home of brown pelicans and many species of wading birds, shorebirds, gulls, and terns. And like the American wetlands in general, the coastal wetlands of Louisiana are under siege—not only by the works of man, but by the devastating power of the tropical storms and hurricanes that rip through all of the Gulf Coast shoreline lands on a seasonal and profoundly destructive basis, wrecking mobile home parks and unpeopled wetlands with fine impartiality and equal ferocity. For this and other reasons, forty square miles of the state's coastal wetlands vanish every year, and the integrity of even such federally-protected enclaves as Delta and Sabine national wildlife refuges is seriously threatened.

Life along the Pacific Coast is at once more sedate and more significantly affected by the works of man—but where the impact has been lightest—or nonexistant—the unaltered coast often is nothing short of breathtaking. The shoreline proper begins at Tijuana Slough near the Mexican border, but it is not until you are long past San Diego Bay, Long Beach, Santa Monica, Malibu, and Point Hueneme that civilization recedes and the splendor of the coast begins to assert itself. Unlike the East Coast, the West Coast is relatively young—it has not been that long since the North American Plate jammed into and over the Pacific Farallone and Juan de Fuca plates—and its continental shelf falls away into the sea far more abruptly. Consequently, its edge meets the water head-on with a more imposing pile of relatively uneroded land mass for the sea to do its work on. You begin to get a sense of that continental weight as you drive up California's legendary Highway 1 from Santa Barbara to San Francisco. The coast opens up to broad, sloping valleys here and there, but the foothills of the Coast Range are never far distant, and for most of the drive they nudge right up to the edge of the sea. Just north of San Simeon Castle—William Randolph Hearst's unintentionally comic tribute to unfettered wealth—the mountains themselves begin to rise with increasing steepness right up from the shoreline, and by the time you reach Big Sur, you are suspended between the worlds of mountain and sea, the road hugging the impetuous slopes of the Santa Lucia Mountains, a chapparal-tangled mass rising three thousand feet above you and falling a thousand feet below, almost straight down to the crescents of rock-ribbed white sand that shine like jewels against the heaving blue flanks of the sea.

Above Big Sur, the hills begin to decline in elevation and the chapparal is replaced by Monterey cypress, those artfully formed trees over which the wind has passed like a great hand shaping enormous bonsai, then by surviving stands of coast redwoods above Santa Cruz, where the highway turns inland to San Francisco Bay. The Bay itself—the only major estuary on the Pacific Coast from San Diego to Puget Sound—is a mere five hundred thousand years old, the result of fault-blocking, mountain-building, and the sudden invasion of the sea. All this geologic violence, of course, is directly related to activity along the San Andreas Fault, that earthquake-prone meeting of continental plates that runs parallel to the coast (and slices clean through most of it along the way) before going out to sea north of San Francisco and disappearing into the ocean floor in the Gulf of Alaska.

From San Francisco to well above Fort Bragg, the crumbling headlands of the coast are reminiscent of those off the coast of Maine, but north of that the mountains are alive with misty dark forests of coast redwoods and above that, past the inlets of Humboldt Bay and Coos Bay, past the wide, beckoning mouth of the Columbia River, past Willapa Bay and Grays Harbor, up around the Olympic Peninsula and into the great, island-studded sweep of Puget Sound, the redwoods are replaced by the Douglas fir, spruce, and western hemlock of some of the few remaining temperate-zone rain forests left in the world.

The ocean shoreline of the continental United States can be said to end there at Puget Sound—53,677 miles of it bracketing much of the more than three million square miles that is the American landscape north of Mexico, south of Canada, from sea to shining sea. As poet Pablo Neruda said, "It's a hell of a big country." Big, and various, and rich, and beautiful, a place to love and to be astonished by, a place it is good to be from and to go back to when you have to leave—a place whose fragile magnificence gives the words resonance and meaning when you say that this is your own, your native land.

Coastlines

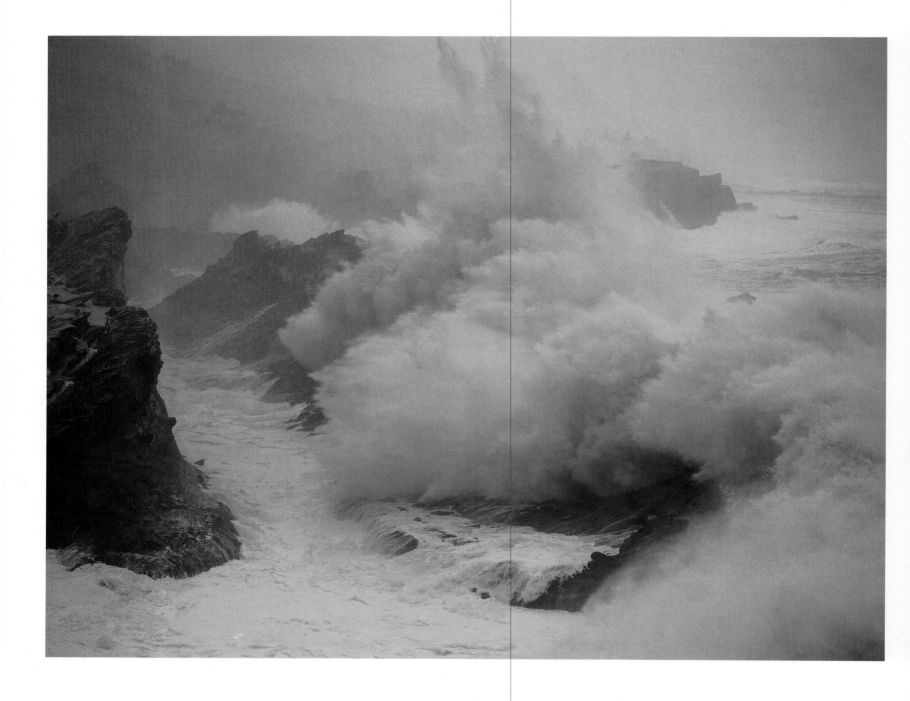

Winter surf, Cape Arago, Oregon

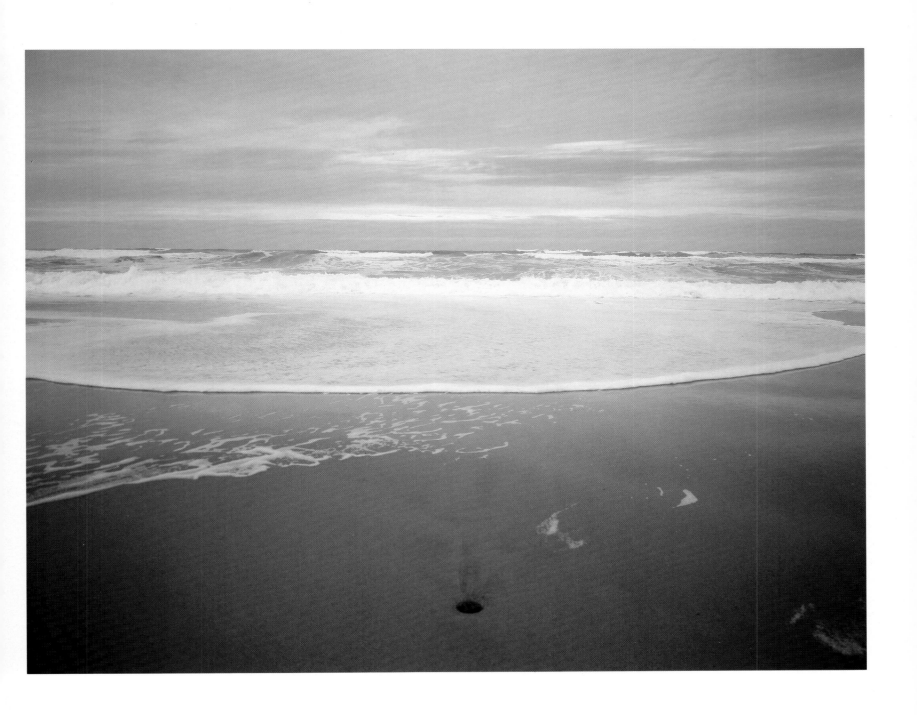

Atlantic surf on Cape Cod National Seashore, Massachusetts

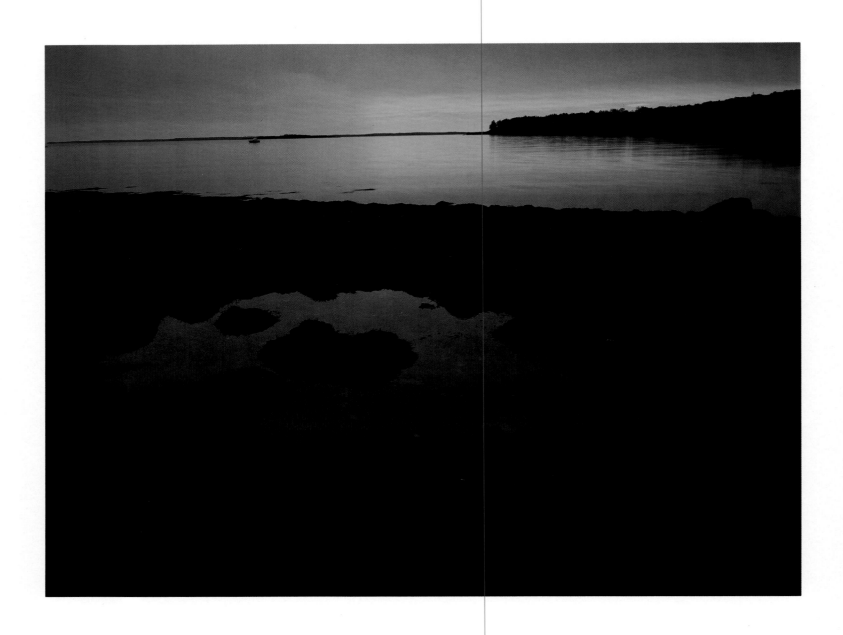

Above: Dawn glow, inlet of Penobscot, Maine

Right: Reflection, Haystack Rock and Cannon Beach, Oregon

Following Page: Pacific wave motion, Union Beach State Park, California

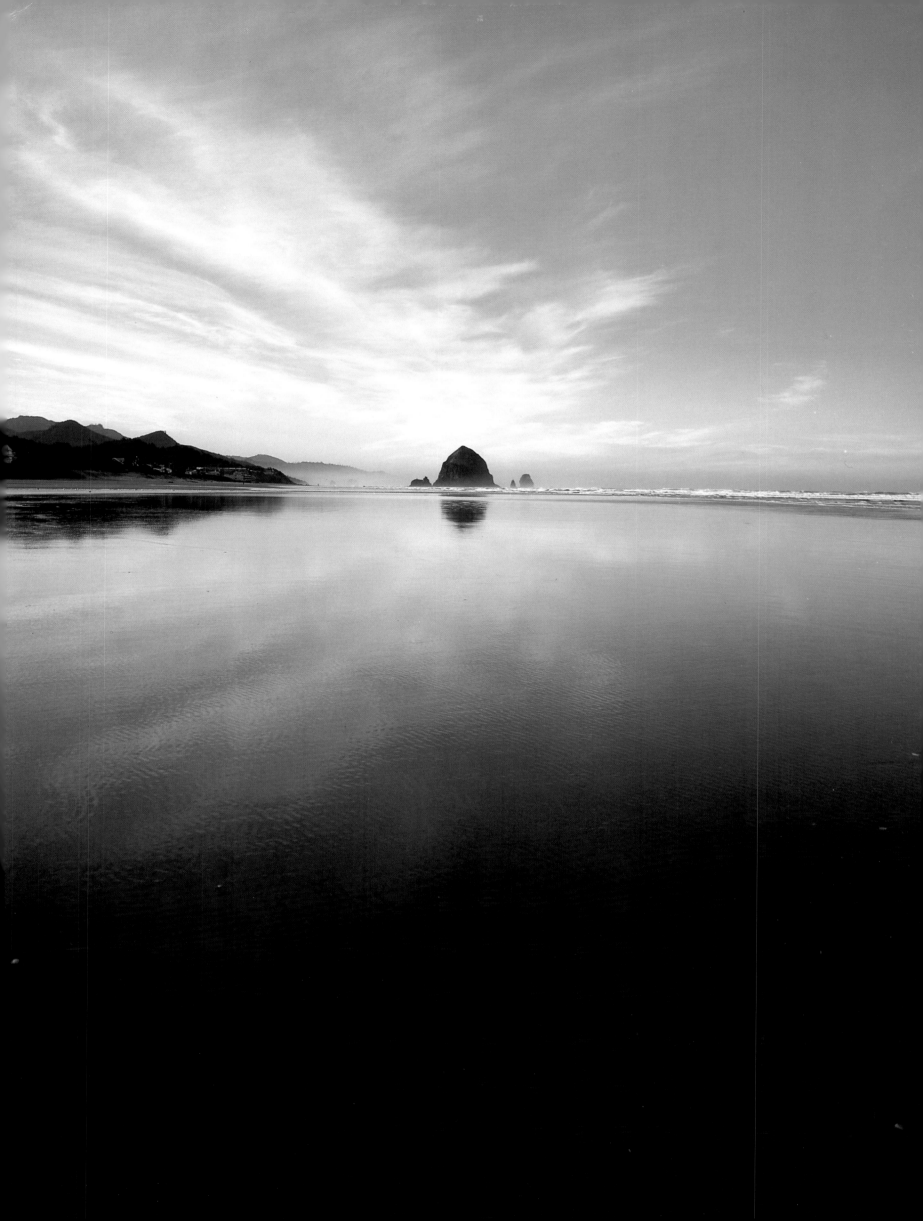

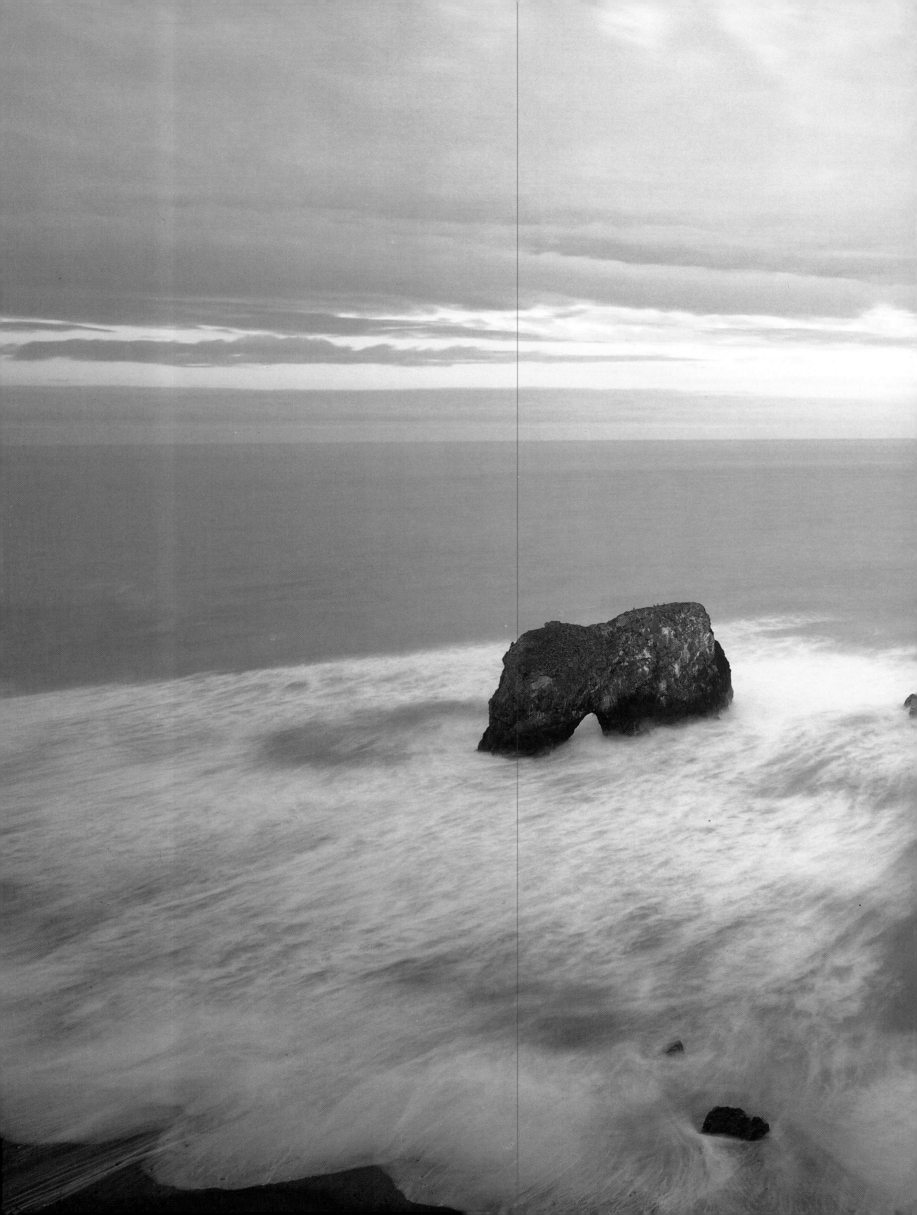

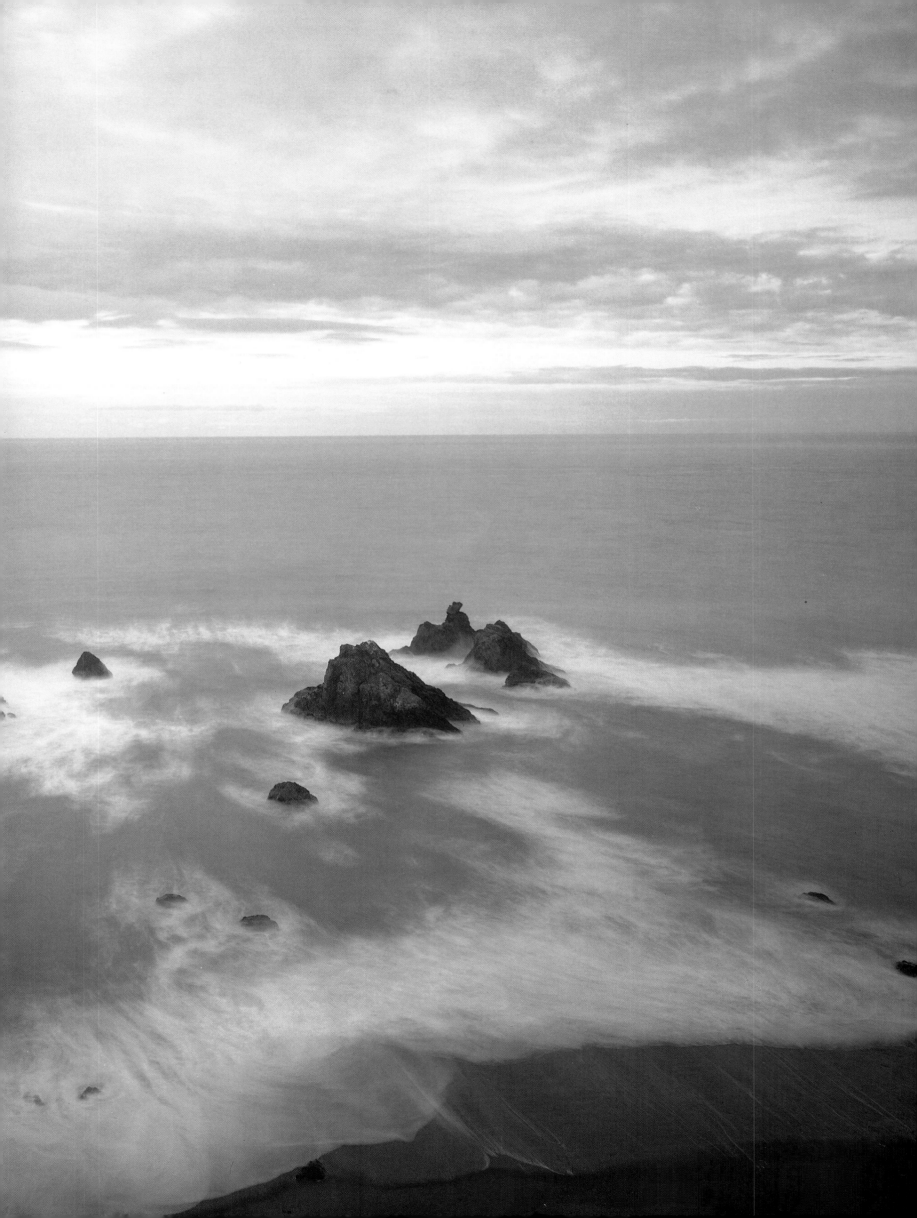

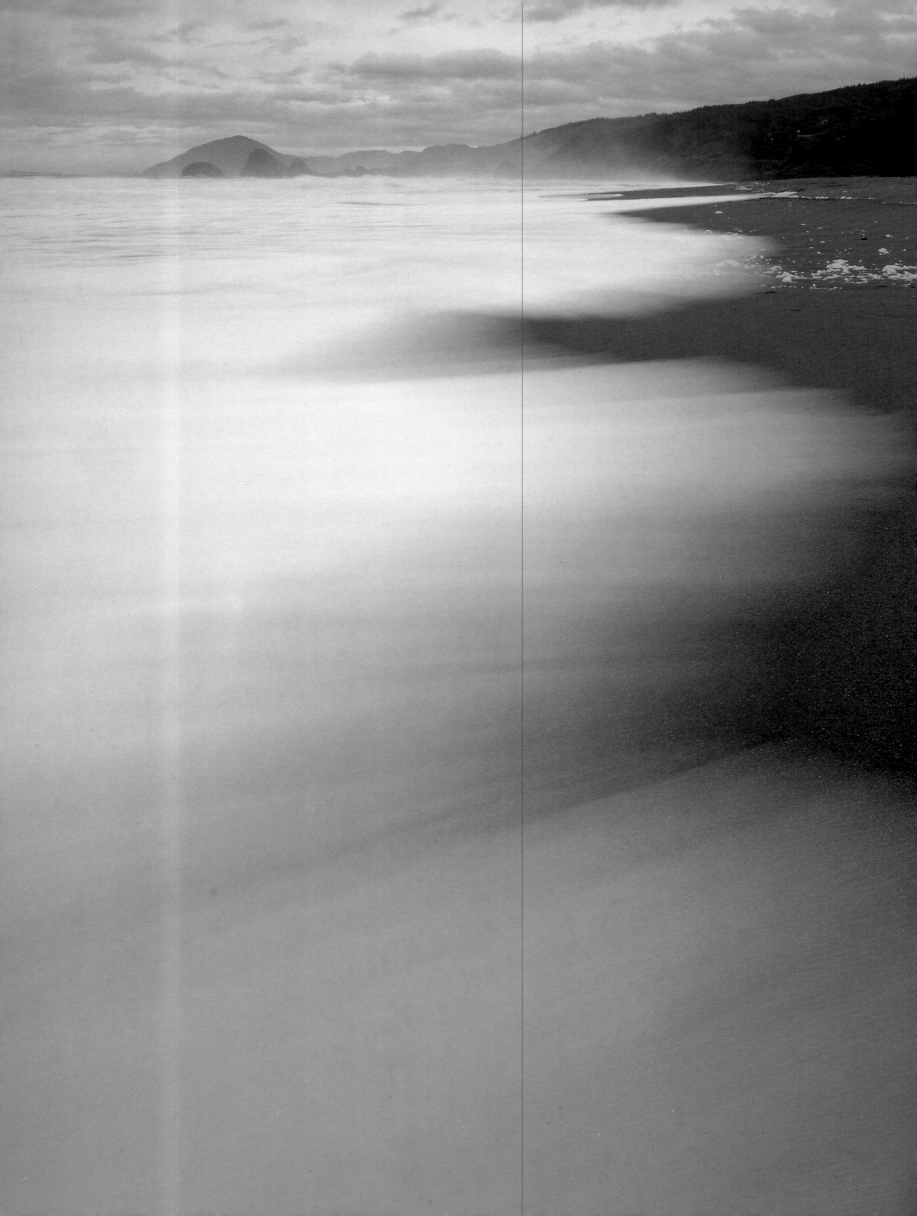

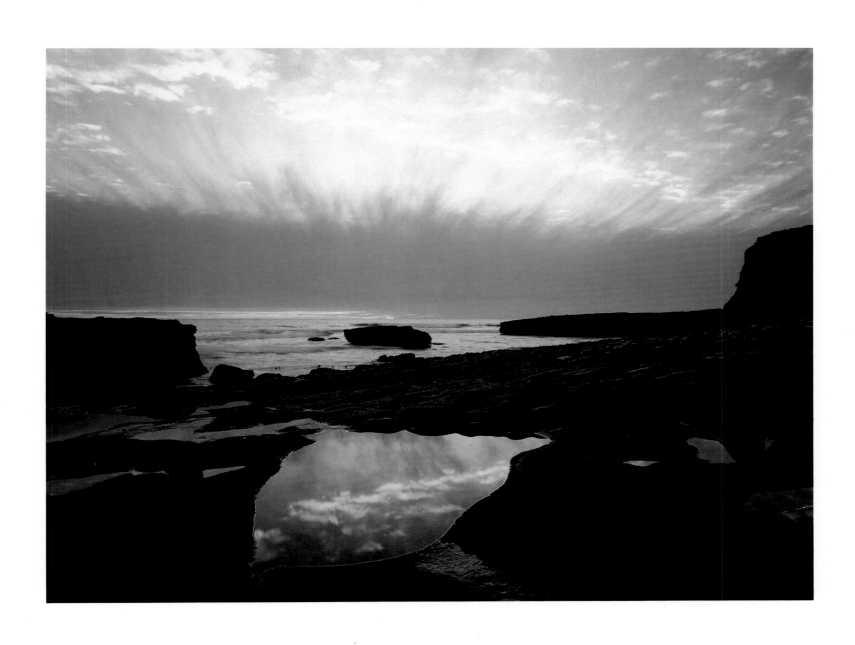

Left: Surging surf, Humbug Mountain, Oregon

Above: Tidal pool, Santa Cruz Coastline, California

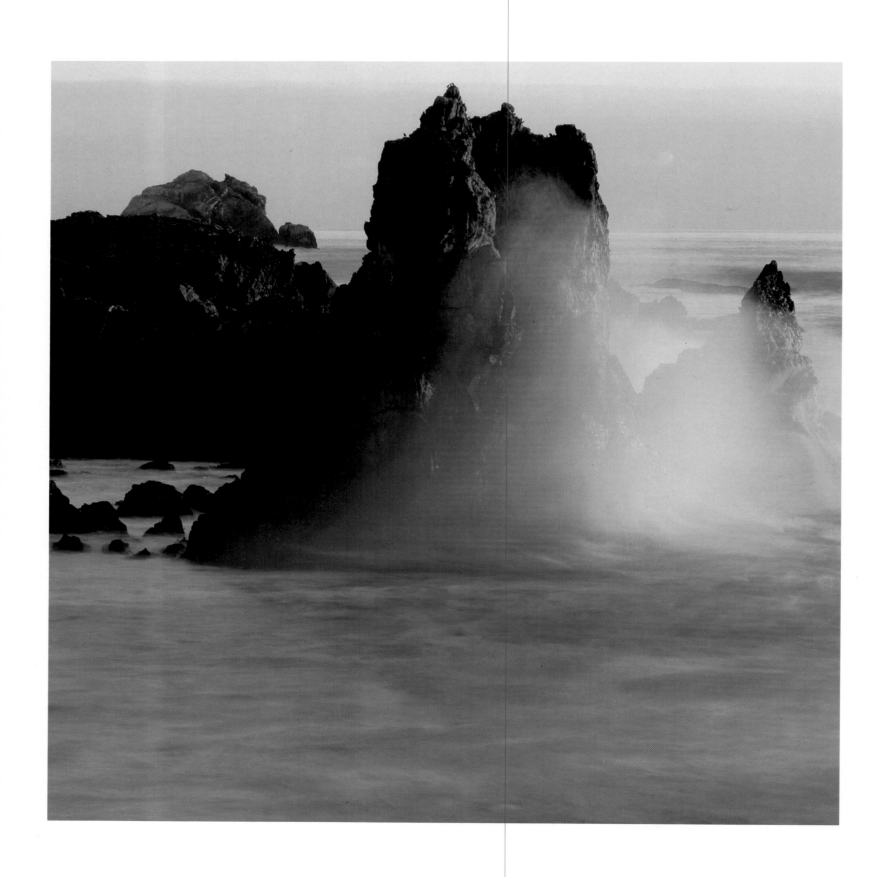

Seastacks and Pacific waves, Big Sur Coastline, California

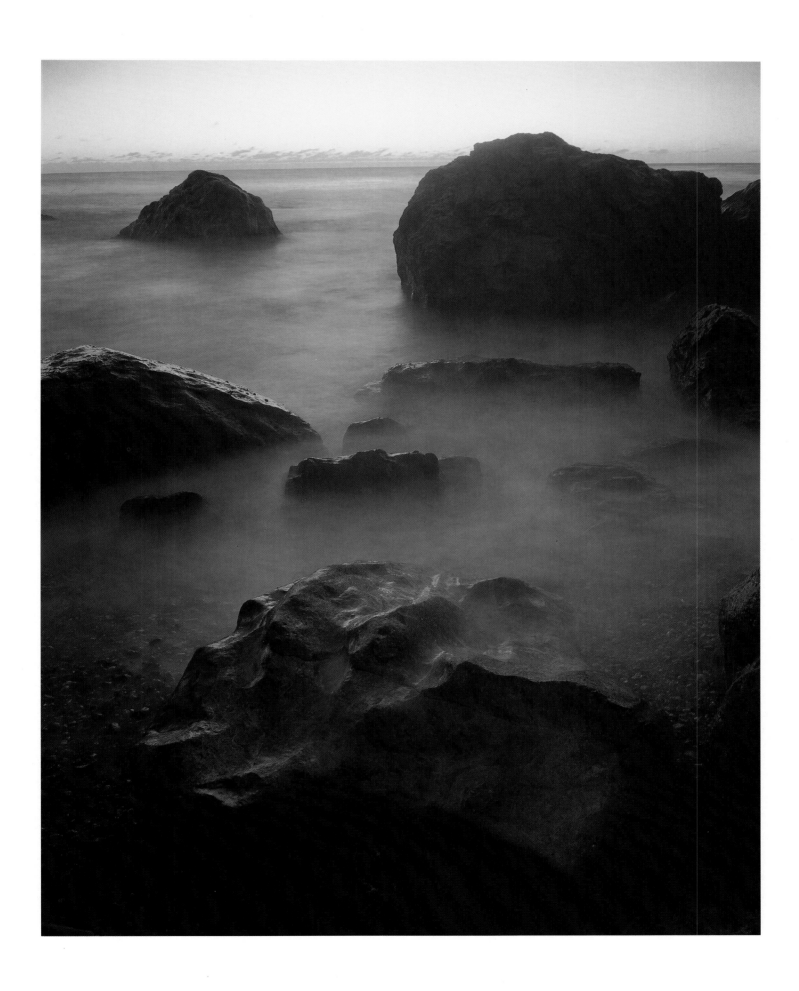

Evening flow of Pacific Ocean, Big Sur Coastline, California

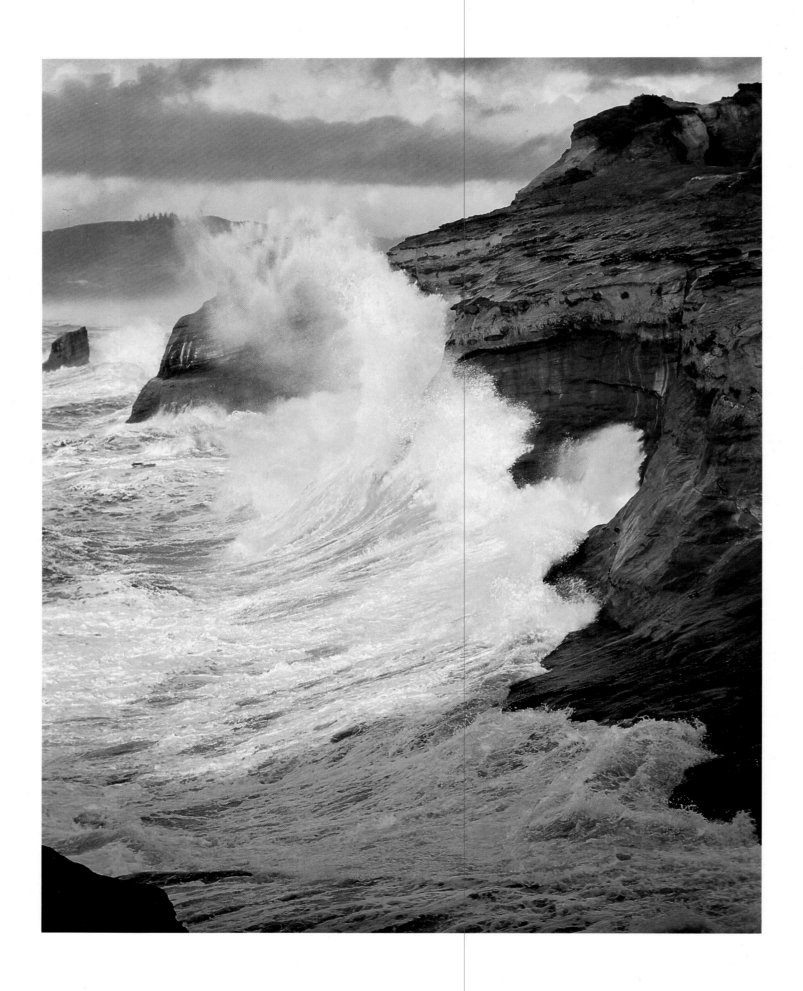

Crashing breaker, Cape Kiwanda, Oregon

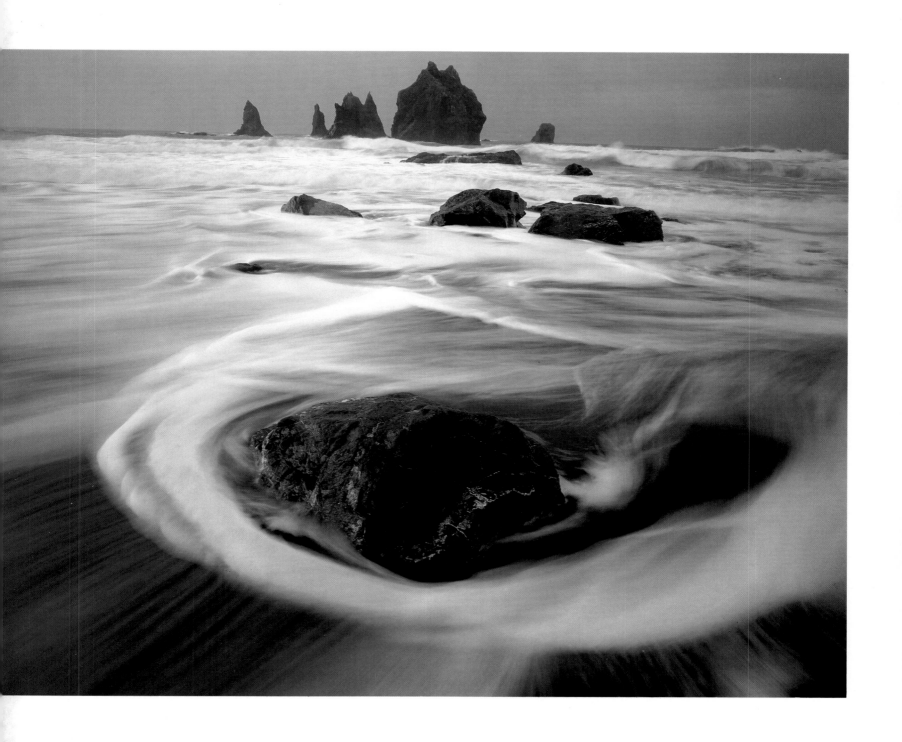

Winter tidal flow, Boardman State Park, Oregon